A Field Guide
to a New Meta-field:

................Bridging the
Humanities–
Neurosciences
Divide

EDITED BY Barbara Maria Stafford

.................UNIVERSITY OF

CHICAGO PRESS

CHICAGO

AND LONDON

BARBARA MARIA STAFFORD
is the William B. Ogden
Distinguished Service Professor
Emerita at the University of
Chicago and Distinguished
Visiting University Professor
at the Georgia Institute of
Technology. She is the author
of numerous books, including
*Echo Objects: The Cognitive Work
of Images*, also published by the
University of Chicago Press.

The University of Chicago Press, Chicago 60637

The University of Chicago Press, Ltd., London

© 2011 by The University of Chicago

All rights reserved. Published 2011.

Printed in the United States of America

20 19 18 17 16 15 14 13 12 11 1 2 3 4 5

ISBN-13: 978-0-226-77054-3 (cloth)

ISBN-13: 978-0-226-77055-0 (paper)

ISBN-10: 0-226-77054-0 (cloth)

ISBN-10: 0-226-77055-9 (paper)

Library of Congress Cataloging-in-Publication Data

A field guide to a new meta-field : bridging the humanities—neurosciences divide /
edited by Barbara Maria Stafford.

 p. cm.

 Includes index.

 ISBN-13: 978-0-226-77054-3 (cloth : alk. paper)

 ISBN-10: 0-226-77054-0 (cloth : alk. paper)

 ISBN-13: 978-0-226-77055-0 (pbk. : alk. paper)

 ISBN-10: 0-226-77055-9 (pbk. : alk. paper) 1. Neurosciences and the humanities.

2. Neurosciences and the arts. I. Stafford, Barbara Maria, 1941– II. Title.

 RC343.F56 2011

 362.2'5—dc22

 2010048814

♾ The paper used in this publication meets the minimum
requirements of the American National Standard for
Information Sciences—Permanence of Paper for Printed
Library Materials, ANSI Z39.48-1992.

Contents

Preface and Acknowledgments

I want to express my gratitude to the John Templeton Foundation for "investing in the big questions," and to the distinguished members of the cross-disciplinary committee at the University of Southern California who invited me to be their Templeton Fellow for 2008. When the conference call first came, I was still in the throes of shepherding my book *Echo Objects* through the editorial rigors of the University of Chicago Press. But, as I told my future colleagues and hosts Don Miller, Firdaus Udwadia, and Ruth Weisberg, I was honored and delighted by the opportunity to take that book's fresh message to the next logical level—that is, to produce a challenging follow-up volume that proposes new methods and practices. The challenge this collection of essays addresses is to ask what is still missing from both humanities and neurosciences research and teaching that requires our joint attention. How might we design collaborative projects in which all the partners have an equal investment and can expect equal outcomes?

This volume embodies the intellectual aftermath of my six public lectures simulcast on the Internet. Collectively entitled "Crystal and Smoke: Putting Image Back in Mind," they became an extended meditation on educational reform. How might we create cross-disciplinary prototypes that demonstrate a new way of doing our intellectual business? Threaded throughout was the interactional question: How do we widen the visual side of the humanities and social sciences with pertinent data coming from the neurosciences? In turn, how do we broaden the revolutionary innovations coming from the cognitive sciences and neurosciences by injecting the long tradition of equally significant findings stemming from the liberal arts into the formulation of science, engineering, and technology research projects? Stepping outside our respective boxes, how do we articulate new joint purposes, develop innovative undergraduate and graduate programs and degrees, and synthesize complex data differently?

At the time, I did not have another groundbreaking monograph lying around in my desk drawer. What I did have, however, was an adventurous

vision for outlining the contours of a new meta-field—correlating the arts, humanities, and social sciences with the emerging brain sciences around central issues we all share. In short, while preparing these lectures and thinking about their experimental nature, I realized that they might serve as a catalyst in the development of an imaginative research, pedagogical, and institutional agenda furthered by others, not just implemented by myself. I am inspired by the distinction drawn by the late great Lukas Foss between improvising, or working with material we already know, and composing, or creating something we do not know.

The eureka moment occurred after the exciting Templeton-funded USC weekend faculty retreat, held in an elegant intellectual boot camp somewhere in the wilds near Santa Barbara. Capping my various indoor performances in Los Angeles, some thirty scholars from not quite as many fields gathered outdoors to critique my efforts under a large tent in bright sunshine and beneath the stars. I am deeply grateful to them all for their insights. Clearly, collaboration was the appropriate model for thinking differently from the way one normally thinks.

I also want to express my gratitude to the Department of Visual Studies at the University of Buffalo/SUNY; to Nancy Anderson, Millie Chen, Stephanie Rothenberg, Anthony Rozak, Benjamin Van Dyke, and Paul Vanouse; to James Bono, chairman of the Department of History; and also to Tim Dean, director of the Humanities Institute, where I was Distinguished Visiting Professor for the spring term of 2009. I also owe special thanks to Jennifer Griffith, my graduate student assistant for this project. The final months of editing occurred during an Australian summer at the University of Melbourne, where I was Miegunyah Fellow. In the happy surroundings of the Elizabeth Murdoch Building and in the midst of supportive colleagues—especially Jeanette Hoorn, Barbara Creed, Angela Ndalianis, and Wendy Haslem—this volume finally came together.

Like Roger Tory Peterson's field guide to myriad birds, this field guide is grounded in collaboration. Peterson devised a new kind of manual, one that avoided excruciating detail. His succinct and vivid descriptions enable the observer to imagine an unfamiliar bird, say, from its telling erect stance, its peculiar long or short runs, and its characteristic red throat. The contributors to this volume share a similar knack for coherence with Peterson, the famed succes-

sor to Audubon. Each of their cross-disciplinary studies asks a critical question whose resolution has the power to renovate an existing field or even inaugurate a new one. From clouds of data, the authors extract core issues that each field alone is unable to address adequately. Their case studies span anthropology, architecture, art history, classics, cognitive psychology, musicology, neuroanatomy, religion, geography, urban studies, time-based media, and cultural studies. In addition to being a field guide, this book serves as a primer to intellectual possibilities and best practices in a metadiscipline that does not yet exist.

To that end, Thomas Habinek knits together the Stoic accounts of perception and epistemology to reflect on the material monism that is an underexamined feature of much contemporary neuroscience. Susanne Küchler explores the relation between smart materials, technical textiles, and distributed personhood, seeing connections between the fibrous-membraneous structure of wearable computing devices and a decentralized self-organizing consciousness. The creation of autonomous systems that mimic and even exceed human performance, however, does not negate the fact that humans are still evolving and responding to natural selection. Naoum P. Issa finds that a surprising amount of complex processing of sensory signals goes on in the eyes and ears well before information reaches the cerebral cortex. This means that physiological reactions and the development of aesthetic sensibilities—such as style and taste—are shaped by an extended, not just embedded, mind.

Philip J. Ethington explores the psychogeography of place-based studies operating at the interface between the experiencing agent and his or her ambient. He modifies the multimodal workspace model of Jean-Pierre Changeux to propose that the humanities and neurosciences come together around the central cognitive/visual issue of *perspective*. By interpreting this bridging concept stereoscopically, he establishes a middle ground between biology and sociology, natural scientific thinking, and critical/historical hermeneutics. Frank Echenhofer's fieldwork on the hallucinatory visions accompanying the ingestion of the Amazonian brew ayahuasca uncovers a compounding system ruling space-time compression. The brain's spontaneous generation of hybrid images during transformative psychedelic healing sheds vital light on syncretic cultural imagery in general—from ancient grotesques to present-day montage. Questions of personal agency, intersubjective behavior, and shamanic divination also preoccupy Anne C. Benvenuti and

Elizabeth J. L. Davenport. Arguing that current academically defined theology is often disengaged from the rituals of everyday life, they call for the rise of a "new archaic," or religious studies grounded in mindful performance. Using a neurophenomenological approach, they construct a practice-based method for integrating ordinary with mystical experience, meditative self-awareness with planetary consciousness.

David Bashwiner is fascinated by the affective power of the sonic and the gestural. He argues that the vertiginous, motion-sharing Viennese waltz demonstrates how certain kinds of music playfully provoke new ways of moving and being moved. Not only does the accelerated whirling of Johann Strauss Jr. make visible the feeling of what happens, but it also sheds light on a general aesthetics of the sensational effect—that is, of danceability itself. Such exultant sensation is the reverse of Sarah Williams Goldhagen's analysis of Alvar Aalto's instinctual rationalism. She unearths an unconventional, anti-Cartesian modernism lodged in the Finnish architect's pragmatic connection of building design to the phenomenology of body-based metaphors. Nicholas Tresilian rounds out our efforts. To refine neuroscientific ideas about mirroring, mirror neurons, and mirror systems, he outlines a theory of collective visual cultural action: many mimicking memes coevolving in a similar direction in many different minds. Conversely, his comparison of Renaissance and modern art movements—engram-like memory pockets—illuminate the enduring operations of the amygdala and hippocampus—those chart or map rooms of the human brain.

My own essay, in turn, serves as an overarching introduction to the entire enterprise. It condenses and distills what I sketched while thinking aloud three winters ago in Los Angeles. Since surprises are the lifeblood of exploration, I tried to preserve in my text the excitement of discovering things directly as I spoke. What I attempt to retain in this writing of those weeks of conversational lecturing is the fact that I could not predict what I would find—because of the lively audience response, the variety and multiplicity of the material, and what I learned about myself and others in the process.

Before I built a wall I'd ask to know,
What I was walling in or walling out.
—ROBERT FROST

INTRODUCTION # Crystal and Smoke

PUTTING IMAGE BACK IN MIND

Barbara Maria Stafford

After watching my Templeton Lectures online, the British art historian Nicholas Tresilian asked whether I could now perhaps write another book, one "for we beginners." If *Echo Objects* correlated cutting-edge facets of the neurosciences with core instances from the history of art, then the conversational directness of the lectures stimulated the voicing of my own insights about mind-artifact relations. *Echo Objects*, then, was all about the rich possibilities. But it needed another book to identify the real potentials for action, and so spring the revolution in thought. Heeding his cry to *cherchez le potentiel*, I offer my intuitions about what the brain sciences need to do to get closer to the truths of art and what the arts need to do to get closer to the truths of science. After all, the concept of the *aesthetic* has long located art within a science of sensuous knowing. What the neurosciences and cognitive science are now adding to the equation is the exciting possibility of getting closer to the underlying *conditions* fueling that ancient relationship. They make it respectable to argue that there is insight that transcends its historical moment.

This enactive or neurophenomenological accounting of the intelligence lodged in the body (that is, in visual, kinaesthetic, haptic, acoustic, olfactory, and visceral sensations) is anticipated in Emily Dickinson's probing question: How is it that in moments of creative invention, "the Mind is so near itself" that it cannot see distinctly, yet is able to fit phenomena together, share actions, and elicit similar emotions in others? A similar perplexity drives physicist Brian Greene, who, in Wordsworth's fashion, wonders at the fact that in all forms of things there seems to be a mind. Could this be why our intellectual journeys are "all uncertainty and possibility engaged in an endless chaotic dance?"[1] Both sides of the wide disciplinary aisle thus seem to need one another, and both contend that it is the mysteries of science as well as those of art that make the soul ache to understand the shaping powers of the hu-

1

man mind—the uncanny ability to cocreate or "half-create" with the rest of creation.

In Dickinson's spirit of reciprocity, then, this volume is neither a survey nor an encyclopedia. The breadth of areas considered and the succinct presentation of topics add up to a notational field guide, not an elaborate fait accompli. The contributors resemble avid birders in that first comes performance, or the initial defining spotting. Our hope is that these glimpses will prompt additional sightings by other researchers and thus bring more and more characteristics to the fore. There is no claim to a comprehensive view— itself an impossible task, as I noted in *Echo Objects*—since the neurosciences continue to grow exponentially and are divided into many theoretical camps, not unlike the humanities and social sciences. Nonetheless, as a group we side with the proponents of an enactive, embedded, phenomenological, and distributed cognition. Specifically, neural Darwinism—seeing biology and culture as complexly coevolving—excitingly opens up for analysis experiences that are beyond words. At its core, this theory concerns the evolutionary adaptation of all biopsychosocial practices with reference to their physical integration into the greater environmental whole and lived reality.

This introductory essay, in tandem with the other essays in this book, cocreates a set of perspectives on one of the most pressing intellectual issues of our times: how to inlay research coming from the humanities and social sciences with that coming from the emerging brain sciences to mutual benefit. Beyond that, we ask in provocative ways how the visual and sensory-based side of the humanities and social sciences might fruitfully contribute its evidentiary share to the neurosciences (expanding the current focus on cognitive linguistics), and vice versa. We believe our template approach lends itself to transdisciplinary implementation within innovative university programs.

Classicist Thomas Habinek's opening gambit on ancient Stoicism's "tentacular" pathway sets the stage for the modern reimagining of higher education through collaborative projects, modeled in the ensuing essays. Habinek's observations on the relationship between Stoic epistemology and the material monism characterizing much contemporary neuroscience as well as the "new" philosophy of mind form the backdrop to Susanne Küchler's study of material innovation embodied in smart mindware. An anthropologist of the Pacific, specifically of New Ireland and Cook Island, Küchler dwells on the

ethnological implications of technological materiality considered in relation to the fiber-based microgenetic stuff of thought. Neuroanatomist Naoum P. Issa is fascinated by the ways in which the precortical principles of perception differentially manifest themselves in various artistic media. How, in fact, do the oscillating phase transitions generating an internal pattern become externalized into a particular form or predictable shape? Appropriately at the midpoint of this book, geographer-demographer Philip J. Ethington reminds readers again of its larger aim. He mobilizes Wheatstone's nineteenth-century discovery of the stereoscope and stereoscopy to construct a historical and hermeneutic model of doubled and redoubling seeing, or what he terms the sociovisual perspective.

Cognitive psychologist Frank Echehofer moves beyond the normal illusions generated by our visual system to create a typology of the visionary kinds of compound imagery unleashed in psychotropic hallucinations. The ritualistic component of his scientific research into ayahuasca ingestion in Peru and Ecuador logically opens out to Anne C. Benvenuti and Elizabeth J. L. Davenport's development of a natural theory of religion. In their dual capacity as ordained ministers and professors of divinity, they focus on the underlying neuroarchitecture that connects global archaic shamanism with the neuroscience of meditation. While spiritual ecstasy cannot be reduced to the frenzy of a Strauss waltz, this mesmerizing dance similarly involves a compulsive response connecting vision, motion, and emotion. Musicologist David Michael Bashwiner asks what is neurophysiologically hypnotic about choreography, sound, and the intelligence of the body that makes listeners consent to the feelings of others and "lift the foot."

The reverse of the coin of embodied sensation is embodied rationalism. Architectural historian and critic Sarah Williams Goldhagen resurrects that undertheorized Nordic practitioner of modernist architecture, Alvar Aalto. The seminal buildings of this Finnish contemporary of Ludwig Mies van der Rohe and Walter Gropius demonstrate both the creator's and the viewer's powers of cross-domain association as well as the universality of qualia-laden body-based metaphors. Historian of broadcast and time-based media Nicholas Tresilan has the last word. In his Bayesian economic and expanded empiricist account of visual cultural development since the Renaissance, this former program director for the BBC in Eastern Europe sketches the contours of

how the micro-structure of particular brain states is momentarily mirrored in worldly macro-trends.

It is not the sum of these essays that comprise the meta-field. It is the significant questions posed, the variety of disciplinary perspectives represented, and the concrete demonstration of what is to be intellectually gained from such a dual manner of inquiry that prepares the ground for emergence. It seems worth repeating that what makes this collection unique is that each of the essays instantiates an *equally knowledgeable* Janus-faced method. Each case study wears the double aspect of the humanities or social sciences and the neurosciences in order to tackle joint problems that would otherwise remain unsolvable and sometimes inconceivable. Consult this field guide, then, like a useful manual. Its purpose is to serve as both the inspiration and the backcloth to the more generalized institutional performance of putting shoulder to the wheel in the construction of a new synthetic field—a dynamic meta- or intersectional field that is still in the state of becoming. No single map yet exists to chart the terrain of its emergence. But we break fertile ground by showing major areas of overlap as well as pointing to the next levels of integration.

. .

Turning to my own labors, I establish a broad conceptual framework for the volume. Its six thematic sections also sketch the progression of my Templeton Lectures and their inquiry into the nature and function of images. I ask why certain generic structures, compositional formats, or types of visual organization—past and present—exist globally. Apparently images and the varieties of imaging—beginning with the information-hungry diagram and extending to compressed and compound figures—are as fundamental to what human beings are, and think they are, as language. Artistic or high-order visual formats, in particular, display a wealth of strategies for revealing conscious and unconscious cognitive functions. While much work has been done on metaphoric mappings,[2] far less has been expended on performative—that is, presentational or mantic—methods of communication. If cognitive science and neuroscience are always going down to investigate microphenomena, and cultural studies are always going up to examine macrophenomena, then space-crossing and process-mapping images are a participatory way of

drawing those two wayward enterprises together. This is true even if the way down is not identical to the way up.

Imaging techniques and technologies lie at the heart of some of the most pressing and persistent problems facing society today. Visualization also paves the way for our current efforts to understand the origin and nature of human cognition. The forgotten systematicity, or formalism, of images—the rules by which they *compose* and *decompose* the structural aspects of experience—and not their illustration of this or that brain mechanism or pathology sheds light on their regulatory role in concept construction as well as on the integrative properties of the nervous system. Milan Kundera, speaking of the need for a world literature rather than just identification with "the small—national—context of whichever literature they [professors] teach," defined "provincialism" as "the inability (or the refusal) to see one's own culture in the large context." The same could be said of continuing to maintain the alienness or inaccessibility of the arts, humanities, and sciences to our deepest concerns.

Visual, acoustic, haptic, gustatory, and olfactory patterns, mobilized in space and time, constitute a vast repertoire of nondiscursive types of communication. That dance, music, architecture, sculpture, painting, film, performance, installation, and Web art variously do things with our bodies and to our minds—signifying through some kind of bodily action—fascinated early phenomenologists from Edmund Husserl to Maurice Merleau-Ponty. Enaction continues to be relevant to research on the embodied, embedded, and distributed aspects of cognition by experts from Humberto Maturana and Francisco Varela to Andy Clark and Alva Nöe. Seeing, then, is not something that happens in the brain; it occurs as we easily or awkwardly, confidently or hesitantly, explore our surroundings.[3] And these surroundings with their attendant emotional atmospheres vary from being comfortably familiar to being disorientingly estranging.

Something of the complexity, as well as the perplexity, aroused by multiplying media ambients is encapsulated in the paradoxical perception that today's museums, especially art museums, are successful despite their failure to communicate. The museum is a good place to begin my reflections because, unfortunately, the public understanding of art as an aesthetic entertainment with leisure value is a perception shared by many scientists. This

perception needs to be kept in mind as an obstacle that still needs overcoming. On the other hand, while it is frequently claimed that "the modern museum's raison d'etre is display,"[4] what does that display, in fact, offer the embodied viewer? Recent practice-based research aspects of curation offer one arena where pragmatic notions of performance are brought together with the art world and its artifacts. Alternate models of curatorial design, such as the exploration of interactive distributed display outside established gallery venues, challenge passive ways of curating old as well as new media (think, for example, of head-mounted augmented reality and multi-user systems, sensor-based technologies, and game- or time-based art). But they also conceptualize design for life—ways to take up the more general challenge of the increasing multimedia nature of contemporary reality, of which the museum—no matter its contents—is but one salient manifestation.

I began with the case of the transdisciplinary multimedia museum—operating at the intersection of engineering, robotics, physical, biological, and computer sciences, digital technologies, myriad arts including performance, and unconventional architecture as well as innovative exhibition spaces—because it trains a new kind of sophisticated agent-viewer. Defying our most deeply rooted mental habits and fixed categories, such shifting environments fundamentally question the stability and persistence of the individual object as well as the self-contained subject. Such novel milieus set the stage for a larger psychophysiological transformation. They have the potential to model for the media-savvy and media-saturated onlooker how to become an intelligent participant, actively cocreating one's surroundings. As is true in real-life situations, a sociable art that breaks isolating modes of reception is something more than a spectator, or single-connoisseur, sport.

The question of what it takes to learn something new is pertinent for the communication of data *tout court*. Insight occurs when we stage ideas as specific shapes: brilliant and hard, or nebulous, fitful, even cascading, so that we become aware of them. As Aristotle put it, there is no thought without images. But the form an image assumes owes to biological and cultural constraints. Its frame or particular look of coherence depends, among other things, upon which operational system is foregrounded. Does it target neural mechanisms that react to the discrete, qualitative properties of a sensation? Conversely, is it attuned to flux and the illusory stream of consciousness? Or

does ambiguity reign, as in equivocal shapes? It would indeed take an imaginatively designed interactive museum setting to put such singular contingencies in revealing dialogue with the dynamic continuum from which they have become abstracted!

But we are getting ahead of ourselves. What exactly is this notoriously vague term, "image?" Its etymology derives from two seemingly contradictory Latin words. The first conjures up the indistinctness of the phantasmatic *imago* as well as the blur of the sketchy *imagines*. The second evokes their apparent opposite: the edgier, contouring *imitare*. Both connotations, whether of vibrating energy source and turbulent emission (as in cloudy apparition, flickering fire, hazy smoke) or of durable information-bearer (as in doubling imitation, duplicating data record, hard copy) emphasize gap-jumping, the fact that images not only make connections but also make the invisible mental leap involved visible and persistent.

This doubleness of vision owes to a hugely complex brain: a tapestry woven of some hundred billion neurons, or nerve cells, each sharing as many as ten thousand connections with other neurons. It is not accidental that arborization metaphors abound in its description. Think of dendrites, the large bush of threadlike branches that project beyond the body of the cell and receive signals from other neurons while the long trunk of the axon extends below, occasionally shooting off, rootlike, to join forces with other neurons. Significantly, most neurons are not tied together but leave gaps between the terminus in one neuron, which transmits electrical signals, and the receptor of those signals in the adjacent neuron. Synapses (from the Greek "to bind together") occur where those signals are transmitted across the twenty-nanometer-wide synaptic cleft. This theory, developed more than a century ago by the great Spanish neuroanatomist Ramón y Cajal, was challenged by an alternative theory spelled out in the 1960s by Jean-Pierre Changeux. Changeux's chemical theory proposed that an electrical impulse caused a chemical signal to move across the cleft and communicate or bind with the most proximate cell in its assembly, although electricity continued to be relayed inside each cell.

Here we can spot a basic congruency between the dual meaning of "image" and the conjunctive powers of the nervous system.[5] With a working theory for neuron-to-neuron communication in hand, Changeux and, increasingly,

other neuroscientists turned to study ways in which larger brain structures might alter these basic interactions through specialized distribution and regulatory networks (that is, by channeling neurotransmitters such as acetylcholine, dopamine, or serotonin). With Jacques Monod, Changeux developed the idea that when a chemical neurotransmitter binds to a receptor located just across the synaptic cleft, it opens a pore allowing ions to flow into the neuron. Thus the chemical signal is converted back into an electrical signal and the message gets passed down the line, affecting the metabolism for a time.[6]

Not unlike higher-order cognitive functions such as memory—that is, the ability to hold in mind a limited amount of information for as long as that information is needed to accomplish some behavioral goal—such operations highlight the many transient alterations occurring in the brain activity of healthy adults. Electrical and chemical messages mostly come and go. The trick is to make them stay awhile. Our body is physiologically designed for shifting sensory input—the pure phenomenological pleasure of just experiencing. But cultural formatting allows it to linger by transforming those fleeting impulses into voluntary movements and the higher perceptual and cognitive activity of cross-cortical integration.

Not coincidentally, Changeux's research also enabled current investigations into adult neurogenesis or neuroplasticity—that is, the formation of new neurons in the brain. This raises the question of how works of art, or any high-order type of imaging, continue to train us to think. I propose that effortful visual formats challenge us to see the contribution of isolated processes to the making of any perceived whole. These conceptually labor-intensive genres, which shoehorn multifaceted data into scaffolding frameworks, stimulate neuroplasticity. Throughout life, they not only oblige us to take in more visual information than we can readily absorb (due to our innate lack of RAM), but also summon us to struggle to organize it. One consequence of this demanding activity is that the behaviors of large populations of interacting cells get renewed in regions like the hippocampus, the brain's learning and memory center.[7]

Changeux traces the outlines of what might be called a performative theory of consciousness, in which learning and awareness evolve.[8] Further, if—as Gerald Edelman, among others, asserts—conscious experience is character-

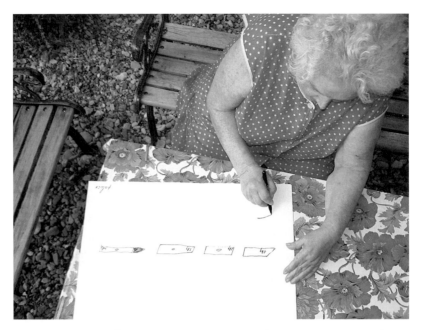

FIGURE 0.1. Kateřina Šedá, *It Doesn't Matter*, 2005. Courtesy of the artist and Arratia, Beer, Berlin.

ized by unity, then the varieties of artistic composition succeed in doing precisely what the individual subject cannot do: subdivide a persistent conscious state into its independent components at any instant and make it visible.[9] This cognitive perspective allows us to see in a new light the practice-based installation piece *It Doesn't Matter*, curated by Czech artist Katerina Šedá for the Renaissance Society at the University of Chicago in 2007 (figure 0.1).

After the death of her husband the artist's grandmother, Jana, no longer dressed or washed herself. She would not cook, or clean, or go out; she just passively watched television. To remind the despondent elderly woman of the energetic person she had once been, Šedá challenged her grandmother both mentally and manually. In effect, she flung down a labor-intensive intellectual gauntlet that necessitated the retraining of faded mental abilities and the development of new practical skills in what was obviously a listless and depressed person. Amazingly, the challenge yielded some 650 diagrammatic drawings made from memory, all labeled, of miscellaneous ordinary objects like putty knives, saw blades, spanners, mops, ladders, typewriters, and even washing machines.

For thirty-three years Jana had been head of a stock room at a home-supply shop in Brunn. Significantly, she remembered not only the essential appearance of its vastly diverse items, but also their prices! This drawing project, then, reconnected her semantic summary knowledge (evident in the parsimonious design format) with her episodic memory database (the cost of various items), thus enabling her to revaluate her own past behavior in light of new information.[10] This cortical reclamation project thus demonstrates the close connection between creativity and memory and provides incontrovertible evidence for plasticity in neural networks. It demonstrates how culture and biology intersect, as well as the effect of the environment on brain activity and its microanatomy—captured in dancer Yvonne Rainer's comment: "The mind is a muscle." Last but not least, neuroplasticity illuminates the real consequences of attending to someone else, illustrates the fact that art is an adaptive social practice, and contributes substantially to the sociality so central to evolution.[11]

Whether conceived as ephemeral or lasting, images have the uncanny ability to bridge binary systems: the material with the immaterial, the physical with the mental, appearance with reality. This action-view of visual media corresponds to our innately performative perceptual processes, which are capable of jumping over great divides. Kinesis is tightly coupled with visual perception. Proprioceptive experiences, stemming from the joints and muscles, are entwined with somatoceptive perceptions, arising from the viscera, and these in turn color our exteroceptive experiences, those visual and auditory events originating at the surface of the body in response to stimuli coming from the surrounding ambient.

Edelman pushes Changeux's Darwinian perspective by taking the great Victorian naturalist's population thinking down to the level of neuroscience. Selectionism, he argues, encompasses the hypothesis that every integrated mental scene results from "reentrant interactions among groups of neurons distributed in the thalamocortical system." Just as variation or diversity in a large animal population provides a basis for competition in the production of "fitter individuals," the brain develops an extensive "primary repertoire" of highly variant neuronal groups shaping brain anatomy that are sculpted by personal experience into a pruned "secondary repertoire" of strengthened connections. These synapses eventually ensure the spatiotemporal correla-

tion of selected neural events and the individually determined reinforcement of reciprocal connections between and among distributed neuronal groups.[12]

For Edelman, memory is an active re-creation of a previous act. Such constructive recategorization far exceeds Changeux's more stable "global" representations replicating a prior event. Edelman explicitly develops a view of memory as enactment with emotional resonance. It is the interactive result of circuitry, synaptic changes, biochemistry, and behavioral constraints which, when taken together, allows for the creative reimagining of an analogous experience separated from the original situation by a lapse of time.

Establishing a fundamental link between creativity and memory is the key to a theory of art rooted not in representation but in performative or mantic presentational/real-time systems. Like the ancient diviner's or shaman's act of summoning an invisible force or spirit to show itself, such art does not re-present what already exists; it presents what is coming into being before the eyes. This physical instantiation of what had been invisible a moment earlier initiates a response pattern prompting the beholder to mirroring reenaction. Demonstration is an art practice that not only makes us conscious that our senses are continuously confronted by a chaotic and shifting world without labels, but summons us to struggle, reckon, and grasp it intentionally. Mirroring thus rises above being an involuntary instinct to being voluntary and reflective.

The mirror-neuron theory first developed by Giacomo Rizzolatti and his colleagues at the University of Parma in the early 1990s considerably advances this view that "the acting brain is also and above all a brain that understands."[13] Vittorio Gallese asks what the relationships are between mirror neurons and the development of intersubjectivity in humans and higher mammals. For Gallese as well as for Jean Decety, social cognition evolves from the emulative and empathetic exchange with other members of a group or tribe. Affect, memory capacity, feature extraction, pattern recognition, and matching all entail a view of the brain-mind continuum lodged deep inside the feeling, phenomenal body. Motor, perceptual, and cognitive processes are thus embedded in all forms of constructive re-imaging or re-imagining. What works of art do that is special, however, is let us witness those hidden dynamics in action as well as spur us to internalize them. More generally, pattern recognition and pattern generation, as types of nonlinguistic cognition,

reveal how humans parse visual information—those compositional forms, formats, formulas, and schemas that allow the brain to digest new images leading to the cocreation of meaning at every instant.

The Emotional Intuition of Form

The form of the lake is most perfect when, like Derwent water, and some of the smaller lakes, it least resembles that of a river.
—WILLIAM WORDSWORTH[14]

Making sense of sight preoccupies Allen Samuels, an industrial designer at the University of Michigan who developed new products over a lifetime. He comments, "Designed objects are created to express to users in non-verbal and visual ways the inherent qualities found in the object. . . ." Not unlike in the case of Wordsworth's appreciation for the natural design of England's Lake District, some forty years of designing artifacts have convinced Samuels that the morphological information conveyed is "universal in some fundamental way."[15] Like art, designed and mass-produced objects are bearers of meaning. The idea that visual cues communicate specific messages has a distinguished ancestry.

Schematic shapes, lodged deep inside messier surface detail, map the initial biopsychological settings, the primitive reactive attitudes, from which we learn to deviate or by whose standard we implicitly adjust our perceptual judgments. Consider them the information-carrying features for the neural signals that drive behavior. Systematic detection is required to seize the telling form from the surrounding chatter. Intervention, as both a pragmatic art and an applied science, isolates or forces the relevant features to pop out from the variation.

According to the *Oxford English Dictionary*, form is the structure of a thing, something that presents itself. It is that which unifies and identifies something in contradistinction to other things. Human minds are structured in such a way that they spontaneously grasp the structure of things. I am not suggesting the mental reproduction of external forms but, rather, their concordance with our neural machinery along the lines, say, of mathematician Jack Cowan's correlation of the crystalline structure of the striate cortex

with the carpentered world of edges. Similarly, cognitive psychologist Mark Hauser revisits the Kantian claim that the origins of our sense of right and wrong are rooted in expectations about patterns of action in the world. Apparently, we all possess a "skeletal database of knowledge about the world available to us even before we can act on the world."[16] But a consideration of the spatiotemporal, "phasic" knowledge of many separate rudimentary phenomena acting together under different conditions is generally lacking in both the arts and neuroscientific research.[17] A key future direction in transdisciplinary design, then, would not just probe isolated cells or objects but capture them during simultaneous activity. The design of syncretic *formats* that pull the essential out of multimodal patterns and tie them together has thus become critical in information processing across the board.

But the most transformative discovery to date comes from the laboratory of Stanislas Dehaene, the French neuroscientist long preoccupied with studying numerical sense and "reading in the brain."[18] Dehaene's research group has developed a theory of "neuronal recycling" based on the Darwinian assumption that humans are primates. Consequently, ventral regions—such as those dedicated to visual recognition in monkeys—have been repurposed in humans during the course of evolution to respond not just to an "alphabet of shapes" (the source of all other shapes) but to other kinds of marks as well. What makes Dehaene's theory so vital for those of us interested in the *image* side of things is his argument that writing systems—which are recent, optional, and had no selective pressure originally driving them—must have emerged *for* the brain *because* they were easily learnable by the brain, and not the other way around.

Dehaene thus convincingly establishes a novel way of conceiving the relationship between vision and language as well as between their cultural manifestations, visual art and literature. As the Romantic creators of a grammar or logic of graphic patterns similarly argued, regular configurations are not just accidents of history. They arose in the minds of our prehistoric ancestors precisely because our neural systems are attuned to *basic visual shapes* (bigrams) that correspond to the statistical features of the external world. Perhaps the shapes that could initially be seen by the brain were constrained by environmental factors demanding that they not be easily occluded. Perhaps we evolved so as to adapt to the linear primes distributed around us.

This neuroanatomical insight into the intersection of the visual with the reading system gains from being embedded within evolutionary psychology. It seems that human neural circuits were designed by natural selection to solve the adaptive problems our ancestors faced during the long developmental history of our species. There are additional corroborating theories concerning the elective stabilization of the synapses, the evolution of the central nervous system, somatic selectionism, and any number of ways in which human brains diverged from those of apes and monkeys. Significantly, these theories all emphasize the key role of selective mechanisms acting positively or negatively during an individual's development. These mechanisms accustom the brain to the internal and external environments to which the organism is instinctively matched.

Neuroscience, then, helps us escape the popular misconception that art is merely a free-for-all, as well as the academic conviction that "formalism" is a laughable construct. Among other things, taking form seriously restores dignity to the Romantic quest for the symbolic logic ruling all mindful compositions. Condensing diagrams and schematic configurations function as markers in a noisy environment; they show perception to be a complex psychophysical process. Subliminal snatching is the spontaneous "retrieval of meaning or direct grasping"[19] of an implicitly understood rule from subtly and not-so-subtly disorganized sensory data.

Skeletal forms resemble what contemporary artist Joel Fisher terms "prepositional drawing." This object- (not subject-)oriented design possesses a collective authorship. The work is co-made, as it were, by all of us, and so is in some sense anonymous, common, and general. What viewers retrieve or extrapolate from the plethora is a spectrum of possibilities that we then apply to new design situations. This simultaneously innate and acquired grammar of expression demonstrates how things tend to annex other things based on the merest graphic sign.

In music theory, the term "underscore" refers to the fact that the buried thread of a melody can stay out of the way of the dialogue, yet influence it. Similarly, Romantic "grammars of expression" sought to uncover the mind's subterranean intuiting and interpreting machinery externalized in the skeletal formats underlying all complex artistic productions. J. H. Fuseli and William Blake maintained that the viewer could not experience the affective

content of an image if its buried structure did not already appeal to preverbal "primes"—those emotion-laden schema integrating nonconscious mechanisms with higher-order cognition. As Anne C. Benvenuti and Elizabeth J. L. Davenport argue in their essay on the "new archaic" in this volume, this sensuous knowing is typical of oral cultures in which magical techniques of animation succeed in materializing an absent, clarifying presence lodged within otherwise scrambled events.

Many contemporary artists are likewise exploring how image formats can be inevitable rather than random: intrinsically bound to the way our brains are organized. I am thinking of photographers such as Andreas Gursky, whose vertical architecture-scapes of the new megalopolises (e.g., Hong Kong, Shanghai) deliberately engage our embodied eyepoint. The viewer is irresistibly caught up in the ascending swing of arcs, the dynamic rise and fall of the curved lines constituting the exposed armature of futuristic steel and glass urban towers (figure 0.2). Our body, straining to view the constructed sublime of endlessness, thus merges with the city's upsurge—always already going on.

Cold Intimacy / Hot Entanglement: Meaning in Combinations

The tip of the nose seemed the first to be lost
then the arms and legs,
and later the stone penis if such a thing were featured.

. . .

That is the way it goes here
In the diffused light from the translucent roof,
One missing extremity after another—

Digits that got too close to the slicer of time,
Hands snapped off by the clock,
Whole limbs caught in the mortal thresher.

But outside on the city streets,
It is raining, and the pavement shines
With the crisscross traffic of living bodies . . .

—BILLY COLLINS, "Greek and Roman Statuary"[20]

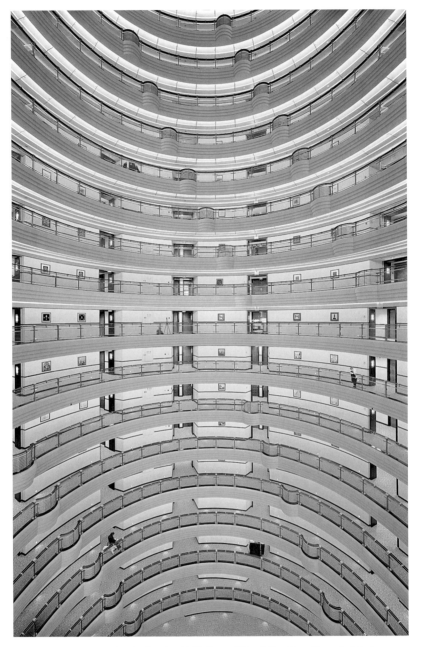

FIGURE 0.2. Andreas Gursky, *Shanghai*, 2000. C-print, 302 × 207 × 6.2 cm (framed). © Andreas Gursky, VG Bild-Kunst, Bonn.

Art is biological because it manifests the designs that life uses to design itself. Art is synthetic because it assembles parts of the body and parts of the world, making them intimate with one another. Art is magical thinking, performing *relationship* or conjugating before our eyes. Art is social because it enacts emotional engagement and mirrors response. Art is about falling in and out of love, deploying the sexual tactics of approach and avoidance, coupling and decoupling. Art romantically generates an ideal world that never was and engineers boundaries within a messy and mutable reality. Art thus is an extension of our central nervous system, making visible how our gestures affect the world while fixing those actions in collective memory.

The fragment, tragicomically evoked in Billy Collins's poem above, liberates the shattered image from the control of the artist. Paradoxically, the dismemberment of a whole, or a totality going to ground, also gives rise to a new form. As a discrete and compoundable entity, the divided piece of matter asserts the autonomy and freedom to commingle with things lying outside the margins of the human. Formatting the fragment, then, becomes a major challenge in designing schemes of cooperation, forging affective networks, and grouping competing subjectivities.

Autonomous processes—like shattering and scattering—open a window onto the erotics of the creative process: that amorous tendency towards disfiguration and figuration, dissolution and coherence. Consider these imagistic lines by Deborah Digges: "The wind blows / through the doors of my heart. / It scatters my sheet music / that climbs like waves from the piano, free of the keys. / Now the notes stripped, black butterflies, / flattened against the screens." The poet shows that our perceptions are torn between the brief certitude of resemblance—that is, knowing who and what things are ("And my dresses / they are lifted like brides come to rest")—and the ambiguity of nonresemblance: the relentless slide of things and situations into entropy and chaos ("From the mantle smashes birds' nests, teacups / full of stars as the wind winds round. / A mist of sort rises and bends and blows / or is blown through the rooms of my heart").[21]

Because of its incompleteness, the fragment also begs to be recomposed. A patching combinatorics lifts discrete units out of their solitary confinement and inserts them into an overall pattern that transforms the former meaning of the parts. A quilt, a kaleidoscope, a Necker cube, and an irregular pane of stained glass (figure 0.3) are all based on the interactive principle of endlessly

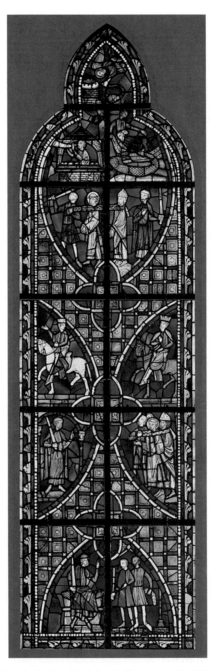

FIGURE 0.3. *Scenes from the Passion of Saint Vincent of Saragossa and the History of His Relics,* 1244–47. Stained glass. Image © The Metropolitan Museum of Art.

recyclable designs unnervingly popping in and out of the visual field and of consciousness. The romance of pattern lies in those moment-to-moment shifts in apprehension marrying the juxtapositive bit to the entangling swirl. Importantly, the intractable and the undulating are complementary modes of imaging. They communicate two fundamental ways of always forming forms: the forceful seizure of shape and the leisurely pursuit of taking shape.

The biological desire to couple is primal, and it has produced an aesthetics of surrender. Love has definite styles of union. By this I mean that the encircling border or closed margin of anything must be either forcibly breached, crashed into, or variously induced to open for a conjunction. In life as well as art, then, abrupt mixtures pose a special organizational problem since they are both a mode of interruption (creating a gap in a continuum) and a type of paratactic adjacency (lying down side by side). Such brusque techniques for forging a physical unity out of disunited components, a one out of many ones, also govern our cognitive processes. Simultaneously self-encapsulated and distributable, juxtaposed bits of data image doublemindedness. They enact a discrete biopsychological way of being in the world: the capacity to stand beside, outside, or alongside oneself.

The mosaic is a reluctant conjugal format because, other things being equal, its natural state is one of rest. This passive functional connectivity, as opposed to active fusion, makes for intimate strangers. A relationship of remote proximity is thus established with someone or something else in which the default mode is deactivation.

Because this reproducible and repetitive artistic format is so ancient, neuroanatomists engaged in observing the brain while in a state of rest should sit up and take note. Recent research has shown that, even at rest, the brain's endogenous activity is *self-organizing* and *highly structured*. Further, it is hypothesized that the mysterious something that is going on is *functional integration* and *distributed processing*.[22] This is exciting to know, because the history of art broadly bears out that the artistic derivatives of this venerable mode of spatial organization (figure 0.4) create connectivity precisely through structural/functional contact that occurs only at the edge. If one ratchets up in scale from the micro- to the macro-level, the bioartistic, biosocial, and biopolitical manifestations are similarly far from static. The meeting of indepen-

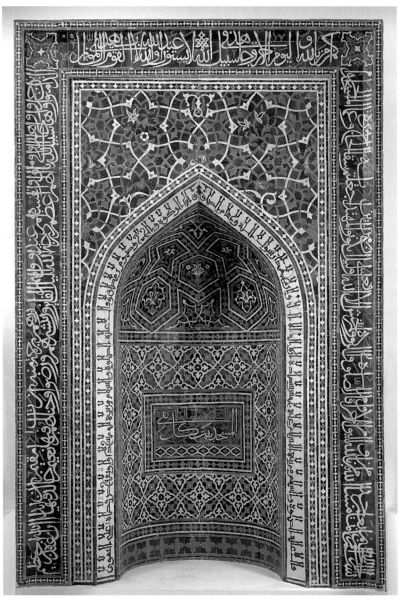

FIGURE 0.4. Mihrab, mosaic of monochrome-glaze tiles on frit body; set into plaster. Image © The Metropolitan Museum of Art

dent units can be abrasive, resulting in behavioral gaucherie—the rough and ready cobbling together of aesthetic, personal, or civic ties.

There is nothing tender or passionate about this stony method of assemblage, which finds a poetic analogue in Ezra Pound's lapidary "imagisme," summed up in the artistic credo of wanting a poetry "as much like granite as it can be." Contrast the marmoreal intractability of Pound's Parnassian visual figures with the gamekeeper Mellor's praise of lush carnality and sensuous touch in D. H. Lawrence's *Lady Chatterley's Lover.* "For passion alone is awake to it [the "living secret body"] . . . the warm, live beauty of contact, and so much deeper than the beauty of vision."[23] The scientific corollary of Pound's custom-built poetics is synthetic biology's vision of cells as hardware. The latter aims to put together a nature-altering foundry of plug-and-play BioBricks made up of standardized pieces of DNA that can be used interchangeably to create and manipulate living cells. Unlike gene manipulation, which has been ongoing for decades, synthetic biology attempts a more radical reconfiguration that transforms molecules into tiny self-contained factories performing entirely new functions.[24]

But the artificial compound challenges more than "the long beautiful Darwinian process of creeping forward by trial and error, struggle and survival" that persisted for millennia. Modifying the smallest components of life as well as art basically entails dismantling, scissoring, or cutting and pasting. The mosaic style of bruising conjunction thus also contrasts with the molten erotics of the intersectional crisscross; consider the evocation of the wind "rak[ing] the bedsheets as though someone / had just made love." Ted Hughes thus speaks of crushing his lover and wife, Sylvia Plath, into his pores in an untamed sexuality. The British poet compares this lack of constraint to the joyful energy of an undomesticated "unpredictable / Powerful bounding fox" held tightly by a man inside his jacket.[25]

Compositional entanglement similarly foregrounds features of the nervous system registering the enveloping impact of strong emotion. As Susanne Küchler notes about fibers and membranes, the example of intertwisting spans a wide range of genres: the lover's knots of interlace, the monograms of embroidery, the interstitch of tapestry, the foliate arabesque, the computational weave of artificial intelligence–laced materials. More broadly, the braiding of contrasting threads with nuanced colors derives culturally from

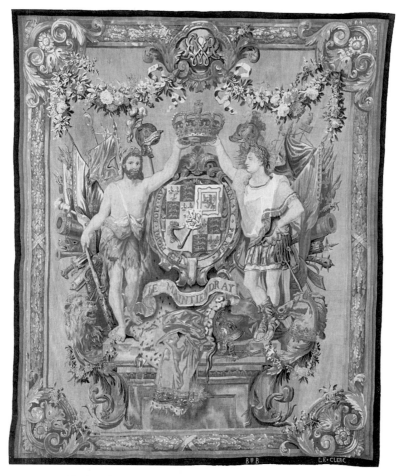

FIGURE 0.5. *The Arms of William and Mary,* 1694–1700. Tapestry. Image © The Metropolitan Museum of Art.

a soft universe of supple cloths and gently draped textiles (figure 0.5). Biologically, it conforms to intermediate vision, which both automatically segregates and groups components together in an otherwise chaotic sensory array. By contrast, the bordered colors and geometric shapes of mosaics—akin to the crystalline facets typical of the mineral kingdom—correspond anatomically to early vision's extraction of simple components from the environment and teasing of constants out of the prismatic blur.

Normally we distinguish between an inner and an outer world. We solip-

sistically consort with our personal demons while putting our subjectivity on display for objective scrutiny. We can do this because the imaginary scenarios devised by the brain recruit the episodic memory system, allowing us to project ourselves backward or forward into other times, places, and perspectives. Rainer Maria Rilke captures this mental oscillation between private fantasy and public action when he defines the artwork as a "condensed and intensified form by which a complex desire might be shown."[26] Rilke concludes *The Book of Hours* with a dualism-breaking stereoscopic moment. Such twin-sightedness, as Philip Ethington reminds us in his essay, is capable of creating unsought correspondences by sliding rhythmically between registers.

> Thus the overflow from things
> pours into you.
> Just as the fountain's higher basins
> Spill down like strands of loosened hair
> Into the lowest vessel,
> So streams the fullness into you

Optically driven attraction initiates the struggle to achieve likeness between individuals who are only approximately alike.[27] Artistic mimesis further enacts this desiring vision by recording not just the questing of our senses but of our entire being. Sight is thus never merely a reaction to a single component in an array.[28] Mounting evidence indicates that visual stimuli come to us in a rhythmic stream corresponding to delta band oscillations in the primary visual cortex. These oscillations, in turn, are entrained to the rhythm of the stream and produce analogous shifts of excitability in local neuronal ensembles.[29]

As Naoum P. Issa's research on the processing of sensory information *before* it reaches the prefrontal cortex shows, mental compounding appears to derive from temporal phase-locking patterns. These are environmentally inflected (predictive) responses to relevant stimuli in the perceptual stream. Importantly, two basic synthesizing styles of formatting sensory experience — the mosaic and the intertwist — suggest a deep interplay between the granularity of consciousness as a first-person singular phenomenon and as an extended third-person phenomenon. The complex formal combinatorics of

visual art and imagistic poetry thus offer a way to reconnect the notion of a unified executive consciousness, under attack since the era of William James and Henri Bergson, with research showing that our actions in fact are initiated even before we are consciously aware of them.[30] That is, they are coupled to corresponding triggers with or without our knowledge.

Philip Lieberman, in his *Toward an Evolutionary Biology of Language*, argues there are three main differences between humans and other species: first, a large vocabulary; second, a rapid and robust transmission system; and third, the ability to combine a finite set of words into a potentially infinite set of sentences. Creation as the capacity to restore what has been scattered or shattered should remind us of the Romantic fascination with universal grammars of expression, reassociating root forms with the real-world referents from which they had become separated over time.

Lieberman's research on macaques is of special interest to humanists working on miming types of communication. Lieberman challenges Noam Chomsky and Steven Pinker, who claim that this combinatorial power arises because people have a species-specific, innate knowledge of universal grammar, thus equating dedicated language modules (Broca's and Wernicke's areas) with localized cortical structures. In contrast, Lieberman makes the case for a reiterative mechanism of sensory imitation—or reciprocal mimesis—that underlies the production of both linguistic and nonlinguistic sequences. Significantly, he gives both the visual and the nonvisual senses their due.

Dance externalizes our combinatorial ability to sequence complex actions (activating the subcortical basal ganglia). It coordinates the physical energies of the dancers with shifting kinetic shapes. Since one must see the intricate actions of a partner in order to combine and recombine them, dance—as the remarkable capacity for coordinating expressive behavior—cannot be pried free of vision. David Bashwiner's research on the vertiginous waltzes of Johann Strauss Jr. reveal them as a dynamic self-cuing and self-regulating type of self-assembly that continuously adapts to changing sonorous surroundings.

Lieberman extends this analysis historically by showing that subcortical structures provide a link to our prelinguistic past. Early hominids, with their dexterous bipedalism and flexible manual skills, capitalized on the newfound freedom to engage in intersubjective social rituals. Lieberman's dance

research is pertinent not only for understanding the revolutionary arrival of *Homo ergaster/erectus* in the Lower Paleolithic Period, but for the coupling of signaling systems and voluntary mirroring with nondiscursive formats in general—including the poetic/graphic/acoustic syncretism typical of the digital age. I am thinking of works by John Cayley, Stephanie Strickland, and Thomas Swiss, who fashion interactive poetry out of navigable bits by incorporating sound, vibrant clip art, and mutable text. The creative and recreative potential in all things having to do with patterning has only become intensified in new media.

Ultimately, edgy, adjacently present formats image the spatiotemporal contiguity of experience.[31] The seriality of perception lies behind such higher mental functions as self-critical detachment and cool reasoning, dedicated to the analytical parsing of incoming stimulation. Consider the lengthy emblem tradition flourishing from the sixteenth to the eighteenth century and hardly extinguished in the nineteenth century. Goya's profile self-portrait (figure 0.6), stationed at the head of his suite of grotesque etchings and aqua-

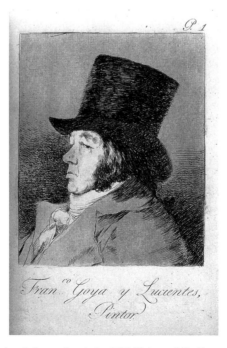

FIGURE 0.6. Francisco de Goya, self-portrait, c. 1797–98. Image © The Metropolitan Museum of Art.

tints, *Los Caprichos*, is the picture of ironic detachment. Significantly, the artist faces away from his satiric creation, thus pressuring the beholder to piece the graphic fragments trailing behind him into an ensemble. Similarly, viewers must fit the tessera-like monsters embedded within each print together, since they have not been prefitted, emplotted, or narrativized into a grand iconographic scheme.

When the artist resists controlling his strange-looking composites, he fosters the self-cultivation, developing awareness, and indeed enlightenment of the viewer. We should think of such demanding inlays as formal training in the construction of meaning and its interpretation. Goya's configurations are deliberately directed at our rational faculties in order to provoke a change in personal behavior. He believed such rotatable images were capable of making a real impact on the life-world. This, then, is instructive art in the service of neuroplasticity! Odd mixtures teach the viewer to avoid the easy elision of distinctive thoughts and things into smoothed forms. They allow us to witness the difficulties of inner synchronization: how the brain works to construct correspondences from discrete contours, bordered light and shade, and disconnected colors, and how these subserve distinctive emotions like jealousy, anger, shame, humiliation, and love. This labor-intensive type of composition promotes self-fashioning and is consonant with progressive Enlightenment pedagogics holding that our senses, tastes, judgment, and reason are educable.

Apparently, inner life took shape in the outer world as a particular kind of relatedness. Hotly entangled formats, in contrast to splitting formats, thus arise from very different actions and sensations. William James aptly observed that the "knowing of things together" arises at the intersection of the two associative axes of human reality: that of successions and that of simultaneities.[32] Walt Whitman's erotic poetry is illuminating because it champions a dreamlike coherence that is not "chopped up in bits" when he sings of "the muscular urge and blending. / Singing the bedfellow's song, [O resistless yearning!]."[33] The American writer highlights inner life as governed by passionate fusion that has nothing jointed about it.

Blendable materials similarly manifest a biological type of relatedness. Despite their diversity, they magically couple and double up: think of miscible oil pigments, malleable clay, silken fibers. These transformational unions are

the artful correlatives of the body's moist membranes and braided tissues. Entanglement creates coherence through penetration, by insinuating or threading its way into the interior of things. In contrast to the manyness of mosaics, the oneness of the blend is developmental. This drawn-outness is rawly visible in the undulant structure of Romanesque capitals, where feral beasts consume one another in an endless dialogic dance. One shape continuously fits the shape of another: moving back while the other moves forward, rising and falling with the visceral eating or inhaling of the other creature to make it one's own. Surrender is essential to this dyadic process because receptive forms, like cells, must open up to let other forms in rather than coexisting with them, estranged and constricted, side by side.

The science of complexity—describing systems with many interacting parts and inferring possible ways in which those parts can connect—sheds light on combinatorial graphic formats. Mosaic and intertwisted compositions differentially map the overall patterning of link strengths across a network of variously interacting images. I have tried to show that they represent two different types of neurological structure and two opposing emotional styles. Culture as well as nature uses many tricks to form strong compositions from otherwise weak starting materials—from airy foam to porous lattice to friable ceramic.[34] By looking at the problem from both sides, we can learn why the creative and neural dynamics of "gluing" different realities together is so cognitively demanding. Art visibly performs the brain's coincidentia oppositorum, the constant transformational activity of the thinking self fleetingly becoming its opposite in the effort to achieve a synthetic unity of consciousness.

Motor Thinking: Performing Other Minds

The hurt of social rejection or exclusion is emotional. But there must be a reason why we so often experience it—and talk about it—as if it were a physical pain. One feels 'burned' by a partner's infidelity, 'wounded' by a friend's harsh words, 'heartache' when spurned by a lover. It turns out, there is a good reason we use such terms. The same circuits in the brain that are responsible for processing physical pain are also called into play when one feels the sting of social rejection.

—MELISSA HEALY, "Feel Like You have Been Socially Burned? It's in the Genes"[35]

Twofold mirroring resembles breathing: a reciprocal give and take, a flow that moves in two directions. The capacity to exchange intimate perspectives in real time reminds us of the truth of William James's aphorism, "Thinking is for doing."[36] Recognition, or the performance of mutual responsiveness, situates us in the realm of the operative image—what Francis Picabia, when speaking of his machine-portraits, meant by "the objectivity of subjectivity."[37] When we recognize someone, we visibly incorporate that person by making their feelings manifest within ourselves. In other words, humans tend to like what is familiar. Repeated "mere exposure" to a stimulus—as opposed to conscious recognition—tends to make people like it better.[38]

Motion is inseparable from emotion, just as intuitive understanding is physically tied to social outreach. Antonio Damasio's neuroanatomical research illuminates the origins of inter-species cooperation. He muses that ethical behavior "may have begun as part of an overall programme of bioregulation." This was an embryonic phase in a long evolutionary progression including "all nonconscious, automated mechanisms that provide metabolic regulation, drives and motivations, emotions of diverse kinds, and feelings." Our homeostatic system then, lies at the heart of any intuitive and cooperative "like me" understanding of others. The critical question remains, however, if this social sensitivity—evident even in very young children as well as in many animals—is reflective (intentional) or instinctive (unintentional).[39]

John Cage's witty Fluxus exercise *A Dance Map for Chicago; or 10 Quick Steps, 62 Waltzes, etc.: A Dip in the Lake* (1978), demonstrates that recognition is literally the path of repetition. As philosopher of mind Alva Noë claims, human perception occurs only through action. Cage anticipated Noë's "enactive approach," brought forth by the embodied relations sustained between humans and their environments, since his dance map—literally a city map criscrossed by choreoographic notations—addresses not just the isolated visual system, but all of our sensorimotor knowledge. Cage's cartographic performance turns time into an image, a memory, an emotion by inducing an analogous motion in the viewer. As time becomes emptied of succession, it is reconstituted as distinctive spatial presence at every spot the agent encounters.

Similarly, recognition is the capacity to walk or move along the same route, both physically and mentally, as someone else. Consider the evidence of social rituals from around the globe that enter us through our bodies.

Dance-based ceremonies, for example, literally transmit their patterns. These are absorbed through hands joined in unison or feet stamping the earth. Significantly, some of the earliest villages, such as Catal Hoyuk in Turkey, feature terra-cotta pots with linked dancing figures (c. 7000 BCE), documenting how cooperation most likely originated in the optics and haptics of duplication and reduplication of tribal group gestures and actions.[40]

But dance as a physiologically and socially situating performance is hardly limited to the past. In his dramatically parsed choreography, David Michalek shows cognition to be a way of thinking embedded in motor skills that are transmitted directly to others. Mimetically placing oneself in someone else's shoes seems to counter objections raised by philosophical minimalists like Daniel Hutto who argue that, when simulating or mirroring, "I focus on the situation as it might be for the other, not on what I would do in such a situation if I were the other."[41] In fact, dance requires one to do both simultaneously: the participant lays down tracks and traces that imprint the receiver.

Projected on the facade of New York's Lincoln Center, Michalek's monumental video piece *Slow Dancing* (2007) captured the rhythmic person in all of us—from frenetically upbeat to quietly tranquil. The unfurling movements of individual ethnic dancers were radically slowed down so that each displacement of a limb became an isolated episode and thus a momentous occurrence. Because of this extreme collapse of space-time, each dancer existed as both a minutely distributed agent and as an enduring self possessing a lasting personal signature. Importantly, Michalek's project draws attention to the imitative foundations of social contagion. Among other things, this extended performance piece shows how we continuously and innately synchronize our behavior with the facial expressions and postures of others. The infectious mimicry links dance to sculpture. It is additive, in the sense of haptic modeling or fitting bits of clay to add up or accumulate into a figure, much like the line dancers decorating recently unearthed Neolithic Anatolian pots. But it is also subtractive in the sense of involving carving, or the hollowing out of ambient air, as the Japanese and Indian performers do with their ballet of hands and thrusting feet in Michaelek's video.

There is immense interest in social cognition as well as in the use of multivariate pattern classification to infer the intentions, percepts, decisions, and biases of subjects using decoding fMRI measurements as well as hemo-

dynamics. While this recent upsurge is sometimes unflatteringly equated with the eighteenth- and nineteenth-century "allure of mind reading," there is no doubt that mimicry is a prelinguistic skill whose neuronal circuitry dates back at least forty million years. But the question remains: Is this interanimating type of embodied communication—for example, chimps or macaques observing and reacting to each other or to another person's gestures—tantamount to understanding another's behavior? Recall that in the early 1990s, Vittorio Gallese and Giacomo Rizzolatti published their experiments on the "mirror neurons" of macaques. Inserting microelectrodes into the premotor cortex (F5), they recorded from individual neurons that fired when the monkey grasped an object as well as when another monkey observed that goal-directed action. Since then, not only have the mirror or matching systems in the brain multiplied, but the animals studied—from elephants to crows—have multiplied as well. Apparently, this socially contagious visual-motor capacity is intuitive, instantaneous, and direct.

Hanna and Antonio Damasio continue to push deeper into the interior of the human organism to explore such "as-if body states." Importantly, their research asks that we bring our sociocultural resources to bear on our cognitive processes. What they felicitously term the "music of behavior" involves the prefrontal cortex as well as mirror systems, which can signal the body-sensing brain regions in ways that simulate the perceived condition of another individual.[42] Quickly bypassing selective attention, this re-cognizing network lies at the heart of any intuitive and imaginative impulse. It is central to that portion of art and aesthetics dedicated to harnessing involuntary viewer response and acknowledging the immediacy of the sensible. Beating what Jane Austen termed "all the cleverness of the brain in the world," such instinctual noticing raises the fundamental question of why and how we spontaneously identify with, and judge, anything.

The self as hybrid, or as unequal mixture of involuntary and voluntary systems, is emerging from two medical imaging technologies deployed by the neurosciences. One way of tracking how someone empathetically recognizes another's experience of himself is to measure the extent of the patient's autonomic neural responses by means of fMRI. Another way is to monitor the skin-conductance response (which measures subtle increases in the secretion of fluid by the skin's sweat glands due to autonomic nervous system

registrations). These imaging technologies support the philosophical hypothesis that all ethical action, especially altruistic behavior, depends upon our ability to empathize. Such strategies of detection have their historical roots in the venerable pseudosciences of physiognomy and phrenology. And they join up with work in new fields such as social cognition or the study of "other-regarding preferences" (inferencing, decision-making, compassion, and bias).

The visual arts as embodied systems—grounded in the reciprocal and dynamical coupling of brain, body, and environment (feedback)—are fundamentally tied up with mimicry and imitation. Like the actuator systems of mobile robots, they distribute control and processing to all aspects of an observer: to the central nervous system and the core musculoskeletal system, synaesthetically to the five senses, and ultimately to all conscious and unconscious interactions with the environment. They make plain that recognition is not a Skinnerian mechanism. But skeptics justifiably ask: Is visual recognition and somatic re-performance in fact just "a quick and dirty method," as Richard Byrne claims? After all, such copying is not based on "logic and rationality that satisfies physicists and philosophers," because only language develops "a sense of cause and effect and [is required] to evolve a theory of mind [TOM]."[43]

To this objection, I answer that it is precisely works of art that exhibit not only how equivocal facial expression can be, but that the face is never merely given: it always possesses more than a single aspect and exceeds any particular feature. One side is turned towards us, but another turns away. And despite plastic surgery's rhetoric of achieving classic timelessness, a characteristic countenance takes a lifetime to shape. No wonder that faces are among the most ancient types of imagery. Consider the span stretching from the literal impression of the Christian Mandylion (the sweat-soaked sudarium of Veronica's veil, figure 0.7)—an image not made by human hands, hence miraculous, presenting the direct imprint of Christ's Passion—to today's digital snapshot and the immediate-capture technology of the iPhone. The swift surface-theft of the latter contrasts with the magical presentness of the person painstakingly recorded in the nineteenth-century daguerreotype, or the continual expansion of the self witnessed in doubling and redoubling gestures. Such maneuvering through subtle shifts in body position is docu-

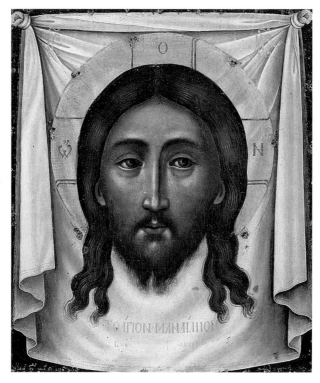

FIGURE 0.7. Simon Ushakov, *Mandylion*, 1677.

mented in the long tradition of visual rhetoric ruling the performative history of portraiture—that is, of commanding, rippling, sweeping poses or dynamic and placid comportment, inspired by the oratory manuals of Cicero and Quintillian.

Consider just one example: Honoré Daumier's trenchant caricatures of the Parisian bourgeoisie. A genius at registering instantaneous and telling social comparisons, he wittily reveals the human and even animal tendency to duplicate another's flattering or demeaning assessment of oneself in oneself. Anthropologists have noted that the making of such quick status comparisons is found in all societies. Further, cognitive psychologists and gesture researchers such as David McNeil and Susan Golden-Meadows point out that according to their experience with test subjects, an individual's emotional state is gauged by watching his or her actions.

A sophisticated understanding of the complex construction and perception of works of art has much to offer the brain sciences investigating affect and mimicry. Art reveals that optical and psychological distortion frequently accompany the operations of doubling. Ambiguities fringe social exchange, and personal illusions may cloud our view of others. Stanislas Dehaene interestingly remarks that some brain areas are *detrimental* to reading. It is not just that in dyslexia the lateral and ventral regions of the left hemisphere do not activate normally in the processing of phonemes. More fundamentally, Dehaene remarks, it is precisely mirror recognition that must be gotten rid of for reading to develop. Individual letters must be recognized independent of their orientation. Even here, though, there are limits to the amount of rotation that the reader can tolerate before legibility becomes impaired.

But what I wonder is if this neuronal operation of getting rid of symmetry has a cultural correlate—namely, that literature inherently possesses distancing properties, as opposed to visual art's inherent characteristic of pulling the beholder towards proximity. Mirror systems thus need to become smokier. The scientific glass needs to be darkened by the acknowledgment that more is involved for the incorporation—that is, comprehension—of another person besides their simple co-presence. And the cultural glass needs to embrace the biological fact that there are circumstances in which we may have to unlearn reflective symmetry.

As Orhan Pamuk writes in his memoir *My Name is Red*:

> I have gone through life convinced that the buildings in which I have lived and the streets I have walked are bad imitations of streets and buildings somewhere in the West. The chairs and tables at which I sat were copies of originals in American films. . . . I cannot say how much of my joy or my seriousness of purpose, my way of standing or speaking, is innate and how much I have unwittingly copied from other examples. Nor do I know how many of those examples are themselves copies of another original or copy. The same can be said of my own words. . . .[44]

New media's electronic mash of images, in particular, refocusses experience through an increasingly aberrant lens. Blocking, filtering, and layering digital technologies are generating shifting and drifting ways of seeing, as well

as producing seamless repetitions. Inez van Laamswerde's doctored entities evoke the easy proliferation that comes with Internet speed. Her morphed images—confected from the reproduced body parts of assorted anorexic teenage models interspersed with those of their older male predators—transform the fashion shot into a lethal weapon directed at that industry's youth and beauty message.

Augmenting the biological organism through the media prosthetics of electronics and robotics has distinctively expanded the look of our species. The performance artist Orlan exploits plastic surgery through operations that are videotapes and broadacast, displaying herself as being literally under the knife undergoing perpetual reconstruction. Her endless mutations go beyond aping the good looks of Hollywood celebrities to mimicking the macabre science-fiction implants of paranormal trans-species. And Warren Neidich's video *Earthling* (2006) shows the near impossibility today of approaching the flesh and blood individual concealed behind the masking media report. He has political figures, like George Bush, stare out at us through slits cut into a morning newspaper. The rest of the ex-president's face remains paradoxically concealed by the article "covering" his activities. If transformational biotechnology and information technology, as well as modificational design and selective enhancement, are fundamentally altering the physical integrity of the human, "corporate intelligence" is altering the look of global business.[45] Forensic accounting, crisis management, and competitor analysis are directed at an ever-widening range of sophisticated concealments: industrial espionage, hostile takeovers, counterfeiting, money laundering, rigging of spreadsheets, surveillance, and identity fraud further crack the two-way mirror.

If physical self-reflection encourages philosophical self-reflection (the fact that you cannot know or appreciate others until you know yourself), what about cyberspace, where people typically do not communicate face-to-face? The facelessness of e-mail has taught us that both sender and receiver must deliberately insert tone or expression to inflect the message; otherwise it is a blank screen onto which one narcissistically projects fears, prejudices, and anxieties. Further, given the interpretive importance of face perception and face recognition, what about the routine erasure of individual traits in those pixilated images broadcast on our nightly televised news of the war dead and

wounded from Gaza to Iraq? Stripped of their countenance, these featureless digital ghosts preclude sympathy or empathy, arousing only indifference in the beholder. If anything, emotional outreach stops dead in its tracks, leading to tactics of exclusion, not inclusion.[46] More generally, then, what are the neural and social consequences of thwarting the basic instinct of all asymmetrical individuals to coordinate visually with others of their species so as to function in concert? What sorts of selection pressures are emerging as a result of this artificial blocking of the mirroring instinct especially, but not exclusively, by digital and computational media? It would seem that we need a new pragmatic philosophy in the field for the co-construction of interpersonal awareness within an increasingly remixed environment.

Inner Sky: Cave Vision and the Landscape of Sensory Deprivation

Some frame the names of runs for frames of mind.
Tremble Copse, Wrath Copse, Anxious Crossroads, Howl,
Doleful and Crazy Trenches, Folly Lane,
Ominous Alley, Worry Trench, Mad Point,
Lunatic Sap, and then Unbearable
Trench, next to Fun Trench, Worry Trench, Hope Trench,
And Happy Alley . . .

A. S. Byatt's poem reviving World War I trench names hauntingly exposes our tendency to link place with emotion. Her plaintive enumeration reveals the unconscious influences that shape all information processing, those spontaneous mental associations that are activated by the sight of a profoundly scarred land. Byatt shows that, in the broadest sense, memory is consciousness. What the brain is doing in all its operations is tapping into vestiges of our emotional and sensorial lives, unleashing a cascade of buried remembrances attuned to spatial prompts. Common wisdom understands what it is "to gouge out tunnels" in sleeping fields, number sunken roads, and "dig out our dens, like cicatrices scored / Into the face of the earth."[47]

For thousands of years, subterranean universes from the slimy karst tunnels and stalactite-draped cenotes of the Yucatan Peninsula to the marked passages of Australia's Northern Territory nurtured human life. No wonder

that the primordial cavern, ranging from sub-Saharan Africa to the dense jungles of Sumatra—"black below shine" and "closer down," in poet Les Murray's words—has long been synonymous with mind. It functions as an illusory parallel universe more potent even than the perilous world inhabited by early humans. Extreme cognition—anxiety, fantasy, delirium, myth-driven imagination, transgression, ritual, cries, and whispers—prevailed inside an enclosed ambient where the disorientation was even greater than that accompanying the perils of survival lying outside. As Frank Echenhofer points out, dark times and dark places encourage the unconscious body to a convulsive intake of sensations to intensify the moment. Romantic opium-eater Thomas de Quincey, in his memoir *Suspira de Profundis*, vividly describes just such a cavernous realm for compounding experience in which consciousness dreamily descends to whatever depth it can penetrate.[48]

But to return to the material and psychophysiological experiences shaping modern humans some two hundred thousand years ago as they migrated out of Africa and Asia: the fossil evidence suggests that evolution was nonlinear. Our ancestors apparently did not evolve in a single environment. A mosaic pattern of change is apparent, whereby at any given time in human evolutionary history, different variations of intermixing occurred side by side with existing hominid species. While much is unclear about the supplanting of the Neanderthal in Europe, one thing seems certain from skeletal and artifactual remains. These early transcontinental travelers were drawn to eat, sleep, and reproduce in safety in the bottomless sinkholes, dank craters, and carved landscapes that studded their multiregional journey.

We have new evidence regarding the environmental conditions governing this curved and layered underground in which the vertebrate skull and brain underwent significant enlargement. It now appears that Ice Age culture was a "central ingredient" in the development of fully human *Homo sapiens* out of small-brained protohuman *Australopithecus*.[49] Present-day caves allow us to understand how the rise of the double-hemisphered brain with its extrapolating imagination could occur within an ancient sheltering matter. Importantly, like the developing human brain, these complex physical spaces were themselves formal/functional systems interconnecting dissimilar elements into larger structures. Entrenched and scarred land shapes, formed by strong wind and water currents, challenged nascent perceptual skills and fostered

manual dexterity. Simultaneously crystalline and aquatic, stony and flowing, they were the objective correlative to the developing nonlinear human mind. The cognitive processing that originally gave rise to mental experience, from organized to disorganized thought, still operates today by cutting"across the superficial physical boundaries between brain, body, and environment."[50]

The distributed "non–brain-based" mind actually looks a lot like a cave, since connectionism maintains there can be no such thing as a *core* mind existing independently of the organism's environment. Because this multisensory domain is an echoing aural, an unhewn tactile, and a low-light mural architecture, it trained discriminating observers. No wonder that anthropologists interested in research on human origins, such as the elusive "Java Man," continue to concentrate their searches for evidence of changes in sentinel behavior and analytical skills (marking the transition between *erectus* to *sapiens*) in grottoes and quarries from Australia to the Sea of Galilee.[51]

But caves are also irrational spaces of irresolvable ambiguity and fantasy experience. Their explorer must work to recover lost ground, since it is a long way up to the surface. Instead of free diving into oceanic water, the extreme caver disappears into earth but similarly feels quite "narked": absorbed, heavy, contracted, verging on blackout—the opposite of topside gliding and neutral buoyancy.[52] Ordinary defenses are softened in seclusion, and the spontaneous memories stored in specific neurons in the hippocampus are easily ignitable. Caves are thus archetypal right-hemisphere environments: they correspond to our sense of how objects interrelate in space, foster the detection and response to unexpected stimuli, and give rise to highly emotional vocalizing.[53]

Like taking Xanax, being submerged underground stops "the inner [autopoetic] chatter" and "creates a silence" in which one thinks and acts differently.[54] Along with its fossilized bones, animal remains, ivory artifacts, chromatic images, and, lately, genetic information, the cavern locates the composite brain at the very heart of the world. Cognition and culture co-evolved in this dark disorienting setting where human behavior first adapted to being immersed in the substance of the natural world and its nonlinear system. It is within these alien deeps that the experience of the conscious self as localized within the perimeter of the body breaks down.[55] Hence, religious ritual and initiatory ordeals were often rooted in sharpened sensations of be-

yondness: the attainment of an extraordinary dimension above, below, along-side, or outside one's normal corporeal boundaries.

As Daniel Dennett has remarked, there are "good moves" in evolutionary design space that are found independently throughout the natural world.[56] Causeway enclosures, such as Newgrange, Durrington Wells, and Avebury from neolithic Britain and northwest Europe, are also networked with en-gravings. In these places of retrospection, inspection, and prospection, fig-ured thought seems to be activated globally by the hot rays of the sun, the cool light of the moon, and the red flicker of fire. The effect can be likened to that produced by the silvery daguerreotype. The action of faint light on vari-ous substances activates the calcareous stone support and its shadowy depos-its, developing the outlines of stimulus objects and their colors. This mantic (as in "bringing forth") as opposed to hermeneutic (or interpretive) opera-tion reminds the contemporary visitor to famous sites from the Dordogne to the Rift Valley just how unconscious we have become of most of what we see.

Merleau-Ponty aptly observed that the perception, which "does not give me the truths of geometry," gives me sacred "presences" instead.[57] But these luminous "presences" do not just exist outside the perceiver; they can be artificially induced, like the brilliant phosphenes generated when we per-sistently rub our eyes. The long history of cavelike audiovisual media (that is, glowing images meant to be seen in the dark) reveals both the cinematic reflexivity of our brain dynamics and the attention-retraining strategies we evolved to become conscious of our altered states.

The brain combines incoming information with stored information to build internal models of the external world. When the brain-mind is not en-gaged with the present, it tends to imagine or simulate—with or without the use of hallucinogens—the emotional consequences of future events. For inhabitants of the twenty-first century media sphere, just as for early humans, the sharp pricks of pleasure and pain driving our neural reward systems are the constellations by which we steer. Once they are activated, they may not necessarily be endorsed at a conscious level, but they predict a given indi-vidual's weighing of information acquired during conscious deliberation.[58]

So it is not accidental that art emerged in a cave. Our ability to remember what we have seen is limited; possibly only two to four objects at the most can be held with precision in visual working memory.[59] Not only do cave walls en-

able the dynamic sharing of all the components of a visual scene with onlook-ers—hence constituting a high-resolution resource—but the unevenness of the surface necessitates perpetual changes in gaze position. The disruptive background thus encourages constant subtle shifts between objects, and the eye movements targeting them. Such physical and psychological groping embodies a viewing from out of the deep, as well as from out of one's own depths.

Further, nature's way of hacking space into inner and outer zones, posi-tive masses and negative openings, suggests the origins of counterfactual thinking. Cracks, fissures, dents, and grooves, unleash the powers of asso-ciation—of intuiting or hazarding an informed guess—that help the viewer make sense of the world. These rents in the fabric of our surroundings stim-ulate visualizations and hypotheses about the unforeseen: the spinning of "what if" scenarios. Seeing into rock also allows what is inside to emerge. Significantly, among the capacities thought to be uniquely human are, first, the autonoetic consciousness, the aspect of self-awareness that allows us to imagine our own experiences in different places, at other times; and, second, the theory of mind (TOM), which allows us to infer the mental states of other people, animals, or even artificial entities.

Take the case of oracle bones from Shang Dynasty China. Tortoise plas-trons and sheep or ox scapulars, when thrown into the fire, develop evocative cracks. Inspected by shamans for signs sent from an alien realm, this divina-tory craquelure inspired the deliberate cuts of pictograms. The oracular ca-pacity to transmit, not bear, messages coming from another dimension char-acterizes all those early graphic systems, spanning the Middle and Far East, that indent apparently intractable materials, including low-relief cuneiform and incised hieroglyphics. Small scratch marks thus share with the monu-mental cavern the ability to puncture the opacity of the world. They encour-age brooding over the past, second-guessing and engaging in prospective thinking through a tactile and kinesthetic reasoning that digs in, excavating the obvious surface of things to reach understanding.

The low-profile formation—a three-dimensional shadow born of earth—is the archetypal ready-made. Like sleep's silent domain, dark hollows, not bright language, are the primal stuff of thought. We intuitively understand the tunneling perspective of such holes in the ground or the hollows riddling

FIGURE 0.8. Jeff Wall, *Flooded Grave*, 2007. © Jeff Wall.

. .

a landscape, because their overall progression from darkness to light power-fully draws the viewer into the vortex. Jeff Wall's backlit Cibachrome light box photograph of a flower-strewn flooded grave (2007, figure 0.8) similarly elicits the psychophysiological sensation of dropping. We feel ourselves ab-sorbed by that vertiginous empty space, plunged into the dark center of a yawning abyss that challenges the safely remote position of the viewer stand-ing at its edge.

Wall also plays on our collective memory of sacred sites linked to primitive subterranean burial rites and to the mythic descent or ascent from the under-world. This physical and mental inhabiting of an endless "land of darkness" haunts all human behavior. It is frequently associated with death, or with the deathlike sinking away in dreams where the dreamer takes his working body—intertwined with vision and movement—into a strange immersive place. Significantly, neuroscientific studies of memory, such as Gerald Edel-man's *A Universe of Consciousness*, have become more oriented towards the fu-

ture rather than the past, focused on our projective construction of creative or fictive scenarios that recruit episodic memory to support imagination.

The transfer of memories from hippocampal to neocortical control is widely believed to involve image replay during sleep. Further, the observed replay of long-term memories quite possibly plays a role in the combinatorics of memory consolidation. As in sleep, it is probable that dim cave environments increase the brain's processing speed, making it likely much faster than in real time. The sensory deprivation typical of such black environments places special adaptive demands on the viewer, who is suspended between bodily immersion and visual control. Being both inside and outside a perplexing ambient opens up a new way of interpreting the superimposed hands pressed into prehistoric pitch-stained walls, and geometric and theriomorphic image-making in caves more generally. The superimposition of multiple figures correlates not only with speed of performance, but also with the fusive dynamics of a vortical visual field allowing one to see a maze, a hand, a troop of aurochs, or a horse panel, as if grappled together.[60]

In sum, the cave in the world matches what David Lewis Williams felicitously called the cave in the mind: that receptive camera obscura developed for intuiting, speculating, or simulating the beliefs and desires of another person or group, on the basis of "second-person" encounters.[61] From enigmatic earthworks, high and low dimensional rings, and geometric geoglyphs shaped like circles, diamonds, hexagons, or interlocking triangles, typical of tall Amazonian settlement mounds and sunken ditches,[62] to the enigmatic Nazca lines outlined in stone on the coast of Peru, to the incised rock art at Lascaux and Chauvet, channel-like depressions rule the prehistoric day.

As Frank Echenhofer demonstrates in his essay based on ayahuasca field research, altered states of depth consciousness are portals to multiple worlds. Going beyond "xenolinguistics"[63] or the study of bizarre language and linguistic phenomena in the psychedelic sphere, Echenhofer generates a compendium of local knowledge gathered from first-person reports about the composite images witnessed when using brain-altering substances. Many of these psychedelically generated realms also fall under the rubric of the "new archaic," defined by Anne Benvenuti and Elizabeth Davenport as a spiritual dimension populated by animate beings: gods, demons, plant teachers, and animal spirits.

These hybrids map geospatial data by cutting across an otherwise daunting range of space-place-time boundaries. We should think of such early polymodal technologies of vision as having initiated changes in the scale of sight, as global positioning systems do today. Like the earthen recesses in which it is found, syncretic imagery seems to bubble out of a landscape of mud, accompanied by qualities that extend baseline perception: deeper lines, more varied tableaux, richer and more intense colors. Combinative hallucinatory art is commensurate with the ways in which the eye-brain is overwhelmed by its extension into mysterious dimensions, dramatically rising or falling in ecstasy or confusion. Caves, then, offer clues for how the brain generates subjective states spanning actual sensory perceptions to the collapse of the real into the unreal in metarepresentations: the pretending brain-mind capable of coupling our imaginary "inner sky" to the dark matter of the galaxy-strewn universe.

The Miscellaneous Subject. Episodic Personhood from Mosaic to Bar Code

. . . You're the same
wilderness you've always
been, slashing through briars,
the bracken
of your invasive
self. . .

I have been unearthing mechanisms of figured thought that are deeper and more basic than either metaphor or narrative. Nature's marks in land and sky are embedded in the crystal and smoke structure of images. This is scarcely surprising, since it is difficult to establish a hard and fast border dividing brain from environment. Adding graphic emphasis to objects out in the world strengthens their alignment with our mental makeup. As Carl Phillips's poem "Civilization" (quoted above) proclaims, "there's an art to everything."[64] Even in the wild, the bracken and the briar mean something when their tangle is made salient by art, and hence memorable. If one function of the visual system is to decide what is present in one's local environ-

ment, thereby resolving potentially ambiguous information into a coherent percept, then another function is its generation of anticipatory "predictive codes" in advance of change. But what, exactly, hits us before we have time to invoke prior information?

The gestalt of mental imagery is unlike smoothed representational pictures or realistic portraits. Instead, the patterns in question present a mosaic composed of dissociated and conflicting sensations.[65] Inlaid works of art allow us to witness the normally concealed neurological processes by which we connect atomic sensory information in unattended and creative ways. One aspect of our brain function is caught up in actively shaping and dynamically patching internal and external stimuli together. The shifting outer environment is thus continuously interlaced with the autonomous nervous system and braided into our goal-directed activities. Consciously as well as unconsciously, we juxtapose self with non-self, combining the two into a conceptual assemblage. But thoughts are not just lapidary and roughly contiguous. In another guise, they are protean and liquid—filmic like the train of phantasmagoria emitted by magic lantern projections. How is this possible?

In his late writings, J. J. Gibson sought a suitable replacement for his earlier concept of the all-embracing "visual field." His revisionary writing introduced the new notion of the segmented plane "seen-now-from-here." As Thomas Natsoulas explains it, these cinematic "here-and-now surfaces" are "equivalent to the totality of the environment and bodily surfaces and parts of such surfaces that are now unobstructedly projecting (i.e., reflecting or radiating) light to the perceiver's point of observation."[66] This suggests, however, that there are also "occluded" surfaces behind the perceiver's head as well as behind the surfaces themselves that can break through at any moment with a tilt of the head, a shift in posture, or a surprising encounter. What is significant is that Gibson moves away from the model of a blended experiential field of sensations and toward a mosaic of discrete environmental aspects disruptively confronting the viewer traveling in real time.

His reformulation argues not only for the *directness* of perceiving, but for the possibility of directly perceiving what Gibson called "virtual objects"—things like films and static works of art—in a way that is akin to perceiving, say, Niagara Falls: "not mediated by *retinal* pictures, neural *pictures*, or *mental* pictures." Gibson seems to be defining the performative *presentations* (not *represen-*

tations) that are the focus of my essay. For him, perceiving is not about having pictures in mind, but about having a *firsthand* experience of the co-constructed activity of looking at the illuminated *real surfaces* of a painting or any work of art. Apprehension and visual awareness thus go hand in hand. Viewing conditions, as well as a neurophysiological sensitivity to light and shade and to an intrinsic geometry, ensure that we spontaneously discern and decipher natural as well as artificial forms: the perpendicular Alps, the contours of a lake, the straight edges of larch plantations, the uneven margin between forest and meadow, the curved bowl of the sky, the circuit traced by hawks.

Gibson's direct notion of perception has profound importance for aesthetics. But it also has exciting implications for contemporary neuroscience, which is beginning to study the brain in terms of universal phenomena—for example, the ways in which anatomy speaks to us through dynamics. Gibson defines perception as being shaped by evoked responses or the "experiencing of things rather than a having of experiences." Hearing the music played by an orchestra in a concert hall, for example, means that the informational acoustic features are instantiated in the air and preserved all along during the course of their transmission, until the instant when the vibrations reach the individual listener's co-creating ears. Similarly, the embodied informational data instantiated in optical images not only produces a stimulus flux at the photoreceptors but also yields a living stream of visual experiences that are distributed in space and co-performed in various brain centers of the viewer.

Consequently, images are mental objects, and they belong back in mind— not as secondary perceptions or mediated representations, but as performances crucially involved in the firsthand awareness of both actual and imaginary or nonexistent things. Artworks and higher-order images present just this sort of situational sensory experience, with one or more of its aspects or circumstances set before our eyes, causing the luminous medium in which they and we are immersed to vibrate chromatically. Gibson's position adumbrates Antonio Damasio's attempt to break down any simplistic mind-body/mind-world dualism. Calling for an "organismic perspective," Damasio believes that "the comprehensive understanding of the human mind requires . . . that not only must the mind move from a nonphysical cogitum to the realm of biological tissue, but it must also be related to a whole organism possessed of an integrated body proper and a brain and fully interactive with the

physical and social environment."⁶⁷ Gibson also anticipates the shared mirroring manifold of subjectivity that Gallese and others speak of: the fact that multiple brains can cohere like mosaics, so that they appear to be one brain, one mode, or one mutually reflecting pattern.

A major message of this book is that one way of getting past what Damasio saw as the "abyssal [Cartesian] separation between body and mind" is for neuroscientists not to limit their cultural considerations to the evidence provided by grammatically complex symbolic languages. We know that our gesturing and tool-making hominid ancestors lacked such syntactical activity. What they had, and we still have, are sophisticated compositional structures for mirroring complex mental and social situations by performing them as intersubjective events. Damasio's critique is hardly out of date, since studying the brain now is like "trying to navigate a vast city without any driving instructions." As Allan Jones, chief scientific officer at the Allen Institute for Brain Science in Seattle, remarks: "You don't know where you are, and you have no idea how to find what you are looking for."⁶⁸ Just imagine the wilderness of this internal space we live in: an as yet unmapped, self-aware tangle of neurons that occupy distinct cortical regions and can make crosscutting connections, but with no one knowing how it all fits together! This book takes a long step in the direction of bringing brain and mind together.

The brain's sheer ongoingness depends upon a host of up- as well as downriver processes. Eyes collect photons of specific wavelengths, transduce them into electrical signals, and send them to the brain. Ears do the same thing with the vibrations in the air (sound waves). Touch receptors under the skin pick up pressure, heat, cold, and pain. Smell involves odors contacting receptors inside the nose, just as taste requires the activation of buds on the tongue. Proprioception, the proverbial sixth sense, relies on a network of nerves in conjunction with the inner ear to inform the brain as to how the body and its limbs are oriented. This thicket brimming with dedicated mechanisms registering hybrid data coming from all the senses all the time must be continuously integrated by the brain into a unified picture of the world. Our mental capabilities and processes are thus inextricably linked to the organism's continuous and dynamic interaction with the environment. Like interlocking tesserae, the multiple cross-linked functions that add up to a brain emerge from this interaction between organism and world.

Reaching for the system that endures beneath Dylan Thomas's "rumpus of shapes," I have proposed that two principal and nonpathological types of sensory combination correspond to two venerable kinds of artistic composition. First, there are those formats that entrain the viewer to pay attention to the pricking of prismatic bits of qualia-laden data—that is, the atomistic episodes underlying our experience of any scene. The bounce of saccades is germane here. The term "saccade" derives from the French word for certain rapid movements of a horse during dressage, and is invoked in optics to describe the discontinuous nature of eye movements. By simply observing the sweep of the gaze during reading, late nineteenth-century vision scientists discovered that scanning was not steady, but composed of little jumps with intervening fixation pauses.[69] My point is that not only are neurons in perpetual motion, but eyes are as well. Visual progress across any surface is made by twitches: fixing a point, making a movement, fixing another point, and so on.

Current research on the dynamics of natural vision is amplifying earlier studies of saccades. It suggests that frequent body, head, and eye movements continually bring new images onto the retina for brief periods.[70] This leaves me wondering whether there might not be a deep connection between vision, which occurs only during the intervals between jerks, and synaptic junctions, which direct continually oscillating neurons towards specific parts of an object in an instant of time. A striking correspondence exists between the illusion we have of vision as being continuous and our equally illusory conviction of first-person consciousness as being a stream. In reality, for both perception and cognition, deliberative awareness lies in the stillness of the gap.

This thing we call "self" possesses a distributed inlay, matrix, or lattice structure shot through with pores. As in James Richardson's poem "Subject, Verb, Object," the construction of an "I" is built by setting instants of time side by side with quanta of space:

Where "I" is not ego, not the sum
Of your unique experiences,
Just, democratically, whoever's talking
A kind of motel room,
Yours till the end—

Anti-illusionistic artworks that are obviously "brocaded," "tiled," "paused," or "fixed"—like "some He, She, It surprised in the mirror"—oblige the viewer to perform their conjunction. This dynamic effort of piecing avoids the "plodding insistence—[of] I, I, I,"[71] since acting externalizes the subject, *turning* him or her into someone or something else.

Consider Jasper Johns's paintings of miscellaneous insignia: bald targets, flags, numerals, letters of the alphabet, flagstones. Johns reminds us of the ordinariness and anonymity of such "crazy paving"—the patient handwork of embedding a patio or garden path with chips of decorative stone or small blocks of crystal. The viewer must fill in and complete the discontinuities, setting in motion a cognitive process that matches the manual distribution of the tesserae. About his harlequin designs, Johns commented that the brusque interaction of color and shape on the picture plane was "remarkably active." Similarly, Samuel Beckett marveled at the independence of Johns's pictorial units: so brilliant and clear that viewers run aground, or "come up against the wall."

Such remarks hit on the fact that a chief feature of piecing formats is their nondiscursivity. These genres are not a language, not a symbol, not a "representation" or "expression" of meaning, but the optical blow itself—the naked aiming of form and color by the environment, with the direct impact of a bullet on the organism. Both sides of the equation are changed by the encounter, configuring a new system. As filmmaker David Cronenberg observed, the affective power of the visual, its sheer physicality and visceral involvement with the raw perception of being in the world, allies it more with the automaticity and random incursion of natural forces than with the learned artifice of various media.

How does this *composable* system work? The basal ganglia, an evolutionarily old brain structure, are clusters of neurons buried deep in the front half of the brain. One of their functions is to package sequences of movements or of reasoning into chunks that are available for further combining when we are learning a skill. Another is to inhibit the dissolution of the actions packaged into these chunks so that there is always a tug of war between unruly impulses and forces of control. The brain-mind is a process, composed of countless interacting subprocesses, all of which are also always in process.

Stuart Davis's jazzy urban paintings—juxtaposing Lucky Strike cigarette packets with garish gasoline stations, flat chain-store fronts, chrome yellow taxi cabs, and the episodic flash of neon signs—are rooted in an improvisational gestural art. Such "swing" pictures conform to the causal structure of the modern world—disjointed, even antagonistic—as well as to the anxious or fearful perceiver. In his own way, Davis demonstrates that unnuanced mosaic formats shock and startle our nervous system. Fractured genres—clashing color blocks, harsh black and white grids, subdivided escutcheons, quartered blazons, heaves of non-articulated paint, segmented video clips—capture the brain-mind's first attempts to extract lucidity from the noisy bluster of the world. They remind us of the truth of Berkeley's empiricist insight that depth awareness requires touch, and is not solely conveyed by the prismatic visual array.[72]

Flowing narrative, as opposed to staccato patchwork, owes to neuroplasticity. It is the byproduct of a brain that is dynamic and changing well into old age, all the while spinning tales automatically. Research on free recall (whatever pops into someone's head), as opposed to recognition or recollection, suggests that at least some of the neurons that fire when a distant memory comes to mind are those that were most active back when the remembered event first happened. This crowd in the mind, composed of intensely mixed imagery, whirls into baroque complications. Like a pebble thrown into a pool, a particular instance ripples outward into a reservoir of feeling and suggestion. This Gongoran aspect of our neural mechanisms, struggling with stimuli that exceed or thwart representation, spontaneously generates stories in the attempt to connect anomalous data. But the mental activity driving our actions and self-narration, is, in Michael Spivey's words, "one continuous trajectory through a state space containing graded attractor basins that often correspond to the apparent units, but this trajectory rarely dwells near any one attractor for long, and indeed spends most of its time in transit, in between labeled regions."[73]

Playing with the ambiguity that often accompanies visual decision-making, Jeff Wall's *Tattoo and Shadow* (2000), a light box Cibachrome, is revealing because it demonstrates that dappling does not produce the clear affective "hits" of, say, Seurat's pointillism. Wall puns on the affinities that connect natural and artificial markings by referencing Cuno Amiet's speckled figure

painting, also housed in the Zurich Kunsthaus. This fin-de-siècle Swiss artist's stylized approach to pattern—broadly interlacing sunlight with shadow to create an arabesqued dress—contrasts with the contemporary witticism of a flamboyantly tattooed couple, decoratively camouflaged in their ornamental skin paint.

These two particolored figures merge with the grassy yard and sink beneath the fretwork canopy of trees under which they sit. Wall shows that—as is true for musical improvisation—harlequin shapes group themselves into synchrony, composing a chromatic ensemble at a particular moment in time. He makes visible the fact that pattern has the self-organizational tendency to communicate with other patterns, intimately sharing a graphic idiom that develops during the course of close-up performance. Keith Haring was right when he said that "cleaning up art," (i.e., vacuuming dots, straightening lines, creating an arrangement out of competing color systems) allows individual forms to stand out from their noisy setting.

Slow Looking: What Holds Vision?

She watches with the raptor's eye,
trained on distance as she is,
and dark—so when she turns
to what is close, so intimate
and huge, she keeps the gift
of sight beyond herself,
neither sentimental nor detached.[74]

News reports agree: in the age of Twitter, MySpace, Facebook, and e-mail or texting via iPhone and BlackBerry, no one seems to linger in the present or the moment anymore.[75] Who, indeed, watches the passing show with "the raptor's eye?" Couple the quick "tweet" modalities of social networking with the videoing and blogging obsession, immersion in video games, overtime on the Internet, and the constant interruption of face-to-face interaction by the cell phone, and you have a recipe for attention deficit in the life world. What are educational institutions to do in the culture of online engrossment and the fast electronic update? What interests me is how the visual side of the hu-

manities might rearticulate its worth in this climate of unexamined absorption. No more pressing issue faces us today than a full-bodied understanding of what poet Eleanor Wilner described as "the practiced eye," able after years spent looking to hold in vision "the foreground of the other side." And no question drives us more to cross disciplinary borders, or pushes us harder to move beyond language into other informational frontiers.

Why is being aware that you are aware important? Why do we need to be conscious that we are conscious? Humans possess an "attentional system" in the right hemisphere—taking in global aspects of the environment—that is particularly sensitive to unexpected, behaviorally relevant stimuli such as danger. In our species, this instinctual wariness has evolved into a spectrum of negative emotions very different from those of the emotionally neutral left hemisphere, which focuses on a limited number of features.

One consequence of this admittedly hazy division of mental labor is that there is a difference between a drive and "a seeking system" in which the mind knowingly performs work. Freud acknowledged this binarism when describing *freier Einfall*, or free association, as referring to notions arising spontaneously in the mind. Although these notions are not obviously connected to a person's conscious thoughts, Freud argued—as had Hume before him—that they have a hidden impact on our waking perceptions.[76]

But the old tension between the conscious and unconscious brain has become more acute, especially given the surge in solipsistic filtering gadgets. So why exploit the gaps in our autopoietic neural systems at all? Why try to circumvent the brain's tendency to discount much visual information and select only what it needs to obtain a certain kind of knowledge of the world? These are the same intrinsic, automatic background systems being targeted by zombie electronic media, as well as by the psychopharmacological armamentarium wielded by a "tailored" personalized medicine.

Just like cocaine, certain simulating video games trigger reward centers of the brain at a level that words cannot reach. A recent Stanford University study suggests that the "game buzz" is felt more by men than by women, and that it excites the addiction circuitry. The flash flood of gaming stimulates the nucleus accumbens to be hyperactive in what has been called "the life-enhancing experience."[77] Philip Toledano's photographic series *Game Faces* (2007) catches male adolescents who are mesmerized by what appear to be

"first-person shooters"—interactive shoot-em-up narratives influenced by military war game simulations. Significantly, Toledano seizes these young men while they are held in thrall to the fast-moving action exploding on the computer screen. Speaking cinematically, these players are unable to pause or "still" the image. Their attention mechanisms are fatigued and overstretched, incapable of fading to black or moving their nervous systems away from a state of exhaustion. Nicholas Carr sums up the downside of the current digital scene when he asserts that now it is all about the speed of locating and reading data. "We are transferring our intelligence into the machine, and the machine is transferring its way of thinking into us." And again: "We are beginning to process information as if we are nodes."[78]

This captivation by live-streaming media contrasts sharply with the attention training typical of old as well as new meditative therapies. From Buddhist contemplation to the transcendental engendering of "an awareness of every sensation as it unfolds in the moment,"[79] such deliberate acts of self-control help patients deal with everything from disabling anxiety to depression. Beyond pathology, if we actually look at how ordinary human beings behave when they involve themselves in more complex cognitive activities such as thinking, communicating, investigating, or observing, we see that they slow down or hesitate. In the perceptive words of neuroscientists Humberto Maturana and Francisco Varela, "to live is to know." By this they mean that human interaction is based on the present moment of meaningful experience. There is a fundamental difference, then, between the concept of automaticity (which stems from cybernetics and is defined by Norbert Wiener as a science of control or prediction of future action as well as a science of form) and spontaneity (which derives from biology and the realm of the imagination). The latter, in fact, is how unfettered organic life—not programmed artificial life—evolved.

If we glance again at Katerina Šedá's installation *It Doesn't Matter* (2007, figure 0.1), we note that one of its aims was to widen an older adult's limited focus of attention and revitalize mnemonic functions through drawing. To be sure, limbering up the aging brain involved subcortical activity—the ascent of serotonergic raphe along the hippocampal pathway.[80] But the subject's recovered sense of agency was spurred by one person intentionally attending to someone else. Šedá's compassion for her grandmother's plight led to an artistic solution

for the neurological challenge of reawakening long lost practical skills. A new enactive subjectivity was born from this pragmatic approach, along with the production of a vast encyclopedia of diagrammatic drawings. Recollection as reimagining thus exhibits how the elastic mind is capable of assimilating and reassimilating data throughout life. Acts of retrieval offer biological evidence for wisdom, or for the capacity of older people to take in more from a situation, combining it with their amassed store of prior knowledge.

The creation of a complete typology of attentive looks would require summoning the entire history of art to bear witness. I offer some telling examples of imaginative empathy instead. Think of how Degas constructs the intellectual curiosity of an antiquarian, the inquisitive look of a milliner trying to figure out how to feather a hat, or the re-cognition embedded in the routine of a dancer whose expert pliés performed in front of a mirror demonstrate to the watchful corps de ballet: "See, it's like this." Or consider visual diagnostics—that is, how painters from Piero Della Francesca to Goya observed things head-on or skewed, slanted, and tilted in order to let us perceive what otherwise can never be perceived. Then there is the searching look of self-assessment and comparative judgment (in which a complex realization is synthesized in the understanding) captured by Rodin in his *Burghers of Calais*. Recall, too, how thoughtfulness is synaesthetic, possessing a palpable heaviness. At an important level, what is Manet's *Dejeuner sur l'herbe* (1863) but the performance of pondered choice, the coming to a weighty decision about the merits of sacred versus profane love, obliging the sitters to embark on a kind of inner immigration? The focused and extended reviewing of one's life requires judiciousness, the assessment of how we arrived at a conclusion. Mixed emotions—such as the unequal mingling of suffering, remorse, grief, shame, resignation, and regret in Guido Cagnacci's *Penitent Magdalene* (c. 1660)—complicate our understanding of how individuals select among conflicting data.

These examples begin to get at the time-based nature of acute wakefulness in contrast to automatic action instantiation without further conscious intent. Rather than beginning with reward systems in the brain as neuroscientists do, I am working from the outside in to ask what kinds of situations we wish to extend because we want to live them longer. What are the sorts of experiences we want to be fully alert and awake for, and whose moment we

wish to protract indefinitely? In short, what can the lingering look teach us about selective attention or that which leads a person to be aware of the fact that she knows? In his religious writings, W. H. Auden comes close to espousing the Buddhist concept of mindfulness. "To pray is to pay attention"—or "to listen to someone or something other than oneself. Whenever a man so concentrates his attention—be it on a landscape, or a poem or a geometrical problem or an idol or the True God—that he completely forgets his own ego and desires in listening to what the other has to say to him, he is praying."[81] Importantly, in contrast to "petitionary prayer," pure adoration asks nothing. Think of Philip Otto Runge's painting *Small Morning* (1808), in which the adoring angels of light, waiting and watching over the Christ child lying in the meadow, manifest a wondering but undemanding and unerotic love. Christian agape is that selfless emotion that is the opposite of human indifference.

To be sure, erotic love also involves long looking—as in longing, the prolongation of animal appetite or sexual desire. To be provocative: eroticism is the opposite of our Taylorized world and its attendant science of management teaching people "to save time for joy!"[82] The troubadour poets, on the other hand, savored the allure of this sweet looking/gentle looking (*"le doux regard"*), whose lengthy progress was chronicled in the *Roman de la rose*: "The more a man gazes on his love, the more burns his heart. It is basted with bacon fat, so the nearer he is to the fire, the more he burns."[83] Titian's paintings of an organ player gazing intently on a reclining nude continue this feudal tradition of unrequited passion. The great Venetian painter, however, grounds it in the voluptuous reality of the ongoing fleshly liaison between a Renaissance prince and a seductive courtesan.

But Correggio remains unsurpassed in registering both the fierce attentiveness of an ardent lover and two people hesitating/fainting together in a single moment. By painting the act that resists verbal definition, he convinces us that sight is indeed the most dangerous of the senses. In his hands, the image does not record but re-performs visceral intimacy, the ensuing tremble that comes with fitting oneself to another person. His Ovidian *Jupiter and Io* (c. 1531, figure 0.9) enacts sacred carnality, putting the sacred in tangible contact with the profane by literally presenting the insatiable hunger of a man for a woman.

FIGURE 0.9. Correggio, *Jupiter and Io*, c.1531. Kunsthistorisches Museum, Vienna

Correggio refuses to sublimate or relocate the sting of passion from the body to the spirit or harden the sexual act into a representation. The result is that we see and feel Io miraculously "ravished"—that is, "taken up" by the god who moistly envelops her while disguised as a cloud. The sensory power of that original instant is preserved and extended in our subsequent enactment of the experience. Erotic pleasure is not exhausted in the recognition of the myth, because it is performed again and again in the viewer's responsive body. The artist's painting is thus miraculous because it survives the moment when it was new: returning each moved beholder to an original and unconstrained touch seemingly without any lapse of time. As with Auden's attentive adoration, we are given the gift of something wondrous by the grace of God.

By contrast, voyeurism thwarts our natural tendency to mirror. Elfriede Jelinek's disturbing novel *The Piano Teacher* offers a case in point since the only perceptual act her heroine is capable of is the fixed stare of lurid curiosity, the interminable fantasizing about a mosaicized flesh. Voyeurism's Medusa-like pathology consists of freezing the viewer's attention by narrowing, tethering, and fixing the gaze. As a result, it ruptures the mimetic logic of binary reciprocity to which the visual system is fundamentally geared. Similarly, part of the icy effectiveness of Duchamp's violent peep show, the *Étant donnés* (1946–66), owes to this abrupt decoupling of vision from motion in the observer. I also wonder, following Stanislas Dehaene's theory of neuronal recycling, if the brain's *writing* system does not become pathologically disrupted and turned to an alien function? Voyeurism dislocates the brain's visual system from its normal operations, apparently wrenching it towards the physical and psychological distancing that comes with writing.

In closing, I want to distinguish being caught up in abstraction, or psychological neglect, from distraction or visual delirium. Photographer Ben Gest's monumental photographs capture individuals trapped in a fluctuating moment. He is interested not so much in the self but in how we inhabit it. Precariously stilled, his sitters hover enigmatically somewhere between fading in and out of consciousness. These life-size images are seamlessly combined from dozens of digital photos featuring a solitary person rooted in his or her immediate surroundings. Their composite nature gradually becomes evident through subtle and not so subtle exaggerations of proportions and perspec-

tive. The fact that they are assembled, even skewed, slows down the viewer's otherwise swiftly identifying glance. Gest's sitters have become dispersed in things, trappings, cars, and furniture. Gest creates a Daniel Dennett kind of third-person-consciousness photograph: a man stopped in his tracks holding a garbage can lid or stalled in mid-step while leaving a car, or a woman pausing in the fastening of a bracelet on her wrist (*Jessica and Her Jewelry*, figure 0.10). All seem utterly self-aware, though functioning on automatic pilot, having retreated into the far reaches of private thought.

Gest documents thought as an elusive and episodic phenomenon located at the periphery, in the accessories. It disconcertingly disappears and reappears. We must wait and watch to see it in action, in the downcast stare or slanting gaze of sitters lacking an object of focus. Gest's combinatorial images allow us to ponder the perceptual and cognitive competition always going on between blind, unconscious habit and an open conscious relation to the outside world. His people are withdrawn from any kind of social engagement. Being abstracted, then, is a very different state of mind from distraction, or the parsed inattention that accompanies multitasking. If in Western culture to be human has always meant the conjunction of body and soul, an animal plus a supernatural element, perhaps now we need to think of the human not as a metaphysical mystery of conjunction but as an incongruity. Art that encourages one to pay attention to the spectacle of our duration and its periodic rupture encourages the development of a consciousness of self not easily swallowed up in immersive systems. .

So if we are an undeniable admixture of nature and nurture, what are some of the educational ramifications of the humanities joining forces with the neurosciences? The problem is not, as a recent article claimed, that "math and science rule the school," but that American education is being retooled into an adjunct of industry, an "instrument of production"[84] across the board. There is a relentless vocationalism about in the land. I do not mean what would, in fact, be the worthwhile recognition that "knowledge work" gets done in handwork.[85] A multisensory education is something quite different from the immediately identifiable utility of "capability building" and business careerism.

This is not to deny that the arts are vital to economic growth and are engines of change. What I am proposing is that the humanities and the neuro-

FIGURE 0.10. Ben Gest, *Jessica and Her Jewelry.* Photograph. © Ben Gest.

sciences need jointly to make the case that learning is incremental and endless, yielding associations that allow us to wander off inventively and independently into new territory. This suggestion has nothing to do with aping our supposedly more successful colleagues or repackaging old material and camouflaging it in scientific jargon. It is about rebuilding our fundamental concepts of what make us human (imagination, memory, reason, emotion) from the ground up. Developing responsible citizens means training our volition so that we are not just blindly led by our reward systems. We need to complicate the current conception of vision and images, making them commensurate with an unsettling present filled with equivocal entities and ambiguous situations.

As we move into the second decade of the twenty-first century, the power to not only modify the smallest components of life through molecular biology but also alter brain function with genetic and drug therapies has enormous consequences beyond the comprehension of those doing the transforming. The essays that follow are proof that the neurosciences cannot dispense with the humanities in their analyses of the brain. Equally, the humanities must reckon with scientific findings. Desegregating those who address the outer and inner worlds gets rid of warring over prestige and funds. Without a dual perspective, we will remain baffled about the biological as well as the cultural aspects of that most mysterious recombinant organ in the human organism. And the human body will remain a puzzle-body. This volume, then, serves as a modest field guide for custom-building issue-driven research partnerships. It demonstrates how one *might* engineer future cross-cutting projects that impact both individual initiatives as well as university programs. If you want to tackle a complex question, we suggest you begin here, with this practical and theoretical Wikipedia for future combinatoric disciplinary relationships.

Notes

1. Brian Greene, "Journey into the Unknown," *Wired* (May 2009), 18.
2. See, recently, Raymond J. Gibbs and Lynne Cameron," The Social-Cognitive Dynamics of Metaphor Performance," *Cognitive Systems Research*, 9 (2008), 64–75.
3. Alva Nöe, *Out of Our Heads: Why You Are Not Your Brain, and Other Lessons from the Biology of Consciousness* (New York: Hill and Wang, 2009), 60.

4. Announcement of 2010-11 theme year at the Getty Research Institute: "The Display of Art."

5. Jean-Pierre Changeux and Alain Connes, *Conversations on Mind, Matter, and Mathematics*, trans. by M. B. DeBevoise (Princeton, NJ: Princeton University Press, 2007).

6. Jean-Pierre Changeux and Paul Ricoeur, *What Makes Us Think? A Neuroscientist and a Philosopher Argue about Ethics, Human Nature, and the Brain*, trans. by M. B. DeBevoise (Princeton, NJ: Princeton University Press, 2004).

7. David Grimm, "The Mushroom Cloud's Silver Lining," *Science* 321 (September 12, 2008): 1434–37.

8. Ibid.

9. Gerald M. Edelman and Giulio Tononi, *A Universe of Consciousness: How Matter Becomes Imagination* (New York: Basic Books, 2000), 20.

10. Stanley B. Klein, Leda Cosmides, Cynthia E. Gangi, Betsy Jackson, and John Tooby, "Evolution and Episodic Memory: An Analysis and Demonstration of a Social Function of Episodic Recollection," *Social Cognition*, 27 (April 2009): 283–319.

11. Scholars are beginning to recognize how intensely visual Darwin's *Voyage of the Beagle* and *The Origin of Species* are. See, for example, Alex Taylor, "Wolseley's Lines," in *Reframing Darwin: Evolution and Art in Australia*, ed. by Jeanette Hoorn (Melbourne: The Miegunyah Press, 2009), 200.

12. Edelman and Tononi, *Universe of Consciousness*, 77–79.

13. Giacomo Rizzolatti and Corrado Sinigaglia, *Mirrors in the Brain: How Our Minds Are Shared Actions and Emotions*, trans. by Frances Anderson (Oxford and London: Oxford University Press, 2007). Also see the rise of e-memory and Microsoft's Gordon Bell's attempt to make everything in the universe fall under "miscellaneous," thus avoiding routine categorizaton. Steven Leckart, "Self-Storage: Gordon Bell's Life in Data," *Wired* (September 2009): 75.

14. William Wordsworth, *Guide through the District of the Lakes, with a Description of the Scenery , &c, for the Use of Tourists and Residents [1810–1835]*, ed. by W. J. B. Owen and Jane Worthington Smyser (5th ed.; Oxford: Clarendon Press, 1974), 179. Also see Julia Sandstrom Carlson, "*Prose mésurée* in the Lakes Tour and Guide: Quoting and Recalibrating English Blank Verse," *European Romantic Review*, 20 (April 2009): 227–36.

15. Allen Samuels, e-mail to author, November 7, 2008.

16. Marc Hauser, *Moral Minds: How Nature Designed Our Universal Sense of Right and Wrong* (New York: Ecco, 2006).

17. Gero Miesenboeck, review essay "The Optogenetic Catechism," special section on advances in neuroscience method, *Science* (October 16, 2009): 395–99.

18. Stanislas Dehaene, "Reading in the Brain," lecture presented at the University of Melbourne, November 12, 2009. Also see his *Reading in the Brain: The Science and Evolution of a Human Invention* (New York: Viking, 2009), 174–80.

19. Joel Fisher, "Notes toward a Prepositional Drawing," Drawing Research Network Conference, Cochrane Theatre, London, October 8, 2009.

20. Billy Collins, "Greek and Roman Statuary," in *Ballistics* (New York: Random House, 2008), 35–36.

21. Deborah Digges, "The Wind Blows through the Doors of My Heart," *The New Yorker* (August 24, 2009): 34.

22. Karl J. Friston, review essay, "Modalities, Modes, and Models in Functional Neuroimaging," special section on advances in neuroscience methods, *Science* (October 16, 2009): 399–403.

23. D. H. Lawrence, *Lady Chatterley's Lover* (New York: Modern Library, 1959), 148.

24. Michael Specter, "A Life of Its Own: Where Will Synthetic Biology Lead Us?" *The New Yorker* (September 26, 2009): 56–65.

25. Ted Hughes, "Epiphany," in *Birthday Letters* (London: Faber & Faber, 2002), 114–15.

26. Cited in David Need, "Bringing God into Being: Rainer Maria Rilke's Use of Visual Art as a Mode of Hermeneutics," forthcoming. I thank the author for sharing his manuscript with me.

27. Keith J. Holyoak and Paul Thagard, *Mental Leaps: Analogy in Creative Thought* (Cambridge, MA: MIT Press, 1995), 131.

28. Anjan Chatterjee, "Prospects for a Cognitive Neuroscience of Visual Aesthetics," *Bulletin of Psychology and the Arts* 4, no. 2 (2004): 55–60.

29. Peter Lakatos, George Karmos, Ashesh D. Mehta, Istvan Ulbert, and Charles E. Schroeder, "Entrainment of Neuronal Oscillations as a Mechanism of Selective Attention," *Science* 320 (April 4, 2008): 110–12.

30. John Sutton, *Philosophy and Memory Traces: Descartes to Connectionism* (Cambridge: Cambridge University Press, 1998). Also see Daniel Dennett, *The Intentional Stance* (Cambridge, MA: MIT Press, 1987).

31. Nuo Li and James J. DiCarlo, "Unsupervised Natural Experience Rapidly Alters Invariant Object Representation in Visual Cortex," *Science* 321 (September 12, 2008): 1502–6.

32. Russell Meares and Sharon Jones, "The Role of Analogical Relatedness in Personal Integration of Coherence," *Contemporary Psychoanalysis* 45, no. 4 (2009): 504–19.

33. Walt Whitman, *Leaves of Grass* (New York: W. E. Chapin & Co, 1867), 96.

34. Paolo Colombo, "In Praise of Pores," *Science* 322 (October 17, 2008): 381–82. Also see Andreas Reichenbach and Thomas Pennicke, "A New Glance at Glia," *Science* 322 (October 31, 2008): 693–94.

35. Melissa Healy, "Feel Like You've Been Socially Burned? It's in the Genes," *Chicago Tribune* (August 21, 2009): 21.

36. William James, *The Principles of Psychology*, vol. 2 (New York: Dover, 1890 [1950]), 334.

37. Francis Picabia, *291* (February 1916): back page (no page number).

38. Joachim Hansen and Michaela Waenke, "Liking What's Familiar: The Importance of Unconscious Familiarity in the MERE-Exposure Effect," *Social Cognition* 27 (April 2009): 161–82.

39. See, for example, John Barresi and Chris Moore, "The Neuroscience of Social Understanding," in Jordan Zlatev, Timothy P. Racine, Chris Sinha, and Esa Irkonen, eds., *Approaches to the Evolution of Language: Social and Cognitive Bases* (Cambridge: Cambridge University Press, 2008), 39–66.

40. See the updated home page of Ian Hodder's ongoing excavations: *Catalhoyuk: Excavation of a Neolithic Anatolian Hoyuk*.

41. Daniel D, Hutto, *Folk Psychological Narratives:The Sociocultural Basis of Understanding Reasons* (Cambridge, MA, and London: MIT Press, 2008), 15.

42. Antonio Damasio, *The Feeling of What Happens* (New York: Basic Books, 1999), 86–87.

43. See the excellent essays in Bertram F. Malle, Louis J. Moses, and Dare Baldwin, eds., *Intentions and Intentionality: Foundations of Social Cognition* (Cambridge, MA: MIT Press, 2001. For an evolutionarily embedded discussion of TOM, see Terrence Deacon, *The Symbolic Species: The Co-Evolution of Language and the Brain* (New York: Norton, 1997).

44. Orhan Pamuk, *My Name is Red* (New York: Random House, 2001).

45. William Finnigan, "The Secret Keeper. Jules Kroll and the World of Corporate Intelligence," *The New Yorker* (October 19, 2009), 42–48.

46. It might be worthwhile for human computer interaction scientists, as well as neuroscientists investigating affect, to factor such cases into their studies of emotional contagion. See, for example, the fascinating Chameleon Project: an emotionally interactive video installation (*After Darwin: Contemporary Expressions*), currently exhibited at the Natural History Museum, London.

47. A. S. Byatt, "Trench Names," *The New Yorker* (April 6, 2009): 54–55.

48. See Rei Terada, "Living a Ruined Life: De Quincey Beyond the Worst," *European Romantic Review* (April 2009): 177–86.

49. Robert L. Martensen, *The Brain Takes Shape: An Early History* (Oxford: Oxford University Press, 2004), 200.

50. Michael Spivey, *The Continuity of the Mind* (Oxford: Oxford University Press, 2007), 300–301.

51. Carl C. Swisher III, Garniss H. Curtis, and Roger Lewin, *Java Man: How Two Geologists' Dramatic Discoveries Changed Our Understanding of the Evolutionary Path to Modern Humans* (New York: Scribners, 2000), 60–62, 197–98.

52. Alec Wilkinson, "The Deepest Dive: How Far Down Can a Free Diver Go?" *The New Yorker* (August 24, 2009): 24–30.

53. Peter F. MacNeilage, Lesley J. Rogers, Giorgio Vallortigara, "Origins of the Left & Right Brain," *Scientific American* (July 2009): 60–76.

54. Sam Shepard, "Land of the Living," *The New Yorker* (September 21, 2009): 85.

55. Alan Dean, *Complex Life: Nonmodernity and the Emergence of Cognition and Culture* (Aldershot, UK: Ashgate, 2000), 82–83.

56. Daniel Dennett, *Darwin's Dangerous Idea: Evolution and the Meanings of Life* (London: Penguin, 1995).

57. Maurice Merleau-Ponty, *The Primacy of Perception* (Chicago: Northwestern University Press, 1964), 14.

58. Silvia Gaddi, Luciano Arcuri, and Bertram Gawronski, "Automatic Mental Associations Predict Future Choices of Undecided Decision-Makers," *Science* 321 (August 22, 2008): 1100–2.

59. Paul M. Bays and Masud Hussein, "Dynamic Shifts of Limited Working Memory Resources in Human Vision," *Science* 321 (August 8, 2008): 851–54.

60. Michael Balter, "Going Deeper into the Grotto Chauvet," *Science* 321 (August 15, 2008): 904–5.

61. Daniel D. Hutto, *Folk Psychological Narratives. The Sociocultural Basis of Understanding Reasons* (Cambridge, MA: MIT Press, 2008).

62. Charles C. Mann, "Ancient Earthmovers of the Amazon," *Science* 321 (August 29, 2008): 1148–51.

63. Posted online by mazerunner [Diana Slattery, University of Plymouth] on February 22, 2008. Also see research on geometric figures and migraine experience: Anjan Chatterjee, "The Neuropsychology of Visual Art: Conferring Capacity," *International Review of Neurobiology* 74 (2006): 39–49.

64. Carl Phillips, "Civilization," *The New Yorker* (March 23, 2009): 46–47.

65. On "blending theory," see Gilles Fauconnier and Mark Turner, *The Way We Think: Conceptual Blending and the Mind's Hidden Complexities* (New York: Basic Books, 2002). I, however, discussed at length the difference between blended and blatantly mixed styles in my *Visual Analogy: Consciousness as the Art of Connecting* (Cambridge, MA, and London: MIT Press, 1998).

66. Thomas Natsoulas, "Virtual Objects," *The Journal of Mind and Behavior* 20 (Autumn 1999): 357–58. The book in question is *The Ecological Approach to Visual Perception* (1979).

67. Antonio P. Damasio, *Descartes' Error: Emotion, Reason, and the Human Brain* (New York: G. P. Putnam, 1994), 259.

68. Jonah Lehrer, "The Brain, Revealed," *Wired* (February 2009): 93.

69. Nicholas J. Wade, Benjamin W. Tatler, and Dieter Heller, "Dodge-ing the Issue:

Dodge, Javal, Hering, and the Measurement of Saccades in Eye-Movement Research," *Perception* 32 (2003): 793–804.

70. Tim Gollisch and Markus Meister, "Rapid Neural Coding in the Retina with Relative Spike Latencies," *Science* 319 (February 22, 2008): 1108–10.

71. James Richardson, "Subject, Verb, Object," *The New Yorker* (2007) http://www .newyorker.com/fiction/poetry/2007/12/03/071203po_poem_richardson.

72. George Berkeley, *The Principles of Human Knowledge, with Other Writings*, ed. G. J. Warnock (London: Fontana, 1962), 123, 228.

73. Spivey, *The Continuity of Mind*, 308.

74. Eleanor Wilner, "Freed from Another Context," in *Reversing the Spell: New and Selected Poems* (Washington: Copper Canyon Press, 1998), 136.

75. Maria Puente, "Relationships in a Twist over Twitter," *USA Today* (April 15, 2009): 1–2D.

76. There are important reassessments of Hume's theory of association. See, for example, Mark Bruhn, "Shelley's Theory of Mind: From Radical Empiricism to Cognitive Romanticism," *Poetics Today*, especially 375–80.

77. Kelli Whitlock Burton, "Got Game?" *Science* 319 (February 15, 2008): 881. Also see James Paul Gee, *What Video Games Have to Teach Us about Learning and Literacy* (2nd ed.; New York: Palgrave Macmillan, 2007).

78. Nicholas Carr, *Does IT Matter? Information Technology and the Corrosion of Competitive Advantage* (Cambridge, MA, and London: MIT Press, 2004)

79. Benedict Carey, "Lotus Therapy, A New Old Path," *New York Times* (May 27, 2008): D1, D4.

80. Viktor Varga, Attila Losonczy, Boris V. Zemelman, Zsott Borhegyi, Gabor Nyiri, Andor Domonkos, Gabor Balazs, Hang Ya, Noemi Holderith, Jeffrey C. Magee, and Taas F. Freund, "Fast Synaptic Subcortical Control of Hippocampal Circuits," *Science* (October 16, 2009): 449–53.

81. W. H. Auden, *A Certain World: Nature of Prayer* (New York: Viking, 1970).

82. Jill Lepore, "Not So Fast," *The New Yorker* (October 12, 2009): 122.

83. Guillaume De Lorris and Jean De Meun, *The Romance of the Rose*, trans. by Frances Horgan (New York: Oxford University Press, 1999), 36.

84. Mark Sloutka, "Dehumanized: When Math and Science Rule the School," *Harper's Magazine* (September 2009): 32–40.

85. Matthew B. Crawford, *Shopclass as Soulcraft: An Inquiry into the Value of Working* (2009).

ONE Tentacular Mind

.STOICISM, NEUROSCIENCE, AND THE
CONFIGURATIONS OF PHYSICAL REALITY

. Thomas Habinek

Among the graffiti preserved on the walls of the buried city of Herculaneum is
a profile of a young woman accompanied by an apparent caption (figure 1.1):

> Hermeros to mistress Primigeneia:
> Come to Timnianus Street in Pozzuoli
> and ask the banker Messius for Hermeros, the freedman of Phoebus.[1]

Although some viewers have speculated that the narrow lines connecting
the portrait of Primigeneia to the words of Hermeros's invitation depict a
grotesquely distorted nose, a more plausible explanation has been offered
by Jean-Paul Dumont, for whom the combination of drawing and caption il-
lustrates the ancient Stoic account of vision as a process in which the brain is
imprinted or reconfigured through unbroken physical contact with an exter-
nal object.[2] According to this view, the graffitist Hermeros expresses the hope
that in extending itself to read his words, the brain (or, as the Stoics would
say, "commanding faculty") of Primigeneia will in turn be impressed or re-
configured with an image of him (note the male profile within the female pro-
file), thereby prompting her to consummate the hoped-for rendezvous. Her
assent to the sense-presentation of Hermeros's scrawl ("Come to Timnianus
Street") is, according to Stoic psychology, identical with the impulse, or com-
mencement, of the corresponding action. Once Primigeneia lets Hermeros
inside her head, her body will already be on its way to merging with his. The
Stoic mind, we learn elsewhere, is like an octopus, each sense a tentacle grasp-
ing the external world, reshaping itself and the world accordingly. Vision is
a physical connection between seer and seen, operating—with the usual
Stoic fondness for paradox—like the walking stick of a blind man, through
two-way transmittal of tensile motion.[3] Mind and world communicate as if

FIGURE 1.1. Graffito from wall of changing room in suburban baths, Herculaneum

. .

along the threads of a spiderweb.[4] In the Herculaneum graffito, then, the lines connecting the face of Primigeneia with the words of Hermeros represent the dynamic rod of pneuma, or fiery breath, that makes sensation and perception possible by uniting brain, body, and environment. Primigeneia's mind grasps the relevant portion of the external world and is reconfigured accordingly.

The Stoic account of perception, preserved in various fragmentary texts and illustrated—if Dumont is right—by Hermeros's drawing, is more than mere historical curiosity, for it bears a striking resemblance to a leading strain of contemporary neuroscience and cognitive science that emphasizes connection, or continuity, between internal mind and external world.[5] For the Stoics, as for continuity psychologists today, thought is as much *external* as internal to the individual organism, the result of dynamic interaction between mind and world; perception is *distributed* across the sensory and cognitive modalities through which it is synthesized (event recognition, for example, does not happen through the eyes or ears alone, but entails an assemblage from across the sensorium); and the brain or nervous system is *plastic*, or changeable over time, precisely in response to its ongoing integration with the objects and patterns of the world beyond the organism. As one neuroscientist explains, "We are thinking beings whose nature qua thinking beings is not accidentally but profoundly and continuously informed by our existence as physically embodied, and as socially and technologically embedded, organisms."[6]

What's more, the Stoic account of cognition, of which perception forms the key component, is sustained by an explicitly articulated physics that is comparable to the physics implicit in much modern science. For the Stoics, the universe is a single organism with all parts interconnected.[7] More than one scholar has described Stoic physics as being, in effect, "cosmobiology."[8] In the Stoic system nothing exists but the material universe, which is a dynamic entity, subject to recurrent expansion and contraction. Because the universe is continuous, boundaries between bodies are in effect useful fictions. We are asked to think not of discrete entities united through compounding or composition, or separated by void, but of configurations of matter pressing against each other to form fuzzy edges, or commingling in a process known as krasis, or total mixture. The octopus and the sea floor are one; the substance of Primigeneia's eye and brain really connects with Hermeros's words, and vice versa. Where the modern physicist speaks of vibrations, waves, and force fields to describe the dynamism of the universe and the relatively stable entities within it, the Stoics hypothesize the ubiquity of pneuma, an exhalation of fiery air whose varying tenor accounts for the observable differences in density, mobility, hardness, and animation of all bodies, including the human mind.

The convergence of key strands of ancient and modern thought about thinking opens up exciting possibilities—and profound challenges—for interaction between humanistic scholarship and scientific inquiry. No longer occupying an intellectual universe composed of discrete bodies of disciplinary knowledge, those who seek a more encompassing understanding of the processes and products of human cognition are faced with various options ranging from total mixture to the blurring of disciplinary edges and reconfiguration of inside through contact with outside. Not on the table, if we follow the ancient Stoics and their modern counterparts, is simple compounding, which by merely adding types of knowledge to one another confirms their separation and presupposes a void through which they approach or diverge. Instead, we are asked—to use another metaphor appropriate to a universe of interpenetrating bodies—to consider disciplines as metastasizing into one another, perhaps even blending entirely in the great mixing bowl of modern intellectual life. Indeed, we might note in passing that the identification of the boundaries of cancer tumors is a notorious medical difficulty, the solution

of which has been hampered in part by the persistence of the Aristotelian assumption of the reality of two-dimensional edges, an assumption now being challenged through the application of fuzzy logic or fuzzy set theory to the visual representation of malignant growths.[9]

Stoic thought, together with its misconstrual by a long and distinguished line of interpreters, provides an excellent case study for both models of convergence. What might we gain by drawing neuroscience into classics, or by extension into any historical discipline? And what challenges and opportunities would ensue from something more like total mixture; in other words, from a recognition that all of us—humanists, social scientists, artists, and natural scientists alike—are interested in the same material, the processes and products of the human mind, and are ultimately answerable to that material's intrinsic logic or laws?

Let us begin with the introduction of at least some types of neuroscience into the closed field of Stoic studies. For several decades now, scholars of Stoicism, especially in the English-speaking world, have resisted a fairly straightforward interpretation of the ancient evidence pertaining to Stoic physics, perception, and psychology.[10] Schooled by Aristotle to think in terms of a categorical distinction between form and matter, still beholden to Plato for unshackling the observer from the observable world and for inventing the realm of the ideal, and disciplined by their own experience of academic genealogy to define the history of thought as each generation's answers to its predecessors' problems, many scholars of Stoicism persist in denying the radical alterity of Stoic physics in comparison with its leading ancient rivals—or, if they grudgingly acknowledge it, they fail to follow through on the implications for understanding other branches of Stoicism, such as ethics and psychology. Stoicism is seen at best as a deviant or ameliorative Aristotelianism: its physical worldview ambitious, if incoherent, and its psychology highly intellectualized. Even the best interpreters tend to run afoul of their own inability to think physically—that is, to accept the Stoic principle that the universe consists only and entirely of matter.

Consider an allegedly "difficult" bit of Stoic teaching: the attempt to explain how an incorporeal entity such as a lekton (on which more momentarily) can affect a body. Here is the relevant text, taken from the writings of the Skeptic philosopher Sextus Empiricus, an opponent of Stoicism:

The Stoics claim that, just as the teacher or drill sergeant sometimes takes hold of the boy's hand to configure him and train him to make certain motions, but sometimes stands at a distance and, moving to a particular rhythm, offers himself for imitation; so too some appearance-causers touch, as it were, and manipulate the commanding faculty to place their cast upon it, as do white and black, and body in general; whereas others have a nature like that of the incorporeal lekta, and the commanding faculty acquires a new appearance in relationship to them, not by them.[11]

On the standard interpretation, which echoes that of Sextus, the Stoic answer doesn't address the challenge. After all, by standing at a distance, the drill sergeant keeps his body separate from that of the trainee he hopes to affect. But this is to miss the point that in the Stoic view, *the bodies of the trainer and the trainee are part of one continuum.* The trainer's reconfiguration of his body reconfigures that of the pupil through the intervening medium, much as Hermeros's script aims to reconfigure the mind of Primigeneia. One body does not in itself touch the other, but that does not mean that the relationship between the two is any less physical.

Now imagine a contemporary neuroscientist describing the same scenario as recounted by Sextus. She or he would almost certainly invoke the mirroring properties of certain neurons: the experimentally observed fact that the same patterns of neural firings characterize an individual's commencement of an action and his observation of another individual undertaking the same action.[12] We may no longer believe in fiery pneuma, but we accept that something is allowing one body to get inside the other. And if we believe that only matter exists, then that something has to be material, and thus is subject to the laws of physics.

Contemporary neuroscience restores and deepens an otherwise evasive coherence in the Stoic physicalist worldview. Indeed, it seems reasonable to hypothesize that Stoic theories arose in part as an attempt to explain observable aspects of perceptual experience, social learning, empathetic identification, and so forth. To take but one example: the Stoic insistence that edges or boundaries are not real corresponds to recent experimental evidence indicating that the human eye tracks the movement of objects, not edges, through the visual field (see figure 1.2).[13] The Stoics knew a fair bit about the circu-

Condition	Diagram	Note
(a) Boxes		Serves as baseline; Occlude each other when intersecting
(b) Lines		Subjects have to track one end of each line
(c) Rubber Bands with Occlusion		Subjects track one end of each RB; controls for size
(d) Rubber Bands without Occlusion		Like rubber bands, but without any occlusion
(e) Necker Cubes		Subjects track one of the two squares present in each 'cube'
(f) Necker Control		Controls for visual clutter in 'Necker cubes'

FIGURE 1.2. Conditions used to test subjects' ability to track whole objects versus ends of objects

latory system of the human body, and in time came to learn about the nervous system as well,[14] but a segregation of anatomy from psychology, or even simple derivation of the latter from the former, would, in antiquity as today, contradict the key Stoic insight concerning the unity of matter. The resurfacing of that insight in the context of contemporary neuropsychology allows us to see how rigorous, coherent, and modern the Stoic view actually was, especially with respect to the ancient thinkers' distinction between sensation and perception, their recognition of communication between and among sensory and perceptual modalities, and their anxiety over the ritualization and fossilization of perceptual pathways (what we might regard as the dark underbelly of neural plasticity, the tentacle turning back to grasp the mind).

On sensation versus perception, the Stoics were clear.[15] Sensory inputs just happen. Phantasiai (not to be confused with representations or the hallucinations of early modern psychology) appear to the relevant sense organs, which are themselves aspects of the unified mind. They make an impression (as in

the passage from Sextus) or cause an alteration (as in the language of other Stoic writers) of the mental or neural material, but only if "assented to." The phrase "assent to" is the standard expression for the process among classical philosophers, but it obscures the physicality of the Greek term *synkatathesis*, which implies the alignment or matching of two actions, as in placing a pebble to mark a vote or making a deposit in a storehouse. The sensation becomes a percept only if the mind aligns itself with the object that prompted the sensation. As the unidentified Stoics cited by Sextus indicate, sometimes that realignment takes place in relationship to the object, and sometimes it is brought about directly by the object. Either way, the process is physical, but it becomes helpful to differentiate between the two variants, then as now.

Consider again Hermeros and Primigeneia. The dark marks on the stucco wall present a phantasia of just that, dark against light (color, as the founding Stoic Zeno put it, is the first configuration of matter).[16] But the dark marks present a host of other phantasiai to Primigeneia (should she see them), and at least some of these phantasiai can be articulated as propositions—for example, that the marks constitute words, that the words mean something, that they refer to Hermeros, that Hermeros is inviting her, that he is sincere, and so on. Equally, what we call the profile of Primigeneia presents itself to the viewer as a pattern of dark and light on a flat surface, but that pattern too can be organized or articulated as a series of increasingly abstract propositions. To the Stoics, a sensation articulated into something meaningful or graspable is called a *lekton*—a word usually translated as "sayable," although its root form, *legein*, in fact refers to any process of picking or gathering a distinct entity from an array—for example, bones of the dead from a battlefield, stones suitable for construction of a wall, or perhaps (although I've found no examples yet in extant Greek) the octopus's grasp of its prey.[17] Yes, the lekton may be something that can be expressed in language as a proposition, but there's no reason to think it has to be. It is similar to, if somewhat broader than, what we today would consider a percept: not the registering of a sensation on neural receptors, but the integration of that sensation into something meaningful within the given sensory modality, or between and among modalities. And of course it, in turn, like the percepts of modern cognition, can generate its own sense-presentations.

As one neuroscientist puts it with respect to vision, "A representation is

synthesized [i.e. from multiple bits of sensory information] rather than deter-mined by a pure analysis of the retinal image."[18] Features from different sub-modalities must be "bound together to segregate figures from their surround and to create object representations;"[19] as a result, "factors such as attention and expectation gain importance even for the very first steps of visual pattern analysis."[20] Language can serve as one of the factors that is not just produced by but also productive of perception. In the well-known McGurk effect, "individuals are presented with two syllables . . . simultaneously, one in the auditory and the other in the visual modality. When the syllable presented in one modality does not match the one presented in the other modality, the individual may perceive a syllable different from both those presented. There is no reason to doubt that both visual and auditory stimuli are cor-rectly analysed (that is the sensation is correct), yet the percept is different."[21]

But what if a significant portion of life consists of something like the Mc-Gurk effect—that is, modalities interfere with one another, or parents, teach-ers, inherited language, cultural institutions, video art, and so forth are all falsifying the relationship between sensation and its cause or are distorting the construction of successive levels of percepts, restructuring percepts in such a way that they no longer correspond to sensations or to the reality they present? For the Stoics this is, tragically, the ordinary course of human affairs, the reason why almost all of us end up living our lives as fools or slaves. Such a condition can, however, be guarded against in two ways. First, be certain that a phantasia is itself *katalēptikē*—i.e., that it grasps or comprehends (*kata-lambanō*) the reality of which it is a presentation. Second, assent, or reconfig-ure one's mental substance, to such phantasiai and such phantasiai alone. If we stick to these two principles, we gradually align ourselves with material reality to the extent that we and it become indistinguishable, an outcome celebrated in the remarkable doctrine of *ekpyrōsis*, or conflagration, which de-notes both the periodic collapse of the cosmos into originary fire and the ulti-mate homecoming of the sage.[22] The core of Stoicism can thus be understood as the application of a physical insight concerning the oneness and continuity of matter to all aspects of our encounters with the world. Like contemporary psychologists who describe thought as a dynamic trajectory through multi-dimensional state space, unifying brain, body, and environment, the Stoics insist on the individual's capacity to appropriate the substance of the external

universe, which is not in any relevant way different from his own substance. They would have agreed with modern thinkers who argue that it is those who exclude culture, language, and experience from biological accounts of cognition who are the real dualists, in that they implicitly or explicitly posit a realm that does not need to be taken into account in the identification and observation of physical and biological laws.[23] Paul Dourish's distinction between cognition as "inhabited interaction" and as "disconnected control" exactly captures what is at stake in the Stoic resistance to alternative—and, for much of history, more influential—models of thought.[24] Indeed, "inhabited interaction" would be an excellent translation of the Stoic term *oikeiōsis*, which refers to the lifelong process of situating oneself within the universe while making more and more of it one's *oikos*, or home.

Let us assume for the sake of argument that my reinterpretation of Stoic physics and psychology is sustained by broader and more detailed treatment of the complex and controversial surviving sources. We could then add Stoicism to a growing list of remnants of ancient culture that have been illuminated by closer engagement with neuroscience and cognitive studies, such as ancient teachings on the emotions, the formal properties of classical art and architecture, and the relationship between literacy and orality.[25] It's not that neuroscience provides definitive answers; rather, by articulating a model of thought and action radically different from those taken for granted by most scholars, neuroscience defamiliarizes the ancient material, opening up new horizons of understanding, much as comparative ethnography and critical theory have done for previous generations of classicists. Neuroscience teaches us very little about the essential nature of the human organism, except that it is constantly changing through "inhabited interaction" with the material universe. But it gives us excellent tools for understanding the constraints upon and characteristics of such interaction. In that sense, it can't help getting inside the heads of humanists, metastasizing into our disciplinary bodies—provided, of course, that we reach toward it, grasp it, give it our assent.

But what if we actually believe in neuroscience (or Stoicism for that matter)—that is, take seriously the unity of brain, body, and environment, and accept that knowledge is a secure reconfiguration of the mind in accordance with sense-presentations that fully grasp reality?[26] In that case we have to ac-

cept some scary if ultimately exhilarating consequences, as the Stoics themselves already recognized. We have to accept that our thoughts are as much a product of our environment and experience as of our volition or biology, that our minds are not exclusively our own.[27] Are we ready to accept the consequences—for our academic disciplines, but more generally and more importantly for our ethics, aesthetics, and politics? Once again the Stoics provide a useful reference point, a way for humanists and historians, even as we immerse ourselves in the total mixture of a materialist universe, to metastasize our knowledge into the body of science. The Stoics took seriously the implications of their materialism; they regarded ethics, physics, and logic as variant presentations of and means of access to the same physical reality. Are we—humanists and scientists alike—willing to do the same?

If so, here are some areas for further reflection. First, if thought is a trajectory uniting brain, body, and environment, who or what gets to set that trajectory? Or, in Stoic terms, if the mind reconfigures in relation to external patterns, who creates the patterns? The easy answer in both cases is that there is "interaction" between the developing organism and its environment. But interaction is a neutral, even benign term, suggesting a virtual equivalence between inside and out. Its use is understandable as a reaction to prior or alternative views of "disconnected control" on the part of the perceiver, but it disguises the fact that there is still control, from the outside in. The environment—broadly understood as including culture and society, as it must— precedes the organism; it presents its own pathways and configurations. Call it interpellation (Althusser), structuring structure (Bourdieu), or ritualization (Rappaport and Bell): humanists and social scientists have long known it was there. Neuroscience and evolutionary biology have now given us another way to understand its inevitability.[28] Sensation has to be organized into perception for the organism to function in the world. Language always has to be already abstracted into lekta in order for the individual human being to enjoy the species-specific advantages provided by intersubjective cooperation, offline storage of knowledge, and social learning. True, the percept or lekton is not natural or inevitable in the sense of being the only possible configuration of or abstraction from matter. But it is inevitable, or virtually so, from the standpoint of the organism seeking to orient itself and flourish. And if—a big if—acquiescence in the reconfiguration prompted by the percept or the

lekton enhances reproductive fitness, then indeed it can, at least in theory, alter the human genome over time.[29]

What all this means is that the human mind is historically contingent. There are certain regularities that allow us to generalize, draw inferences, and make comparisons about human cognition across space and time, but they are never more than probabilistic trajectories themselves. The world is one reality but we experience it differently, in our very biology, depending on time, place, and context. This is one implication of Cicero's explanation of the Stoic doctrine of *oikeiōsis* in terms of seating in a Roman theater. As he argues: "Just as the communal nature of a theater is compatible with the correctness of saying that the place each person occupies is his, so in the city or world which they share no right is infringed by each man's possessing what belongs to him."[30]

Cicero is concerned with the communistic political theory of the early Stoics and turns the language of habitation or appropriation against them by invoking Roman notions of property rights. But he does not want to lose the idea that we are all part of the same unitary world, regardless of our vantage point upon it. Where I sit may be predetermined by gender, social status, and political power (as indeed it was in the Roman theater), but we are all sitting in the same theater looking at each other. Cicero's logic of spatial particularity is easily transferable to temporality as well: the Stoics were clear that the nature of one's inhabited interaction with the universe changed in accordance with age, and they may even have believed in something like the "period mind" as analyzed by art historians like Michael Baxandall and John Onians—that is, the idea that not only individual experience but also the experience of a culture or historical moment shapes perceptual pathways, determining what we do or don't attend to.[31]

Stoicism's insistence upon the dynamism of matter and of all processes of reconfiguration, including those of human perception and cognition, serves as a challenge to any static model of mind, any neuroscientific or other account, that would make claims about human thought without acknowledging the full force of experience, location, and history. It reminds us that little is gained if we replace a mind/body dichotomy with an equally rigid and equally misleading distinction between nature, or biology, and culture. Total mixture means total mixture. The wise man (who has never existed) is

the one who can explain the full sequence of causes back to the origins of the universe. We'll never get there, but that won't keep us from trying. And as we do, we need to make certain not to assent to accounts that are anything less than comprehensive in their grasp of the reality they claim to describe.

Awareness of the contingent nature of cognitive processes prompts a second type of reflection. Given the control the world holds over us even as we make our home within it, how do we avoid succumbing to false or misleading presentations? One answer, already hinted at, is to press on with the search for causes. Do not be satisfied with the akataleptic, or "non-grasping," phantasiai. Expand the chain of causation by integrating history, experience, and context into the narrowly physical and biological. Humanists and historians already understand how to do this; they just lack access to the scientific language that until now has presented itself as the authoritative configuration of knowledge about physical reality. Surely one goal of collaboration between humanists and scientists ought to be to develop a discourse that makes it possible for us to recognize that we are all talking about the same thing. In the words of Michael Spivey, "The embedding of [the] neural dynamical subsystem inside the larger environmental dynamical system prevents them from being categorically separable."[32] The implication of such a claim is not just that the integration of humanistic and scientific inquiry is desirable. The integration is necessary, even though it will be a long time coming, given the nature of disciplinary structures and professional rivalries.

So in the meantime, practice withholding assent both as an academic and as a human inhabitant of the universal order. I'm not endorsing the skepticism of Sextus Empiricus or any of the other critics of the Stoic theory of knowledge, but am instead recommending awareness of the fact that our perceptions—at every level—are preconditioned by pathways, regimes, and so on that are beyond our individual control. The Stoic insistence on alignment with reality can seem like a recipe for quiescence: accept your fate as a slave, an alien, a pauper. But if everybody did it, then there would be no masters, no nativists, no possessors of excess wealth. We would not have succumbed to false presentations disconnected from reality; we would have touched them and let them go. The Stoics hold out the possibility that even as the knowledge generated by neuroscience creates new mechanisms for outside control, manipulation, and reconfiguration of our material minds—a devel-

opment that seems well underway, and is even cause for celebration in some circles[33]—we can, by withholding assent, create space for human freedom. In Stoic terms, assent—that is, the realignment of mental matter so as to grasp reality—is just another way of describing impulse, or *hormē*, the inclination to action. The Stoics would have appreciated the observation of Giacomo Rizzolatti, one of the discoverers of mirror neurons, to the effect that "perception and action share the same neural substrate."[34] (Monkey see, monkey do.) Assenting, or not assenting, is thus the core and foundational ethical act.

Modern scholars explore the neuroscientific aspects of decision making or choice,[35] and write of the "neural correlates of consciousness."[36] But such work can too easily presuppose the fixity or prior status of the human subject who decides or thinks.[37] The deeper lesson, articulated by neuroscientific research itself and anticipated by the Stoics, is that there is no such thing as the fixed human subject; he or she is always in flux. Thus, before presuming to assess how humans arrive at decisions, and before constructing a "science of virtue," as some have proposed, we would do well to consider how we become the kinds of subjects who conceive of our options as we do. Only by reexamining the chain of causation that leads us to experience choice and action as such can we possibly hope to assent and act appropriately. If Primigeneia has already allowed her commanding faculty to be re-formed through the misleading presentations of her place and time, she'll have little choice but to yield to Hermeros's proposal. Stoicism challenges both the ahistoricism and the biological reductivism of much contemporary cognitive science while fully embracing its underlying physics. Indeed, Stoic education, which respects the distinctive protocols of its own subdivisions (logic, ethics, and physics), nonetheless insists that the would-be sage, whatever his or her point of entry, recognize the interconnectedness of the entire philosophical system and the identity of the knowledge toward which any given pathway leads. In this respect, ancient Stoicism may be as much a model for "bridging the gap" between science and the humanities as a case study of the intellectual benefits to be derived therefrom.

One final point, by way of invitation to still another path of inquiry traversing past and present, humanities, history, and science: For the Stoics, as for any materialist, logic or reason cannot exist in any realm other than the material. Stoic reason, unlike that of its ancient rivals, is not a criterion of

judgment imposed upon the world. Instead, it is the articulation of the order already present in the material universe. The Stoics would have appreciated Rodney Brooks's assertion that "the world is its own best model."[38] As a result, it is misleading for scholars to continually assimilate Stoic reason, or logos, to linguistic categories. Language is hardly the only or even the best means of articulating the order intrinsic in matter. Contemporary neuroscience has done the study of human cognition a great service through its disproportionate attention to vision, thereby decentering language as the exclusive or primary basis for understanding mental processes. Those of us who are interested in the history of mind and its products can take advantage of this decentering by paying closer attention to humans' identification of and alignment with natural order via the direct manipulation of matter, especially in the form of the visual and plastic arts.[39] What else are these practices at heart but explorations of the order implicit in paint, stone, and clay? And where better than in the work of the artist can we study the tensile movement and mutual reconfiguration between inside and out?

Cognitive archaeologists and others who study the remains of cultures that have left no linguistic record have begun to work in this vein, partly of necessity.[40] But there is no reason not to think in this way also about cultures and periods that are well represented by linguistic remains. Language, like color and texture, is material, but is so abstracted and mediated, entailing such a complex layering of lekta, that it's hardly surprising that reflection on it has estranged us from physical causation and, until recently, from embodiment itself.[41] The philosopher Alva Noë rightly draws an analogy between perceiving and painting, suggesting that both "involve the temporally extended process of reaching out and probing the scene."[42] So far the Stoics would agree. But they would amplify his further claim that "the causally efficient substrate of the production of the picture . . . is the dynamic engagement among the painter, the scene, and the canvas" by reminding us that the brush, the pigment, the binding agent, and the glaze are also substrate: part of the same material universe as the painter and the scene, and just as likely to reveal its order and its laws. For the Stoics, God was not a speaker or a name giver, but "designing fire" revealed in and through the investigation of matter. In the centuries between antiquity and modernity, their insight, so closely linked to their understanding of vision as physical process, has flick-

ered, now dimly, now brightly, in the artistic tradition even as it has been obscured by the words of philosophers, theologians, and poets.[43] No wonder it's taken an art historian like Barbara Stafford to open our eyes to the possibility of a more unified account of the order of physical reality and the place of the human within it.

. .

Thomas Habinek is professor and chair of Classics at the University of Southern California. His previous work has focused on the pragmatics of cultural production, especially in classical Rome. His books include *The Politics of Latin Literature* (Princeton 1998), *Ancient Rhetoric and Oratory* (Blackwell 2005), and *The World of Roman Song: From Ritualized Speech to Social Order* (Johns Hopkins 2005), winner of an Outstanding Achievement Award from the Association of American Publishers. The present essay is part of a larger set of projects considering the aesthetic and ethical implications of models of mind, past and present.

Notes

1. Text and figure adapted from Catalano 2002, 111, 231, and pl. XXXVI. My thanks to Kristina Milnor for helping me find this source. Thanks also to Barbara Stafford, Philip Ethington, Hector Reyes, and James Collins II for comments on a draft of this essay; obviously none is responsible for its limitations or excesses.

2. Dumont 1989. Dumont reports, based on his inspection of the graffito, that the lines connecting the caption to the portrait in fact continue all the way to the dark dot marking the pupil of the eye. Early Stoics located the commanding-faculty in the heart, but over time the brain became the preferred location.

3. The Greek term *baktēria* found in the Stoic sources is usually translated "rod," but the word is used elsewhere in Greek literature for the walking stick of a blind man. Descartes seems to have understood this, for it's the image he uses to describe vision: see *Oeuvres des Descartes*, ed. C. Adam and P. Tannery (Paris 1964–76) 6, 83–84. See also Noë 2004, 1, for "a blind person tap-tapping his or her way around a cluttered space" as the paradigm of human perceptual engagement with the world.

4. Chalcidius, *Commentary on Timaeus*, 220. According to the same source (237), the Stoics also liken vision to the movement of a charge from "electric" fish through the fishing line and pole to the fisherman's body.

5. See most recently Spivey 2007, Clark 2008. As Spivey summarizes, "A static

freeze-frame of brain, body, and environment is not mind-like. The continuous trajectory that describes their coupled state changes is what is mind-like" (2007, 327).

6. Clark 2008, 217.

7. For the general principles of Stoic physics, see White 2003; White 1992, esp. chapter 7; and Sambursky 1959. For contemporary approaches to matter, see Reisse 2006.

8. E.g., Barnouw 2002.

9. On the difficulties involved in representing cancer tumors, especially through digital means, see the work of S. Ramalingam and collaborators, discussed at http://www.vision-systems.com/display_article/334222/19/none/none/TECHN /Image-processing-and-fuzzy-logic-to-automate-cancer-detectio, accessed September 12, 2008.

10. For a brief history of the controversy, see White 1992, esp. chapter 7. The battle continues: see Inwood 2007 versus Spinelli 2007.

11. Fahle and Greenlee 2003, xii; cf. Stafford 2007, 135–74.

12. The bibliography on mirror neurons is vast; the claims for their significance sometimes overstated. Key items include Rizzolatti and Arbib 1998, Hurley and Chater 2004, Arbib 2006.

13. Pylyshyn 2002, 143, 151; Scholl, Pylyshyn, and Feldman 2002, 170–71 (emphasis theirs).

14. For the Stoics' ongoing engagement with their scientific contemporaries, see Annas 1992, White 2003.

15. The best discussion is that of Ioppolo 1990. Also helpful is Barnouw 2002.

16. Zeno on color as first configuration of matter: Aetius 1.15.6; *Doxographi Graeci*, ed. H. Diels (Berlin 1876); *Stoicorum veterum fragmenta*, ed. J. von Arnim (Leipzig: Teubner, 1921–24), 4 vols., 1.91.

17. For a selection of Stoic sources pertaining to lekta in Greek and Latin with English translation, see Long and Sedley 1987: section 33, 1.195–202 and 2.196–204. Other uses of the root word are found in Liddell-Scott-Jones, *A Greek-English Lexicon*. The language of picking out characterizes the neuroscience of vision as well: e.g., Pylyshyn 2002, 145.

18. Fahle and Greenlee 2003, xii; cf. Stafford 2007, 135–74.

19. Fahle 2003, 179.

20. Ibid., 193.

21. Rizzolatti 2006a, 285–86. See also Karnath-Milner-Vallar 2002. Fahle 2003 notes that the distinction between sensation and perception is relevant to all senses.

22. On *ekpyrōsis*, see Rosenmeyer 1989.

23. De Grandpre 1999.

24. Dourish 2001.

25. On the emotions, see Graver 2008; on art and architecture, Onians 2007; on

literacy and orality, Johnson and Parker 2008, especially the essay by Olson. Nussbaum 2001 makes some reference to neuroscientific research on emotions in relation to ancient theories, including those of the Stoics, but her own philosophical and ideological commitments are some distance from those of the Stoics as I read them.

26. For Stoic definitions of *epistēmē* (Latin *scientia*), or knowledge, see Long and Sedley 1987, section 41, 1.253–59.

27. See, for example, Spivey 2007; Dennett 2003; Donald 2002.

28. Althusser 2001, Bourdieu 1977, Rappaport 1999, Bell 1992. The latter two are applied to Roman cultural practices by Habinek 2005. Also relevant is Connolly 2002.

29. For some speculation in this regard, see Smail 2007.

30. Cicero, *On Ends* 3.67, translated Long and Sedley 1987, 1.349.

31. Baxandall 1980, 1988; Onians 2007. As a parallel in Stoic thought we might consider their interest in the astrology of nations: stellar influence varied by place and time because it interacted with other, experiential aspects of the material world. We may no longer accept a simplistic account of stellar influence, but the Stoic belief that similar (or differential) patterns of physical interaction with the external world could lead to similar (or differential) configurations of mental material is perhaps not so far-fetched.

32. Spivey 2007, 305.

33. E.g., Neidich 2003.

34. Rizzolatti 2006, 285–86.

35. For a popularizing account, see Lehrer 2009.

36. Metzinger 1999; 2004.

37. See, for example, Gross 2007, critiquing Damasio 1994.

38. Cited at Hutchins 2005, 1560.

39. For further reflections in this vein, see Habinek 2010.

40. Tilley 1999; Renfrew and Scarre 1998; Mithen 2006; Gamble 2007; Joyce 2008.

41. E.g., Lakoff and Johnson 1999; Johnson 1987; now revised with greater attention to historical and cultural specificity by Goatley 2007. Cf. Connerton 1989 for a concise discussion of inscribed versus embodied history.

42. This and the following quotation from Noë 2004, 223.

43. Habinek and Reyes, in progress.

References

Althusser, L. 2001. *Lenin and Philosophy and Other Essays*, trans. B. Brewster, intro. F. Jameson. New York: Monthly Review Press.

Annas, J. 1992. *Hellenistic Philosophy of Mind*. Berkeley: University of California Press.

Arbib, M. 2002. "The Mirror System, Imitation, and the Evolution of Language," in

Imitation in Animals and Artifacts, ed. C. Dehaniv and K. Dautenhahn. Cambridge, MA: MIT Press. 229–80.

———. 2006. *Action to Language via the Mirror Neuron System*. Cambridge: Cambridge University Press.

Baxandall, M. 1988. *Painting and Experience in Fifteenth Century Italy : A Primer in the Social History of Pictorial Style*. New York and Oxford: Oxford University Press, 2nd ed.

———. 1980. *The Limewood Sculptors of Renaissance Germany*. New Haven: Yale University Press.

Barnouw, J. 2002. *Propositional Perception: Phantasia, Predication, and Sign in Plato, Aristotle, and the Stoics*. Lanham, MD: University Press of America.

Bell, C. 1992. *Ritual Theory, Ritual Practice*. New York: Oxford University Press.

Bourdieu, P. 1977. *Outline of a Theory of Practice*, trans. R. Nice. Cambridge: Cambridge University Press.

Catalano, V. 2002. *Case, abitanti e culti di Ercolano*. Revised by L. García y García and G. B. Panzera. Roma: Bardi.

Clark, A. 2008. *Supersizing the Mind: Embodiment, Action, and Cognitive Extension*. Oxford: Oxford University Press.

Connerton, P. 1989. *How Societies Remember*. Cambridge: Cambridge University Press.

Connolly, W. 2002. *Neuropolitics: Thinking, Culture, Speed*. Minneapolis, MN: University of Minnesota Press.

Damasio, A. 1994. *Descartes' Error: Emotion, Reason, and the Human Brain*. New York: Putnam.

DeGrandpre, R. 1999. "Just Cause?" *The Sciences* 39(2): 14–18.

Dennett, D. 2003. *Freedom Evolves*. New York: Viking.

Descartes, R. 1964–76. *Oeuvres des Descartes*, ed. C. Adam and P. Tannery. Paris: J. Vrin. 12 vols.

Donald, M. 2001. *A Mind So Rare: The Evolution of Human Consciousness*. New York: Norton.

Dourish, P. 2001. *Where the Action Is: The Foundations of Embodied Interaction*. Cambridge, MA: MIT Press.

Dumont, J.-P. 1989. "La stoïcienne d'Herculanum. Un regard au vestiaire des thermes," *Du banal au merveilleux: Melanges offerts à L. Jerphagnon*. Les cahiers de Fontenay, 55, 56, 57. ENS Fontenay. St. Cloud. Dec. 1989. 63–75.

Fahle, M. 2003. "Failures of Visual Analysis: Scotoma, Agnosia, and Neglect," in Fahle and Greenlee 2003, 179–258.

Fahle, M., and Greenlee, M. 2003. *The Neuropsychology of Vision*. Oxford: Oxford University Press.

Gamble, C. 2007. *Origins and Revolutions: Human Identity in Prehistory*. New York: Cambridge University Press.

Goatly, A. 2007. *Washing the Brain: Metaphor and Hidden Ideology*. Amsterdam and Philadelphia: John Benjamins.

Graver, M. 2007. *Stoicism and Emotion*. Chicago: University of Chicago Press.

Gross, D. 2006. *The Secret History of Emotion: From Aristotle's Rhetoric to Modern Brain Science*. Chicago: University of Chicago Press.

Habinek, T. 2005. *The World of Roman Song: From Ritualized Speech to Social Order*. Baltimore and London: Johns Hopkins University Press.

———. 2010. "Ancient Art versus Modern Aesthetics: A Naturalist Perspective," *Arethusa* 43, special issue on *The Art of Art History in Greco-Roman Antiquity*, ed. M. Squire and V. Platt.

Habinek, T., and Reyes, H. D., in progress. "Methodical Fire: Physics and Artistic Theory from Zeno through Baudelaire."

Hurley, S., and Chater, N., eds. 2005. *Perspectives on Imitation: From Neuroscience to Social Science*. Cambridge, MA: MIT Press. 2 vols.

Hutchins, E. 2005. "Material Anchors for Conceptual Blends," *Journal of Pragmatics* 37: 1555–77.

Inwood, B. 2007. "Moral Causes: The Role of Physical Explanation in Ancient Ethics," In *Thinking about Causes: From Greek Philosophy to Modern Physics*, ed. P. Machamer and G. Wolters. Pittsburgh: University of Pittsburgh Press, 14–36.

Ioppolo, A.-M. 1990. "Presentation and Assent: A Physical and Cognitive Problem in Early Stoicism." *Classical Quarterly* 40: 433–49.

Johnson, M. 1987. *The Body in the Mind: The Bodily Basis of Meaning, Imagination, and Reason*. Chicago: University of Chicago Press.

Johnson, W., and Parker, H. 2009. *Ancient Literacies: The Culture of Reading in Greece and Rome*. Oxford: Oxford University Press.

Joyce, R. 2008. "When the Flesh is Solid but the Person is Hollow Inside: Formal Variation in Hand-Modelled Figurines from Formative Mesoamerica," in *Past Bodies: Body-Centered Research in Archaeology*, ed. D. Borić and J. Robb. Oxford: Oxbow Books, 37–46.

Lakoff, G., and Johnson, M. 1999. *Philosophy in the Flesh: The Embodied Mind and its Challenge to Western Thought*. New York: Basic Books.

Lehrer, J. 2009. *How We Decide*. New York: Houghton Mifflin Harcourt.

Long, A. A., and Sedley, D. 1987. *The Hellenistic Philosophers*. Cambridge: Cambridge University Press. 2 vols.

Metzinger, T., ed. 2000. *Neural Correlates of Consciousness: Empirical and Conceptual Questions*. Cambridge, MA, and London: MIT Press.

Metzinger, T. 2003. *Being No One: The Self-Model Theory of Subjectivity*. Cambridge, MA, and London: MIT Press.

Mithen, S. 2006. *Singing Neanderthals: The Origins of Music, Language, Mind, and Body*. Cambridge, MA: Harvard University Press.

Neidich, W. 2003. *Blow Up: Photography, Cinema, and the Brain*. New York: Distributed Art Publishers.

Noë, A. 2004. *Action in Perception*. Cambridge, MA: MIT Press.

———. 2007. "Understanding Action in Perception," *Philosophical Psychology* 20.4: 531–38.

Nussbaum, M. 2001. *Upheavals of Thought: The Intelligence of Emotions*. Cambridge: Cambridge University Press.

Onians, J. 2007. *Neuroarthistory: From Aristotle and Pliny to Baxandall and Zeki*. New Haven and London: Yale University Press.

Pylyshyn, Z. 2002. "Visual Indexes, Preconceptual Objects, and Situated Vision," in Scholl 2002: 126–58.

Rappaport, R. 1999. *Ritual and Religion in the Making of Humanity*. Cambridge: Cambridge University Press.

Reisse, J. 2006. *La longue histoire de la matière*. Paris: Presses Universitaires de France.

Renfrew, C., and Scarre, C. 1998. *Cognition and Material Culture: The Archaeology of Symbolic Storage*. Cambridge: McDonald Institute for Archaeological Research.

Rizzolatti, G., and Arbib, M. 1998. "Language within our Grasp." *Trends in Neuroscience* 21:188–94.

Rizzolatti, G. 2006. "Discussion" in Chadwick, D. and M. Diamond, eds. *Percept, Decision, Action: Bridging the Gaps*. Novartis Foundation Symposium 270. Chichester, UK: John Wiley and Sons, 285–86.

Sambursky 1959. *Physics of the Stoics*. London: Routledge and Paul.

Scholl, B., ed. 2002. *Objects and Attention*. Cambridge, MA, and London: MIT Press. Special issue of *International Journal of Cognitive Science*.

Scholl, B., Pylyshyn, Z., and Feldman, J. 2002. "What is a Visual Object? Evidence from Target Merging in Multiple Object Tracking," in Scholl 2002, 159–78.

Smail, D. 2007. *On Deep History and the Brain*. Cambridge, MA: Harvard University Press.

Spinelli, E. 2007. "Ancient Stoicism, 'Robust Epistemology,' and Moral Philosophy," in *Thinking about Causes: From Greek Philosophy to Modern Physics*, ed. P. Machamer and G. Wolters. Pittsburgh: University of Pittsburgh Press, 37–46.

Spivey, M. 2007. *The Continuity of Mind*. New York: Oxford University Press.

Stafford, B. 2007. *Echo Objects: The Cognitive Work of Images*. Chicago: The University of Chicago Press.

Tilley, C. 1999. *Metaphor and Material Culture*. Oxford, UK, and Malden, MA: Blackwell.

White, M. J. 1992. *The Continuous and the Discrete: Ancient Physical Theories from a Contemporary Perspective*. Oxford: Clarendon Press.

White, M. J. 2003. "Stoic Natural Philosophy (Physics and Cosmology)," in *Cambridge Companion to the Stoics*, ed. B. Inwood. Cambridge: Cambridge University Press. 124–52.

TWO The Extended Mind

AN ANTHROPOLOGICAL PERSPECTIVE ON
MIND, AGENCY, AND "SMART" MATERIALS

Susanne Küchler

When Goethe wrote his novel *Elective Affinities*, about the analogy between chemical and human relationships, the notion of elective affinities captured a cultural moment in which chemistry increasingly occupied the mind and leisure time of the European public.[1] Chemical substances were said to unite "like friends and acquaintances" or stay as "strangers side by side," depending on their natural differences. A whole array of moral lessons could be drawn from the behavior of chemical substances and their human analogues, making chemistry "an authentic discipline" with prestige and public visibility well before the onset of the Chemical Revolution, nearly a century earlier than modern physics. Goethe eloquently captured the magical enchantment of chemical connectivity at a time when family alliances and loyalties had lost their efficaciousness in society and were replaced by contractual relations of labor.

The question raised in this chapter is that of whether, two hundred years on, we have reached a point at which Goethe's reflections on the nature of connectivity are resonating once again. Today the text appears to offer us access to more than just the world of contractual relations supporting industrial economy over the last two hundred years. Rather, it directs us to rediscover what we have lost or lost sight of in an age governed by technological developments, such as electricity, that appear to underscore the rising immateriality of connectivity in which mind can flourish without its material trappings in the body and in material culture. In a stroke that is surprising to many of us who believe we inhabit an age of digital technology that grants access to a virtual world, vehicular interlocutors have become commonplace that are capable of managing connectivity between things, and between persons via things, in an enchanted and yet indexical manner. Andy Clark has termed these material interlocutors "mindware," signaling a concept of mind that is extended beyond the person to a material world made by design.[2] As

the stuff of mind becomes tangibly present in the everyday world, mindware begins to carry the full weight of a sociality that is no longer tied to the labor market but that is defined by difficult-to-disentangle relations between persons, and between persons via things. An understanding of the nature of the material mind and the difference made by its actions in society will require anthropology and neuroscience to work together in unprecedented ways.

What this working relation might entail and what obstacles must be overcome in developing interdisciplinary methodologies is the subject of this chapter. The chapter will be concerned with what is ostensibly called the advent of "smart materials" that no longer serve as the cover for hidden devices capable of storing, processing, and reacting but actually manifest mind, or at least display mind-like capacities to interact with the world in ways that challenge our assumptions about an "inner," egocentric, and anthropomorphic consciousness. This distributed and materially embedded cognition forces us to engage with questions of the mind in relation not only to its manifestation in behavior, but to the designed material world that has long been excluded from the study of social cognition.[3] I shall argue in this chapter that the advent of "smart materials" allows an ethnographic analysis centered in material culture to engage with neuroscience in ways that can reach beyond the egocentric first-person preoccupation that has for so long dominated anthropological and neurobiological explorations of the human mind. Such a new partnership will pave the way toward looking at the mind in unprecedented ways as we turn to a world designed with particular capacities and effects in mind, and make it accessible to approaches that complement existing work on social cognition.[4] By studying the material technologies that extend the mind beyond its physical boundaries in the human body, the micro-perspective of ethnography and the macro-perspective of neurobiology can be connected in new ways, undercutting the long-assumed divisions between subjects and objects—divisions whose emergence made Goethe's invocation of the loss of connectivity so powerful in its time.

The Skin Ego: Toward a Theory of the Membrane

When the French psychoanalyst Didier Anzieu wrote his treatise on the developmental formation of the "skin ego," which is at once a protective bar-

rier and a filter of exchanges, he thought of the bodily skin as the central metaphor for the concept of ego and its development.[5] Taking its cue from Freud's throwaway remark in *The Ego and the Id* that "the ego is ultimately derived from bodily sensations, chiefly from those forming on the surface of the body," Anzieu developed his theory of a sonorous envelope, an audiophonic or sound bath that surrounds the infant, soothing, supporting, and stabilizing it, turning skin into the imaginary equivalent of Lacan's mirror stage.[6] The multiple functions of the skin as a psychosomatic membrane that forms both a boundary and a point of contact between the inner and outer worlds allowed Anzieu to point to the connectivity of thinking and doing, of mind and body, and to the presence of what Thomas Metzinger has recently called the "ego tunnel" in the skin enclosing the body.[7] Published in French in 1974 under the title *Le moi peau*, *The Skin Ego* was conceived of in the years during which the first "smart" fabrics were designed for space travel, with specially designed, multilayered, and interactive membrane-like envelopes to facilitate the extension of intelligent technology beyond the safety of the spacecraft, thus replicating the bodily container.

Writing in the very early days of smart fabric technology, when the future development of such fabrics was not yet clearly grasped even by those responsible for their existence, Anzieu can be credited with having foreseen what rapidly became a reality with the technical development of softswitching solutions and ever more minute computing devices. When the first lab for research on intelligent materials at the Massachusetts Institute of Technology opened its doors in 1995, membranes were designed there in analogy to human skin, not to represent the mind but to replace it, serving as a vehicle for extension of the mind beyond the human body.

At centers like the MIT lab, artificial membranes are designed to be capable of learning and adapting to different environments and material interactions. "Intelligent" materials that work like membranes should one day process information and deliver feedback interactively while networking with any number of other materials. Sophisticated sensing devices on the surfaces of such membranes are meant to service coordinated architectures that augment, animate, and coordinate networks of things and provide seamless interfaces that bridge digital, physical, and human creative expression. A

full understanding of context and affect should eventually make such membranes capable of decisions based on moral considerations and feelings.

Some of these new mind-like membranes are still at the prototype stage, while others have found practical applications in medicine, sports, and construction. These include a coat that changes color with the wearer's blood pressure; a rope that emits a sound if it is close to breaking; running shoes with cushioning that automatically adjusts itself to its environment; sunglasses that double as an MP3 player; an iPod-ready coat with controls on its sleeves; a chip-embedded watch that replaces the traditional ski-lift pass; underwear that monitors its wearer's heart rate, body temperature, and insulin level and calls an ambulance if needed; a "thermogenerator" designed by Germany's Infineon Technologies that monitors the temperature difference between a garment and its wearer's body and adjusts the perforation of the fabric accordingly; and a "joy" dress, dreamed up by the Italian designer Alexandra Fede, that massages its wearer.

What is perhaps most striking about these novel curiosities is that one membrane can perform a number of different object functions. Whereas we are beginning to be familiar with objects that have multiple functions, such as the new Apple iPad, the idea that such technical capacity can be extended beyond the object itself by means of its analogue material constitution alone is distinctly novel. I have elaborated on this novel perspective in a previous paper, and will merely invoke here the notion of the inter-artifactual and indexical nature of membranes that work *on* as well as *off* the body, insofar as such "smart" membranes can include anything from walls to furniture and beyond.[8]

These new material embeddings of the mind have possibly never before been so defined by loci, nor have they been so overt, problematic, and anxiety-making—from the perspective of the consumer *and* the producer—as at the beginning of the new technological revolution, following the industrial and the cybernetic ones, into which we are undoubtedly moving today. This "third industrial revolution," as it is sometimes now called, is defined *not* just by the ubiquitous role of software but also by what Nigel Thrift has called the materiality of "*screenness*," in which the technical rises to the surface and becomes the exterior.[9] Such a materiality of exteriorized interiority has

been compared to an interactive and constantly unfolding and expanding second skin (an idea expressed by architects such as Neil Denari, whose buildings emulate continuous surfaces that wrap around the world like a ribbon with exchangeable inner and outer faces). In striking contrast to a concept of network based on vertically conceived hierarchies, intelligent membranes invite a notion of horizontally extended networks of interlocking artifacts that not only become indistinguishable as they are all enveloped by one surface, but may soon actually morph into each other.

Membranes that connect discrete things with one another on account of their analogical composition create a world in which systems of classification that once allowed for the hierarchical ordering of things no longer apply. The epistemology of the non-classificatory world in which relations are pervasive and emergent in transformations, rather than bound by canons of mimetic expression, points us not just to the future but also to a past whose waning was captured by the historian and philosopher Gottfried Herder in his account of the roles of emotion and logic in the poetic arts at the close of the eighteenth century.[10] Today, once again, the accustomed divisions that set the world of things apart from the mind collapse, freeing us to see the designed world as manifestation of an indexical mind that is disposed to intuit connections and effects beyond the first-person perspective.

The technical potential of laboratory-designed membranes complements and extends the personification of neuronal mechanisms in Anzieu's skin ego. As it rises to the surface and becomes the exterior envelope, it is capable, at least ideally, to maintain thoughts (reminding you to switch off your mobile phone when in a silent place), to contain ideas and affects (reminding you of names and appropriate responses when meeting apparent strangers), to provide a protective shield (raising an alarm before breaking down or when its relation to the enveloping environment is out of balance), register traces of primary communication with the outside world (responding to changes in the sense-scape by registering heat, sound, and touch), to manage intersensorial correspondence (heat regulation being an already achieved primary function), to individuate, to support sexual excitation, and to recharge the libido. Where Anzieu looked toward writing, drama, and painting to find expressions of the correlation between the formation of the skin ego in early childhood and its consequences for the psychopathic development of the

mind in later life, laboratory technicians are today interfering with the skin ego and have begun to shape and inform its constitution, reminding one of ethnographies, which describe the effect of exterior cloaking on the creation of a third-person consciousness and its institutionalization.[11]

This newly inhabited distributed cognition comes into its own through a technological development known as *rapid prototyping* (RP). Like its advanced form, known as *rapid manufacturing* (RM), rapid prototyping enables distinct artifacts to be related to one another by the way in which their material has been transformed in production. The essential character of rapid prototyping technology is an additive mode of transformation driven by a digitized code which bonds a powdered substance layer by layer to form objects—quite in contrast to mechanical processes of fabrication such as milling or turning, in which objects are formed through repetitive action by removing material to create a distinctive shape. RP products can be transmitted to any printer anywhere in the world, their resulting form and material consistency being capable of variation without severing connectivity. A bone graft can morph into a chair or a lampshade, connected to it solely by an electronic file.

Beneath the seemingly innocuous and familiar terminology of making prototyping more "rapid" thus lies a profound difference of effect: RP does not result in a prototype that can be serially reproduced in manufacture, nor does it produce a simulacrum by giving shape to an idea or thing that already exists. What happens in RP is that the material transformation, which defines the technique, becomes an intrinsic property of the product's materiality. Each and every product of RP is new, made to measure and to material specifications that are unique—and, insofar as it is "new," it is different and distinct from anything that has come before or will come after, finding its analogue solely in terms of the concrete decisions that inform the proportioning, multiplying, and scaling of a product in the additive process of being made.

The central idea of RP thus creates visions of a decenterd mind wherein transformational patterns furnish connections that are no longer egocentric, anthropomorphic, and relative, but are subject to a disposition toward relational action that emerges from an indexical mind. RP suggests a radically new and yet profoundly old way of drawing things together not by pen and paper, but by an intuitive apprehension of algorithmic pattern.[12]

This decentralized mode of cognition invoked by RP is reflected in the

localized architectures that are constructed through smart materials. On the one hand, using electronic wiring sewn into surfaces, seemingly distinct objects are constructed on a circuit driven by electronic streams of coded data that may connect the most disparate items in a designed environment. Chemistry, on the other hand, is fashioning alternative smart membrane structures in which the environment is no longer outside but inside the materials that envelop us in layers like those of an onion, held together by the "recipes" for molecular structures that enable the mind to inhabit a stronger, faster, lighter, safer, and smarter second skin.

Arguably, a world designed to take over the functions of the mind in the folds of its material trappings is a greater challenge to our existing apprehension of concepts such as consciousness, self, and memory than prior innovations that supported an immaterial modality of connectivity. This is because a radically distributed mind no longer allows us to invoke methodologically an anthropomorphic, egocentric, and relative perspective as the starting point of our data gathering and analysis. The following section will introduce some of the difficulties that are beginning to emerge as we attempt to manage an agentive, inherently transformative material world. As vehicles of complex intentionalities and as a knowledge-based resource whose access is subject to proprietary rights, "smart" materials challenge us to rethink some of our most trusted assumptions that have long tied the mind to the body and to agents and loci of classification such as pen and paper as well as libraries. We need to be aware of these challenges before asking the question of how ethnography can assist in devising a new tool for the tracking of the distributed mind.

Managing the Extended Mind

Despite the realization that the self-organizing capacity can be achieved in material forms that have no basis in either brain or body, the most prevalent theoretical description of how to extend person-like agency is today still a predominantly abstract comprehension of systemic connections that are modeled upon the human body.[13] This abstract modeling of connectivity operates as a means of framing programs, framing wider technological systems, and making assumptions about how the world is going to shape up. An inter-

esting separation is emerging, however, between the development of robotics, which is largely informed by biological concepts, and the development of wearable computing and so-called ambient intelligence, which are now driving technical advances in the distribution of communication in ways largely independent of biological concepts, while using the body as a platform for reconceptualizing inter-artifactual and systemic networks.

It is fairly well known that we have two general and distinct approaches to the artificial mind, both of which are grounded in the science of biology: The first is *artificial intelligence* or AI, the top-down approach that explores the biological plausibility of the simulation of mind. Following the principles of biology, AI starts "at the top," considering the organism as a complex biochemical machine that it intends to simulate in its function (material and look being significant only in structural and functional terms). *Artificial life* or ALife, on the other hand, starts instead "at the bottom" by constructing aggregates of simple objects that interact mutually and nonlinearly in support of global, lifelike dynamics. Both see their machines as tests for their theories, which aim to explain the emergence of life, biological evolution, and development, as well as the functioning of neural networks in complex, integrated settings.[14]

There are thus several biological descriptions that inform the designing of artificial life, yet one is particularly relevant to this context. It is the so-called bottom-up approach of artificial life, which recently has been credited by researchers with assisting us in fundamentally reconceiving cognition as the operation not of disembodied logical operations, but of a massively distributed nervous system whose emergence can be simulated and observed in machines. While sympathetic to this idea and working in accordance with it, smart materials development has identified a problem with this and other existing biological approaches to artificial intelligence. It points out that the biological description of artificial intelligence conceives machinelike action to be the same as *retrospectively* studied actions that have an essentially repetitive character, which can classically be monitored and studied in laboratory situations.[15] The agentive capacities of smart materials must work, however, "in the wild," where cognition is characteristically unpredictable, transformative, and future-directed.[16] In modeling this cognition, one cannot use

abstract and visual tools of understanding and apprehension, but must instead turn to a deeper level where connections are intuited at the level of the concrete.

The science of the concrete is, as the anthropologist Claude Levi-Strauss observed long ago, bound to a proliferation of concepts and a technical language that goes with a constant attention to the properties of the world, alert to the distinctions that can be discerned between them.[17] "This thirst for objective knowledge," as he observed in his treatise on the science of the concrete, "is one of the most neglected aspects of the thought of people we call 'primitive.'"[18] Here it can be observed that the same attention to the concrete defines the work of those who design materials. The science writer Phillip Ball has aptly referred to designed materials as materials that are "made to measure," referring to the role of fine-grain distinctions made between materials in terms of concepts of proportion and scale.[19]

In contrast to materials extracted from natural resources, new materials produced synthetically through a variety of technologies including biomimesis are composites in nature and invite additive modes of construction. The description of materials in science today is thus essentially a mathematical one, whereby any distinction between materials evokes associations with quantifying gestures of enumeration that are intuitively realized when handling a material. Radical as it may seem, the attention to material knowledge practiced by the materials scientist is no different from the thought practiced by people we tend to exclude from discussions of science.[20]

Empathy with the world from the perspective of the concrete attends to how we know distinctions that can be introduced into its material properties. Importance is attached to what materials are believed to "be," based on an understanding of how they have been "made" and what they are seen to "do," and not to what they are believed to mean. The inroads into the world we inhabit physically of the products of materials science, which we use to extend our intentions and consciousness beyond our bodies, force us to rethink our attitudes to material knowledge and call upon us to understand anew how cultural empathy with materials is conditioned. Such a change of perspective, however, is hindered by the existing institutional isolation that tends to allocate the teaching of material knowledge to the materials sciences, with the exploration of material knowledge remaining low on the

agenda of the social sciences. As a result, engineers preside over material innovations whose adoption by society is not guaranteed, and whose consequences are not fully understood.[21] The existing divisions hinder not just the development of smart materials and our understanding of their implications for our models of mind, but also the management of the new resource of material knowledge, access to which poses problems not just at the practical level.

It is now an uncontroversial yet little-known fact that the number of designed materials has begun to vastly exceed the number of discrete categories of things and thing functions that constitute the classificatory paradigm with which we have tended to order our knowledge of the world. It is, however, precisely this unclassified status of new materials, their ability to take on any object form, that is crucial to their valuation and their capacity to create new worlds. A famous example of this world-creating capacity is plastic. Polymers, molecules that are bound together in a string-like fashion, have become a prevalent part of our lives and are now, as a cheap, tough deformable material, a symbol of the modern age of travel, leisure, and a domesticity with unforeseen consequences beyond the lives of individuals.

The unclassified status of designed materials, however, presents not just opportunities but also problems. The first problem is how to store and secure access to material knowledge in ways that retains their characteristic open-endedness. Knowing materials well enough select from several thousand that fulfill more or less the same object function has become a specialist domain for the material consultant, backed by an increasing number of materials libraries that serve as actual or virtual data banks. To help designers steer through this minefield, there is now a burgeoning literature on the huge range of engineered materials from which they and manufacturers can choose.[22] While materials have become imbued with capacities once attributed solely to the human mind, thinking with materials in mind has thus also a crucial aspect of manufacture and design.

Handbooks furnish the designer with an image of a material and its functional characteristics, such as luminosity or tensile strength, but they leave out any discussion of experience of use. Jonathan Ashby and Mark Johnson have recently began to fill this gap with a phenomenologically oriented guide to new materials, modeling their various effects so that architects and design-

ers can take them into consideration when creating relational structures that consist of more than one material.[23] Using grid systems, they map out the acoustic, olfactory, tactile, and motion-sensitive factors that are inherent in materials, and arrange these on a spectrum at the center of which is a person's egocentric and relative sensorial space. This highly popular text reflects a resurgence of interest across the social sciences in sensorial interface with the material world.[24]

Over and above the practical issues involved in managing a resource without classificatory tools that supplement other ways of knowing new materials, the new surface-oriented ontology of screenness that membranes impart forces us to reconcile material *capacities*, now turned inside-out, which are *not* domesticated and thus are *not* readily possessed by corporate institutions.[25] Bruno Latour captured the new ontology of material agency long ago, inventing for us a vocabulary that makes manifest the agency of nonhumans and the recalcitrant materiality of humans—tantalizingly capturing a world in which persons no longer are substituted for by things, but instead are manifest in things.[26] More recently he wrote of a "parliament of things" to draw attention to the ways in which new material technologies form assemblages that interrupt, revise, or restructure political life, in the hope to recover a model we can use to understand the processes and nature of relation in a world beyond taxonomy.[27]

Material agency works by means of what Alfred Gell has termed cognitively "sticky" inter-artifactual relations that are intuited in the concrete rather than known on the basis of abstract concepts.[28] For anthropology, the advent of materials made by design is potentially catastrophic: having relied on an aesthetic language and a method of describing relations with materials that took our distance from the material world for granted, anthropology is lost when comprehending conditions of intuition that are born out of a loss of distance between human and nonhuman worlds. Simulating fibrous cloth, membranes much like skin form both a boundary and a point of contact between the human and the material world, binding people in social and economic relationships at the same time as they define their difference. It is therefore with reference to the intuited and inherently relational actions of binding which membranes instantiate and make possible that we can see a

new relevance of anthropology for discussions of empathy and of conscious-ness in neuroscience.[29] The question is, however, how the extended mind in-terfaces with the social in ways that make a shared empathy with the lived-in world not just possible, but also the springboard for self-conscious acts of resistance or transmission.

One could assume the manner by which membranes are designed to in-teract with one another to be manifold, reflecting routinized practices and ideas about connectivity. As we have seen, however, there are already two emerging relational models of membrane interfaces that take expression in radically different types of designed materials and architectures. The first modality of aggregation is driven by electro-engineering, which has seized on the availability of smaller, cheaper and more powerful electronic compo-nents and of wireless communication to develop soft-switching solutions that make information transmission not just ultraportable and immediate, but also independent of any kind of container, by embedding in the form of carbon-coated fibers into generalized cloth surfaces that can take the form of clothing, wallpaper, furniture coverings, architectural structures, and (of course) screens. The second mode of aggregation is driven by chemistry or materials science on the back of the production of composite materials that can respond to light and heat so as to conduct information rapidly across a range of surfaces that interact with each other without the need of external support. Both of these modalities, in fact, envision materials working in sub-stantially different ways: engineering conceives of architectures of network-ing membranes that create ever more expansive environments by colonizing new artifacts and attaching them to the network, while chemistry conceives of the environment as residing within the material itself, and perceives net-working as a process of transformation from the inside out via a process of envelopment.

What is striking about these technical methods of extending the mind ma-terially is how they are built upon a generalized logic of connectivity. The logic at work in these architectures invites attention and the projection of intentionality, which in turn serves to jump-start an intuitive attachment or resistance to a new way of thinking and being in the world. Thus, while neuroscience can help with explaining how the extended mind can be made

to work in the world, anthropology can help with understanding how mind-stuff is taken up and passed on and how this process might change the way we think about thinking at its very core.

Recovering the Concrete

The mind-made material arguably allows us to undercut not just the divisions we have placed between subjects and objects, but also far more routinized divisions between the noumenal and the phenomenal as two expressions of science.[30] Thus there is no jump at all in principle from the fabrication of smart materials to Pacific artifacts made for exchange; in both cases the connectivity depends on an adept handling and recognition of what above we called material knowledge.

Both in the laboratory world and in the Pacific, material knowledge conditions personalized skills in handling spatial and temporal processes of transformation whose intuitive grasp attaches people to one another.[31] In the Pacific, the artifacts of such skills circulate in material form as *taunga* or "treasures," connecting the most distant homelands and diasporas today in ways that are unmatched by rival networking technologies. This is no less true in the laboratory world. A good example is nanoscience, which demands a keen intuitive sense for the timing of actions when predicting effects such as the loss of color or change in positions of atoms.[32] The acquisition of in nanoscience thus requires a long period of trial and error during which the intuitive feeling for correct timing is developed, turning actions of scaling down and up across a range of material translations from macro- to microphysics into the shared modality of thinking and being in the laboratory world. In worlds where there is no distinction between subjects and objects and where mind is distributed across networks, the spatiotemporal transformations of scaling, proportioning, and multiplying become crucial in the making of distinctions whose recognition in turn allows connections to be intuited as shared, intersubjective, and manifold.

The laboratory products whose distribution may lead to a new concept of mind beyond the first-person perspective are still too new and unarticulated for an effective ethnography without guidance in making a case for the difference that the science of the concrete can make to the modeling of the

distributed mind. Ethnographies of knowledge economies in which persons
control vast networks of relations by virtue of the material agents they have
put into circulation are available in abundance, and are particularly well the-
orized and modeled in the Pacific, where early scholarly work provoked a
rediscovery of the phenomenon in the late 1970s, when the demise of indus-
trial economy had become apparent with the ending of the Fordham mode of
production.[33] I will turn here to an example in this tradition, which will show
the role of the personalized skill of scaling, proportioning, and multiplying,
and of the attention to the transformative capacities of materials in the dis-
tribution of person-like agency. The case study is based in the Cook Islands
of Eastern Polynesia, where five-meter-long wooden sculptures with verti-
cally replicated figures across the front, wrapped in layers of bark cloth and
cordage, came to be replaced in an act of skeomorphic translation by equally
oversized patchwork with the introduction of Christianity.[34]

Patchwork today is hugely popular across Eastern Polynesia, and a
must-have in the ceremonies that punctuate the life cycle, including signifi-
cant birthdays, first haircuts, weddings, and funerals (figure 2.1). The huge
2.5-by-3.5-meter quilts are hand-stitched by women for exchanges that con-
nect one of the world's most prolific and scattered diaspora populations

FIGURE 2.1. Three Tivaivai patchwork quilts hanging on a line: *ta taura* and *manu*. Rarotonga, Cook
Islands, 2004. Photograph by the author.

with its homelands. The paths taken by the quilts can be compared to super-highways along which other immaterial and material goods flow to and fro, stretching the boundaries of Cook Island culture to wherever they touch down.

Possibly as a result of its role in cementing and crafting the transnational relations that comprise the construction of Cook Island identity, patchwork sewing uses "new" material, thus detaching the quilt's materiality from the local associations that worn and reused fabric may harbor. The hand-stitching of the cloth, however, confers upon each patchwork an agency whose nature is comprised in the Polynesian notion of *mana*, a concept of life energy inherent in all human beings and their products. As Elizabeth Arkana said about Hawaiian quilts, "Quilts contain much *mana*. If one should die and leave much spirit behind, it could be damaging and might never be able to achieve real rest."[35] The intense attachment of person and patchwork means that quilts are separated only temporarily from their makers, eventually being returned at death. While Hawaiian quilts were burned, Cook Islands quilts are buried with the dead in tomblike concrete structures erected next to the entrances of houses.

We cannot understand the empathy provoked by such sewing, however, unless we note that the pattern that results from the patching of cloth is not the result of a random assemblage of scraps, but one that documents a consciously executed plan that preceded the purchase of the material—a pattern whose carefully timed actions surpass the quilt's apparent functionality as a decorative cover and situate it squarely in the mental mapping of complex kinship relations. The Polynesian quilt, and Cook Islands sewing in particular, is not just a documentation of something we can verify externally by recourse to history, oral narrative, or written or remembered genealogies; rather, it is the means that enables such discourses about history and biographical memory through recourse to an abstract map of biographical relations that shape people's lives. Cook Island patchwork is thus a time map that condenses a complex decentered spatial topology of kinship into a temporal logic that captures non-causal but *modalized*—that is, logically describable—chains of events in what Alfred Gell called "B-series time."[36] According to Gell, B-series time reflects the temporal relationships between events as they really are, while the A-series provides subjective and tensed perceptions

of events that happen in the B-series temporal territory. In order to know how to act in a "timely" manner, plan and anticipate what might happen, but also defend claims about the past, we have to construct representations of B-series time, so-called time maps, that allow us to "navigate" in time based on an understanding of how possible worlds are connected with one another. Time maps, like maps we use to navigate in space, rely on images that correspond to how the world appears to us, but the images would be useless for navigation if not visualised in a map-like manner. This translation of non-indexical space-time beliefs into images and back into maps creates what Gell called "indexical fixes" or perceptual beliefs, which in turn give rise to our inward sense of time. Image-based maps of B-series time are not the "real thing," but as no experience is possible of "real" four-dimensional space-time, we are forced to rely on such reconstructions in mastering time.

There are three different types of patchwork, each involving distinct skills of making and associated patterns and each marking in exchange distinct genealogical relations, which dictate the flow of mana. The most valuable type of quilt is a patchwork called *taorei* (literally, handkerchief), in which several thousand tiny rectangular or diamond-shaped pieces of cloth are sewn together (figure 2.2). *Taorei* always consist of a single multiply replicated motif (*pu*) that is connected by trails (*tarere*), creating an asymmetrical checkerboard pattern. There are two principal variations on this type of quilt: the construction of this *tivaivai* (literally, to patch) can involve the fabrication of squares that are repeated across its surface in a reflexive, transitive, and yet asymmetric manner; that is, identical squares are linked so that the eye can pass from one to the next without the emerging pattern being reducible to a point symmetry. By repeating the core motif in the round, rather than along the horizontal plane, a new motif can be made to appear, consisting of enchained and integrally related fractal components that are repeated in twelve to sixteen triangles from a central point. The basic shape used for this construction is a diamond. Central to the construction of the pattern in both types of quilt are mathematical ideas, as tiny colored pieces of shredded cloth are threaded in exact number and sequence onto a string before being restitched into a pattern. Ideally, the fractal pieces of the overall pattern are to be sewn by different women—usually sisters or, today, work colleagues, though in practice women now find it often less time-consuming to do the

FIGURE 2.2. Tivaivai *taorei*. Rarotonga, Cook Islands, 2004. Photograph by the author.

sewing themselves. Individual pieces of the *taorei* can be kept and used as a template for recreating the quilt when the sewing has begun to disintegrate. *Taorei* are personal possessions that, if not wrapped around the owner at death, are gifted as tokens of "vertical" succession—usually to a favorite grandchild who is also designated to be the recipient of certain tacit knowledge, such as of traditional medicine, dance, or song. As tokens of knowledge transmitted across generations, these quilts hardly ever leave the household and tend to be retained in the original owner's treasure box even after having been gifted to a grandchild.

The most popular sewing, which circulates most rapidly between related households on successive gifting occasions, is *ta taura*, which is characterized by appliqué and embroidery, usually of floral motifs with leaves (figure 2.3); the use of multicoloured thread in the overstitching makes the design appear three-dimensional by carefully repeating a singular motif on each appliqué piece with exactitude. These distinctive *pu* or motifs usually consist of a single

FIGURE 2.3. Tivaivai *ta tataura*. Rarotonga, Cook Islands, 2004. Photograph by the author.

flower with its leaves positioned on the quilt's surface with a rotating or di-agonally offset symmetry that is both reflexive and transitive, in that the pair-ing of two motives allow the remaining composition to be logically deduced. Such *ta taura* are the preferred gift at weddings and sons' hair-cutting cere-monies, where they inspire recollections of "horizontal,"—that is, temporally coexisting—genealogical connections formed through marriage which link islands, villages, and named clans across generations.

The third type of quilt pattern is called *manu* (bird), in which a cut out is superimposed upon a background of opposing color (see figure 2.1). In con-struction, the material is folded twice (in half and in quarter) to create four segments when unfolded, or three times (in half, in quarter, and diagonally) to create eight segments when unfolded. Care is taken to create an even bal-ance of positive and negative space, with the motif unfolding symmetrically along the central axes. The cutting and sewing must show a clear line, vis-ible on the back of the quilt, with no obvious beginning or end. Tracings of cutout designs are commonly drawn on tissue paper and carefully stored for future reference. Such *manu* are the quickest to make and, as they generally involve no more than two colors, are easier to plan and less expensive to pro-duce than other sewing. They are the preferred gift for people outside the immediate family, are readily "lent" to friends who need help in acquiring sewing that can be gifted, and are even sold to strangers. While such gifts are often lost in exchanges, their patterns can be remade repeatedly.

As the patchwork is in effect the burial shroud of its maker, anticipating a future state of being where all possible past and present temporal worlds coalesce, a deep association—one that traverses the production, circulation, and "style" of the quilt—exists between concepts of time and the actions of patching. The intuitive recognition of the relational nature of action under-lying the patterns of patchwork conditions connectivity in the modern Cook Island diaspora. Vittorio Gallese's invocation of the capacity of mirror neu-rons to condition such shared intersubjective intuitions points to the possi-bility of conjoining anthropological and neuroscientific work on the condi-tions for empathy in worlds where the concept mind is extended beyond the first person to encompass a sociality in which relations are comprised not just of persons, but of persons' relations via things.[37]

Conclusions: Surfaces, Materialities, and Sensibilities

We have barely begun to theorize materiality beyond the fetish and mind beyond the first-person perspective, as we have to get up and adjust our thinking again to a new scientific and technological revolution. But, just as it is usual to be attracted to a phenomenon as it is about to end, it may be no coincidence that this present age may become known as a time when materiality presided over disciplines as much as the body had done a decade earlier. For what is "new" now appears not in the guise of what it *is* on the basis of its form and associated interpretation, but as what it *does* or can do of its own accord, without any additional technical support, revealing a *vehicular notion of materiality* which displays signs of what we call animation or agency without a hidden, interior, invisible essence — terms that now appear to be in as much need of revision as our notion of materiality. We must beware of assuming from this that we are moving from a mechanical materialism to a kind of material vitalism, for what is really at stake is a new kind of surface ontology that replaces the opposition of inside and outside, invisible and visible, and immaterial and material with a complementary relation that thrives on transformation rather than distinction. The new material and agentive membranes discussed in this chapter are not merely a new cover for electronics, but are in fact the new electronic equipment — equipment that is lightweight, durable, flexible, and cost-competitive as well as additive, both in the built environment and on the body.

When distributed cognition and third-person consciousness step out into the world, we face an upheaval similar to the one that shook European epistemological and scientific tradition in the eighteenth century, when what Wolf Lepenies called the empirical imperative (*Empirierungszwang*), itself a product of the pressure of ever-expanding material growth in knowledge founded upon experience and observation (*Erfahrungsdruck*), forced the radical reorientation of intellectual labor and its institutional framework.[38] Then, the work of the noumenal and the work of the phenomenal became separated in the different institutions of science and the arts. Today, the gulf between the "horizon of expectation" and the "space of experience," which for long had remained a symptom of modernity,[39] is merely a ghost in a magical act of

synthesis in which the process of giving form to matter is also the process of understanding how to be "in relation."

This chapter has argued that it is time for anthropology and neuroscience to work together in ways that go beyond the borrowing on both sides of concepts and models of mind and of sociality as we wake up to the realization that a material world *made by design* may strangely unite those accustomed to examining cognition in the laboratory with those accustomed to observing it in the wild. Now that we are fully aware of the need to understand our new experience of diversity in the face of an extended mind in action, we realize that we have to rethink our trusted theories and methods to accommodate the radical displacement of European epistemological and scientific tradition. We must do such rethinking together, and it must involve a not yet practiced mode of interdisciplinarity, on the basis of which a methods chapter can one day be written.

Notes

1. J. Adler, "Goethe's Use of Chemical Theory in His Elective Affinities," in *Romanticism and the Sciences*, ed. A. Cunningham and N. Jardin (Cambridge: Cambridge University Press, 1990). Kim, M. G., *Affinity, That Elusive Dream: A Genealogy of the Chemical Revolution* (Cambridge, MA: MIT Press, 2003).

2. A. Clark, *Mindware: An Introduction to the Philosophy of Cognitive Science* (Oxford: Oxford University Press, 2000).

3. Notable exceptions to this bias towards the social and biological analysis of cognition are to be found in the work of Tim Ingold; cf. K. Gison and T. Ingold, eds., *Tools, Language and Cognition in Human Evolution* (Cambridge: Cambridge University Press, 1993); T. Ingold, "From the Transmission of Representation to the Education of Attention," in H. Whitehouse, ed., *The Debated Mind: Evolutionary Psychology versus Ethnography* (Oxford: Berg, 2001), 113–55. See also Christina Toren, *Mind, Materiality and History* (London: Routledge, 1999); T. Marchand, *Minaret Building and Apprenticeship in Yemen* (Richmond: Curzon, 2001).

4. M. Bloch, *L'anthropologie cognitive a l'epreuve du terrain* (Paris: Fayard, 2006) and *Essay on Cultural Transmission* (London: Berg, 2005). See also P. Boyer, *Religion Explained* (London: Basic Books, 2001); M. Tomasello, *Cultural Origins of Human Cognition* (Boston: Harvard University Press, 1999); D. Sperber, *Explaining Culture* (Cambridge, MA: Whiley & Blackwell, 1996).

5. D. Anzieu, *The Skin Ego* (New Haven: Yale University Press, 1989).

6. S. Freud, *The Ego and the Id* (London: W.W. Norton, [1923] 1990).

7. T. Metzinger *The Ego Tunnel: The Science of the Mind and the Myth of the Self* (New York: Basic Books, 2009).

8. S. Küchler, "Technological Materiality: Beyond the Dualist Paradigm." *Theory, Culture and Society* 25(1):101–20.

9. N. Thrift "Beyond Mediation: Three New Material Registers and Their Consequences," in D. Miller, ed., *Materiality* (Durham, NC: Duke University Press, 2005), 231–56.

10. G. Herder, *Sculpture: Some Observations on the Shape and Form from Pygmalion's Creative Dream*, ed. and tr. by Jason Gaiger (Chicago: University of Chicago Press, 2002 [1750]). See also H. Bredekamp, *Die Fenster der Monade: Gottfried Wilhelm Leibniz's Theater der Natur und Kunst* (CITY OF PUBLICATION?: Akademie Verlag, 2008).

11. A. Barry, "Pharmaceutical Matters: The Invention of Informed Materials," *Theory, Culture and Society* 22(1): 51–69. I am thinking here also of ethnographies which amplify the action of "wrapping" and third-person consciousness; see G. Feeley-Harnik, *The Green Estate* (Washington: Smithsonian Institution Press, 1994), which points to the relation between "cloaking," wrapping, and spirit possession in Madagascar, and A. Gell, *Wrapping in Images* (Oxford: Oxford University Press, 1994), which elaborates on the relation between tattooing in Polynesia and the institutionalization of the distributed person. On decentered cognition and the importance of third-person perspective in New Guinea, see J. Wassmann, "The Yupno as Post-Newtonian Scientists: The Question of What is Natural in Spatial Description," *Man* (n.S. 29£): 645–66.

12. The relation between hand, number, and memory is investigated by B. Butterworth in *The Mathematical Brain* (London: Macmillan, 1999). In anthropology, this topic has been developed by R. Eglash in *African Fractals: Modern Computing and Indigenous Design* (Rutgers, 1999).

13. R. Cordeschi, *The Discovery of the Artificial: Behaviour, Mind and Machine before and beyond Cybernetics* (Dordrecht: Kluwer Academic Publishers, 2002).

14. Ibid., 230.

15. H. M. Collins, *Artificial Experts: Social Knowledge and Intelligent Machines* (Cambridge, MA: MIT Press, 1990).

16. E. Hutchins, *Cognition in the Wild* (Cambridge, MA: MIT Press, 1996).

17. C. Levi-Strauss, *The Savage Mind* (Chicago: University of Chicago Press, 1962).

18. Ibid., 2.

19. P. Ball, *Made to Measure* (Oxford: Oxford University Press, 1999).

20. A. Biersack, "The Logic of Misplaced Concreteness: Paiela Body Counting and the Nature of the Primitive Mind." *American Anthropologist* 84 (4): 811–29.

21. B. Bensaude-Vincent and M. Newmann, eds., *The Artificial and the Natural: An Evolving Polarity* Cambridge, MA: MIT Press, 2007); R. Silberglitt, *The Global Techno-*

logical Revolution: Bio/Nano/Materials Trends and their Synergies with Information Technology by 2015 (Santa Monica, CA: Rand, 2001).

22. The handbooks include J. Benyus, *Biomimicry* (New York: Perennial, 1997); G. Beylerian and A. Dent, *Material Connexion: The Global Resource of New and Innovative Materials for Architects, Artists and Designers*, ed. A. Moryadas (New York: Wiley & Sons, 2005); D. Gay, V. H. Suong, and S. Tsai,. *Composite Materials: Design and Application*, 4th ed. (Boca Raton, FL: CRC Press, 2002); T. Hongu and G. O. Philips, *New Fibers*, 2nd ed. (Cambridge:UK or MA? Technomic Publishing Company; 1997); D. A. Satas and A. Tracton, *Coatings Technology Handbook* (New York: Marcel Dekker, 2000); N. Stattmann, *Ultra Light–Super Strong: A New Generation of Design Materials* (Basel: Birkhäuser, 2003); J. Wessel, *The Handbook of Advanced Materials: Enabling New Design* (New York: Wiley-Interscience, 2004).

23. M. Ashby and K. Johnson, *Materials and Design: The Art and Science of Material Selection in Product Design* (Oxford: Butterworth-Heinemann, 2002).

24. D. Howes, ed., *Sensual Relations: Engaging the Senses in Culture and Social Theory* (Ann Arbor: University of Michigan Press, 2003).

25. D. Halbert, *Resisting Intellectual Property* (London: Routledge, 2005).

26. B. Latour, *Aramis or the Love of Technology* (Cambridge, MA: Harvard University Press, 1996).

27. B. Latour. and G. Rossler, *Das Parliament der Dinge: Naturpolitik* (Frankfurt: Surkamp, 2001).

28. A. Gell, "The Technology of Enchantment and the Enchantment of Technology," in A. Shelton and J. Coote, eds., *Art, Anthropology and Aesthetics* (Oxford: Oxford University Press, 1992). See also A. Gell, *Art and Agency* (Oxford: Oxford University Press, 1992).

29. V. Gallese, "The 'Shared Manifold' Hypothesis: From Mirror Neurons to Empathy." *Journal of Consciousness Studies* 8 (2001).

30. B. M. Stafford, *Body Criticism: Imaging the Unseen in Enlightenment Art and Medicine* (Cambridge, MA: MIT Press, 1993).

31. C. Knappett, "Photography, Skeomorphism and Marionetes: Some Thoughts on Mind, Agency and Objects." *Journal of Material Culture* 7 (1): 97–117.

32. M. Johannson, *Next to Nothing: A Study of Nanoscientists and Their Cosmology at a Swedish Research Laboratory* (Gothenburg, Sweden: Geson, 2008).

33. M. Mauss, *The Gift. The Form and Reason for Exchange in Archaic Societies* (London: 1954 [1924]); M. Strathern, *The Gender of the Gift: Problems with Women and Problems with Society in Melanesia* (Berkeley: University of California Press, 1988); E. Martin, "The End of the Body." *American Ethnologist* 49 (1).

34. S. Küchler and A. Eimke, *Tivaivai: The Social Fabric of the Cook Islands* (London: British Museum Press, 2009).

35. E. Akana, *Hawaiian Quilting: A Fine Art* (Honolulu: Hawaiian Children's Society, 1986).

36. A. Gell, *The Anthropology of Time* (Oxford: University of Oxford Press, 1992), 238–41.

37. Gallese, "The 'Shared Manifold' Hypothesis."

38. W. Lepenies, *Das Ende der Naturgeschichte: Wandel Kultureller Selsbtverständlichkeiten in den Wissenschaften des 18ten und 19ten Jahrhunderts* (Baden Baden: Romer, 1978).

39. R. Koselleck *Vergangene Zukunft: Zur Semantik Geschichtlicher Zeiten* (Frankfurt, 1992).

THREE Tartini's Devil

PERIPHERAL MECHANISMS THAT
UNDERLIE SENSORY ILLUSIONS

Naoum P. Issa and Ari Rosenberg

Of the demon myths that surround violinists, the story of Tartini is perhaps the oldest. Renowned for his virtuosity, Tartini is said to have received his inspiration directly from the devil. Unlike that of his successor Paganini, the tale of Tartini's demonic muse was almost certainly bolstered by his ability to produce tones apparently unrelated to the notes he played on his violin. These were not simple overtones, harmonics of a fundamental note, but rather were completely different notes whose temporal progression could differ from that of the notes being played—sometimes rising in pitch when the notes being played were falling, or falling when the notes being played were rising. Tartini had discovered the concept of difference tones, which he called "third sounds" and described in his work *Trattato di musica secondo la vera scienza dell'armonia.*[1] Without recognizing it, he had stumbled onto a fundamental property of sensory systems.

The scientific impact of Tartini's discovery of difference tones has grown over the last twenty years. How we, or more specifically our nervous systems, represent "illusory features" has been debated for decades, but modern studies that explain the perception of Tartini's difference tones might also explain how other sensory systems create illusory perceptions. The fundamental questions come down to: Where in the nervous system are illusory features first encoded, and to what extent do these illusory features affect our perception of the sensory world? Neurophysiological and psychophysical studies have begun to answer these questions, and in the process they argue that at least some illusions are first constructed by sensory receptors, not in the brain.

Colloquially, "sensory illusions" are misinterpretations of the real world—tricks of sensation produced by our sensory systems that mislead us into believing in something that does not exist. It is important to distinguish these

illusions from hallucinations or dreams, which are constructed from inner representations without reference to a current stimulus in the world around us. A sensory illusion requires a physical stimulus. The perception of that stimulus, however, is not a faithful representation of what actually exists. We can look at a static black-and-white picture, for instance, and perceive colors or movement. There is a physical stimulus in the surrounding world, but our perception of that stimulus is different from the reality.

In many ways, the perception of illusions is at the heart of neuroaesthetics. If our perceptions were faithful and unbiased readouts of the physical world, there would be no room for interpretation or nuance. Instead, biological systems are constructed in such a way that information is biased to emphasize what is important for survival, reproduction, and—after eons of evolution— neurochemical satiety. Thus the key to understanding sensory perception, and ultimately neuroaesthetics, is not to catalog the different ways in which sensory processing is faithful to the external world, but rather to identify where it imposes its biases and gives rise to illusory perceptions.

Constructing meaningful illusory features from the sensory environment is not a trivial task. Any sort of fault in neural processing can degrade or disrupt a sensory signal, producing the perception of illusory features; however, these would not be meaningful or helpful for survival. The biological processes that produce meaningful illusory features must therefore be precise, despite being distortions of the real world. Because of this precision and the salience of the illusory features we detect, it is generally thought that the neural representation of illusions originates in the cerebral cortex. Indeed, one explanation for why there are so many different areas of cortex subserving a single sensory system is that this allows for multiple stages of "nonlinear" processing, producing increasingly more complex types of illusory features along the way. Emerging evidence tells a more surprising story, however, and the notion that the representation of illusory features may begin within the sensory periphery, like the eyes and ears, is starting to take hold.

In this chapter we review some of the evidence in support of the argument that important illusory features are first encoded in the periphery, specifically in the end-organs of the auditory and visual systems. To many neurobiologists who study the cerebral cortex, the idea that complex sensory processing has already happened before the circuitry of the cortex is engaged seems im-

probable. Nonetheless, evidence from a variety of sources—fruit flies, fish, bullfrogs, and even guinea pigs and cats—suggests that this is precisely the case.

Auditory Illusions and the Bullfrog Ear

Sensory illusions are a part of our everyday experience, although this is hardly ever recognized because of how thoroughly ingrained they are in perception. For instance, it is surprising that an auditory illusion lies at the heart of our ability to tune stringed instruments. One way to tune a string is to compare its tone with a reference tone, but most of us would have very poorly tuned instruments if we simply tried to match two tones according to the similarity of their frequencies. For the average person, the ability to match two frequencies is not very good; a tone can typically be matched to within 10 percent of the reference frequency.[2] Yet despite such poor frequency matching ability, we are able to tune stringed instruments almost perfectly.

What accounts for our ability to tune a string? The answer is in our ability to detect Tartini's third sounds or "beat frequencies." Anyone who has tuned a stringed instrument or a melodic percussion instrument is familiar with a beat frequency: it is a perceived sound whose frequency is equal to the magnitude of the difference between a reference tone and the test tone produced on the instrument being tuned ($F_{beat} = |F_{reference} - F_{test}|$; see figure 3.1). As the frequencies of the reference tone and the tone produced by the instrument being tuned get closer together, the frequency of the beat gets smaller until it finally disappears at the point where the frequencies of the two tones match perfectly. Because we can perceive the beat frequency, our ability to tune an instrument is completely independent of our ability to match two sound frequencies.

Why can we detect a beat frequency? The easy answer would be that it is a sound in the range of frequencies that we can hear, but that would be wrong. In fact, the beat is not a physical sound at all. If it were, air would be compressed and rarefied at the beat frequency, but pressure measurements do not reveal any compression-rarefaction waves at that frequency. Moreover, people lack hearing receptors that are sensitive to sounds below 20 Hz, yet they readily perceive beat frequencies near 0 Hz.[3] The beat is detected

FIGURE 3.1. Auditory beats. The sine wave in the top panel represents the time course of compression and rarefaction of air pressure caused by a single pure tone. The second panel represents the pressure wave form of another pure tone with a slightly different frequency. The bottom panel is the pressure waveform produced by playing both tones together; constructive and destructive interference produces a modulation of the overall intensity at a beat frequency defined by the difference in the two pure tone frequencies.

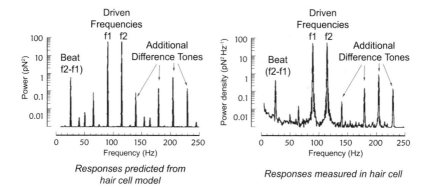

FIGURE 3.2. Hair cell nonlinearity generates difference tones. The left panel shows the power (amplitude) of vibrations at different frequencies, predicted from a model of hair bundle mechanics. In the simulation, the hair bundle was driven by two pure tones, one at frequency f1 and the other at f2. The hair bundle was predicted to vibrate not only at f1 and f2, but also at a series of other frequencies including f2 − f1, 2xf2 − f1, and 2xf1 − f2, and so on. The right panel shows measurements of actual hair bundle motion when a physical stimulus composed of two frequencies (f1 and f2) was delivered to an isolated bullfrog hair cell. The actual motion matched that predicted by the model, and recapitulated Tartini's difference tones in a dish. Figure adapted and reprinted by permission from Macmillan Publishers Ltd.: F. Jaramillo, V. S. Markin, and A. J. Hudspeth, "Auditory Illusions and the Single Hair Cell, *Nature* 364, no. 6437 (August 5, 1993): 527–29, ref. 6.

because the sound sensors in the ear are imperfect transducers, introducing distortions into the signal and passing those distortions on to the central nervous system as though they were part of the natural sound.

The mechanism by which auditory beats are first constructed remained unknown until physiologists were able to record the movements of the inner ear in a living animal. If the inner ear responded faithfully to two simultaneously presented pure tones, the resulting vibrations in the inner ear would occur only at those two frequencies. Instead, a variety of frequencies were observed in the vibrations of the inner ear structures,[4] indicating that beat frequencies are introduced by biological tissue at the very first stage of sound processing. If the output of the inner ear were evaluated using the same criteria as those used for a sound-system speaker, it would be rejected because of its poor sound quality.

The source of these extra frequencies was discovered in a collaboration involving an electrophysiologist, a theoretical electrochemist, and a biophysicist.[5] The group knew from previous experiments that the sound-detecting cells of the ear, the hair cells, had mechanical components that did not follow simple rules of oscillatory motion.[6] They had constructed a theoretical model of the motion of the hair cell's hair bundle (the part of the cell that moves in response to sound) and wondered how the model hair bundle would respond if simultaneously driven by two different frequencies. The result of their simulations was surprising: when driven by two pure tones, the hair bundle oscillated not only at those two frequencies (f_1 and f_2), but also at the beat frequency ($|f_1 - f_2|$). Even more surprisingly, there was a large group of additional frequencies in the predicted motion of the bundle, corresponding to a series of difference tones like $2 \times f_1 - f_2$, $2 \times f_2 - f_1$, and so on. In a rare example of a closed circle in neuroscience, measurement of the motion of real hair bundles driven by pairs of frequencies recapitulated the model's predictions almost exactly (figure 3.2) — suggesting that Tartini's difference tones, including the beat used to tune stringed instruments, are created by the transduction apparatus of the inner ear.

The key to understanding the significance of this experiment is that it was done in a dish, with individual, isolated hair cells. There was no brain, no neurons, no feedback to modify mechanical movements — just the cells that

transduce sound into electrical signals in the ear. Despite the relative simplicity of this biological system, Tartini's difference tones appeared.

Second-Order Processes in Vision

The peripheral origin of difference tones in the auditory system may be a prototype for how other sensory systems introduce illusory features. Visual illusions—in particular, visual beats—can be studied in much the same way as auditory beats. Despite the added dimensions required for vision (auditory stimuli presented to an ear are one-dimensional, varying only in time, while visual stimuli presented to an eye vary in time and two dimensions of space), there is a simple visual analog of auditory beats. Whereas an auditory beat is constructed by simultaneously presenting multiple pure (sinusoidal) tones, visual beats are constructed by simultaneously presenting multiple sinusoidal gratings, the higher-dimensional spatiotemporal analog of pure tones. When visual beats are studied in the laboratory, three-component beats (those generated by adding together three sinusoidal gratings) are typically presented (figure 3.3).

When a stimulus like the one to the right of figure 3.3 is shown, a visual beat (labeled "beat") with a distinct orientation and a lower spatial frequency (more broadly spaced bars) than those of any of its three sinusoidal components is perceived. In the vision sciences literature, three-component beats and other closely related stimuli are often referred to as "second-order" features. Like auditory beats, these features are not part of the physical stimulus; they are illusions. In the visual beat shown in figure 3.3, for example, there are no actual image components that are horizontally oriented or of a low spatial frequency, but a pattern with these properties is perceived nonetheless. We perceive this second-order feature because the visual system, like the auditory system, distorts sensory input in a specific and precise way.

Such a precise distortion system developed during evolution presumably because it conferred a competitive advantage. This evolutionary advantage, whatever it may be, must be substantial because many species even distantly removed from *Homo sapiens* detect second-order features. For instance, shortly after hatching, zebrafish larvae display a reflexive behavior in which

FIGURE 3.3. Constructing a visual beat. A visual analog of the auditory beat seen in figure 3.1 can be constructed by adding together multiple sinusoidal gratings. Three gratings, each with a unique combination of orientation (tilt of the bright and dark bars) and spatial frequency (spacing of the bars), are shown on the left. When the three gratings are added together, constructive and destructive interference produces the visual beat shown on the right.

they follow alongside any low-spatial-frequency object that is moving. They also display this behavior when high spatial frequencies combine to create a low-frequency beat; in other words, they track the beat as if it were actually present in the stimulus.[7] In an analogous study, the sensitivity of fruit flies to second-order visual features was examined. Like zebrafish larvae, fruit flies will follow a drifting bar. If that bar is replaced with a second-order stimulus, the flies track the motion of the second-order pattern.[8] Whether the mechanisms for constructing second-order features are evolutionarily old or have developed independently multiple times, the fact that they are found in a variety of taxa suggests that second-order feature perception is beneficial, perhaps fundamental, to visual perception.

Equally important, these studies indicate that the cerebral cortex is not a necessary processing stage for the detection of second-order features. Neither fruit flies nor zebrafish larvae have a cerebral cortex, so the mechanisms

they use do not depend on cortex. The issue is not so clear-cut in mammals in which both a peripheral mechanism (in the eye) and a central mechanism (in the cerebral cortex) have been proposed for the construction of second-order features.[9] Early neurophysiological work in nonhuman mammals suggested that sensitivity to visual beats arises relatively late in visual processing, in secondary visual cortical areas.[10] More recent functional magnetic resonance imaging of brain activity in humans supported this hypothesis.[11]

A parallel set of studies, however, supports a peripheral mechanism for the construction of second-order visual features. A class of retinal ganglion cells and the cells to which they project in the lateral geniculate nucleus (the thalamic nucleus of the visual system that relays information from the retina to the cerebral cortex) have been found to respond to visual beats.[12] The authors of these studies suggest that visual beats are first represented subcortically. More significantly, the responses of these cells, called Y-cells, can account for many properties of cortical responses to the same stimuli, thus calling into question the idea that the cortical representation of beats originates in cortex.[13]

While scientists have a tendency to choose a single mechanism to explain a phenomenon, it is important to note that the existence of peripheral and central mechanisms for constructing second-order features are not mutually exclusive possibilities. Actually, both play a role in the detection of beats. In the auditory system, binaural beats can be perceived when one pure tone is presented to one ear and a different pure tone is presented to the other.[14] Likewise, in the visual system, binocular beats can be perceived when different patterns are presented separately to the two eyes.[15] The representation of binaural and binocular beats necessarily requires central processing at a location that receives input from either both ears or both eyes. This means that beats are not introduced only at a single neural site, but rather at multiple locations, both peripheral and central. That both peripheral and central mechanisms for the construction of beats exist across sensory systems suggests that beat illusions are important components of perception.

Pointillism: Pixels or Beats?

With the exception of some experimental stimuli used in scientific labs, every visual scene contains second-order image features. Unlike first-order im-

age features (such as boundaries between dark and bright regions) which are defined by variations in light intensity, second-order image features (such as boundaries between differently textured but equally bright pieces of cloth) are defined by variations in contrast.

Despite the omnipresence of these second-order features in natural scenes, it is hard for us as observers to distinguish them from first-order features, in part because the two covary tightly.[16] However, the work of Georges Seurat and other pointillist painters provides an avenue for examining the contributions of first-order and second-order features to the perception of an image. Second-order image features are particularly prominent in pointillist paintings because pointillists used high-spatial-frequency components—small colored dots—to construct large-scale images. With the advent of computer monitors it is easy to claim pixelization as pointillism's greatest insight, yet it more than any other style highlights the perceptual salience of second-order image features. To illustrate this, we consider Seurat's *A Sunday on La Grande Jatte*. In the original painting there are many cues that allow us to segment objects and figures, including differences in hue, brightness, color saturation, and texture. The clearest boundaries are those defined by transitions in light intensity, many of which are apparent in the monochrome version of the painting shown in the top panel of figure 3.4. These transitions from dark to bright are first-order cues, and are arguably the most important features used by the visual system to segment an image.

However, the painstaking use of individual points of color creates more than just light/dark boundaries. Recall that beats are illusory low frequencies arising from interactions between different high-frequency components. In pointillist art, the entire image is constructed from high-frequency components (small dots)—so while there are low frequencies in the image, it is also likely that beats contribute important segmentation cues. To estimate the strength of the second-order features in the pointillist painting *A Sunday on La Grande Jatte*, we have removed the color (top panel, figure 3.4) and processed the monochromatic image using a "filter-rectify-filter" algorithm.[17] This procedure reveals where high-frequency components combine to produce low-frequency beats (bottom panel, figure 3.4).

A great deal of the information defining a visual scene is carried by second-order features, such as changes in texture that cue object bound-

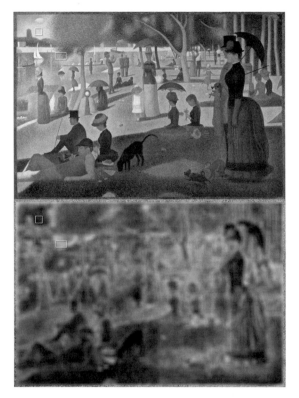

FIGURE 3.4. Second-order information in a pointillist painting. Top: a monochrome image of Georges Seurat's *A Sunday on La Grande Jatte–1884*, 1884–86. Oil on canvas, 81¾ × 121¼ in. (207.5 × 308.1 cm). Helen Birch Bartlett Memorial Collection, 1926.224, Art Institute of Chicago. Photography © Art Institute of Chicago. Reprinted by permission of The Art Institute of Chicago. Bottom: a transformation of the image that shows second-order information. This transformation was accomplished by high-pass spatial filtering, squaring the intensities in the filtered image, and then low-pass spatial filtering. Regions of the painting in which there is little second-order information (square box) and substantial second-order information (rectangular box) are marked in both panels.

aries. This point is readily demonstrated in pointillist paintings. In the filter-rectify-filter image in the bottom panel of figure 3.4, the brightest regions indicate where variations in high spatial frequencies give rise to low-spatial-frequency beats. We have marked two regions in the image: one that encloses a patch of sky and is comparatively smooth (square box and another that includes a boundary between the water and the leaves of a tree (rectangular box). In the bottom panel showing the locations of second-order image features, the region of sky is dark because there is little texture variation in

that area, while the boundary between the tree and water is bright because there is substantial texture variation between the two regions. Edges are apparent throughout the second-order image precisely because second-order features are a common cue for object boundaries.[18]

Part of the aesthetic interest of pointillism derives from how the paintings change with the distance from which they are viewed. From close by, little overall structure is apparent; just random dots of color are perceived. From far away, the individual dots are no longer visible and the painting appears much like any other painting formed with broad strokes. From intermediate viewing distances, however, the uniqueness of pointillism stands out. Despite clearly being composed of dots scattered about the canvas, pointillist paintings viewed from moderate distances give distinct perceptions of form and structure. Because the perception of second-order features requires both the ability to see high frequencies (which decreases with viewing distance) and the ability to see a large enough area of the image to detect low-frequency variations (which increases with viewing distance), it is at intermediate viewing distances that second-order features contribute most to visual perception. To illustrate this, we present the second-order features of the monochrome version of *A Sunday on La Grande Jatte* as if it were viewed from various distances (figure 3.5). At very long distances only first-order cues of varying light intensity define form. As the viewing distance decreases, beats provide progressively greater information about the structure in the image. Arguably, the unique aesthetic of pointillist paintings at intermediate distances is attributable to the availability of second-order information.

Conclusions

Complexity in sensory perceptions can have many origins — starting with the stimulus itself, ending with emotions overlaid on imagined percepts, and distorted in the middle by the wide variety of encoding and decoding steps of the nervous system. The goal of this chapter has been to identify one class of distortion and to argue that it alters our perception in a specific and meaningful way.

Both the auditory system and the visual system introduce beat frequencies early in the sensory cascade. From a purely mechanistic standpoint this

FIGURE 3.5. How second-order information changes with viewing distance. To simulate the effect of viewing distance on second-order information, several versions of the painting shown in the top panel of figure 3.4 were put through the filter-rectify-filter algorithm. To simulate the longest viewing distance, a low-resolution version of the painting in which none of the dots that comprise the painting were visible was analyzed. While first-order information in the form of light intensity remains (not shown), almost no information about the image structure is available from second-order cues. Viewing the image from a closer distance, simulated by analyzing progressively higher-resolution images, increases the amount of image structure defined by second-order cues. The contrast in each panel was stretched to simulate maximal sensitivity to the second-order features detected at each viewing distance; even with maximal sensitivity there is little second-order structure at the longest viewing distances.

does not have to be the case; at least in the visual system there is an alternative pathway that lacks beat distortions (the "X-pathway").[19] It is also known that more central neural stages (in the midbrain or cerebrum) can inject beats, as evidenced by binaural beats (constructed by playing different pure tones separately to each ear)[20] and binocular beats (constructed by showing different patterns separately to each eye).[21]

In a general way, this raises the fundamental question of what exactly the

cerebral cortex contributes to perception. Does it create new features out of simple inputs from the peripheral sensory organs, as is traditionally thought? Or does it receive signals that have already been manipulated to create the important distortions? If the latter is correct, is subsequent processing in the cortex more nuanced, based on an individual's idiosyncratic experience? The most likely answer is a combination of both, but understanding how and to what extent this admixture occurs is a necessary prerequisite to defining the neural underpinnings of perception and aesthetics.

Tartini struggled to understand the physical basis of harmony, producing in the end a flawed theory.[22] Despite this, his discovery of third sounds provided an important clue about the nature of sensory processing. Many important questions remain to be answered regarding the role of beat frequencies in perception. First, it is surprising that we still do not have a compelling explanation for why beat frequencies are so important that they are represented in disparate species and different sensory modalities, and are introduced at multiple stages of sensory processing. A general explanation comes from modern theories of sensory perception which invoke neural processes that evolved over eons to guide interpretation of the world in the absence of context or experience,[23] and it is likely that the mechanisms for detecting beats are among them. But it is still not clear how we would be disadvantaged if sensory processing were limited to first-order cues. Second, because it is challenging to present first-order and second-order features independently, it is difficult to separate their influences on perception. As a result, the extent to which second-order cues influence our appreciation of a piece of music or a particular image is still mostly guesswork. Finally, it is clear that inputs to the cerebral cortex are neither simple nor objective representations of the real world — so how must we change our concepts of high-level processing to accommodate these distorted inputs? Perhaps through the integrated study of neuroscience and aesthetics, we can begin to answer these questions.

Notes

1. G. Tartini, *Trattato di musica secondo la vera scienza dell' armonia* (Padua: 1754).

2. C. C. Wier, W. Jesteadt, and D. M. Green, "Frequency Discrimination as a Function of Frequency and Sensation Level," *J Acoust Soc Am* 61 (1977), 178–84.

3. G. Oster, "Auditory Beats in the Brain," *Sci Am* 229 (1973), 94–102; A. J. Hudspeth, "Hearing," in *Principles of Neural Science*, E. R. Kandel, J. H. Schwartz, and T. M. Jessell, eds. (McGraw-Hill, 2000).

4. L. Robles, M. A. Ruggero, and N. C. Rich, "Two-Tone Distortion in the Basilar Membrane of the Cochlea," *Nature* 349 (1991), 413–14.

5. F. Jaramillo, V. S. Markin, and A. J. Hudspeth, "Auditory Illusions and the Single Hair Cell," *Nature* 264 (1993), 527–29.

6. V. S. Markin and A. J. Hudspeth, "Gating-Spring Models of Mechanoelectrical Transduction by Hair Cells of the Internal Ear," *Annu Rev Biophys Biomol Struct* 24 (1995), 59–83.

7. M. B. Orger, M. C. Smear, S. M. Anstis, and H. Baier, "Perception of Fourier and Non-Fourier Motion by Larval Zebrafish," *Nat Neurosci* 3 (2000), 1128–33.

8. J. C. Theobald, B. J. Duistermars, D. L. Ringach, and M. A. Frye, "Flies See Second-Order Motion," *Curr Biol* 18 (2008), R464–465.

9. J. B. Demb, K. Zaghloul, and P. Sterling, "Cellular Basis for the Response to Second-Order Motion Cues in Y Retinal Ganglion Cells," *Neuron* 32 (2001), 711–21; C. L. Baker, Jr., and L. Mareschal, "Processing of Second-Order Stimuli in the Visual Cortex," *Prog Brain Res* 134 (2001), 171–91.

10. L. Mareschal and C. L. Baker, Jr., "Cortical Processing of Second-Order Motion," *Vis Neurosci* 16 (1999), 527–40; "A Cortical Locus for the Processing of Contrast-Defined Contours," *Nat Neurosci* 1 (1998), 150–54; "Temporal and Spatial Response to Second-Order Stimuli in Cat Area 18," *J Neurophysiol* 80 (1998), 2811–23.

11. H. Ashida, A. Lingnau, M. B. Wall, and A. T. Smith, "FMRI Adaptation Reveals Separate Mechanisms for First-Order and Second-Order Motion," *J Neurophysiol* 97 (2007), 1319–25; J. Larsson, M. S. Landy, and D. J. Heeger, "Orientation-Selective Adaptation to First- and Second-Order Patterns in Human Visual Cortex, *J Neurophysiol* 95 (2006), 862–81.

12. Demb, Zaghloul, and Sterling, "Cellular Basis for the Response to Second-Order Motion Cues in Y Retinal Ganglion Cells," 711–21; A. Rosenberg, T. R. Husson, and N. P. Issa, "Subcortical Representation of Non-Fourier Image Features," *Journal of Neuroscience* 30 (2010), 1985–93.

13. Rosenberg, Husson, and Issa, "Subcortical Representation of Non-Fourier Image Features."

14. Oster, "Auditory Beats in the Brain."

15. L. W. Baitch and D. M. Levi, "Binocular Beats: Psychophysical Studies of Binocular Interaction in Normal and Stereoblind Humans," *Vision Res* 29 (1989), 27–35.

16. A. P. Johnson and C. L. Baker, Jr., "First- and Second-Order Information in Natural Images: A Filter-Based Approach to Image Statistics," *J Opt Soc Am A Opt Image Sci Vis* 21 (2004), 913–25.

17. C. Chubb and G. Sperling, "Drift-Balanced Random Stimuli: A General Basis

for Studying Non-Fourier Motion Perception," *J Opt Soc Am A* 5 (1988), 1986–2007; A. P. Johnson and C. L. Baker, Jr., "First- and Second-Order Information in Natural Images: A Filter-Based Approach to Image Statistics," *J Opt Soc Am A Opt Image Sci Vis* 21 (2004), 913–25; Wilson, "Nonlinear Processes in Visual Pattern Discrimination," 9785–90.

18. A. P. Johnson, N. Prins, F. A. Kingdom, and C. L. Baker, Jr., "Ecologically Valid Combinations of First- and Second-Order Surface Markings Facilitate Texture Discrimination," *Vision Res* 47 (2007), 2281–90.

19. Rosenberg, Husson, and Issa, "Subcortical Representation of Non-Fourier Image Features."

20. Oster, "Auditory Beats in the Brain."

21. Baitch and Levi, "Binocular Beats: Psychophysical Studies of Binocular Interaction in Normal and Stereoblind Humans," 27–35.

22. A. E. Planchart, "A Study of the Theories of Giuseppe Tartini," *Journal of Music Theory* 4 (1960), 32–61.

23. J. J. Gibson, *The Ecological Approach to Visual Perception* (Psychology Press, 1986); E. F. Clarke, *Ways of Listening: An Ecological Approach to the Perception of Musical Meaning* (Oxford University Press, 2005).

FOUR **Sociovisual Perspective**

.VISION AND THE FORMS OF

THE HUMAN PAST

.**Philip J. Ethington**

Cultural studies and many social science fields have been under the spell of an intellectual rift for many decades, united in the belief that the humanities enjoy immunity from dialogue with natural scientists on common areas of inquiry such as "vision" and "visuality." This sense of immunity was institutionalized by the first generation of university-based intellectuals in the late nineteenth century. Wilhelm Dilthey, in the 1890s and the following decade, won a major political fight in Germany for the independence of the human sciences (*Geisteswissenshaften*, including what in English are called the "humanities" and many of the "social sciences").[1] French and Anglophone systems followed suit. The humanities—especially history, art history and criticism, literature studies, philosophy, and classics—were deemed "interpretive" studies concerned with social phenomena, studied not as natural phenomena but as independent of so-called natural laws. Institutions such as language, religious belief, ideologies, political history, marriage customs, and traditions were deemed human inventions that were "real" only in symbolic thought, much as software is considered independent of hardware. To be sure, Marx and many other "founders" like Durkheim tried to establish the study of human institutions on a "scientific" basis, but since Dilthey's leadership in the 1890s, most humanists have insisted that such cultural forms were shaped primarily by other "social facts," rather than being traceable to innate or *natural* facts.[2]

The mind is embodied, however—and since Freud, most humanists have known this while avoiding its implications. Indeed, "embodiment" has become a leading key word among humanists.[3] I argue in this essay that embodiment spells doom for a very old taboo on recognizing that scientific explanations might actually be *valid* and not merely an object of intellectual critique.[4] I will use several exemplars of fine and influential studies of visual culture by

TO BE WITHIN ARM'S REACH OF DISTANT ·COUNTRIES IT IS ONLY NECESSARY TO BE

WITHIN ARM'S REACH OF THE UNDERWOOD STEREOGRAPH-TRAVEL SYSTEM

FIGURE 4.1. "The Underwood Travel System." Underwood and Underwood catalog, 1913. Keystone-Mast Collection.

critical humanists in reconsidering Dilthey's divorce decree. In retrospect, the depth of this divorce in many areas is surprisingly extreme, but there actually has been more interaction than most humanities journals would indicate. The general universe of psychology, psychiatry, neurosciences, and philosophy of mind has long offered porous boundaries.

I hope to exploit this opening by exploring the key word *perspective* as it is studied by several separate disciplines with deeply divergent *perspectives* on the construct. Visual studies is a field that has fully matured in the humanities, and the neurosciences have long studied the visual system of optical pathways and processing centers in the visual cortex. Cognitive neuroscientists and cognitive linguists have long merged the most biological of neurosciences with traditional philosophy, and much of this work is either about or highly relevant to the general question of "vision" in both humanist and neuroscientific discourses.

This essay interrogates the concept of perspective in order to sketch a general map of the terra incognita between the fields of *critical cultural studies* and *cognitive neuroscience* regarding *vision* and *visuality*.

Parallel Universes of Research

Failure to communicate is a two-way street. In a few short paragraphs I want to sketch two universes of discourse that at this point travel mostly in parallel, traversing the same territory but not—with some important exceptions—talking across the Diltheyan divide.

An exploding body of research into the "brain-mind continuum" is far too young and divergent to allow the identification of a dominant school, or to be dealt with broadly here. But the overall achievement since the early 1990s has been to show that abstract thought, emotions, feelings, symbolic communication, visual perception, and other cognitive processes take highly specific pathways through the neural networks and processing centers of the brain. The processing centers are extraordinarily complex engines of biochemical and electrochemical interactions with the outside world, with other parts of the brain, and with all the haptic or sensory organs of the body: those of sight, hearing, smell, taste, and touch. These pathways and processing centers are increasingly well identified in maps of the brain. While they occupy stable general locations, their boundaries are not usually precisely drawn. Instead, these functional centers, called "maps," can expand or contract in important ways. Further, within each center, neurons are not always permanently specialized to respond to particular external stimuli. Instead, they are "tuned" through practical engagement with the world.

Visual processing centers are highly mappable with "functional magnetic resonance imaging" (fMRI; see figure 4.2), electrophysiological recordings, and other tools. Neuroscientists, including cognitive neuroscientists, have produced an increasingly revealing picture not only of where, but *how* the mind processes perceptual information. As we shall see, the processing centers for visual perception perform combinatory and interpretive work on the raw sensory inputs long before they reach conscious awareness, so a fair measure of "innateness" seems to shape visual perception. But the phenomenon of neuronal tuning is a critical bridge between the plastic view of human institutions within the social constructionist paradigm descended from Dilthey and Durkheim and the findings of cognitive neuroscience.

Conversely, humanists and social scientists over the past century—despite their willful disregard of neuroscientific studies of the brain and mind—have

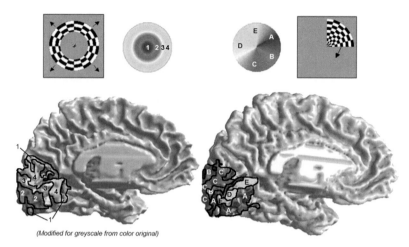

(Modified for greyscale from color original)

FIGURE 4.2. fMRI image of "the retinotopy paradigm." "Two stimuli are used to measure the retinotopic maps in cortex. Expanding ring stimuli map eccentricity and rotating wedge stimuli map polar angle. The phase of the best-fitting sinusoid for each voxel indicates the position in the visual field that produces the maximal activation for that voxel. Thus, these pseudo-color phase maps are used to visualize the retinotopic maps. Data are shown for the left hemisphere of one subject." R. F. Dougherty, V. M. Koch, A. A. Brewer, B. Fischer, J. Modersitzki, and B. A. Wandell (2003), "Visual Field Representations and Locations of Visual Areas V1/2/3 in Human Visual Cortex," *Journal of Vision* 3(10): 1, 586–98. http://journalofvision.org/3/10/1/, doi:10.1167/3.10.1.

. .

developed several sophisticated and empirically tested models of social or cultural construction, which have been willfully disregarded by scientists of the brain and mind. Michel Foucault, to take one major example, developed a model and method of discursive "archeology," identifying "epistemes," or historically specific ways of thought that have proven highly useful for mapping (in the metaphoric sense) the knowledge structures of whole societies during centuries-long "epochs." Another enduring model has been that of "ideological hegemony," first proposed by Antonio Gramsci in the 1920s and carried forward by the Birmingham School of cultural Marxism in the 1950s and 1960s.

The "linguistic turn" inspired by Ferdinand de Saussure generated several important models of cultural cognition, including Claude Levi-Strauss's structuralism and ultimately Chomskyan linguistics. Much of cognitive philosophy has long engaged in crossover work through such vehicles as Benjamin Lee Whorf and Edward Sapir's linguistic relativity thesis, which seeks to base each society's worldview (weltanschauung) in its syntactic and semantic system. These fields of inquiry are very much at the border between the hu-

manities and the natural sciences, thus inviting a close look at the interface of nature and culture. But they are also part of an excessively language-based cultural inquiry. The broad field of visual studies has begun to escape from the so-called prisonhouse of language by showing the myriad ways in which humans communicate and think in visual ways that are not or may not be reducible to narrative, discursive structuralist models.

Another very important escape route from the limits of the linguistic turn is the newer "spatial turn."[5] My own research agenda as a historian and political scientist features the model "historical institutionalism," modified by a radical spatialization of time.[6] "Every past is a place," I have asserted. "All action and experience takes place, in the sense that it requires place as a prerequisite, and makes place, in the sense of inscription."[7] To make such a case, I draw heavily on Edward Casey's recent phenomenological philosophy of place. As Casey explains, "places gather . . . being in a place is being in a configurative complex of things." Furthermore, "places also gather experiences and histories, even languages and thoughts." Places "hold" and "keep," in Casey's terminology. Memories "belong as much to the place as to my brain or body." Places are the condition of possibility for human culture itself: "To be cultural, to have a culture, is to inhabit a place sufficiently intensively to cultivate it. . . . Culture is carried into places by bodies. To be encultured is to be embodied to begin with."[8] My use of the term "topoi" carries both a discursive meaning, drawn from the new criticism in literary studies of the late 1940s, and an embodied meaning, of practice and performance in "real spaces."[9] As my study "Placing the Past" concludes:

> *Topoi* are recognizable because we can map them within a general topology of the known or familiar. All action, whether building pyramids, making love, writing, or reading, takes and makes place. . . . Reading our environment is a holistic endeavor. . . . Every element, every sign, is only legible in relation to the entire mental map of the world carried within our crania. The cranium also serves as a referential point-coordinate (perspective).[10]

This spatial institutionalism postulates long-enduring patterns of social, cultural, and governing relations that are inscribed into the landscape, taking and making the places of the globe. Such patterns are both eminently mutable (in

both evolutionary and revolutionary increments) but also deeply layered, so that all the actions of previous generations bleed through to the present, imposing conceptual, normative, and behavioral structures that haunt us as ghosts.

It is in fact my object in this essay to refine my spatial theory of the past by elaborating on its visual dimension through the topos of "perspective." In the following sections I argue that visual perspective is the experiential intersection between the embodied and metaphoric senses of place. Perspective is a key word of crucial importance at the intersection of cultural studies and the cognitive neurosciences. Within the segregated discourse of cultural studies, it is usually a highly metaphoric concept, understood as nongeometric "social positionality," or a person's "place" (again metaphoric) in social "structures," "hierarchies," and other metaphorically spatial dimensions. From another direction, visual perspective has been a major field of investigation by visual scientists, art historians, philosophers, and cognitive researchers for many centuries. Indeed, perspective is one area in which art historians and psychologists had a relatively substantial dialogue during the twentieth century.

Can the wide-ranging sense of social perspective be reconciled with the neurologic-cognitive approach to visual perspective? What is the role of visual studies in this intersection or convergence of epistemologies?

Perspectives on Perspective

"Perspective" is one of the most important metaphors of the humanities and social sciences. Metaphoric social perspective refers to the local bias of a given subject in a larger context of "locations" within the hierarchies and segregations of organized social life. Early twentieth-century "relativism" in anthropology—a nascent form of multiculturalism—relied heavily upon the metaphor of perspective to account for the radically different interpretations of a common event or phenomenon given by members of different cultural communities. The concept of "worldview" in the Sapir-Whorf hypothesis is an important variant. More recently, the sociological theory of Pierre Bourdieu has influentially developed "social position" as a conceptual tool.[11] The post-structural and postcolonial critique of Enlightenment-style universal knowledge has maximized the uses of "perspectivalism" to portray all knowledge and understanding as radically contingent upon the social lo-

cation of the subject. Perspectivalism, along with related concepts of "subject positions" and "positionality,"[12] has been deployed extensively in the current crisis of knowledge to undermine the possibility of any objective or certain knowledge. Postcolonial scholarship has regionalized and even *provincialized* Western epistemology.[13]

Richard Rorty's latest version of pragmatism represents perhaps the maximum program of perspectivalism. In Rorty's account, any claim of knowledge to be the "mirror of nature" is moot because the suspension of knowledge and communication within linguistic communities ends the dream of sentence-to-fact correspondences. Rorty does endorse knowledge construction, but avers that it can only achieve validation from the discursive communities, or audiences, to which it is addressed. We should, he writes, "drop the idea that when I make an assertion I am implicitly claiming to be able to justify it to all audiences, actual and possible."[14]

Visual perspective is the ground of these metaphors. It is literally a "point of view." In the graphic arts, "perspective" is a general term for all the various methods of representing the three-dimensional world on two-dimensional surfaces. So called "single-point," "Albertian," or "Cartesian" visual perspective was a crucial component of the Renaissance construction of knowledge, inaugurating that episteme Foucault calls the "new relations" of "representing."[15] But, as the best work in the cultural constructionist paradigm has shown, the visual cultures of the past half millenium have been inseparably bound up with distinctive cultures of spatiality.

Until recently, a self-congratulatory "master narrative" presented the following plot: Renaissance aesthetics and the rules of spatial perspective were "discovered" by Filippo Brunelleschi and theorized by Leon Battista Alberti in fifteenth-century Italy. This single-point geometric perspective, based on a "vanishing point" at the horizon of a picture, created the illusion of depth and enabled realistic representation. Albrecht Dürer and other European artists spread this doctrine. The geometrical rules of vision itself were further theorized by René Descartes in the seventeenth century and associated with his ideal of an impartial objectivity. The entire scientific revolution came to be associated, if not equated with, "Cartesian perspectivalism."

This heroic and unilinear account came under attack at the beginning of the twentieth century from many directions. First and most dramatic was

the artistic practice of Pablo Picasso in his cubist phase, willfully violating Alberti's rules to portray the front and back sides of human faces and bodies from the same angle of view. At about the same time, the great art historian and philosopher Erwin Panofsky made it clear in his work during the 1920s that systems of proportion and perspective in the visual arts were not to be considered as increasingly better, more realistic, nor more accurate, but rather as *social constructs* embedded historically in specific epochs. Systems of projecting the three-dimensional world onto flat surfaces are themselves "symbolic forms," or ways of conveying cultural meaning.[16] Panofsky was, of course, participating in the rise of metaphoric perspectivalism described above.

After Panofsky, the trajectory of Western art practice continued to assail the supposed privilege of Albertian single-point perspective once considered so axiomatic in art education and criticism. The modernist aesthetic came to regard the compositional rules of perspective — what Clement Greenberg called "fictive space" — as antithetical to artistic value. By the 1940s, Greenberg and his circle of critics (especially Harold Rosenberg) and artists (Willem de Kooning, Jackson Pollock, Franz Klein, and Mark Rothko), denigrated the contrived perspective of illusory depth and exalted "flatness" as the proper form of visual art.[17] "From Giotto to Courbet," wrote Greenberg, "the painter's first task had been to hollow out an illusion of three-dimensional space on a flat surface. One looked through this surface as through a proscenium into a stage. Modernism has rendered this stage shallower and shallower until now its backdrop has become the same as its curtain, which has now become all that the painter has left to work on."[18]

The leveling work of the abstract expressionists has been followed by a remarkable range of art-historical criticism that has put Albertian perspective in its place, as it were, as just one of many valuable methods of spatial projection. In 1972 Rudolf Arnheim began a fascinating dialogue on "inverted perspective," in which, contrary to Albertian rules, objects appearing to be closer to the viewer (nearer to the bottom of the picture plane) look smaller rather than larger than those farther away (in the upper portion of the picture). Arnheim showed that inverted perspective, once considered "naïve" or unrealistic, could be "an approach better adapted to the interpretation of pictures than the surviving traditional one, based on the illusionistic doctrine."[19] Boris V. Rauschenbach took Arnheim's thesis even further, arguing that Albertian or

Renaisssance perspective did not even deliver the realism that its proponents had always claimed: "Renaissance perspective with lines projected to a vanishing point on the horizon is satisfactory only for depicting objects at a large distance from the viewer."[20] At close range, Rauschenbach showed, "parallel perspective" was much more realistic because parallel lines near an observer really do appear to be parallel.

Even during the height of the Renaissance, Svetlana Alpers and Martin Jay have shown, Cartesian perspectivalism was not the sole model of visual depiction. Alpers shows that a Dutch alternative, which she calls the "art of describing," evolved separately from the Albertian model: "Theirs was not a window, as in the Italian model for art, but rather, like a map, a surface on which was laid out an assemblage of the world."[21] The Cartesian model depends on "the positioned viewer, the frame, and the definition of the picture as a window through which an external viewer looks." But the cartographic projection "is, one might say, viewed from nowhere. Nor is it to be looked through. It assumes a flat working surface."[22]

Martin Jay then adds a *third* "scopic regime of modernity": that of the Baroque. Drawing on the work of Christine Buci-Glucksmann, Jay appraises Baroque visuality as "celebrating the dazzling, disorienting, ecstatic surplus of images in baroque visual experience" in its "rejection of the monocular geometricalization of the Cartesian tradition." As Jay observes, "although no one system can be seen as its correlate, Leibniz's pluralism of monadic viewpoints, Pascal's meditations on paradox, and the Counter Reformation mystic's submission to vertiginous experiences of rapture might all be seen as related to baroque vision."[23]

The question of realism in visual depiction in the humanistic and social sciences reached a rather crucial point in the widespread debates about the nature of photography. There is now a substantial body of scholarship showing that the camera obscura (a giant pinhole camera, in which painters could stand and trace the image of a scene) was commonly used by Renaissance painters such as Jan Vermeer.[24] Photography since Louis-Jacques Mandé Daguerre has, to many, represented the apogee of perspectival realism, a logical culmination of the Renaissance efforts toward realistic depiction.

But the rise of critical theory and the social construction model has sought to undermine the authority of the photograph, marking it as symptomatic

FIGURE 4.3. Johannes Vermeer, *Die Malkunst* (The Art of Painting), 1666–67. Kunsthistoriches Museum, Vienna. Photograph; reproduction studio and calibration scale visible. Vermeer kept this masterpiece for himself, possibly as a *chef d'oeuvre* to impress clients. Its Albertian perspective — possibly executed with the help of a small camera obscura — is mixed with the Alpersian "art of describing." Its perspective is self-referentially framed as the perspective of the viewer, who pulls back the curtain with (our) left hand on this scene. The model is garbed as Clio, the muse of history. One full quadrant is dedicated to a map of the Netherlands, one of many maps that Vermeer featured in his paintings. So convincing is the detail rendered in *Die Malkunst* that this map was believed to exist for centuries before anyone could find it. "Here we can almost feel the map's cracked and varnished surface and sense its weight as it pulls down on its two tiny supports." The map was ultimately identified by Albert Flocon in 1962 as having been published by Claes Jansz Visscher in *The Seventeen Provinces*, and to this day the Bibliothèque Nationale has the only known copy. James A. Welu, "Vermeer: His Cartographic Sources," *The Art Bulletin* 57:4 (December 1975): 529–47.

. .

of the shallowness of modern culture, of its detachment from the world. In this frame the photograph is not an artifact of realism, but rather its opposite: illusion. The photograph is sometimes portrayed as reaching deeply into the quotidian details of the world, exposing its minutest secrets (Walter Benjamin). At other times it is portrayed as the quintessence of shallowness, a mute impression of light that replaces or displaces critical reason (Theodor Adorno). But across this range, the photograph has been portrayed as an artifact of larger social forces. A mainstream "constructionist" position has emerged. Two historians of visual culture, John Tagg and Jonathan Crary, attempt to reduce photography and its related genres, movies and stereoscopes, safely within a set of socioinstitutional practices. For Tagg, the photograph is always forced to perform some function, by capitalist markets or by the police as agents of state power. For Crary, the photograph is merely one artifact in the general reconstruction of culture that was part of the rise of capitalist consumer culture and the rise of "modernity." These forces, according to Crary, fragmented the world so that the observer became detached and began to experience it through free-floating images, much like the alienated commodities of the capitalist marketplace.

This cultural construction of the photograph attempts to tame or normalize it by contextualizing it as a mere species of text within a wide network of power and institutions that make each photograph perform specific functions. In this view, photographs have no special access to reality in general, let alone the past. An extraordinary exception to this school of thought is the work of Roland Barthes, one of the leading figures in the critical-studies field of semiotics. In his 1981 study of photography, *Camera Lucida*, Barthes argued that the photograph gives unmediated access to reality, and asserted that "from a phenomenological viewpoint, in the Photograph, the power of authentication exceeds the power of representation."[25] Photography, he claims, gives unmediated access to reality: "Certainly, the image is not the reality but at least it is its perfect *analogon* and it is exactly this analogical perfection which, to common sense, defines the photograph. Thus can be seen the special status of the photographic image: it is a message without a code. . . ."[26] Barthes recalls a photograph of a nineteenth-century slave market that he had clipped as a child: "For my horror and my fascination as a child came from this: that there was a certainty that such a thing had existed: not a

FIGURE 4.4. Mark Rothko, *No. 10*, 1950. Oil on canvas, 229.2 × 146.4 cm (90¼ × 57⅝ in.), Museum of Modern Art, New York; gift of Philip Johnson, 1952. © ARS, New York. Photo: Museum of Modern Art / SCALA / Art Resource, New York.

question of exactitude, but of reality. The historian was no longer the media-
tor, slavery was given without mediation, the fact was established without
method."[27] An even more emphatic case for photographic realism is made by
Kendall L. Walton, who insists that "we really do see our dead ancestors" in
photographs, which are instruments allowing us to see into the past just as
mirrors are instruments that allow us to see around corners, and as micro-
scopes allow us to see very small things.[28]

More dramatically than standard photography, stereoscopic photog-
raphy seems to hold out the promise of realist depiction. Stereographs are
twinned photographic images made with twin-lens cameras, the lens sepa-
ration being roughly equal to that of eyes on Europeans' heads (70 millime-
ters). Mounted on rectangular cards, stereographs are typically viewed in
a handheld "Holmes-type" viewer, which uses refracting lenses to force the
eyes to see the two images as a single superimposition, thus reproducing the
cognitive processing that converts the subtended angles of binocular vision
into perceptions of spatial depth and volume. Stereoscopic photography is a
"virtual reality" that enjoys a continued life in cinematic and digital formats
of the twenty-first century.

Stereoscopy actually predates photography, and it was deeply inter-
twined with the latter's emergence as a technology of seeing. The procedure
for printing images that could be seen three-dimensionally was discovered
by Charles Wheatstone and presented to the Royal Society in London in
1838, one year before the Institute de France officially unveiled Daguerre's
invention of the basic photographic process as we know it today.[29] The ap-
plication of Wheatstone's discovery to photography followed quickly upon
Daguerre's epochal invention. Sir David Brewster, the inventor of the kalei-
doscope, is credited with introducing stereoscopic photography in 1844.[30]

Jonathan Crary, in his important and influential book *Techniques of the Ob-
server* (1990), devotes a great deal of attention to the stereoscope. A promi-
nent proponent of the cultural construction paradigm, Crary attempts to
undermine its realism, claiming that "there is no longer the possibility of per-
spective under such a technique of beholding."[31] He attempts to establish the
construction of a new kind of "observer" in the early nineteenth century, as-
serting "that some of the most pervasive means of producing 'realistic' effects
in mass visual culture, such as the stereoscope, were in fact based on a radical

abstraction and reconstruction of optical experience."[32] Crary has continued this line of reasoning in *Suspensions of Perception: Attention, Spectacle, and Modern Culture* (2001), seeking to suspend all forms of depiction within the large-scale institutions of modern capitalist society, rather than linking them to the world in any durable way.[33]

In the contrast between the Tagg-Crary position and that of Barthes we have a very deep divide. On the one side, the photograph is a social construction like any other "social fact." On the other, it has a special status, autonomous from language and discourse. Crary and Tagg's theses are of utmost importance when considering the growing fund of knowledge about brain and mind flowing from the neurosciences. They represent a categorical refusal to admit of realism in depiction, whether photographic or graphic. Crary, especially, is at pains to treat all natural scientific knowledge as perspectival, suspended in webs of political economy, and therefore, as in Rorty's account, never amounting to positive knowledge that accumulates in a durable way.

From Metaphor to the World and Back

Paul Ricoeur, in *Rule of Metaphor* (1980), argued that metaphor provides a primary escape route from the prison house of language because, in defiance of structural linguistic rules, metaphors allow speakers to bend language toward expressive purposes that stretch beyond the semantic and syntactic properties of words, as in Shakespeare's "All the world's a stage." In that same year, George Lakoff and Mark Johnson published *Metaphors We Live By*, the opening volume in a series of books in which Lakoff and his colleagues have built a formidable theory about the metaphoric basis, or "grounding," of higher-level concepts. Grounded metaphors, in this framework, arise from the embodied mind and the practical experience of embodiment. For example, in *Where Mathematics Comes From* (2000), Lakoff and Rafael E. Núñez argue that basic visual shapes and patterns in the world, motion, or pathways provide the model for such basic mathematical operations as arithmetic (collections of objects along a pathway) or sets (objects in containers).

The grounded-metaphor theory has gained increasing support from ongoing research into the neurological processes of perception. In brief, I will

sketch some of the most well-accepted and noncontroversial findings of this research regarding vision, in order to return to the subject of perspective as neuroscientists have studied it. The neurobiological operations of vision, although immensely complex, have steadily come under increasing understanding over the course of the last century, since Santiago Ramón y Cajal first revealed the neuronic structures in drawings that are still used in textbooks today. The steps between the sensing of electromagnetic radiation in the visible spectrum to high-order cognition about the visible world are many. The architecture of "retinal wiring" begins with the retina at the back of the eye, which is similar to the film plane in a camera. "The cone mosaics in the retina sample the image and form three interleaved visual field maps; each map measures a different spectral band. Subsequent retinal wiring compares and combines signals from these cone mosaics into a dozen different retinal ganglion cell mosaics with receptive fields that measure different spatial, chromatic and temporal features of the image. These output neurons again comprise a set of mosaics that are arranged as interleaved visual field maps."[34]

The data contained in the visual field maps are next encoded so they can be transmitted to the visual cortex via the severe bottleneck of the optic nerve. "All information captured by 125 million photoreceptor cells in humans is carried into the brain by only 1 million ganglion cell axons."[35] This and subsequent combinatory operations are of great importance for any consideration of perception, because here and farther downstream, vast amounts of unconscious interpretation are carried on prior to conscious awareness of visual objects. Stuffing the information from 125 million receptor cells into 1 million ganglion cells requires compression, multiplex operations, or both, but in any case the information has already been greatly transformed by the time it reaches the visual cortex.

After exiting the optic nerve, visual signals are processed and reprocessed several times. The destinations of this information are understood as "maps" because each neuronal pathway carries its signal to a distinct location, or processing center, which in turn sends it along the way for further processing. Approximately nine maps subdivide the visual cortex. These are referred to as V1, V2, V3, V3A, V3B, V7, hMT (also known as V5), hV4, and VO-1. Each of these is an identifiable processing area—of variable size because, within

certain limits, neurons in the brain are not, generally speaking, permanently specialized. Instead, they are "tuned" to perform certain tasks, like motion or depth perception.

The neural networks that organize visual perception are layered and staged, proceeding by way of "receptive fields." In the first instance these are regions of the physical world that are detected by a certain set of receptors: right eye information, left eye information, and quadrants of each eye. Discrete bundles of ganglion cells correlate with discrete regions (upper, lower, right, left) of the physical world. The signals from those neuronal receptors are in turn bundled and sent along neural pathways, where they become the receptive field for downstream sets of synapses and processing centers: the nine maps named above. The spatial geometry of the world matches—albeit in newly distorted ways—the spatial geometry of the retina, and this geometry is echoed again in distinct regions of the primary visual area of the cortex, a pattern called "retinotopy" (figure 4.2).

Two well-studied regions of the visual cortex are the ventral (hV4 and VO-1) and dorsal (V3A, V3B, V7) pathways, which separately process "what" information (objects, faces, etc.) and "where" information (depth and motion). The judgments rendered by these centers are then passed along to higher levels of synthesis, so that eventually we perceive a complex of activity with known and unknown objects moving in all directions and speeds. Indeed, given the sequential and coordinated nature of visual signal processing, it is appropriate that Andreas Bartels and Semir Zeki have developed a new form of cerebral cartography to reveal the "chronoarchitecture" of the cerebral cortex. Using functional magnetic resonance imaging (fMRI), Bartels and Zeki have begun to create time maps of the brain's functional activity during "natural" viewing activities, such as watching the James Bond film *Tomorrow Never Dies*.[36]

The clearly segregated performance of so many subdivided functions is well known through studies of brain damage, leading to such conditions as "motion blindness" or "face blindness" (known as prosopagnosia).[37] Subjects suffering from motion blindness "see" only a series of snapshots, so that people and automobiles simply appear and reappear like still photographs in different locations. Such subjects find it impossible to pour a cup of coffee, which to them appears to fill only by discrete frozen increments.

That the discrete regions of the visual cortex can continue to perform their functions, to process depth and object recognition, without the perception of motion is powerful proof that major aspects of visual perception are handled prior to conscious thought about objects, and that those aspects need to be combined by a processing center after they leave the visual cortex. That center of recombination is well known to be the parietal lobe. Again, patients with parietal lobe damage exhibit remarkable disassociations. One subject studied by Ann Triesman and colleagues, "R.M.," lost the ability to combine colors with shapes: to him, colors floated freely from shapes.[38]

Considering the remarkably fragmented and distributed cognitive work involved in vision, the process of synthesizing all of these varied activities looms large in our consideration of the ways of seeing. Indeed, as Donald Hoffman and others have amply shown, we literally create what we see, though apparent "rules" of synthesis. Hoffman, in his *Visual Intelligence* (1993), offers thirty-five such rules, such as the "minima rule": "Divide shapes into parts along negative minima, along lines of curvature, of the principal curvatures."[39] This "rule" explains why we think that the "ripple" diagram is subdivided correctly along the dotted lines as seen in figure 4.5, but not when the same figure is turned upside down and the new minima are unmarked by dotted lines. (Try it.)

FIGURE 4.5. Ripple diagram showing Donald Hoffman's "minima rule" for visual processing. Image courtesy of Donald Hoffman.

FIGURE 4.6. Two identical polygons. Image by Philip J. Ethington after Roger Shepard, *Mind Sights: Original Visual Illusions, Ambiguities, and Other Anomalies* (New York: W. H. Freeman and Company, 1990). I used a single image layer for the tabletop polygon, made from a photograph of wood grain, and then copied and rotated the left tabletop ninety degrees (with no shape distortion) into the right-hand tabletop position. The wood grain patterns help us visually to evaluate the phenomenon.

Michael S. Gazzaniga offers another striking proof that major operations of automatic visual processing take place prior to our conscious awareness of a visual object. In a drawing from the research of Roger Shepard, two rectangles, identical in dimensions, are disguised as an Albertian perspective drawing of two table surfaces, one oriented along the vertical axis and the other along the horizontal axis (figure 4.6). As Gazzaniga explains, the unconscious mind is strongly influenced by the visual cues of the vertical and horizontal axis: "Even though you can fully understand that the images are exactly the same and your personal consciousness knows this truth, the knowledge has no effect on your perception. The brain automatically supplies the correction, and you can do nothing about it." Indeed, the illusion is so hard to accept that one measures the two rectangles in disbelief. As Gazzaniga recommends, "do it and marvel."[40]

It is striking that Jonathan Crary and Donald Hoffman published their books on vision—*Techniques of the Observer* and *Visual Intelligence*, respectively—at almost the same historical moment in the early 1990s. Both concern the disaggregation and synthesis of visual objects by thinking subjects, and both explore the constructedness of vision. But their perspectives on

the subject are almost diametrically opposed. Crary portrays vision as constructed by the historical institutions of Western capitalist society. The constructive process is entirely outside of the body. To Hoffman, construction is entirely internal to the body. The outside world provides signals that reach the retina, but the acts of construction all take place neurologically thereafter.

The limits of Crary's analysis can be seen most clearly in his account of stereoscopic photography. The stereoscope provides viewers with a striking three-dimensional effect precisely because it so closely models natural binocularity. Primates all share a visual system characterized by "extreme orbital convergence," or eyes that are very close together. The evolutionary benefit of binocularity is depth perception, which also requires a high degree of acuity in the central visual field. The eyes of deer and other herbivores, by contrast, are placed on opposite sides of the head, which allow them to monitor the widest possible field for potential danger.

But central visual acuity in primates was purchased in evolutionary time by a corresponding lack of acuity in peripheral vision. Cerebral mapping has demonstrated "a concentration of ganglion cells in the central retina [the fovea], together with a greatly expanded representation of the central field in visual cortex. . . ."[41] Known as cortical magnification, these anatomical structures vastly oversample the central, or foveal, visual field by a ratio of about one hundred to one over peripheral vision. Indeed, Leonardo da Vinci, who coined the term "line of sight," was among the first to observe that perfect acuity is only possible at the center of the visual field. Thanks to cortical magnification, primate depth perception is extremely sensitive, capable of detecting disparities between the retinal images of the two eyes by an angle of one-half an arc second: "This is equivalent to a depth difference of approximately 0.1 mm at arm's length. Such exquisite sensitivity must have evolved to be useful for tasks such as object manipulation or camouflage breaking."[42] And of course this exquisite sensitivity has been put to use in skilled artisanship and the fine arts.

In short, the cognitive operations of depth perception were correctly modeled by Brewster and Wheatstone's stereographs. Even providing that Brewster, Wheatstone, and Daguerre shared a historically unique moment in the 1830s and 1840s, nearly two centuries of research since their time has

only reaffirmed the correctness of their modeling of human vision. The illusion of depth is striking to most people who view a stereograph that has been properly produced. Stereographs have limits, however. For instance, they do not provide a realistic three-dimensional effect at great distances. Crary complains that the people and objects in a stereograph appear as two-dimensional cardboard cutouts arrayed disjointedly in space, as though floating and detached. But his conclusion that such effects "were in fact based on a radical abstraction and reconstruction of optical experience" is entirely unfounded—or, more precisely, it is founded only in social analysis, in disregard of neuroscience. Granted, the stereoscopic photograph represents depth in something like 2.5 dimensions. Indeed, Crary's thesis is neatly undermined by the very fact that human visual perception is so precise and sensitive to depth that it is not fooled by the combination of two two-dimensional surfaces to produce a three-dimensional effect. The evolved sensitivities of binocular vision can easily break the camouflage of artificial instruments.

Throughout both of Crary's two major works on vision, there is a consistent distancing from any recognition that the findings of the scientists he often cites might constitute durable knowledge, worth a humanist's time and labor to learn from. Instead, each finding is treated as another text within the rising discourse of "modernity." *Suspensions of Perception* explores the ways that "attention" became a major object of inquiry during the last decades of the nineteenth century among psychologists, neurologists, and many branches of the natural sciences. Indeed, it continues to be a major concern for studies of mind even today. Crary's object, however, is not to sift the enduring value of any of this work, but rather to show that the widespread research into "attention" was an integral part of the career of capitalism and urban modernity of spectacle in those very decades. Indeed, he often puts the Victorian-Edwardian era scientists in their place by referring to their new "truths" in quotation marks, to accent the provisional and perspectival condition of all knowledge.

I do not disagree with Crary's goal of mapping any serious discourse onto the surrounding, suspending political and economic institutions, but I am critical of his failure to take the neuroscience of vision, both early and recent, seriously as *potentially valid* in its own right. Crary classes stereoscopic pho-

tography with large panorama displays as constituting a new "optical model" that destabilized relations between center and periphery, and between figure and ground. Similarly, he argues that the camera obscura and a "camera obscura model of vision" reinforced and helped to construct the isolated, liberal, individual self as an integral part of modern capitalist societies.[43] A vast range of humanist and social science scholarship on the sociology of knowledge similarly follows the radical implication of Thomas Kuhn that knowledge is *only* as good as the paradigm that produced it.

I am proposing a very different goal for the humanities and for visual studies more specifically: a method of mapping our research agendas into the past that treats prior sciences of mind not as relics of historic political economies, but as potentially valid nodes or topoi in the structures of knowledge. Santiago Ramón y Cajal, for example, who won the 1906 Nobel Prize for his work in making neuronal structures visible, merits only passing mention in a footnote of Crary's *Suspensions of Perception*. But Ramón y Cajal's microscope drawings are so superb and precise that they are still used in neurology textbooks more than a century later. Building directly on Ramón y Cajal's achievements, a larger movement to map the brain began in 1905 with simultaneous works by Alfred W. Campell and Korbinian Brodmann, launching a field of "cerebral cartography" that thrives today.[44]

A distinct alternative to Crary's approach to visual studies is to follow maps that continue to reveal more and more about the interaction between mind and society. Here we need to appreciate the full implication of a "visual field map." As explained earlier, the processing centers of the visual cortex are not stable physical structures, so they are referred to very intentionally as "maps," describing the location of a kind of processing for distinct purposes (what, where, motion, color, and more complex operations like object recognition). Maps at higher levels map these distributed processes into further syntheses. As Brian A. Wandell and coworkers explain: "Visual field maps preserve the topology of the scene itself: nearby scene points are represented in the responses of nearby neurons. Visual field maps then facilitate computations involving spatially localized comparisons between neurons specialized for carrying information about colour, motion, and orientation."[45] The radical implications of this structure suggest that our mental maps of com-

plex social institutional forms, like "the presidency" or "the Roman Catholic Church," are literally mapped into the brain's structure of neurons, synapses, ganglia, and energy potential pathways.

Now these paths through the space-time of knowledge production have converged again as we reach the limits of cultural constructionism in light of the embodied mind, and as the neurobiologists exhaust their available paradigms for understanding complex social networks and processes. The terra incognita between the humanities and social sciences on the one side and the neurosciences and sciences of mind on the other has been shrinking, and now it is too narrow for either side to ignore the other's research. The most powerful example of research in this uncharted territory is the opus of Barbara Stafford, whose many books have uniquely united a study of the arts with a study of the mind. Her style and attitude toward scientific knowledge contrasts with the more typical humanist approach exemplified by Crary. Stafford is engaged in dialogue with the neuroscientists to develop more valid accounts of the mind and its past in several scales: evolutionary, historical, and contemporary. Deeply conversant in the complete body of Western philosophical thought, Stafford seeks to bring what she calls an "aesthetic perspective" to the study of mind. She seeks, for example, to "pin down a definition of the elusive concept of 'mental representation.'" After a wide and deep discussion of contemporary work, she synthesizes the state of knowledge and proposes her account of recognition, in which "the visual system turns the neural representation of each object on and off in serial fashion, testing each representation against a stored template. But it processes all the streaming objects in parallel. The visual system, confusingly, is biased in favor of those neurons that represent critical features of the target, until the target emerges from its camouflage in the background."[46]

Stafford's treatment of mental representation here is part of her overall attempt to unravel the "binding problem," discussed earlier, of the reassembly of so many percepts involved in a single scene: shapes processed by one visual map, motion processed by another, color by another, and so on. Stafford's current work is far too complex to summarize here, but she proposes "the mutual interdependence of pattern generation with pattern recognition" as the embodied mind interacts with the world.[47] Her work shuttles between "social practices [ranging] from the magical to the technological" and the

neurological structures and processes that current research reveals about the brain and mind. Stafford's research mostly concerns art history (very broadly conceived, to include technologies of perception and popular culture). But her method of research, and potentially her case for the "mutual interdependence of pattern generation with pattern recognition," is very broadly applicable.

The time has come for humanists and social scientists as well as the various scientists of mind to enter the terra incognita of institutional forms. As I recounted earlier, we have several very profound (highly developed and empirically supported) models of complex social forms, processes, and structures (such as Foucault's). The contemporary research I have cited in this essay raises the real possibility that complex social forms can be mapped onto cerebral structures and processes, and then mapped in ways that both humanists and neuroscientists can discuss and debate. As I have discussed elsewhere, Georg Simmel's "formal sociology" was a pioneering step toward research on the relationship between shapes in the mind and shapes in society.[48] Currently, researchers are attempting to map relatively simple concepts, but the grounded-metaphor school has felt itself ready to begin major attempts at explaining social processes, as in Lakoff's theory of "moral politics."[49] The problem is that the cognitive neuroscientists seem to have reached the limit of their competence in social and cultural theory. Lakoff's model of contemporary U.S. political culture as derived from a simple parental metaphor is very thought-provoking and often consistent with the political ideologies of recent decades, but compared to available models from history and political science, it is shallow in the extreme.

Conclusions

Let me conclude by answering the question posed at the beginning of this chapter. What can we gain by approaching the key word "perspective" from two perspectives: that of the humanities and social sciences, and that of the neurosciences and sciences of mind? First, the relationship between the metaphoric sense and the neurophysiological sense has been greatly clarified. The concept of cultural perspective is neither an empty metaphor nor an innocent one. The metaphor is clearly grounded in the extremely perspectival

structures of our bodies, and by the clear spatial separations and relations among cultural, professional, religious, consumer, political, and other kinds of groups. Hence my term "sociovisual perspective" is offered here to fuse the knowledge base about perspective from both sides of the Diltheyan divide, which I hope also to have weakened.

A second payoff is to advance the case for positive, even nearly universal knowledge in a cautious sort of Enlightenment revival. The universal validity of all kinds of knowledge has been cast into doubt by leading thinkers, including Richard Rorty. But the merger of cognitive neuroscientific and sociocultural knowledge forms a new kind of reflexive certainty that is not subject to the limits of linguistic structures because, as Barbara Stafford has been at pains to remind us, visual thinking cannot be contained by linguistic form. Cultural perspectives develop unevenly across space-time, through embodied and emplaced segregations in the global landscape. Relations of all kinds have specific footprints. Thus, the "hermeneutic circle" that Dilthey identified leads back to each knower's position in the network of relations that can be mapped outward through space-time, from the present back into the past. This can be seen as a strong case for the positive accumulation of valid social and cultural knowledge, historical and otherwise—a prospect not thought possible during the second half of the twentieth century.

We can say that all knowledge is perspectival. But that which endures transcends its perspective of origin and networks with many other perspectives. Perspectives can map themselves together, so the absolute barriers to understanding proposed by Rorty seem extremely unlikely. The ultimate sense of my view of knowledge here merges the *map* with the *world*. We are each a node in a vast multidimensional space-time network of topoi. What we call cultural forms are very much like the shifting and tuning visual field maps in the mind: they are constantly in flux, they undergo constant infusive dynamism, and in the last analysis they link discrete monadic individual bodies, just as the vast complexity of consciousness unites billions of independently signaling neurons. Are these two forms, the social and the mental, echo objects? Are they visual analogies?[50]

I have previously made a case for mapping the past as the way to know it. With this essay I hope to have deepened the visual sense of that proposal, and

to have shown that *sociovisual perspective* closes the gap between metaphoric and graphical senses of mapping the world.

Future Research

The crucial question for researchers attempting to map this new territory is to sort and identify cases of pattern generation, whereby the mental maps can be used to explain the patterns of social life, and also cases of pattern recognition, whereby the mind interprets the world in biased, that is *perspectival*, ways. As alluded to above, however, pattern recognition by investigators is also situated within a map. Thus, knowledge maps of the past and present include the mapmaker.

Evidence to date would suggest that there are several evolutionary and experiential scales at which to study the mutual interdependence of shapes in society with shapes in the mind. The most evolutionary scale highlights the anatomical structures such as extreme orbital convergence and binocularity, with its coevolved neural processing ("cortical magnification," privileging central or foveal vision, for example). This scale has been mostly the domain of neuroscientific research on such topics as perspective and attention. At another temporal scale, learned or acquired individual experience (which is always also social experience) is mapped in the brain in many forms—such as "mirror neurons," "place cells," and "neural tuning"—and myriad memory networks. These are highly mutable inscriptions laid down during an individual's life course as a social being within highly specific cultural contexts, which are also places. Of a man who was restored to sight late in age and could only see blurs, Oliver Sacks writes: "When we open our eyes in the morning, it is upon a world we have spent a lifetime learning to see. We are not given the world: we make our world through incessant experience, categorization, memory, reconnection."[51] Perspective in the (formerly metaphoric) cultural-sociological sense refers primarily to this scale of analysis.

Between these two scales is the scale of *historical institutions*. Individuals learn their history and place in a world of friends and enemies, gods and demons, taboos and aspirations, as part of the life course. Leaders and ordinary people alike inhabit institutional forms that are ancient in genealogy.

Modernist thinkers attempted throughout the twentieth century to insist on a radical break in human institutions that had existed since the time of the French Revolution (or alternatively during the Renaissance and Reformation), but we can recognize myriad institutions that are thousands of years old, and the revolutionary cheerleaders of modernity (who sought to smash the ancien régime) need not be taken at their word.

Indeed, until recently, historians limited themselves to an arbitrary (biblically-inspired) and very short chronological period of about four thousand years. Daniel Smail has effectively dismantled the case for limiting human history to so short a scale. He has also proposed a new form of "neurohistory," to begin to account for the coevolution of mind and society during many millennia of human history before the Flood.[52] Thankfully, Smail is not alone in the recent effort to reconstruct this long history within frameworks that have been chastened by the radical skepticism of the linguistic turn and cultural relativism.[53] Indeed, the multigenerational critique of historical objectivity that characterized most of the twentieth century has borne much fruit, primarily in the confidence we now have that knowledge is perspectival. Hence the increasing attention placed on place, time, and the mapping of the past. Some historians are already confident about overcoming these perspectival challenges.[54]

What I think this chapter suggests, however, is that we take a deep breath and prepare for a long period of investigation into the linkages between the three scales that I have named: the evolutionary, the institutional, and the personal. The evolutionary scale will involve humanists and social scientists in the most fundamental of the questions that I have raised in this essay and that thinkers such as George Lakoff have already begun to explore: How do the deep structures of neurobiological processing shape or produce concepts that we work with in everyday life, such as hierarchies to understand social structure and perspectives to understand cultural difference? At the personal scale, investigators will increasingly ask how neurological processing shapes and is shaped by the experiences of a lifetime. But between these two scales is the institutional, and I would argue that institutions are the hardest nut to crack. Here we are confronted with social shapes—some of which, such as marriage, took form thousands of years ago, and in turn became "environments," which may indeed have shaped further heritable neurological de-

velopment. On the basis of a full century of anthropology and sociology, we can certainly say that those institutional environments shaped the personal lifetime scale of cognitive development. How that personal development, of memory and social thinking, takes neurological shape is another great frontier for the collaboration of humanities, social science, and neuroscience to tackle. But I would contend that progress in identifying how social learning takes neurobiological form, and how that neurobiological form shapes social behavior, will require a greater understanding of the middle scale: the rise and fall of the "epistemes" and "worldviews" Foucault and others have already identified, which have relatively short life cycles, such as centuries, and yet form the stable, preconscious background for social functioning in any given time and place. Given the progress shown so far at the fundamental, evolutionary scale, it seems that the time is ripe for a program of investigation to map the processing centers for institutional consciousness and behavior.

Notes

1. This political-intellectual story is told in Hans Ulrich Gumbrecht, *The Production of Presence: What Meaning Cannot Convey* (Stanford, CA: Stanford University Press, 2004), 42–43.

2. Durkheim, in his 1895 *Rules of Sociological Method*, was very clear about the independence of "social facts" from natural ones. E. Durkheim, *The Rules of Sociological Method and Selected Texts on Sociology and its Method*, ed. Steven Lukes, tr. W. D. Wells (New York: Free Press, 1982).

John Searle, in *The Construction of Social Reality* (New York: Free Press, 1995), uses the term "institutional facts" in the same sense as Durkheim's "social facts."

3. Characteristically provocative and germane to the present argument is Barbara Maria Stafford, *Body Criticism: Imaging the Unseen in Enlightenment Art and Medicine* (Cambridge, MA: MIT Press, 1993). Among hundreds of recent titles, a few examples include Margaret A. McClaren, *Feminism, Foucault, and Embodied Subjectivity* (Buffalo: SUNY Press, 2002) and Caroline A. Jones, ed., *Sensorium: Embodied Experience, Technology, and Contemporary Art* (Cambridge, MA: MIT Press, 2006).

4. My sense of this term "valid" is drawn from the Pragmatist tradition: provisional recognition of a truth value among a broad community of thinkers. The pragmatic tradition denies transhistorical truths and keeps all kinds of knowledge in a single universe, rather than the practice of segregating interpretive from positivist models. The pragmatist tradition is *perspectival*, however, so this essay is also about the subject of "valid" knowledge.

5. Now-classic texts that instigated this "turn" include Edward W. Soja, *Postmodern Geographies: The Reassertion of Space in Critical Social Theory* (London: Verso, 1989) and Henri Lefebvre, *The Production of Space*, trans. Donald Nicholson-Smith (Cambridge, MA: Blackwell, 1991). For a representative collection, see John May and Nigel Thrift, eds, *Timespace: Geographies of Temporality* (London: Verso, 2001).

6. Philip J. Ethington, "Placing the Past: 'Groundwork'; for a Spatial Theory of History," with responses by Thomas Bender, David Carr, Edward Casey, Edward Dimendberg, and Alun Munslow, *Rethinking History* 11, no. 4 (December 2007): 463–530.

7. Ethington, "Placing the Past," 483.

8. Edward S. Casey, *The Fate of Place: A Philosophical History* (Berkeley: University of California Press, 1997), 24–25, 34.

9. David Summers, *Real Spaces: World Art History and the Rise of Western Modernism* (New York: Phaidon Press, 2005).

10. Ethington, "Placing the Past," 484.

11. Pierre Bourdieu, *The Logic of Practice*, tr. Richard Nice (Stanford, CA: Stanford University Press, 1980).

12. Dominick LaCapra, *History in Transit: Experience, Identity, Critical Theory.* (Ithaca, NY: Cornell University Press, 2004), quotations at p. 5.

13. Gyan Prakash, *Another Reason: Science and the Imagination of Modern India* (Princeton, NJ: Princeton University Press, 1999); D. Chakrabarty, *Provincializing Europe: Postcolonial Thought and Historical Difference* (Princeton, NJ: Princeton University Press, 2000). See also J. M. Blaut, *The Colonizers' Model of the World: Geographic Diffusionism and Eurocentric History* (New York: Gilford Press, 1993).

14. R. B. Brandom, ed., *Rorty and His Critics* (Oxford: Blackwell, 2000), 56.

15. Michel Foucault, *The Order of Things: An Archaeology of the Human Sciences* (New York: Random House, 1970), 46.

16. Erwin Panofsky, *Perspective as Symbolic Form* [1927], tr. Christopher S. Wood (New York: Zone Books, 1997).

17. Clement Greenberg, "The Crisis of the Easel Picture," *Partisan Review* (April 1948), reprinted in *Clement Greenberg:Tthe Collected Essays and Criticism*, ed. John O'Brien: vol. 2, *Arrogant Purpose, 1945–1949* (Chicago: University of Chicago Press, 1986) , 221–25, quotation at 222.

18. Clement Greenberg, "Abstract, Representational, and So Forth," in *Art and Culture: Critical Essays.* (Boston: Beacon Press, 1961), 136.

19. Rudolf Arnheim, "Inverted Perspective in Art: Display and Expression" *Leonardo* 5:2 (Spring 1972): 125–35, quotation at 134.

20. Boris V. Rauschenbach, "On My Concept of Perceptual Perspective that Accounts for Parallel and Inverted Perspective in Pictorial Art," *Leonardo* 16, no. 1 (Winter 1983): 28–30, quotation at 28.

21. Svetlana Alpers, "The Mapping Impulse in Dutch Art," in *Art and Cartography:*

Six Historical Essays, ed. David Woodward (Chicago: Chicago University Press, 1987), 51–96, quotation at 59.

22. Alpers, *The Art of Describing: Dutch Art in the Seventeenth Century* (Chicago: Universitry of Chicago Press, 1984), 138.

23. Martin Jay, "The Scopic Regimes of Modernity," in Hal Foster, ed., *Vision and Visuality* (Seattle: Bay Press, 1988), 3–29, quotations at 16–18.

24. David Hockney, *Secret Knowledge: Rediscovering the Lost Techniques of the Old Masters* (New York: Viking, 2001); Philip Steadman, *Vermeer's Camera: Uncovering the Truth behind the Masterpieces* (Oxford: Oxford University Press, 2002).

25. Roland Barthes, *Camera Lucida: Reflections on Photography*, tr. Richard Howard (New York: Hill and Wang, 1981), 89.

26. Roland Barthes, *Image-Music-Text*, tr. Stephen Heath (New York: Hill and Wang, 1977), 17.

27. Barthes, *Camera Lucida*, 89, 80.

28. Kendall L. Walton, "Transparent Pictures: On the Nature of Photographic Realism," *Nous* 18 (1984).

29. Charles Wheatstone, "Contributions to the Physiology of Vision," *Philosophical Transactions* (1838), 371–95.

30. Michel Frizot, "1839–1840: Photographic Developments," in Frizot, ed. *A New History of Photography* (Cologne: Koneman, 1998), 23–31; Pierre-Marc Richard, "Life in Three Dimensions: The Charms of Stereoscopy," in Frizot, *New History*, 175–83.

31. Crary, *Techniques*, 128.

32. Ibid., 9.

33. Jonathan Crary, *Suspensions of Perception: Attention, Spectacle, and Modern Culture* (Cambridge, MA: MIT Press, 2001).

34. Brian A. Wandell, Alyssa A. Brewer, and Robert F. Dougherty, "Visual Field Map Clusters in Human Cortex, *Phil. Trans. R. Soc. B* 360 (2005): 693–707, quotation at 693.

35. Stryer, Lubert. "Vision: From Photon to Perception," *Proceedings of the National Academy of Sciences of the United States of America* 93, no. 2 (Jan. 23, 1996): 557–59, quotation at 558.

36. Andreas Bartels and Semir Zeki, "The Chronoarchitecture of the Cerebral Cortex," *Philosophical Transactions of the Royal Society B* 360 (2005): 733–50.

37. J. Zihl, D. von Cramon, and N. Mai, "Selective Disturbance of Movement Vision after Bilateral Brain Damage," *Brain* 106 (1983): 313–40; J. C. Meadows, "The Anatomical Basis of Prosopagnosia," *Journal of Neurology, Neurosurgery, and Psychiatry* 37 (1974): 489–501.

38. Reported in Michael S. Gazzaniga, *The Mind's Past* (Berkeley: University of California Press, 1998), 93.

39. Donald Hoffman, *Visual Intelligence: How We Create What We See* (New York: Norton, 2000), 89.

40. Michael S. Gazzaniga, *The Mind's Past* (Berkeley: University of California Press, 1998), 87–88.

41. R. A. Barton, "Binocularity and Brain Evolution in Primates," *Proceedings of the National Academy of Sciences of the United States of America* 101, no. 27 (Jul. 6, 2004), 10113–15, quotation at 10113.

42. Julie M. Harris, "Binocular Vision: Moving Closer to Reality," *Philosophical Transactions: Mathematical, Physical and Engineering Sciences* 362, no. 1825 (Dec. 15, 2004), 2721–39, quotation at 2724; B. T. Backus, D. J. Fleet, A. J. Parker, and D. J. Heeger, "Human Cortical Activity Correlates with Stereoscopic Depth Perception." *Journal of Neurophysiology* 86 (2001): 2054–68.

43. Crary, *Suspensions of Perception*, 24, 39, 292, 295–96. For a very different approach to visual culture at the end of the nineteenth century which advances the reality of modernist perception, see Vanessa R. Schwartz, *Spectacular Realities: Early Mass Culture in Fin-de-Siècle Paris* (Berkeley: University of California Press, 1999).

44. Samir Zeki, "Introduction: Cerebral Cartography 1905–2005," *Philosophical Transactions of the Royal Society B* 360 (2005): 651–52.

45. Wandell, Brewer, and Dougherty, "Visual Field Map Clusters in Human Cortex," 693.

46. Barbara Maria Stafford, *Echo Objects: The Cognitive Work of Images* (Chicago: University of Chicago Press, 2007), 168–69.

47. Stafford, *Echo Objects*, 3.

48. "Georg Simmel y la cuestión de la espacialidad," *Trayectorias: Revista de Ciencias Sociales* 19 (Sept.–Dec 2005), 46–58; "The Intellectual Construction of 'Social Distance: Toward a Recovery of Georg Simmel's Social Geometry," *Cybergeo* 30 (Sept. 1997): http://www.cybergeo.eu/

49. George Lakoff, *Moral Politics: How Liberals and Conservatives Think* (Chicago: University of Chicago Press, 2002).

50. I refer here to Barbara Maria Stafford, *Echo Objects* (2007), and to her earlier work, *Visual Analogy: Consciousness as the Art of Connecting* (Cambridge, MA: MIT Press, 2001).

51. Oliver Sacks, *An Anthropologist on Mars* (1995), quoted in Jürgen Weber, *The Judgement of the Eye: The Metamorphoses of Geometry—One of the Sources of Visual Perception and Consciousness (A Further Development of Gestalt Psychology)* (New York: Springer-Verlag, 2002), 10.

52. Daniel Lord Smail, *On Deep History and the Brain* (Berkeley: University of California Press, 2008).

53. J. R. McNeill and William McNeill, *The Human Web: A Bird's-Eye View of World History* (New York: Norton, 2003); Cynthia Stokes Brown, *Big History: From the Big Bang to the Present* (New York: New Press, 2008).

54. David Christian, *Maps of Time: An Introduction to Big History* (Berkeley: University of California Press, 2005).

FIVE Ayahuasca Shamanic Visions

.INTEGRATING NEUROSCIENCE,
PSYCHOTHERAPY, AND
SPIRITUAL PERSPECTIVES

.Frank Echenhofer

Spontaneous imagery narratives—or, more precisely, spontaneous waking
visual and kinesthetic transformative imagery narratives—have been widely
reported in many cultures throughout recorded history. Our research find-
ings[1] concerning the experiences reported after ingestion of the Amazonian
psychoactive brew ayahuasca, which has its origins in shamanism, agree with
prior research literature that ayahuasca often elicits spontaneous imagery
narratives that are reported to be very intense and meaningful, and often
related to psychological and physical healing, problem solving, knowledge
acquisition, creativity, spiritual development, divination, community cohe-
sion,[2] and encounters with disincarnate entities or beings.[3]

Although ayahuasca recipes differ, the most widespread and well-studied
brew combines the leaves of *Psychotria virdis*, containing the psychoactive
agent N,N-dimethyltryptamine (DMT), with the pulverized *Banisteriopsis
caapi* vine, which contains beta-carboline alkaloids (MAO inhibitors). DMT
is not orally active, but when it is combined with the caapi vine, the resulting
brew stimulates an altered state of consciousness that usually lasts from three
to five hours. Reviews of the history of the ethnobotanical[4] study and neuro-
pharmacology[5] of ayahuasca are available, and later in this chapter some of
the brew's bodily correlates will be described.

Because ayahuasca has been reported to reliably facilitate profound heal-
ing and creative and spiritual experiences, and because it can be studied in
neuroscience laboratory settings, it offers extraordinary opportunities for
the kind of research bridging neuroscience and the humanities that is advo-
cated in this book. This chapter offers an example of ayahuasca research as a
part of this new meta-field. The central question of the inquiry is: How can
the spontaneous imagery narratives that are so prominent during the use of

ayahuasca produce the widely reported benefits? To answer this question I will draw from neuroscience, psychology, anthropology, religion, and my own research. Recent neuroscience evidence and theory offer exciting new insights into the specific brain processes that possibly occur, and this may lead to enhanced applications in psychotherapy, creative activity, and spiritual development.

I will present my own model of the nature and function of spontaneous imagery narratives; this model incorporates both previous and new views, and uses imagery from a variety of religious traditions to depict the creative psychophysiological and spiritual processes involved. One new hypothesis that ayahuasca research clearly supports is an ancient idea placed in a new context: *that creative human activities are a blending of deliberative thought processes and spontaneous experiencing.*

To begin the discussion, I will first very briefly summarize the anthropological ayahuasca literature, relying on anthropologist Michael Harner's review of reports gathered from indigenous informants.[6] Harner reports that across indigenous Amazonian peoples, the common visionary themes that emerged during ayahuasca use were of geometric designs, one's own death, constantly changing shapes, jaguars, snakes, birds, entity encounters, distant cities, divination, and descriptions of the shamanic journey. Harner relates a quote from the anthropologist Milciades Chaves that recounts the ayahuasca journey experience of a Siona Indian from eastern Colombia (*yagé* is the Siona name for ayahuasca):

> But then an aging woman came to wrap me in a great cloth, gave me
> to suckle at her breast, and then off I flew, very far, and suddenly I
> found myself in a completely illumined place, very clear, where every-
> thing was placid and serene. There, where the yagé people live,
> like us, but better, is where one ends up [i.e., on a yagé trip].[7]

The Chilean psychiatrist Claudio Naranjo administered ayahuasca to thirty-five nonindigenous volunteers from Santiago, Chile, to examine how their visions compared to those in ayahuasca reports from the indigenous respondents. Naranjo reports that the common visionary themes were of a geometric grid with a central focus, a rotating vision with a central focus,

eyes, a perceiving central eye or other form, caves, prehistoric scenes, monstrous or sardonic masks, going unconscious, being devoured, and dying. Other themes were of serpents, large felines, and birds of prey. Themes related to the shamanic journey to other worlds were of ascending, leaving the body, flying, landscapes and cities, pearls, devils and angels, Jesus Christ, and heaven and hell. Naranjo suggests that these visions share a pervasive mythic-religious quality of life and death, of the human drama unfolding, and of accepting everything in existence, including evil and death, as well as a sense that by this acceptance, evil and death were transformed.[8] He proposes that the complex relations between these themes are significant, and he provides an example of this complexity in the following ayahuasca journey experience of a twenty-five-year-old female research participant born of European parents, who had lived in Chile since late in her childhood. She says:

> At first, many tiger faces. . . . Then *the* tiger. The largest and strongest of all. I know (for I read his thought) that I must follow him. I see the plateau. He walks with resolution in a straight line. I follow; but on reaching the edge and perceiving the brightness I cannot follow him.[9]

The young woman says that later she is able to follow the tiger, and that she looks into the abyss of hell: it is round, it looks like fluid fire, and people swim in it. She goes on to say:

> The tiger wants me to go there. I don't know how to descend. I grasp the tiger's tail and he jumps. Because of his musculature the jump is graceful and slow. The tiger swims in the liquid fire as I sit on his back. . . . All kinds of lizards and frogs begin to appear now. And the pond gradually turns into a greenish swamp of stagnant waters, though full of life: primitive forms of life. . . . I rise on the tiger on the shore. . . . I go onwards with the tiger. I walk next to him, my arm over his neck. We climb the high mountain. . . . There is a crater. We wait for some time and there begins an enormous eruption. The tiger tells me I must throw myself into the crater. I am sad to leave my companion but I know that this last journey I must travel. I throw myself into the fire that comes out of the crater. I ascend with the flames towards the sky and fly onwards.[10]

The reports of Harner and Naranjo suggest a surprising commonality in the thematic content of ayahuasca experiences. It further appears, however, that there is less commonality when shamanic journeys to other worlds are described; cultural variances in religious belief may explain these differences.

Benny Shanon, a cognitive psychologist, offers the most recent, comprehensive, and systematic phenomenological analysis of ayahuasca experiences, which he has described in terms of content,[11] theme,[12] and typological structure.[13] Some of his content categories include personal autobiographical material; human beings; naturalistic and non-naturalistic animals; plants and botanical scenes; beings that are neither human nor animal; cities; architecture; art; vehicles of transformation; symbols and scripts; landscapes; historical and mythological beings; and scenes of creation, evolution, and heaven. Some of Shanon's thematic categories include psychological understanding; birth and death; masculine and feminine; health; the majesty and mystery of nature; forces in the physical world; the life force; royalty; the divine and praising the divine; philosophy and metaphysics; and the ambience-related themes of enchantment, rapture, and love. Shanon has also created a typology of the structural types or forms in which ayahuasca visions occur, and he "aims at the discernment of internal patterns and regularities as well as lawful relationships."[14] His eighteen typological structures, in the order in which they arise during a session, are "visions without semantic content, primitive figurative elements, images-scenes-visions of light, bursts-puffs-splashes, repetitive non-figurative elements, patterned geometric designs, rapid figural transformations, designs with figures, kaleidoscopic images, presentation of single objects, serial images, snapshots, glimpses, full-fledged scenes, grand scenes, virtual reality, geometric compositions, coloured visual space, darkness, the spider web, and supreme light."[15] Shanon also suggests that with just a few exceptions, there is a progression over the course of the ayahuasca session towards the more "figurative, well-defined and well-formed, stable, global, content rich, encompassing scope, powerful and real, psychologically significant, spiritually important, integrative, interactive, narrative complexity, insightful, learned, and veridical."[16]

Shanon's analyses are largely congruent with my own research results. My thematic and narrative approach complements his more typological ap-

proach to examining ayahuasca experiences, and I fully endorse his more personal view that

> ayahuasca visions are exceedingly beautiful. The universal feeling that drinkers of the brew have is that the beauty revealed in the visions surpasses any thing seen, dreamt or imagined. The colourings of the geometrical designs can be richer than any perceived in the physical world, the palaces and artistic objects appearing in the visions (often, constructed or made out of gold, crystal and precious stones) are sheer marvels, celestial and heavenly scenes are wondrously sublime, and what I referred to as supreme light may shine as strongly as the sun.[17]

In this chapter I will incorporate and refer to the work of Harner, Naranjo, and Shanon as I present a new model of spontaneous imagery narratives which aims to integrate fresh insights from neuroscience and the humanities that might help explain a number of unanswered questions raised in prior research about ayahuasca. My focus is on the subset of ayahuasca experiences that I call spontaneous waking transformative imagery narratives; I will attempt to demonstrate that the sequence of specific kinds of imagery and related processes within these narratives is most relevant to the experiential change processes that are reported during ayahuasca use. The purpose of this model is not to answer any of the unresolved questions, but rather to develop more refined testable hypotheses. A multidisciplinary approach was used to integrate fresh insights from neuroscience and the humanities. The following two primary questions guide this investigation: (1) How might ayahuasca facilitate the reported benefits in healing, creativity, and spiritual development? (2) What might be the neural image processing mechanisms that underlie the sequence of imagery and benefits related to ayahuasca experiences?

Although this model focuses upon ayahuasca experiences, it may also apply to other spontaneous imagery narrative processes. My model will attempt to demonstrate (1) that it is the impact of a sequence of specific kinds of imagery and related processes within these narratives that is most relevant to the experiential change processes reported during ayahuasca, and (2) that

these same processes are involved in successful psychotherapy and in spiritual development.

I use three approaches in devising this model. One approach is to work from the most common themes relative to the questions above, in order to identify specific lines of related research in psychotherapy, psychology, anthropology, and religion that have been found to include experiential transformational change processes. This comparative method can be used to reveal the common imagery, concepts, and processes that may be occurring in all of these examples.[18] A second approach is to view the ayahuasca experience as a specific state of consciousness and determine what features it shares with other states of consciousness, such as dreaming, mind wandering, and spontaneous thought. I have adopted neuroscience findings on these other states of consciousness as this model's account of spontaneous narrative processes in general, using them to explain what happens during ayahuasca use.[19] A third approach is to use the multidisciplinary approaches of dynamical systems and embodied cognitive science to reexamine the relationship between ayahuasca experience, consciousness, and brain function.[20] The model will first be presented in a brief overview without supportive evidence, so that it can be seen quickly as a whole. Then, each part will be introduced in more depth with supportive citations.

A Model of Spontaneous Imagery Narratives

What I have called "spontaneous imagery narratives," Harry H. Hunt, a dream researcher and consciousness theorist, refers to as *dreaming*—but Hunt's definition of *dreaming* expands the range of mental processes typically associated with that word. This has important theoretical implications regarding the functions of these processes:

> Dreaming involves far more than the specific conditions of the REM (rapid eye movement) state. Dreaming appears not only in the higher levels of non-REM (NREM) sleep and in the hypnagogic period of sleep onset, but also under hypnosis (where dreams can be directly suggested), in "daydreaming" as studied under laboratory conditions, and in the "waking dreams" or guided fantasies characteristic of various therapeutic traditions.[21]

Evidence of the potential value of experiences that appear spontaneously and effortlessly in the mind can be traced at least as far back as Freud's introduction of his free-association technique. Of all the many ways to explore what Hunt (1989) calls *dreaming* states, the research approach using ayahuasca offers the greatest range of spontaneous narrative experiences. I have found that ayahuasca readily elicits transformation narratives in many individuals, making systematic collaborative multidisciplinary neuroscience and phenomenological research possible.

My research suggests that although the experiences that occur in each ayahuasca session are quite varied, three overarching and sometimes overlapping foci frequently emerge: healing, creative processes, and spiritual development. Beginning sessions often are primarily about healing processes, whereas later ones tend to be more creative and spiritual. (I will discuss the significance of these observations following presentation of the model.)

Many initial ayahuasca session reports, like the one above, seem related to unresolved memories of difficult childhood experiences. Ayahuasca reports vary widely, and it may be that if an individual has significant unresolved difficult memories, initial sessions with the brew are likely to "excavate" them in narratives that seemingly strive towards healing and meaning-making. The excerpt below, reported in John Heuser's research, is from an early session of a Western-educated man's ayahuasca experience in which psychological healing is prominent:

[I] . . . began to feel even more intense grief . . . for my mother's sadness and my inability to connect with her and help her when she was alive . . . for the lack of mothering I received from her. . . . Much more weeping and sobbing. . . . More nausea. . . . Every time I would get distracted from my emotions . . . the nausea would surge up to unbearable levels. . . . As soon as I could get back to the feelings, it would subside. . . . Eventually [vomited] . . . [found] myself lying on the floor . . . with racking sobs. After . . . [an] hour . . . start[ed] to settle down. Still very sad. Saw [image of] my mother. . . . She could see me and spoke but no sound . . . could not read her lips. She looked about same age as when she died but not sick. . . . I could tell she was very sad about what had happened in the past and extremely happy about what I was doing now and felt freed and released by it.[22]

After reviewing hundreds of ayahuasca reports involving psychological healing, it quickly became apparent that, along with the powerful imagery content, there clearly was a structure of experiential movement from negative affect, to intensified negative affect, to a relational exchange, and finally to resolution. This process is not so different from an experience we all know, of first being unable to cry, then finally breaking down and crying, and finally, hopefully, feeling some relief. I believe that the structuring of these narratives is spontaneous because, depending upon circumstances, the many layers of innate bodily process can be experienced consciously.

To provide a conceptual context for the material to come, I will first briefly present my model of the imagery and process changes that occur during spontaneous waking transformative imagery narratives. The model (see figure 5.1) suggests that there are three major sequential stages of imagery and physiological process change that occur. In the first stage, forms of imagery spontaneously arise that reflect the healing of difficult unresolved memories.

Once those memories have been relatively resolved, a second stage can begin, in which the imagery reflects creative processes. If those processes are sufficiently complex, a third stage builds upon that complexity to generate more coherent and meaningful ways of experiencing the self and the world. These experiences are reported as spiritual or aesthetic experiences, depending upon the individual's worldview. Figure 5.1 presents the model in the shape of a sine wave to suggest a general pattern of experiential movement which first descends, then ascends, and finally returns to the place of origin. This pattern will later be related to mythological themes, ayahuasca imagery, sacred art, and brain correlates. The wave's repetitive movement suggests that any passage through the cycle may be repeated. Each of the cycle's three major stages is subdivided into three substages containing different imagery and change processes.

Form Dismantling and Healing Processes

The model proposes that in spontaneous waking transformative imagery narratives during the first major stage, *form dismantling and healing*, forms of imagery and physiological changes arise spontaneously that reflect a process of

(1) Form Dismantling and Healing Processes	(2) Form Creation Processes	(3) Form Expression Processes
Fig 5.1a Enhanced conflicting energy	Fig 5.1d Enhanced inner attunement	Fig 5.1g Enhanced field complexity
Fig 5.1b Tolerating overwhelming experiences	Fig 5.1e Enhanced form fluidity	Fig 5.1h Enhanced vertical attunement
Fig 5.1c Dismantling of self- schema	Fig 5.1f Enhanced compressed complexity	Fig 5.1i Enhanced horizontal attunement

FIGURE 5.1. Main model stages and substages of form dismantling, creation, and expression for spontaneous waking visual and kinesthetic transformative imagery narratives.

healing difficult unresolved memories. This first major model stage has three substages, the first of which is felt as numbness, depression, and/or agitation and is called *enhanced conflicting energy* (figure 5.2a). The second substage is often experienced as fear of the unknown in oneself or in the world, and is called *tolerating overwhelming experiences* (figure 5.2b). The third substage is

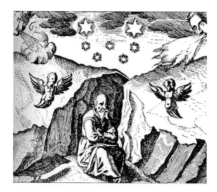

FIGURE 5.2. Upper left: (a) alchemist in the nigredo state: enhanced conflicting energy. Upper right: (b) "Face of Glory": tolerating overwhelming experiences. Lower left: (c) king dying and being reborn: dismantling of self-schema.

experienced as a painful, deathlike fragmentation called the *dismantling of self-schemas* (figure 5.2c).

The rationale behind the labels for these three substages will be explained below. I believe that because spontaneous waking, dismantling, and healing imagery narratives unfold through innate bodily processes, it is possible to delay and avoid them; but once they are surrendered to, the many layers of memory content, thoughts, feelings, and physiological sensations can potentially be brought together into consciousness. Then, if reflective awareness is present, healing can occur as new meaning is created from old experiences. Depending upon circumstances, unconscious layers of incoherent content are made meaningful to the extent that they are incorporated into more encompassing and coherent life narratives.

The posthumously published autobiography of the Swiss psychologist Carl Jung contains many classic examples of spontaneous transformative imagery narrative. Sigmund Freud had chosen Jung as his successor, and had

given him significant responsibilities just as his understanding of the uncon-
scious as being the creative source of spiritual truths was increasingly diverg-
ing from Freud's views. Jung realized that he could never develop his own
ideas if he remained with Freud, and so in 1912 he terminated his role and
relationship with him. Jung says of his experiences at this time:

> After the parting of the ways with Freud . . . inner uncertainty . . . a state of
> disorientation[23]. . . . One fantasy kept returning: there was something dead
> present, but it was also still alive. For example, corpses were placed in crema-
> tory ovens, but were then discovered to be still living[24]. . . . I lived as if under
> constant inner pressure. At times this became so strong that I suspected
> there was some psychic disturbance in myself.[25] [I] . . . often felt as if gigantic
> blocks of stone were tumbling down upon me. One thunderstorm followed
> another . . . [it was] helpful . . . to . . . find the particular images which lie
> behind emotions[26]. . . . In order to grasp the fantasies which were stirring
> in me . . . I had to let myself plummet down into them . . . [but] I was afraid
> of losing command of myself and becoming a prey to the fantasies . . . I saw
> that there was no other way out. I had to take the chance[27]. . . . I was sitting
> at my desk . . . thinking over my fears. Then I let myself drop. Suddenly it
> was as if the ground literally gave way beneath my feet, and I plunged down
> into dark depths. I could not fend off a feeling of panic . . . my eyes grew
> accustomed to the gloom . . . like a deep twilight. . . . Before me was the
> entrance to a dark cave, in which stood a dwarf with leathery skin, as if he
> were mummified. I squeezed past him through the narrow entrance. . . .[28]

Jung's response was to both endure these experiences and intensify his
study of mythological and spiritual symbolism, particularly sixteenth-century
European alchemy, in search of imagery that seemed to intuitively match the
qualities of his disturbing inner experiences. He believed that some alche-
mists had explored the spiritual transformation processes they depicted in
their alchemical illustrations.

Marie-Louise von Franz, perhaps Jung's only peer in regard to her under-
standing of alchemy, suggests that a necessarily difficult beginning stage of
the alchemical transformation is the nigredo state. Figure 5.2a is an engraving
from the German alchemist J. D. Mylius's 1622 alchemical work *Philosophia*

reformata, which von Franz suggests represents the psychological equivalent to the nigredo state: a situation of psychological conflict and depression.[29] From his alchemical studies, Jung was gaining confidence that "the purpose of the descent . . . of the hero is to show that only in the region of danger can one find the treasure hard to attain."[30]

In communicating his inner experience, Jung uses the words *uncertainty, disorientation, inner pressure, disturbance,* and the image of blocks of stone tumbling down, all of which are congruent with the first substage, where I suggest that a process involving *enhanced conflicting energy* is occurring and influencing spontaneous imagery similar to that seen in figure 5.2a. It appears that a transformation requires an increase of conflicting energy. Jung was afraid of "losing command," yet had "to take the chance," and so he chose to let himself "drop" to suddenly be "plunged down"—all congruent with the second substage, *tolerating overwhelming experiences* (figure 5.2b). Empirical research regarding the crucial importance of this same psychophysical process has been identified by the psychotherapy process researchers Eugene Gendlin[31] and Lesley Greenberg.[32] Greenberg labeled this stance towards experience "allowing and accepting,"[33] and found that psychotherapy clients who could allow and accept their experience in the moment noticed that a dynamism arose within them which allowed them to feel more alive and experience more fully.

If we compare the excerpt from Jung's autobiography with the above-quoted account by the Western-educated man reported in Heuser's research, it can be seen that in both cases the substages of *enhanced conflicting energy* and *tolerating overwhelming experiences* occur, but that only in the account reported by Heuser does the third substage of *dismantling of self-schemas* appear, in which unbearable nausea, vomiting, and sobbing is experienced. Figure 5.2c is an illustration from *Atalanta fugiens,* by the German physician Michael Maier (1568–1622). For both von Franz and Jung, this alchemical illustration depicts the symbolic death of the hero king in the foreground, and can be seen as the kind of imagery that spontaneously arises as part of the *dismantling of self-schemas* substage. For many people, such experiences can rarely be consciously approached and "allowed and accepted," but they can be endured if they occur spontaneously. This may be why ayahuasca is so effective in the healing of seemingly unbearable unresolved childhood memories: it brings

about an unfolding of spontaneous visual and kinesthetic waking transformative imagery narrative that otherwise is very difficult to bring oneself to experience. (The later rebirth of the new hero king in the background of figure 5.2c represents another substage of spontaneous imagery, to be discussed below.)

Mythological narratives may be maps of transformation processes that explain why difficult truths must be faced—such as why our sense of self, if it is too rigid, must sometimes be dismantled. Joseph Campbell told of the myth of Kirtimukha,[34] the fierce Face of Glory that appears over many doorways leading into many Hindu and Buddhist temples. Figure 5.2b is a photograph of the thirteenth-century Hindu temple of Candi Kidal in East Java. A certain King Jalandhara was foolhardy enough to send the giant Rahu to try to steal Shiva's bride, but Shiva became so enraged that from his brow a terrifying monster with insatiable hunger emerged to devour Rahu, whereupon Rahu begged for mercy and Shiva relented. The monster screamed that he was ravenous and asked what he was to do, and Shiva, looking at him for a moment, said that he could devour himself. So the monster ate all of himself but his head, and Shiva said, "This is my most magnificent creation ever! Henceforth it shall be known as Kirtimukha, the Face of Glory, and must always remain at the entrance of my door. From now on, nobody comes before me unless they first bow to Kirtimukha."

There are, of course, many interpretations of this myth, but I will select and amplify those elements that suggest why negative affect must be intensified for transformation to occur. We can all be frustrated and depressed raging monsters, hungry for what we feel we must have but must avoid. To reach Shiva, however, we must directly face our own raging feelings without protest; in doing so we enter into a self-consuming symbolic dying-like process that is required if we are ever to become truly alive and creative.

Neuroscience Research Models of Dreaming and Waking Spontaneous Thought

When asked which other experiences were most similar to their ayahuasca experiences, my research participants reported that ayahuasca was most like dreaming or waking spontaneous experience, but that it lasted longer (from

two to four hours), and that it was more intense and bizarre, yet highly mean-ingful. Given these consistent reports, it is instructive to search for common underlying physiological processes in the recent neuroscience research lit-erature. (It is important to note, however, that although this literature docu-ments extensive research into the bodily correlates of dreaming, it has much less information regarding spontaneous thought and ayahuasca experiences.)

The model I propose suggests that for spontaneous waking transforma-tive imagery narratives that occur after ayahuasca ingestion, or during nor-mal dreaming and waking spontaneous thought, there are three major se-quential stages of imagery and physiological process change that I have called *form dismantling and healing processes, form creation processes,* and *form expression processes.* This section will summarize the research on the bodily correlates of dreaming and spontaneous thought with an emphasis on the model's first major stage, *form dismantling.* The subsequent sections will emphasize the second and third major stages, *form creation processes* and *form expression pro-cesses.*

A very recent neuroscience review of the literature suggests that the REM state and dreaming function to self-regulate the kinds of higher arousal ex-periences that are required for daytime learning:

> During the REM state and dreaming human emotional memory pro-cessing takes place . . . REM sleep reactivates previously acquired affec-tive experiences from the day and decreases the emotional anxiety that was present at the time of the learning . . . REM offers large-scale network cooperation at night, allowing the integration and, as a consequence, greater understanding, of recently experienced emotional events in the context of pre-existing semantic memories stored in the neocortex. . . . This model suggests that if this process is not achieved, the magnitude of "affective charge" remaining within autobiographical memory networks will persist, resulting in the potential condition of chronic anxiety.[35]

It is also suggested that while REM sleep may offer a neurobiological state that is especially well suited for the preferential processing of emotional ex-periences, it is also quite possible that various kinds of waking states could

serve the same purpose, modulating affective experiences by similar under-lying mechanisms.[36]

Usually, important experiences are incorporated into long-term memory because we pay focal attention to them during the day; and then memory consolidation occurs during REM sleep at night. This normal process of day-time experiencing and dreaming-assisted memory consolidation can be dis-rupted, however, if the daytime experiences are intolerably stressful. In such situations our attention focus diminishes, possibly as a part of a protective mechanism. Without sufficient focal attention only the gist or implicit mem-ory of the traumatic situation is remembered, and that traumatic memory remains in an unstable state where it can be "reactivated" if the present envi-ronment has cues similar to the gist of the implicit memory. A "reactivated" implicit traumatic memory does not include the sense of a memory being recalled. It merely recreates the experience of emotion, behavior, and per-ception of the original traumatic memory as though it were occurring in the present moment.[37]

The state of consciousness called spontaneous waking thought shares some features of ayahuasca experiences, and recent neuroscience research on spontaneous thought, or mind wandering, has dispelled the notion that this state is an undesirable or wasteful distraction. We spend a third of our waking lives in thoughts unrelated to present tasks, and spontaneous thought seems to be as necessary for semantic memory formation as sleep. It has been found to be crucial in emotional processing and decision making, and it should be viewed as an essential part of human cognition.[38]

Many reports from our research participants suggest that ayahuasca may serve functions similar to those of dreaming and spontaneous thought. One of the most obvious and intriguing aspects of these reports is how often they recount the resolution of old painful memories in a process that has a spon-taneous narrative structure and often is described as healing. My view is that because both ayahuasca-elicited narratives and other kinds of waking spon-taneous imagery narratives combine a dreamlike experience with conscious awareness, the power of the meaning-making process is greater than in nor-mal dreaming. This view is supported by reports of lucid dreamers, who also are conscious in their dreams, and who attest to the value of lucid dreams for

meaning-making. It is also noteworthy that many spiritual traditions have specific meditation practices to develop lucidity in the dream state. Further, even the dream state itself is considered in these traditions to be a more subtle state of consciousness than the waking state.

Daniel Siegel notes that the "theory of nonlinear dynamics of complex systems," or "complexity theory," has been applied to living systems in order to understand the often "unpredictable but self-organizing nature of complex clusters of entities functioning as a system."[39] A driving force of human development is the movement from simplicity towards complexity.[40] The complexity of mental states is "enhanced by a balance between the continuity and flexibility of the system," where continuity refers "to the strength of previously achieved (mental) states," the probability of their repetition, or their familiarity and predictability. Flexibility is a measure of the system's "sensitivity to environmental conditions"; thus, it is a measure of the system's "capacity for variability, novelty, and uncertainty."[41] Organisms adapt by automatically self-regulating their internal environments and their behaviors toward the outer environment. This self-organization includes emergent enhancements to regulatory systems at the neural network and synaptic levels, allowing the system to shift toward maximal complexity. All self-regulatory mechanisms such as those regulating core temperature or sense of well-being necessarily have limitations or constraints.[42] From this perspective, dysfunctions in self-organization are seen as any pattern of constraint modification that does not allow movement towards complexity. Siegel gives as an example the intrusions from memory that occur in post-traumatic stress disorder, which create fragmented and low-complexity mental states.

So that some additional ideas can emerge, I will now reexamine the first three substages of my model in light of the previously discussed neuroscience theory and evidence on spontaneous thought, dreaming, memory, the narrative process, and complexity theory. The model's first three substages — enhanced conflicting energy, tolerating overwhelming experiences, and dismantling of self-schemas — all seem to involve the identification and elimination of protective or limiting conditioning so that unresolved implicit memories can be reexperienced, and new meaning made. Memories consolidated into long-term memory result in more coherent and complex life narratives.

These same processes would also be seen as removing the constraints upon

the system that block enhanced complexity. In short, old and outworn ways of being, experiencing, and expressing must make room for new ways. I suspect that these three substage processes are accompanied by spontaneous imagery which reflects the gist of unresolved memory content and new dismantling experiences. Every stage model must explain the mechanism that is hypothesized to move the process from stage to stage; in this model that mechanism is the system's constant bias toward higher complexity, which works to develop states that are maximally flexible while still maintaining the system's continuity.

The protective conditioning created in childhood serves to limit the damage caused by overwhelming experiences, but later in life this protective conditioning overly constrains the mind's complexity. This protective conditioning often contains implicit fearful memories of unresolved experiences. Because they are implicit, they have no link to a prior time; thus, they feel not like a memory, but like something occurring in the present. When this memory content is activated, it becomes the content of the spontaneously arising imagery narrative and is initially reexperienced as overwhelming and happening in the present, yet related to the past. A mental state is created with ayahuasca in which the waking spontaneous imagery narrative and lucidity are both displayed in consciousness. During a series of ayahuasca sessions, a capacity to successfully "navigate" difficult experiences may develop. Often these developing skills are called navigation skills. Were it not for the enhanced lucidity that ayahuasca provides, simply reliving a traumatic experience intensely could be retraumatizing. But enhanced lucidity allows the adult's mind to make meaning by reflecting with focal attention upon what is happening, which in turn makes possible the encoding of new consolidated memories regarding the meaning of these experiences within the life narrative.

Not every unresolved memory is resolved in dreams or ayahuasca experiences, so there are limits to the meaning-making process. Depth psychotherapy and ayahuasca make overly rigid protective barriers more porous, thus providing a situation in which the allowing and accepting of experience is possible, though this cannot be guaranteed. But in my view, the movement in each dream cycle and ayahuasca session, driven by the system's bias towards enhanced complexity, is towards more coherent and complex life nar-

ratives, and experiences that are described as healing. During the ayahuasca experience, if the previous two substages have been successfully navigated, the third substage, *dismantling of self-schemas*, can unfold. This is when nausea, vomiting, and sobbing often occur. Figure 5.2c depicts this symbolic death in the alchemical illustration of the dying and resurrecting king. While the experience of losing one's old sense of identity can be frightening, it also creates an experiential situation of openness and a readiness to experience a sense of self conditioned not by past suffering, but by creative processes outside conscious awareness that manifest themselves during the next substages of this unfolding process.

A question not yet discussed about healing-stage imagery facilitated by ayahuasca concerns the sources of the specific form, content, and dynamic properties of the visual and kinesthetic images. In dreaming or any kind of spontaneous imagery, the imagery could well be based upon memories of the previous day or on more distant memories. Many ayahuasca reports suggest, however, that the most memorable and valuable imagery exceeds what has ever been experienced in the waking life or in dreams. What, then, could be its source?

One possible answer may be found in Mark Johnson's work on image schemas. Johnson suggests that human beings interact with and understand the world through basic structures of sensorimotor experience called image schemas. Johnson characterizes an image schema as "a dynamic, recurring pattern of organism-environment interactions," and suggests that to sense the range of image schemas is to "ask yourself what are the most fundamental structures of perception, object manipulation, and bodily movement, given that human bodies share several quite specific sensorimotor capacities."[43]

Research has shown that when motor actions are imagined, some of the same brain regions that are involved in actually performing those actions are activated.[44] Other research has demonstrated that when a visual scene is imagined, the same brain regions that are involved in actually perceiving such a scene are activated.[45] These studies suggest that many of the same neural networks that are activated during sensorimotor interactions with the world are reactivated when mental imagery of those engagements is remembered or imagined. This evidence supports the view that image schemas could be the fundamental structuring mechanisms that provide the form and dynamic

properties of both the sensorimotor cortex–mediated experiences of the external world and the sensorimotor cortex–generated simulation of the inner world's spontaneous imagery experiences during dreaming, spontaneous thought, and ayahuasca experiences.

To examine how an image schema might structure ayahuasca imagery, I relate a quote from one of our research participants, a Western-educated male in his fifties, whose experience relates to the first substage, *enhanced conflicting energy*, and the second substage, *tolerating overwhelming experiences*:

> Without warning a menacing face appeared. . . . I was frightened and opened my eyes to get away from it . . . when I closed my eyes again the face was still there and I tried to calm myself so I could look at it . . . it reminded me of the kinds of faces I had seen in Buddhist paintings depicting wrathful deities . . . but I was still uneasy because it seemed too powerful and cold and otherworldly . . . I didn't trust it . . . the face was at the center of a matrix of lines of energy that was related to the face . . . at the center of the face there was some kind of heightened energetic movements and if I kept my attention there it grew stronger and if I looked away it diminished . . . as I focused at this central place it opened as a round portal and I could see inside into another realm that was a luminous blue with white star-like objects shining . . . after a long time of inner debating I grew more calm and somehow knew how to let go enough to pass through the portal. . . .[46]

Although each ayahuasca report is unique, this one clearly reflects elements of the previously summarized themes: a monstrous mask, a geometric grid with a central focus, entity encounters, and the shamanic journey. Johnson suggests that because of the nature of our bodies, "we project right and left, front and back, near and far, throughout the horizon of our perceptual interactions."[47] Our perceptual fields encompass an area of attention focus and periphery. Johnson identifies a center-periphery image schema, based on this horizontal character of our perception. The face and matrix described above appear to reflect the features of the center-periphery image schema. Johnson suggests that because of the ongoing forces we experience upon our bodies, we experience *compulsion, attraction*, and *blockage of movement* image schemas.[48] As previously discussed, dream imagery and related brain pro-

cesses—and, by extension, spontaneous ayahuasca imagery—are portrayals of those aspects of experience that have an emotional charge requiring meaning-making and eventual integration into a larger narrative process of self-understanding. In the experience quoted, both the *attraction* and *blockage of movement* image schemas appear to be involved. As we face unresolved emotional memories, there is often the feeling of being drawn both to approach and to avoid. The ayahuasca experience quoted above suggests that this impasse is resolved when fear can be tolerated, when attention can be calmly kept on the central concern, and when the process itself is trusted enough so that it can unfold spontaneously. This is a simple example of how several image schemas might be related to our bodily experience of our inner world. While image schemas initially develop through our engagement with the world and with our many ways of communicating with our environment, we simultaneously use them also in our inner dream life and spontaneous thoughts, as we consolidate the meaning of our body-based experiences into a revised life narrative. So image schemas structure the ways we communicate both with the world and with ourselves.

Form Creation and Form Expression Processes

The model suggests that in the initial major stage, *form dismantling and healing processes*, outmoded forms are eliminated so that in the second major stage new forms will spontaneously unfold in which spontaneous imagery narratives display these processes in consciousness. This allows awareness to crucially engage with the imagistic displays that reflect these processes. Some aspects of these processes can be seen in the above-quoted account by the Chilean woman having a very difficult dismantling experience followed by seeing her mother no longer looking sick, at which point she felt a sense of being released by this interaction and perhaps healed by new qualities of her mother's presence.

All the material presented above regarding the initial major stage, *form dismantling and healing processes*, shares considerable detail and correspondence with psychotherapy process research, mythology, and possible neuroscience mechanisms. However, this is not the case for either of the next two major stages of the model: *form creation processes* and *form expression processes*.

Everyone has formed attachments to people or things, and therefore must go through the first major stage of this process in minor or major ways. I suggest that as we experience losses throughout life, we are taken through this form-dismantling stage in order to accommodate to our new life situations. I think it is for this reason that much more is known about this first major stage. And while everyone also must go through form creation processes and form expression processes, what may be different there is the extent to which these later stages are experienced consciously, and how they might be used in the overall process of fuller human development. Artists and creative individuals of all kinds clearly traverse the second major stage in ways that involve enhanced creativity, complexity, and coherence of mind and expression. And perhaps individuals with a more refined spiritual sensibility traverse the third major stage in similarly enhanced ways.

One way to discuss this model that accommodates individual differences would be to look at figure 5.1 and imagine changes in the shape and height of the sine wave as representing the paths of different individuals through these three major stages of the change process. Perhaps the degree to which individual people descend into full dismantling of self-schemas might determine whether they find themselves more consciously exploring the second and third more creative and spiritually oriented processes. Artists often feel there is a link between their neuroses and their creativity, and perhaps in a sense they are right. We might also imagine that individuals who traverse this path and have relatively little unresolved memory need not move downward for dismantling at all, but might instead enter immediately into the second major stage, *form creation processes*. Similarly, someone who feels quite centered in the moment, and who has explored the creative domain—for example, an advanced spiritual teacher—might immediately enter into the third major stage, *form expression processes*. Used in this way, the model allows for an infinite variety of individual paths while still retaining some uniform structure within each region of the model, which does not determine the *specific* content of the experiences, but does suggest that imagery with specific dynamic properties will unfold in each of the substages and be displayed within the spontaneous transformative imagery narrative.

Form Creation Processes

There is less evidence for the second and third major stages of the model, which thus are more speculative, but enough evidence exists to describe them and their functions. Evidence for the model's suggestion of a clear sequential relationship between intense form-dismantling processes leading to highly valuable and creative form creation and expression processes can be seen in Jung's personal experiences: "The years when I was pursuing my inner images were the most important in my life—in them everything essential was decided. It all began then; the later details are only supplements and clarifications of the material that burst forth from the unconscious, and at first swamped me. It was the *prima materia* for a lifetime's work."[49]

In the model, the three substages of the form creation processes are *enhanced inner attunement*, *enhanced form fluidity*, and *enhanced compressed complexity*. It is suggested not that these three processes are essential to creativity in general—only that they were observed to be most prominent in the reports of our ayahuasca research participants, and have been used to develop this stage of the preliminary model. The first substage, *enhanced inner attunement*, identifies an experience that has been widely reported to be crucial at moments when the dismantling process is most intense. It could occur at the unbearable experiential moment when an individual, who has long ago lost faith in asking for help, cries out. Von Franz suggested that Jung equated the Annunciation in Christian tradition with the alchemical process *rubedo*, both of which he thought signified the beginning of new life coming from a stage of darkness. She quoted Jung: "Analysis should release an experience that grips or falls upon us as from above, an experience that has substance and body such as those things that occurred to the ancients. If I were to symbolize it I would choose the Annunciation."[50]

During most portrayals of the Annunciation, Gabriel, who is the angel of revelation, appears to Mary in a vision with the good news that she will be the mother of the world savior. From my perspective, that would certainly qualify as a waking spontaneous transformative imagery narrative. The Flemish fifteenth-century painter Rogier van der Weyden (1399–1464) depicts the Annunciation (figure 5.3a). Looking at it as an imagery narrative and not as sacred dogma, one sees some of the major elements of transformative narra-

FIGURE 5.3. Top: (a) Rogier van der Weyden, *The Annunciation*, c. 1435. Photograph © Verlagsgesel. Center row, left to right: (b) the angel Gabriel's gestures; (c) the Virgin Mary's gestures. Bottom row, left to right: (d) *Gateway of the Sun*, Tiahuanaco tapestry; (e) attendant deity in version 1; (f) attendant deity in version 2; (g) attendant deity in version 3.

tive. An angel of revelation exists to assist human beings; this particular angel specializes in revelations; in this case the revelation has to do with news that the divine is to be made flesh; and Mary, a human being, has the role of the mother who uses her body to give birth to that process.

I have included two additional images (figures 5.3b–c) to emphasize the artist's suggestion that Gabriel and Mary communicate through nonverbal gestural attunement. I would suggest that while this painting displays an abundance of visual detail, it also communicates something about a kinesthetic experience of gestural attunement. Although neither von Franz nor Jung wrote about this dimension of the communication between Gabriel and Mary, the importance of such attunement has been widely examined in the context of infant attachment research, which indicates that when infants are securely attached to their mothers, there is a quite rapid and energetic nonverbal dance of gesture and vocalization between the two that allows the infant to learn that energetic dyadic exchanges can be quite pleasurable and reliable, thus enabling the infant to become familiar with and unafraid of the high-energy states associated with pleasure, creativity, and uninhibited self-expression commonly observed in securely attached infants.

As the infant's immature nervous system slowly develops, so do its own capacities for self-regulation, assisted by a process of "attuned communication involving the resonance of energy and information"[51] between mother and infant. This process also occurs between therapist and client, and I suggest that it happens as well between spiritual teachers and their students, shamans singing as part of the process of healing their patients, between lovers, and in all loving relationships. Many reports from our ayahuasca participants mentioned that at moments that were most difficult for them, they experienced a tender presence, or they themselves prayed for help and care. In many cases it was at the most difficult moments—when the individual was in anguish and no longer felt able to struggle—that the care came to them. Research examining ayahuasca encounters with disincarnate entities also uncovered a specific class of entities that seemed to serve the function of providing tender care.[52] Reports of enhanced inner attunement coupled with some kind of guiding, tender, and soothing entity, presence, or force seem to arise spontaneously after the most difficult parts of ayahuasca journey experiences.

After the *enhanced inner attunement* substage has occurred, the individual

typically feels a much greater expansiveness and freedom to explore the inner world. This is reminiscent of how the mother serves as a solid base for the securely attached infant who thus feels empowered to move away from her to explore the new and exciting physical environment, and to return when feeling threatened. It is the cooperative and attuned experiencing of heightened energies while retaining a coherence of mind at this substage of *enhanced inner attunement* that provides a much more secure foundation to consciously explore the dazzling displays of novel forms that ayahuasca famously helps to facilitate during the next two substages, *enhanced form fluidity* and *enhanced compressed complexity*.

While it is very hard to communicate in words what kinds of visual and kinesthetic imagery can be experienced during the use of ayahuasca, there are suggestive images created by the Huari pre-Colombian Peruvian culture (750–1000 CE), which used as a sacrament not ayahuasca but a hallucinogenic snuff made from the seeds of the plant *Anadenanthera colubrina*, which contain bufotenin, a compound with a chemical structure similar to that of DMT.[53] Huari tunics are widely prized by collectors and museums for their unprecedented material qualities and abstract textile designs. In modern Bolivia, a monument called the Gate of the Sun incorporates the depiction of a fierce deity; I believe its function is similar to that of the Face of Glory, which is discussed above. On both sides of the main deity are found two vertical rows of attendant deities, one of which appears in figure 5.3d. Figures 5.3e, f, and g are drawings of the different abstract depictions of this attendant deity in the fabric designs on various Huari tunics. I have adapted these drawings from Alan R. Sawyer, who has examined the iconography in great detail.[54] I offer them to demonstrate visually an example of the *enhanced form fluidity* that is so very common during this substage of the *form creation processes*.

By the phrase "form fluidity," I refer to a dynamic process whereby a basic form, such as the one in figure 5.3d, undergoes a series of transformational changes that ayahuasca research participants have described as *playful, dynamic, morphing, extremely novel, experimenting with possibilities, improvisation around a theme, intricate*, and *intelligent*. I believe that form fluidity, and in fact all of the processes described herein, are multimodal. This fluidity is also reported to occur in spontaneous gestures and is similarly described, but with the additional descriptors of *embodied, channeled movements, attuned tac-*

tile communications with some kind of kinesthetic force or presence, delicate, tender, and exquisitely nuanced. Spontaneous vocalizations have also been reported to have the same properties.

Neuroscience Correlates of Ayahuasca

As a clinical and research psychologist, my focus has been to extend psychotherapy and psychology of religion research using phenomenological methods to examine the spontaneous imagery narratives elicited by ayahuasca while simultaneously recording brain waves or electroencephalograms (EEG) to identify the neural network activity associated with these imagery experiences. Before presenting our findings, I will briefly review the research on the brain correlates of ayahuasca experience other than EEG correlates.

A study[55] using single photon emission tomography (SPECT) has shown that ayahuasca activates specific frontal and paralimbic brain regions that are known to be involved in the processing of somatic awareness, emotional arousal, and emotional processing, and that significant activation has occurred in the right anterior insula, a region proposed as supporting interoceptive subjective feeling states and self-awareness.[56] Interoception is redefined from its narrow sense to

denote this generalized homeostatic sensory capacity . . . The sensory afferents that represent the condition of the body subserve *homeostasis*, which is the ongoing, heirarchically organized neurobiological process that maintains an optimal balance in the physiological condition of the body . . . Homeostasis in mammals comprises many integrated functions and includes autonomic, neuroendocrine and behavioral mechanisms. Thermoregulation is a good example of a homeostatic function . . . The primordial means of thermoregulation in vertebrates is motivated behavior, similar to hunger and thirst. In humans, such affective motivations are accompanied by distinct homeostatic (interoceptive) "feelings," and these modalities include not only temperature, pain, itch, hunger and thirst, but all feelings from the body, such as muscle ache, visceral urgency . . . I regard these feelings as *homeostatic emotions* that drive behavior . . . The neuroanatomy of the forebrain pathways . . . compel this concept.[57]

In a magnetic resonance imaging (MRI) study of long-term meditators, the right anterior insula was also linked to increased awareness of the interoceptive stimuli of breathing sensations. This suggests that enhanced interoception can result from meditation and use of ayahuasca.[58]

Research studies have also examined the neurotransmitter mechanisms that are presumed to be related to ayahuasca experiences. Research has shown that DMT, the most potent psychoactive ingredient in ayahuasca, binds to serotonin (5-hydroxytryptamine [5-HT]) neurotransmitter systems with high affinity to the 5-HT2A receptor.[59] Serotonin neurotransmitter systems are considered to be involved in the pathophysiology of depression, and drugs that increase serotonergic activity usually exert antidepressant effects on patients.[60] Endogenous DMT has been found in human urine, blood, and cerebrospinal fluid, and recent biochemical, physiological, and behavioral experiments have indicated that DMT is an endogenous agonist for the sigma-1 receptor.[61] New drugs have been developed that target the sigma-1 receptor and have demonstrated relatively rapid antidepressant-like actions in preclinical studies, and clinical trials of these drugs have now commenced.[62] Psychostimulant drugs such as cocaine and methamphetamine also bind with sigma receptors, and new drugs to treat addiction targeting the sigma-1 receptor are now being considered.[63]

Neuroscience Correlates of Ayahuasca and Form Dismantling and Healing

As the above review suggests, ayahuasca appears to exert its beneficial effects by targeting the same neurotransmitter systems as are involved in the latest drugs for depression and addiction. Indigenous people of the Amazon probably discovered ayahuasca more than a thousand years ago and have been refining its use since that time, thus suggesting that a closer examination of its use by Amazonian indigenous communities is warranted. Just such an effort was begun in 1992 when Jacques Mabit, a French physician, founded the Takiwasi Center in Peru, where patients with addiction problems live in a therapeutic residential community for an average of nine months. The center's screening criteria excludes individuals from the ayahuasca treatment program with serious metabolic disorders such as diabetes, functional de-

ficiencies such as cardiac insufficiency, and digestive lesions such as stomach ulcers or dilated veins of the esophagus that could degenerate into hemorrhages during the force of the vomiting. Also excluded are individuals taking antidepressants, because of the risk of serotonergic shock; individuals with dissociative disorders; and women who are pregnant. The center integrates views and methods from Western psychotherapy and the indigenous use of ayahuasca, and it offers individual psychotherapy, daily group therapeutic activities, and once-a-week evening ayahuasca sessions totaling an average of twenty-five for the entire process. An unpublished study of 380 addiction patients treated from 1992 to 1998 showed that 67 percent improved after two years.[64] Mabit has drawn upon the indigenous practices of the Amazonian basin to create a spiritual therapeutic context for his treatment, using ayahuasca to heal the body and transform the despair, damaged self-esteem, and meaninglessness associated with addiction. His "program is designed to create an initiatory experience, similar to a rite of passage that reveals and integrates the authentic self," and he suggests that "an initiatory death" experience often occurs in those patients with positive treatment outcomes.[65] In the model I have presented, the initiatory death experience can be seen as being comprised of the first four substages. The first substage is *enhanced conflicting energy*, and ayahuasca seems to naturally facilitate the shift from it to the next substage, *tolerating overwhelming experiences*, which is what individuals normally cannot do but ayahuasca and depth psychotherapy can often facilitate. If an individual feels confident to move deeper to the third substage, *dismantling of self-schemas*, then it is possible that the fourth substage, *enhanced inner attunement* can also occur. This, in my view, completes the initiatory death-and-rebirth experience that is so often reported in ayahuasca accounts.

In addition to using SPECT to examine the impact of ayahuasca upon the central nervous system, the EEG has also been used. A review of the findings of early EEG and psychedelic research, which was conducted before the development of quantitative EEG analysis, reported that the impact of psychedelics on the EEG was to decrease the global absolute amplitude of the slower theta and alpha frequencies and to increase the global relative amplitude of the higher beta frequencies. This was interpreted as a generalized and pronounced increase in cortical activation.[66] The effect of ayahuasca on the EEG as viewed using quantitative analysis found a global reduction in

the amplitude of all EEG frequencies and a relative shift toward higher EEG frequencies that is congruent with older reports on the effects of classical psychedelics on the EEG. A detailed analysis of frequency changes revealed a profile also shown by pro-serotonergic drugs, supporting the view that the psychoactive DMT in ayahuasca binds with the serotonergic 5-HT2 receptor, thus causing its effects in the central nervous system.[67]

Neuroscience Correlates of Ayahuasca and Enhanced Form Fluidity

In collaboration with the Colombian anthropologist Luis Eduardo Luna, I traveled with my dissertation student David Stuckey[68] to a retreat center in the Amazonian jungle near Manaus, Brazil, in 2000. After setting up a portable field laboratory we were able to examine the effects of ayahuasca on the EEG of two experienced research participants. As expected, it was immediately apparent that ayahuasca decreased the amplitude of the EEG across frequencies, as had been widely reported in previous research. During one of the recording sessions, while watching the EEG in real time on the computer screen I clearly saw that most of the nineteen EEG tracings were rising and falling precisely together, thus suggesting that many cortical regions were generating highly correlated electrical patterns at specific frequencies—an EEG measure called coherence. Although it entailed much additional effort and time, Stuckey agreed to also include EEG coherence in his analysis, which revealed ayahuasca-enhanced EEG coherence at the beta and gamma frequencies from many cortical regions, with the highest global coherence increases in the gamma frequencies.[69] This was the first time that an EEG study had shown any psychedelic-altered EEG coherence, and it could potentially be an important finding; but because the study had only two participants with little artifact-free data, it needed replication.

This replication had to wait for our second field research project, which took place in Brazil in 2005; we obtained EEG recordings and subjective reports from twelve research participants before, during, and after ayahuasca sessions. The particpants typically reported that they noticed the initial effects of ayahuasca about fifteen to forty minutes after ingestion. On the basis of the experience of hundreds of ayahuasca sessions, it is fairly certain that most individuals encounter the *form dismantling* and *healing processes* stage

about twenty to forty minutes after feeling the initial ayahuasca effects. On average, the *form creation processes* stage lasts for the next forty to sixty minutes, with the *form expression* stage lasting for the next forty to sixty minutes after that. The total range of time from ingestion until cessation of effects ranges from approximately 2 to 3.5 hours for most individuals. Because the process of recording EEG requires that individuals remain quite still in order to reduce muscle artifacts, it is possible to acquire reliable data before effects are felt and before the *form dismantling* and *healing processes* begin, but usually not during this main stage, because its intensity makes it all but impossible for participants to maintain muscle relaxation. Since the first substage of the form creation process is also quite prone to artifacts, our most reliable EEG research data has been collected from 80 to 110 minutes after ingestion. On the basis of the phenomenology of ayahuasca reports and of my model, our EEG recordings were acquired from our participants during the substage of *enhanced form fluidity*, and do not reflect the many other kinds of experiences that can occur during an ayahuasca session. The following is a report of a fifty-five-year-old male made during the *enhanced form fluidity* substage, ninety-five minutes after ingestion.

> There is a shield-like quickly morphing form composed of illuminated rectilinear lines of energy and solid shifting planes that retains a certain similar kind of geometry but also seems to be constantly experimenting with novel versions of itself . . . that is right at the center of my visual field with my eyes open or closed . . . when I look directly at it, it seems to energize it, and it becomes more intensely illuminated . . . the colors are earth tones of gold and dark red and dark green . . . lines also radiate out from this form and it seems to generate an entire field around itself . . . once when I look right at it, it opened in some way and what it looked like inside was like a dark night sky with points of light slowly rotating . . . it was very beautiful and the entire experience lasted for about 5 minutes.[70]

We recorded EEG from our twelve participants during an eyes-closed baseline condition just prior to the ingestion of ayahuasca, using discrete gold sensors attached to the scalp. Nineteen EEG tracings were obtained in this way, using the standard international 10-20 system to establish the pre-

cise scalp locations. After 80 to 110 minutes, we recorded the EEG again from the same participants, who, still with eyes closed, were by this time fully experiencing the effects of ayahuasca. Although EEG can be analyzed in many ways, the finding that discriminated most robustly between the two conditions was EEG coherence, which is equivalent to the correlation of EEG activity at a particular frequency in one location on the scalp compared to another. The measure is presumed to reflect the relative strength of neural network connectivity between specific EEG locations; it indicates the level at which information is processed with higher coherence, and thus signifies enhanced cooperative activity between the regions.[71]

Coherence is often averaged over a specific range of frequencies, because evidence suggests that different frequency ranges, or EEG "bands," are related to different neural processes. We found that ayahuasca has significant effects upon EEG frequencies from one to fifty cycles per second; and the EEG band that we found to best discriminate the baseline from the ayahuasca condition in our participants was a frequency range from twenty-five to thirty cycles per second, which is known as the high beta EEG frequency band. Figure 5.4a shows the standard nineteen locations where we recorded EEG activity.

Figure 5.4b shows EEG high beta frequency coherence differences between eyes-closed ayahuasca compared to eyes-closed baseline conditions, averaged for the group of twelve research participants. The solid lines in-

FIGURE 5.4. Left: (a) standard EEG locations for scalp recording. Right: (b) ayahuasca and baseline EEG beta (25–30 cps) coherence differences.

dicate significant increases ($p \leq .01$) in EEG coherence between cortical regions, suggesting enhanced information processing between these regions during ayahuasca as compared to the baseline condition. The dashed lines indicate significant decreases ($p \leq .01$) in EEG coherence between cortical regions, suggesting decreased information processing between these regions during ayahuasca as compared to the baseline condition.

Our findings are congruent with Francisco Varela's research and theoretical writing; he speculates that "a unified cognitive moment relies on the coordination of scattered mosaics of functionally specialized brain regions . . . [and that] . . . although the mechanisms involved in large-scale integration are still largely unknown . . . the most plausible candidate is the formation of dynamic links mediated by synchrony over multiple frequency bands."[72] Our participants' heightened, complex, and creative ayahuasca experiences during the substage of *enhanced form fluidity* could be related to the fact that their EEGs showed very significant changes in EEG coherence over many frequency bands. These coherence changes may be related to the neural network dynamics required to sustain the *enhanced form fluidity* our participants reported. The kinds of future research needed to replicate and clarify the significance of these findings will be discussed in the concluding section of this chapter.

Enhanced Compressed Complexity

After the substage of *enhanced inner attunement*, the unfolding narrative may seamlessly progress through the *enhanced form fluidity* substage. During the *enhanced compressed complexity* substage, more complex narrative experiences start to occur; these are reported to be more vivid, realistic, dramatic, and lengthy narratives that sometimes include encounters with entities and the classic shamanic journey to other worlds. Often in these other worlds, strange symbolic objects are a part of the encounter, as the following excerpt from one of our participants illustrates:

> There is an object in front of me. All kinds of equipment. They were showing me something. Something that was curled, about this long. [The participant holds both hands out about 30 inches apart.] Some-

thing that was curled like this, like a rod. It was like art, it was like an object that was made by some being, but it was like a staff, like a psychic staff. They [the staffs] were just laying on something [an ornate desk or table], ten or twelve staffs laying together in parallel.[73]

Another example of a spontaneous imagery narrative showing *enhanced compressed complexity* and involving a vivid encounter with a disincarnate entity can be found in Janet Gyatso's translation of the secret spiritual autobiography of the revered Tibetan master, Jigme Lingpa (1730–1798), which includes many descriptions of spontaneous visionary experiences that he later used to create tantric visualization meditation practices that are still widely practiced by both Tibetan and Western meditators. The passage below is drawn from Jigme Lingpa's *Dakki's Secret Talk*, written from 1767 to 1769.

I mounted an attractive white lioness and was carried to an unrecognizable (place) . . . I encountered . . . the face of the dakini . . . She committed to me a flattened casket made of wood, in the shape of an amulet box . . . she said, ". . . This is the Treasure of Samantabhadra's heart-mind, the symbol of the great expanse of Awareness-Holder Padma, the great secret repository of the dakinis. Symbol's dissolved!" As she said that, she vanished . . . filled with great delight, I opened up the box. From inside came rattling out five rolls of yellow paper. . . . At once I carefully opened up the large roll of paper. There was an immeasurable effusion of the aromatic fragrance of camphor . . . I opened [the roll] . . . slowly . . . which was filled with scrambled secret dakini sign-letters, which the mind could not make sense of. Since I could not read it, I began to roll it up, when just in that instant, like an optical illusion . . . all of the symbolic characters inside turned at once into Tibetan.[74]

Tibetan Buddhism has a mind terma tradition that is very relevant to the central topic of this paper. The mind terma is a spiritual teaching that consists of an imagery narrative which arises spontaneously in the minds of only very advanced meditators, and then on very rare occasions—but it does allow new teachings to come into the Tibetan tradition through visionary experiences. A part of this tradition is that during a spontaneous kinesthetic and visual transformative imagery narrative, the meditator engages with a celestial en-

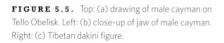

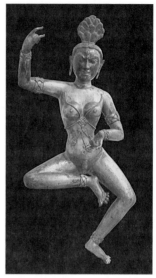

FIGURE 5.5. Top: (a) drawing of male cayman on Tello Obelisk. Left: (b) close-up of jaw of male cayman. Right: (c) Tibetan dakini figure.

. .

tity, a sky dancer or dakini (figure 5.5c) known to destroy conventional forms and to teach by nonverbal means that which is beyond conception. When I was first introduced by Barbara Stafford[75] to her notion of the "cognitive work" being done by compressed compositions of the sixteenth-century European emblem tradition, I was immediately struck by the similarities between these European compositions and the special kinds of imagery I had been investigating from reports of ayahuasca experiences and spiritual visionary experiences of dakini script.

A final example of an image demonstrating *enhanced compressed complexity* comes from one monumental sculpture of the pre-Colombian Chavin culture (800–200 BCE): the Tello Obelisk, found in Peru at Chavin de Huantar, which is carved with what are probably a male and female cayman facing each other. Their bodies are covered with kenning, or visual metaphors. Figure 5.5a shows the male cayman. Peter Roe suggests that the images on the Tello Obelisk depict the two caymans, plants, the jaguar, and the harpy eagle, all of

which are of Amazonian origin.[76] In figure 5.5b the compressed composition of embedded animal images comprising the jaw region of the male cayman can be more easily seen in an enlargement of that section of the image.

At lower left in figure 5.5b a cross-sectional slice of the San Pedro cactus can be observed; many more of these are included throughout the relief. Research suggests that the San Pedro cactus, which contains mescaline and hallucinogenic snuffs that include DMT-like compounds, was probably used in Chavin religious practices,[77] and the resulting visions must have exerted a powerful impact upon methods of rendering imagery in pottery, in stone, on shells, and in textiles. In all of this creative work, the form creation processes I have called *enhanced form fluidity* and *enhanced compressed complexity* can be seen.

Because spontaneous imagery is so central to the ayahuasca experience and to spontaneous thought, the closing section of a recent neuroscience review article concludes that spontaneous thought may play a very significant role in human creativity, similar to that of dreaming. This may also provide important clues about the ayahuasca experiences as well.

Spontaneous thought facilitates memory consolidation—or the integration of isolated episodic experiences into a coherent, meaningful autobiographical structure that gives us a sense of self. Similarly to sleep, the function of spontaneous thought may be to help us make sense of our experiences by building a coherent and meaningful structure out of the isolated, and at first unrelated, events that constitute our everyday lives. When we let our mind wander, we shift our mode of thinking to a more spontaneous, less controlled kind of thinking, which can help us reach more creative, less predictable conclusions. This could broaden the amount of information and the number of factors we could take into account while thinking. In contrast to sleep, however, wakefulness may allow this integration to occur at a more conscious level—by allowing spontaneous thought to interact with deliberate, goal-directed thought. . . . when it produces a cognitive benefit, spontaneous thought either proceeds or follows a period of more goal-directed, deliberate thought. This temporal alternation between the two different modes of thought may be what leads to some of the most beneficial outcomes, such as new insights, deeper levels of understanding, and novel, creative ideas.[78]

During ayahuasca experiences, individuals are immersed in the flow of spon-
taneous imagery much more deeply than during spontaneous thought. With
experience, however, the imagery during ayahuasca sessions can also be very
lucid. In this sense, there is no temporal alteration between spontaneous and
reflective modes of consciousness; in fact, the two modes can be simultane-
ous. Perhaps this is one reason why so many individuals report that ayahuasca
experiences are profoundly creative.

Form Expression Processes

The final major stage of the model involves the *form expression processes*, with
the substages of *enhanced field complexity, enhanced vertical attunement*, and *en-
hanced horizontal attunement*.

Only two of our twelve subjects reported ayahuasca experiences that were
clearly related to *form expression processes*. The model suggests that the major
stage of form creation is a necessary preparatory foundation for emergence
of the form expression stage. Because fewer ayahuasca reports specifically
describe the experiences of the form expression processes, this stage of the
model is necessarily more speculative. If form creation processes function to
explore the possibilities of form fluidity and compressed complexity as they
can be appreciated, form expression processes allow for expression of the
richness of these forms and their accompanying meaning. Our two research
participants who reported these form expression experiences had many years
of prior training in one or more forms of spiritual practice.

The first substage is *enhanced field complexity*; an image representing this
is the Tibetan Buddhist Kalachakra mandala, shown in figure 5.6a. Since it is
well beyond the scope of this chapter to explain this mandala in any but the
most summary manner, the intent here is to suggest only a few of its obvious
features which directly correspond to experiences of our participants and
to the model. In summary, the mandala, along with the sacred mountain,[79]
temple, shrine, or tree, is the sacred environment that supports the transfor-
mative process of awakening at the symbolic sacred axis of the world, or axis
mundi.[80] Rudolph Arnheim observes, "When we speak of the center we shall
mean mostly the center of a field of forces, a focus from which forces issue and
toward which forces converge."[81] Tibetan Buddhism suggests that there is ac-

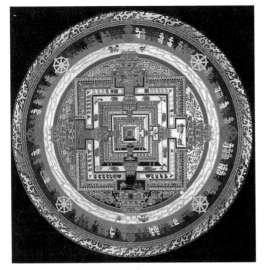
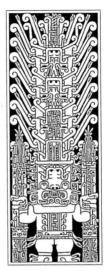

FIGURE 5.6. Top left: (a) Tibetan Kalachakra mandala: enhanced field complexity. Top right: (b) Raimondi Stela, Chavín: enhanced vertical attunement. Bottom left: (c) Tibetan Bodhisattva Tara (*Sitatapatra*): enhanced horizontal attunement. Bottom center: (d) Ramakrishna in trance. Bottom right: (e) Mevlevi dervish dancing.

tually no real self at the center of things, and while we experience ourselves as the center of everything, in reality we *construct* a self. Through meditation practice, the reality of no-self can be directly realized. So the journey to the center of the mandala is a discovery that there exists no separate self. Often a mandala is visualized as a part of Tibetan Buddhist visualization practice: it is round, surrounded by protective fire, and it contains sacred symbolic objects. It has a square central portion that is the palace of the deity, and four gates

facing the four directions; the deity sits upon a throne at the center of the palace. Surrounding and supporting the mandala are many attendant beings and an area outside of the palace that is beautifully ornamented.

Although the mandala is often represented in only two dimensions, when visualized it also has the vertical dimension of the palace walls; the palace building itself rises many stories and has a central high axis. This general plan of a palace in which the deity resides at the central axis is a very widespread narrative that Eliade referred to as the symbolism of the center.[82] For the meditator, the culminating processes related to awakening take place at the central axis. For the Shapibo shaman, the central wooden axis of the *maloka*, or sacred building where only ayahuasca ceremonies are held, is the where Shapibo sacred narrative processes unfold. Two of our participants reported that they found their way into situations where they were at the center, and that the center possessed certain unique properties. One participant had experiences reflecting the *enhanced vertical attunement* substage:

I was feeling energy in the area of my neck and the top of my head when suddenly there a blinding flash of white light and what felt like a waterfall of downflowing energy coming down through the top of my head and washing through my body . . . my body was shaking and trembling but the feeling was ecstatic and beyond words . . . it also felt electrical and powerful . . . it lasted for perhaps 20 seconds and for quite a while I had no thoughts and my mind was still and spacious.[83]

Many spiritual traditions employ esoteric systems that explain the vertical movement of some kind of spiritual energy in the area of the spine, and which consider such movement to be related to spiritual development. In my view, such experiences are spontaneous and primarily kinesthetic waking transformative imagery narratives.

My hypothesis is that in the major stage of *form expression processes*, the experiences shift from being visual to more kinesthetic, because to be expressive the motor system must be operative and attuned. One way of characterizing these processes is to see them as a shift from inner experiencing to outer expression of subtle, highly complex states of mind, as would be required by a master artist or spiritual teacher who not only experiences what is profound

and meaningful, but also develops the capacity to express it to others. My intuition is that sacred art forms communicate information related to inner developmental processes, such as *enhanced vertical attunement*, that were first directly experienced and later rendered into a form. Figure 5.6b illustrates the Raimondi Stela, another Chavin major deity from Chavin de Huantar, the imagery of which was probably inspired by the psychedelic San Pedro cactus. Again, keening is used throughout this image, with snakes and animal heads incorporated throughout the deity's body and the extreme vertical movement of the image suggesting intense "peaking" to most individuals who have had strong psychedelic experiences. Multiple heads or energy lines radiating from the head, such as halos, are ways of graphically portraying profound inner experience that are used both in the sacred art of cultures that employ psychedelics as a sacrament and in Buddhist, Islamic, and Christian sacred art depicting religious figures. The last substage of the *form expression processes* is *enhanced horizontal attunement*. Unlike the *enhanced vertical attunement*, which receives the vertical flow of spiritual energies, the *enhanced horizontal attunement* continues to receive down- and possibly up-flowing spiritual energies, but also simultaneously projects energies horizontally and outwardly to other beings as transmissions of healing, as can be seen in figure 5.6c, which depicts the Tibetan Bodhisattva Tara. Figure 5.6d is a photograph of the Indian twentieth-century saint, Ramakrishna, surrounded by his disciples at a time when he is reported to have remained in deep ecstatic trance in standing postures, embodying the image of verticality for long periods of time. His unusual arm and hand postures, I suggest, are ways in which spontaneous transformative experiences can be embodied and expressed in a kinesthetic form. One of the challenges for a spiritual teacher is to communicate the ineffable.

The model suggests that the function during this main stage of *form expression processes* is to communicate, which means to embody highly complex inner experiences so that they can be outwardly shown. Figure 5.6e is a photograph of a Mevlevi dervish performing his ecstatic sacred dance. Here again, expressive and elegant body posture in rapid spinning motion around the vertical axis shows something of the verticality and energetics of the inner experience that words, or even a static image, cannot convey. From the standpoint of this stage model's emphasis on creation and expression, once old forms are allowed to die, a parallel process can be seen in the origin of this

ecstatic dance. The Persian poet Rumi had been deeply in love, and when he lost his lover, out of the maddening despair that drove him deep into himself, what emerged were ecstatic movements that brought him back to life and deepened his capacities to communicate not only in spiritual poetry but also spontaneously through his body. In this manner he was able to express something that otherwise would have remained hidden. Gyatso suggests that the ground from which these kinds of nondual states arise "is understood to be intrinsically expressive"; perhaps it is for this reason that when human beings can allow this ground to flow through them unimpeded, the expressive display strikes us as being inspired.[84]

Both of these expressive forms, *enhanced vertical attunement* and *enhanced horizontal attunement*, have as their necessary foundation the resources of the *enhanced field complexity* depicted by the mandala; these expressive processes work in tandem with these field dynamics. In Figure 5.6c the Tibetan Bodhisattva Tara, from the Tibeto-Chinese sixteenth century, exemplifies the capacity to provide abundance to others in the imagery of her thousand arms, hands, heads, and legs.[85]

Conclusion

Two primary questions guided this inquiry. The first was how ayahuasca might facilitate the reported benefits in healing, creativity, and spiritual development. The second question was what neural image processing mechanisms might be activated during ayahuasca spontaneous imagery narratives, and how these mechanisms might contribute to the benefits reported for ayahuasca. This section will summarize the model used to explain the nature and function of ayahuasca imagery narratives, and discuss its limitations. While the model is new and speculative, it generates potentially productive hypotheses and suggestions for future research.

The model is a stage model, and evidence for the characteristics of each stage comes primarily from research that I have so far gathered on change processes during ayahuasca, psychotherapy, and spiritual experiences. The research evidence includes verbal descriptions of change processes, interpretations of those processes, and sacred art representing them. Future research clearly is needed to see whether additional relevant evidence supports the

model. Additional research is also needed to examine spontaneous imagery narratives in dreams where change processes are apparent. The changes should conform to the model's assumptions regarding the sequence of specific kinds of imagery. Additional work is also required to better define the image-schematic characteristics of each of the model's stages. The model suggests that in consciousness, the image-schematic display of these normally unconscious neural mechanisms allows for the emergence of more complex experiences that are reported as healing, enhanced creativity, and spiritual unfolding. It is suggested that the model may apply to Tibetan Buddhist visionary experiences that sometimes arise spontaneously during daytime meditation practices and during dreaming, and further research could test some of the model's assumptions. The fifth Dalai Lama's secret autobiography contains many shamanic-like themes, and is certainly worth examining in detail.[86] In some Tibetan Buddhist religious writing, dreams are said to be unreal, deceptive, and of no value, while in other writing from that tradition working with dreams is presented as a magical art to be mastered by the yogi, with the meaning of dreams being of supreme value.[87] This apparent contradiction may in fact highlight the importance of being mindful that there may be different kinds of spontaneous narratives, some of great worth and some without value. A more comprehensive examination of the Tibetan Buddhist literature may offer insight into this question.

Because image schemas are defined as reflecting the dynamic experiences of human beings interacting both mentally and physically in a physical environment governed by universal laws, many of them are considered to reflect universal human experiences; the model should thus apply across cultures. Research has suggested that image schemas serve to structure both ordinary thought and dreaming, and a systematic analysis of the image schematic aspects of dream imagery has shown that it is possible to discern how dream images are connected to the expressed desires, fears, and other important concerns of the dreamer.[88] Future image schema research could develop more precise methods of analyzing the kinds of spontaneous visual and kinesthetic imagery that arise in ayahuasca experiences and determine whether future findings are similar across cultures. In addition, such research could attempt to examine each of the model's different stages in terms of sequences and combinations of image schemas.

Our EEG research examined ayahuasca experiences 80 to 110 minutes from the time of ingestion, because we found that was a time when our research participants were still actively involved in imagery narratives, but past the "peaking" phase of the session; at 100 minutes after ingestion they could more easily speak and relax their muscles, and this allowed the recording of EEG data uncontaminated by muscle artifacts. Our reported EEG findings are therefore limited to the *enhanced form fluidity* stage of the model. In figure 5.4b, the eight EEG locations indicated by a black circle are susceptible to muscle artifacts, and EEG changes from these locations were not reported. Future EEG coherence and ayahuasca research is needed to show the full extent of neural network changes from all cortical regions. Given these limitations, it still can be observed that the solid lines in figure 5.4b, showing significant increases in the EEG high beta 25 to 30 cycles per second (cps) frequency band coherence caused by ayahuasca, mainly connecting brain regions within both hemispheres, may suggest increased cortical processing within each hemisphere. It can also be seen that the dashed lines which indicate significant decreases in the high beta 25 to 30 cps frequency band coherence mainly connect brain regions across the two hemispheres, which may suggest either decreased cortical processing across them or some kind of alteration in the way they function together. Future research is needed to address these possibilities, but this new direction in research may be important because it may also be linked to the findings, reported earlier in this chapter, that reflective thought and spontaneous thought appear to function in a more unified manner during ayahuasca, with spontaneous thought being mediated more by the right hemisphere and reflective thought more by the left. Based on our EEG coherence findings of decreased EEG 25 to 30 cps beta coherence across the hemispheres, it could be hypothesized that these changes are part of the neural network activity necessary for both reflective thought and spontaneous thought to arise together in consciousness during the *enhanced form fluidity* stage of ayahuasca experience. This may actually be true for ayahuasca experiences in general, and these findings may also apply to other related states in which reports of reflective thought and spontaneous thought exist together, such as lucid dreaming and certain meditation states.

Because significant amounts of muscle activity and body movement occur during the most intense ayahuasca experiences, there is currently no reliable

method to record artifact-free EEG of those experiences. Future research is needed to develop better ways of examining and correlating brain changes and experiential changes across the entire ayahuasca session. As previously mentioned, current research supports the notion that human neural networks can be viewed as complex systems exhibiting emergent properties, and the model suggests that some of the model's stages, such as *enhanced form fluidity*, may be associated with emergent and more complex neural network processes that underlie creative image processing. Our research did find widespread ayahuasca-related changes in EEG coherence across many brain regions and frequencies, but we have not yet calculated or reported that EEG neural network complexity is correlated with the changes in cognitive image content and complexity across the model's stages. Future research using more refined measures of cognitive and neural complexity are needed to provide more than suggestive evidence that complexity theory persuasively explains the mechanisms relating neural network changes to psychological change processes.

While a selection of relevant neuroscience evidence has been provided in this chapter, a much more extensive review of that evidence is needed to determine how well the model can accommodate it. Future research recording ayahuasca brain and experiential correlates with very experienced participants is clearly the most direct test of the model's assumptions. All stage models must contend with problems caused by human individual differences. There are significant metabolic differences that alter the intensity of ayahuasca experience but not the overall profile of intensity effects.[89] Once an individual's metabolic response to ayahuasca is established, it is theoretically possible to adjust the ayahuasca dosage to provide an ayahuasca experience that is equally intense across individuals. However, our research indicates that even with this adjustment individuals report significantly different kinds of experiences, and at this stage in our research it is unclear which specific factors contribute to these individual differences. We believe that relative psychological maturity and prior experience with ayahuasca are probably two important individual factors, but future research is needed to examine the individual differences more fully. Individuals who are both psychologically mature and very experienced with ayahuasca have also been among those who are capable of speaking and reflecting upon their experiences during the ayahuasca experience without diminishing its intensity. Shamans prob-

ably have developed similar complex skills. This capacity is crucial in our re-search because we need rich experiential descriptions given during the aya-huasca experience. Future research could more closely examine which neural network activation patterns, and possibly personality or temperament mea-sures, are associated with different capacities for self-reflection and precise verbal articulation during ayahuasca experiences. The model would suggest that these capacities are emergent, and it would require that spontaneous and deliberative thought processes would be available either within one mental state with a correspondingly more widespread neural network joining these usually segregated processes, or as an enhanced and fluid alternation between these two processing modes and their respective neural network activity pat-terns.

The model's three main sequential stages are *dismantling and healing pro-cesses, form creation processes,* and *form expression processes.* The first stage of the model involves *dismantling and healing processes.* Clearly not everyone is in-terested in a form of psychotherapy or change process that requires one to willingly endure enhanced conflicting energy, tolerate overwhelming expe-riences, and allow one's sense of self to be dismantled, but this is just what many spiritual traditions suggest is required for an authentic understanding of oneself. Future neuroscience research that explores these kinds of change processes may provide a more nuanced understanding of why such methods are effective, and may help to refine these methods so that they appeal to a wider range of psychotherapy clients in modern cultural contexts. In some sense this process may be analogous to how modern drugs have been devel-oped from traditional medicines. With close collaboration between tradi-tional and modern understandings of healing, like that which exists in the clinical addiction treatment and research program directed by Jacques Mabit in Peru,[90] enhanced psychotherapy methods may be developed.

The second main stage of the model is that of *form creation processes.* The model suggests that ayahuasca facilitates spontaneous thought, but that un-like normal spontaneous thought, this includes reflective thought that may account for the insights, deeper understanding, and fresh and creative ideas reported for ayahuasca. The model further suggests that the level of this creativity should be correlated with the greatest intensity of spontaneous thought processes while the lucidity of reflective thought is maintained. Fu-

ture multidisciplinary research examining ayahuasca, spontaneous thought, reflective thought, and creativity using neuroscience and phenomenological methods could examine these hypotheses.

The model also suggests that the third main stage of ayahuasca spontaneous imagery narratives is that of *form expression processes*, in which spiritual and/or creative processes are experienced and expressive capacities develop to communicate these experiences. Multidisciplinary research designed to bridge the neuroscience/humanities divide may face special challenges when the inquiry concerns spiritual experience. Members of a multidisciplinary research team may differ on how to view the value of spiritual experiences embedded within the spontaneous imagery narratives reported by research participants. We have some preliminary evidence regarding the impact of prior belief in spiritual experience on subsequent ayahuasca experiences. We found that our research participants took one of two primary epistemological stances when they first experienced a spontaneous imagery narrative that included an entity encounter. Six of our twelve participants reported such experiences. Of these six, three reported that during the experience they reflected that the entity was probably a projection of their own mind's unconscious processing. They also reported that the effect of this reflective stance was to diminish the intensity and complexity of the experience. In fact, they reported often using this line of reasoning to maintain control when frightened. The other three participants reporting these encounters reflected that they were possibly encountering an actual intelligent entity, and that the result of this stance was to greatly intensify the experience — in most cases causing the entity to come towards them, leading in turn to a deepening involvement in the unfolding narratives involving the entity, which in some cases triggered the full-blown classical shamanic journey experience.

The neuroscience/humanities divide was bridged by the members of our research team representing the disciplines of psychology, anthropology, cognitive neuroscience, religion and psychopharmacology. Each member of our research team had a significant amount of personal experience with ayahuasca, and each held somewhat different views regarding the meaning of their own entity-encounter experiences. But all of our team members agreed that one of the most fascinating aspects of ayahuasca is that it can reliably facilitate profoundly meaningful religious experiences, including revelatory

experiences involving entity encounters, in appropriately prepared indi-
viduals even in our neuroscience field laboratory conditions. Jigme Lingpa's
eventual stance towards his experiences with entities is worth noting: he sug-
gests that such experiences are, at their core, indeterminate. The effect of this
stance seems to be to intensify and greatly enhance the complexity of subse-
quent experiences while also minimizing naïve idealization and fantasy. So
it seems that neither rejection nor belief in the validity of such experiences
is optimal in terms of enhancing ayahuasca experience; the indeterminate
stance seems congruent with the standards of scientific objectivity, and it
was the perspective that our research team found was optimal for our work.

The model's value can be determined by seeing how well it provides
greater coherence in integrating the relevant multidisciplinary research evi-
dence on the nature and function of spontaneous imagery narratives and re-
lated change processes in psychotherapy, sacred art, and spiritual develop-
ment. Future multidisciplinary ayahuasca research that effectively bridges
the neuroscience/humanities divide may be of significant value, because
ayahuasca makes available to scientific investigation many usually hidden
dimensions of cognition that are central to the neuroscience of image pro-
cessing, the psychophysical change processes in psychotherapy and spiritual
development, and the psychophysiology of creativity.

Notes

1. Frank G. Echenhofer, Katee O. Wynia, David Joffe, Luis Eduardo Luna, Greg-
ory A. Benitz, John Burton, Sidney Sudberg, and Dennis J. McKenna, "EEG Correlates
of Spontaneous Mental Imagery after Ingestion of the Shamanic Brew Ayahuasca"
(working paper, 2009).

2. Benny Shanon, *The Antipodes of the Mind: Charting the Phenomenology of the Aya-
huasca Experience* (New York: Oxford University Press, 2002).

3. John Heuser, "Ayahuasca Entity Visitations: A Thematic Analysis of Internet-
Reported Encounters," PhD dissertation, California Institute of Integral Studies,
2006. *Dissertation Abstracts International*, publ. nr. AAT3218522, DAI-B 67/05.

4. Dennis J. McKenna, "Ayahuasca: An Enthopharmacologic History," in
R. Metzner, ed., *Ayahuasca: Hallucingogens, Consciousness, and the Spirit of Nature* (New
York: Thunder's Mouth Press, 1999), 187–213.

5. Jace C. Callaway, "Phytochemistry and Neuropharmacology of Ayahuasca," in

R. Metzner, ed., *Ayahuasca: Hallucingogens, Consciousness, and the Spirit of Nature* (New York: Thunder's Mouth Press, 1999), 250–75.

6. Michael J. Harner, "Common Themes in South American Indian Yagé Experiences," in M. J. Harner, ed., *Hallucinogens and Shamanism* (Oxford: Oxford University Press, 1973), 155–75. Quotations at 172–73.

7. Milciades Chaves, "Mitica de los Siona del alto Putumayo," *XXXI Congreso Internacional de Americanistas, Miscelanea Paul Rivet Octogenario Dictata* 2 (Mexico: Universidad Nacional Antonoma Mexico, 1958), 121–51. Quotation at 131.

8. Claudio Naranjo, "Psychological Aspects of the Yaje Experience in an Experimental Setting," in Michael J. Harner, ed., *Hallucinogens and Shamanism* (Oxford: Oxford University Press, 1973), 176–90. Quotations at 177–90.

9. Ibid., 184.

10. Ibid., 184–85.

11. Benny Shanon, *The Antipodes of the Mind: Charting the Phenomenology of the Ayahuasca Experience* (Oxford: Oxford University Press, 2002). Quotations at 113–40.

12. Ibid., 141–59.

13. Ibid., 86–98.

14. Benny Shanon, "Ayahuasca Visualization: A Structural Typology," *Journal of Consciousness Studies* 9, no. 2 (2002): 5.

15. Ibid., 24.

16. Ibid., 25.

17. Ibid., 28.

18. The specific research examined in psychotherapy is that of experiential psychological change processes. In the psychology of religion, it is the research that examines experiential spiritual change processes. In the anthropology of religion and religious studies, it is the research examining the transformation themes that are depicted in sacred texts and art.

19. Research evidence from psychotherapy, psychology, developmental neuropsychology, and neuroscience will be presented to show that the functions and mechanisms of dreaming and REM (rapid eye movement sleep), mind wandering, and spontaneous waking thought processes all are states of consciousness that share the processes of spontaneous imagery narratives, and that these processes may be crucial for emotional self-regulation, long-term memory consolidation, coherent self-narratives, and creative activities generally. Research will also be presented regarding the presumed underlying bodily mechanisms that are involved in these processes.

20. Francisco Varela, Jean-Philippe Lachaux, Eugenio Rodriguez, and Jacques Martinerie, "The Brainweb: Phase Synchronization and Large Scale Integration," *Neuroscience* 2 (2001): 229.

21. Harry H. Hunt, *The Multiplicity of Dreams: Memory, Imagination, and Consciousness* (New Haven: Yale University Press, 1989), 3.

22. John Heuser, "Ayahuasca Entity Visitations: A Thematic Analysis of Internet-Reported Encounters," PhD dissertation, California Institute of Integral Studies, 2006. *Dissertation Abstracts International*, publ. nr. AAT3218522, DAI-B 67/05, 70.

23. Carl G. Jung, *Memories, Dreams, Reflections* (New York: Vintage Books, 1989), 170.

24. Ibid., 172.

25. Ibid., 173.

26. Ibid., 177.

27. Ibid., 178.

28. Ibid., 179.

29. Marie-Louise von Franz, *Alchemy: An Introduction to the Symbolism and the Psychology* (Toronto: Inner City Books, 1980), 223.

30. Carl G. Jung, *Psychology and Alchemy* (Princeton, NJ: Princeton University Press, 1953), 335.

31. Eugene Gendlin, *Experiencing and the Creation of Meaning: A Philosophical and Psychological Approach to the Subjective* (Evanston, IL: Northwestern University Press, 1997).

32. Leslie S. Greenberg and Jeremy D. Safran, *Emotion in Psychotherapy* (New York: Guilford Press, 1987).

33. Ibid., 252–54.

34. Joseph Campbell, *The Mythic Image* (Princeton, NJ: Princeton University Press, 1974), 118.

35. Matthew P. Walker and Els van der Helm, "Overnight Therapy? The Role of Sleep in Emotional Brain Processing," *Psychological Bulletin* 135, no. 5 (2009): 741.

36. Ibid., 743.

37. Daniel J. Siegel, *The Developing Mind: How Relationships and the Brain Interact to Shape Who We Are* (New York: Guilford Press, 1999), 65.

38. K. Christoff, A. Gordon, and R. Smith, "The Role of Spontaneous Thought in Human Cognition," in O. Vartanian and D. R. Mandel, eds., *Neuroscience of Decision Making* (Psychology Press, forthcoming).

39. Siegel, *Developing Mind*, 214.

40. Ibid., 217.

41. Ibid., 219.

42. Ibid., 222.

43. Mark Johnson, *The Meaning of the Body: Aesthetics of Human Understanding* (Chicago: University of Chicago Press, 2007), 136.

44. M. Jeannerod, "The Representing Brain: Neural Correlates of Motor Intention and Imagery," *Behavioral and Brain Sciences* 17 (1994): 187–245.

45. K. M. Kosslyn, *Image and Brain: The Resolution of the Imagery Debate* (Cambridge, MA: MIT Press, 1994).

46. Echenhofer et al., "EEG Correlates of Spontaneous Mental Imagery."

47. Johnson, *Meaning of the Body*, 137.

48. Ibid.

49. Jung, *Memories*, 199.

50. Von Franz, *Alchemy*, 269.

51. Siegel, *Developing Mind*, 71.

52. Heuser, *Ayahuasca Entity Visitations*.

53. For a description of the archaeological iconographic evidence from Huari textiles, snuff paraphernalia, ceramics, and stone sculpture depicting the hallucinogenic plant *Anadenanthera colubrina* and its possible role in Huari shamanic religious practices, see Patricia J. Knobloch, "Wari Ritual Power at Conchopata: An Interpretation of *Anadenanthera Colubrina* Iconography," *Latin American Antiquity* 11, no. 4 (2000): 387–402.

54. Alan R. Sawyer, "Tiahuanaco Tapestry Design," *The Textile Museum Journal* 1, no. 2 (1963): 27–38.

55. Jordi Riba, Sergio Romero, Eva Grasa, Esther Mena, Ignasi Carrió, and Manel J. Barbanoj, "Increased Frontal and Paralimbic Activation Following *Ayahuasca*, the Pan-Amazonian Inebriant," *Psychopharmacology* 186 (2006): 93–98.

56. A. D. Craig, "How Do You Feel? Interoception: The Sense of the Physiological Condition of the Body," *Nature Reviews Neuroscience* 3 (2002): 655–66.

57. Ibid., 658.

58. S. W. Lazar, C. E. Kerr, R. H. Wasserman, J. R. Gray, D. N. Greve, M. T. Treadway, M. McGarvey, B. T. Quinn, J. A. Dusek, H. Benson, S. L. Rauch, C. I. Moore, and B. Fischl, "Meditation Experience Is Associated with Increased Cortical Thickness," *Neuroreport* 16 (2005): 1893–97.

59. D. J. McKenna, D. B. Repke, L. Lo, and S. J. Peroutka, "Differential Interactions of Indolealkylamines with 5-Hydroxytryptamine Receptor Subtypes," *Neuropharmacology* 29 (1990): 193–98.

60. Madhu Kalia, "Neurobiological Basis of Depression: An Update," *Metabolism Clinical and Experimental* 54 (suppl. 1, 2005): 24–27.

61. Dominique Fontanilla, Molly Johannessen, Abdol R. Hajipour, Nicholas V. Cozzi, Meyer B. Jackson, and Arnold E. Ruoho, "The Hallucinogen N,N-Dimethyltryptamine (DMT) is an Endogenous Sigma-1 Receptor Regulator," *Science*, 323 (February 13, 2009): 934–37.

62. T. Hayashi and S. M. Stahl, "The Sigma-1 (Delta-1) Receptor and its Role in the Treatment of Mood Disorders," *Drugs of the Future* 34, no. 2 (2009): 137.

63. Rae R. Matsumoto, "Targeting Sigma Receptors: Novel Medication Development for Drug Abuse and Addiction," *Expert Review of Clinical Pharmacology* 2, no. 4 (2009): 351–58.

64. Jacques Mabit, "Ayahuasca in the Treatment of Addictions," in Michael

Winkelman and Thomas B. Roberts, eds., *Psychedelic Medicine (Vol. 2): New Evidence for Hallucinogic Substances as Treatments* (Westport, CT: Praeger/Greenwood Publishers, 2007), 87–103.

65. Ibid., 97.

66. J. Riba, P. Anderer, A. Morte, G. Urbano, F. Jané, B. Saletu, et al., "Topographic Pharmaco-EEG Mapping of the Effects of the South American Psychoactive Beverage Ayahuasca in Healthy Volunteers," *British Journal of Clinical Pharmacology* 53, no. 6 (2002): 613–28.

67. Ibid., 621–26.

68. David E. Stuckey, "EEG Gamma Coherence and Other Correlates of Subjective Reports during Ayahuasca Experiences," PsyD dissertation, California Institute of Integral Studies, 2004. *Dissertation Abstracts International*, publ. nr. AAT3162121, DAI-B66/01.

69. Ibid., iv.

70. Echenhofer et al., "EEG Correlates of Spontaneous Mental Imagery."

71. Robert W. Thatcher, Carl J. Biver, and Duane M. North, "EEG and Brain Connectivity: A Tutorial—6: What is Coherence," July 28, 2004 to June 13, 2008, http://www.brainfitness.com/researchEEG.html, 17.

72. Francisco Varela, Jean-Philippe Lachaux, Eugenio Rodriguez, and Jacques Martinerie, "The Brainweb: Phase Synchronization and Large Scale Integration," *Neuroscience* 2 (2001): 229.

73. Echenhofer et al., "EEG Correlates of Spontaneous Mental Imagery."

74. Janet Gyatso, *Apparitions of the Self: The Secret Autobiographies of a Tibetan Visionary* (Princeton, NJ: Princeton University Press, 1998), 56.

75. Barbara Stafford, *Echo Objects: The Cognitive Work of Images* (Chicago: University of Chicago Press, 2007), 43–73.

76. Figure 5.5b is an adaptation of a drawing made by Peter G. Roe, professor of anthropology at the University of Delaware. The original drawing is of the male cayman on the Tello Obelisk found at Chavín de Huántar in Peru. This image was downloaded and adapted, with Dr. Roe's permission, from his website at http://copland.udel.edu/~roe/chavin.html#tello.

77. The examination of a series of stone head sculptures at the Old Temple at Chavin de Huantar shows the stages of a priest transforming from human to a jaguar-like being that could serve as an intermediary between the human and supernatural realms. Mucus can be seen flowing from the nose of some of these stone heads, and this has been interpreted as evidence for the use of hallucinogenic snuffs, since these potent substances irritate the mucous membranes of the nose, causing discharges and visionary altered states of consciousness. The San Pedro Cactus is also prominently depicted in the iconography at Chavin, suggesting that hallucinogenic snuffs containing compounds similar to DMT and mescaline from San Pedro probably

facilitated the spontaneous visionary experiences at Chavin and contributed to the development of religious beliefs and practices and styles of sacred art. See Richard L. Burger, *Chavin and the Origins of Andean Civilization* (London: Thames and Hudson Ltd., 1995), 157.

78. K. Christoff, A. Gordon, and R. Smith, "The Role of Spontaneous Thought in Human Cognition," in O. Vartanian and D. R. Mandel, eds., *Neuroscience of Decision Making* (Psychology Press, forthcoming).

79. John G. Neihardt, *Black Elk Speaks* (Lincoln: University of Nebraska, 1998), 46.

80. Mircea Eliade, *Images and Symbols: Studies in Religious Symbolism* (New York: Sheed & Ward / Rowan & Littlefield, 1969), 27.

81. Rudolf Arnheim, *The Power of the Center: A Study of Composition in the Visual Arts* (Berkeley: University of California Press, 1982), 2.

82. Eliade, *Images and Symbols*, 27–56.

83. Echenhofer et al., "EEG Correlates of Spontaneous Mental Imagery."

84. Gyatso, *Apparitions of the Self*, 200.

85. Marylin M. Rhie and Robert A. F. Thurman, *Wisdom and Compassion: The Sacred Art of Tibet* (New York: Abrams, 1991), 321.

86. Angela Sumegi, *Dreamworlds of Shamanism and Tibetan Buddhism: The Third Place* (Albany: State University of New York, 2008), 4.

87. Ibid., 184–85.

88. George Lakoff, "How Metaphor Structures Dreams: The Theory of Conceptual Metaphor Applied to Dream Analysis," *Dreaming: Journal of the Association for the Study of Dreams* 3, no. 2 (1993): 77.

89. J. C. Callaway, "Fast and Slow Metabolizers of *Hoasca*," *Journal of Psychoactive Drugs* 37, no. 2 (2005): 157–61.

90. Mabit, *Ayahuasca in the Treatment of Addictions*.

SIX The New Archaic

. A NEUROPHENOMENOLOGICAL APPROACH
TO RELIGIOUS WAYS OF KNOWING

. Anne C. Benvenuti and Elizabeth J. L. Davenport

Solvitur ambulando. It is solved by walking.
—DIOGENES OF SINOPE, FOURTH CENTURY BCE

Se hace camino al andar. You make the road by walking.
—ANTONIO MACHADO, TWENTIETH CENTURY CE

The cloaked and inwardly directed figure walks the ancient labyrinth that
has been constructed in a contemporary garden from rocks rounded over
millennia by the surge of the river. Her intention is to walk inward as a seeker,
and outward again with new insight taking shape within her (figure 6.1). She
is participating in that kind of knowing into which we enter as entire be-
ings: a multisensory engagement of our physical, intellectual, sensory, and
emotional systems which Barbara Stafford describes as mantic knowing.[1] It
is our hypothesis that spiritual practice such as this creates a specific kind of
mantic knowledge, an integrated situating of humans within a framework of
relationships; and that the neurocircuits created by engaging in such spiritual
practice serve to orient individuals to their place in larger schemes, in an em-
bodied and participatory manner, beyond belief or a set of beliefs and dis-
tinct from intellectual theological interpretation.

We refer to contemporary spiritual practice as a *new archaic* in order to
suggest its continuity with that of ancient humans, a continuity based upon
the body that defines our species, and a suggestion which opens a pathway for
reimagining ourselves. Essentially, we suggest, we share with ancient humans
a need for the binding of fragmentary experience and behavioral practices to
create such bindings. We think, for example, of the Neanderthals who buried
their dead with grave goods, tools, beads, and medicinal plants, apparently in
recognition of the questions raised by their own mortality, and of the mod-
ern humans of the Upper Paleolithic whose painted caves have been inter-

FIGURE 6.1. *The Labyrinth.* Photo by Elizabeth J. L. Davenport.

preted as mechanisms of shamanic journey between ordinary daily life and the realm of the spirits.[2] Our argument builds upon and runs somewhat parallel to that of archaeologists David Lewis-Williams and Thomas Dowson in their carefully constructed case for interpreting cave art of the Upper Paleolithic with reference to geometric light patterns seen within the eye during altered states of consciousness in the experience of twentieth-century shamans.[3] The continuity we propose is based fundamentally upon the shared human body and brain, modern humans being in genetic and phenotypic continuity with the cave-traveling shamans of the Upper Paleolithic.

More recently, archaeologist David Whitley has developed the case that cave and rock art represents ritual performance for the purpose of transformation in the organization of cognitions, particularly in the direction of enhanced creativity.[4] The case we are making is that with modern humans, life on earth entered into a more complex form in which biological, psychological, and social life became inseparable and flexibly interactive, especially as expressed by way of culture. Certainly the cultural context of postmodern global humans is more complex than that of early humans, yet we do claim continuity based in the body and the mechanisms of the body. Neuroscience gives us a unique and previously unavailable window into the biological processes that underlie subjective experience, by way of understanding the brain, which has not changed from those Paleolithic times to ours. Although the content of spiritual practice changes with context and culture, the need for the binding of fragmentary subjective experience does not change because it is based in the body. We hypothesize that performative spiritual practice, which may include ancient or newer elements or a blending of the two, creates such binding.

It is through body and brain that humans experience the subjective sense of "I am" and of being "here, within this world." From this embodied and relational perspective, we access a fundamental and integral sense of human being, and escape imprisonment in the inherently divided and conceptually divisive legacy of Cartesian dualism. This integral sense of being bears relation to the engagement of infants with the world, described by Mark Johnson as an "immanent, preconceptual, nonpropositional meaning [that] is the basis for all meaning."[5] We would align ourselves with Johnson's seeking "an antidote to disembodied and overly intellectualized propositional theories

FIGURE 6.2. *Embrace the Gap.* © Lisa McCann. Used by kind permission of the artist.

of meaning and reason" in our understanding of religion in its essence as performative practice.[6]

The brain is body, yet extends beyond it; and the brain is the aspect of body that permits us conscious self-awareness. Lisa McCann's painting *Embrace the Gap* (figure 6.2) is a visual meditation on the nature of conscious experience as both unitary and fragmented. It suggests the challenge of integrating fragmentary subjective experience, but also its beauty in the present moment. The subjective "I," the subjective "other," and the rules or physics of sensation, perception, and reflection are visually presented in a relational field of the canvas, the contextual whole that contains the images, even as they also suggest opening out beyond the canvas.

Since the mid-1990s, neuroscientists have made continuous progress in understanding how biomechanical operations of the brain give rise to our subjective experiences of self and world. The rapid increase in scientific knowledge has been made possible by new imaging techniques combined with older techniques of measuring electrical activity in the brain, and by an ever increasing and detailed bank of data from clinical cases.[7] What we have

learned about the brain is perhaps best expressed in the single term "complexity." And, as many questions of both theoretical and clinical significance have been answered, the "hard questions" (to use the language of neuroscientists) have become ever more clearly defined. We now know with certainty that we do not know the world as it is, but as we are; we humans share a common experience of the world because we possess common neurosensory mechanisms and brain organization.

The problem of consciousness itself is perhaps the most central hard question: how do these billions of minute neural events create the subjective experience of "I am here" as a unitary experience? Or, to reflect the title of Antonio Damasio's book on the neuroscience of consciousness, how do we get from neuronal events to *the feeling of what happens*?[8] In one of several classic books in which neuroscientists grapple with the question of consciousness, Gerald Edelman and Giulio Tononi suggest that "conscious experience is associated not with a single area of the brain, but with changes of activity patterns occurring simultaneously in many regions of the brain."[9] They add that "what is required [for consciousness] is that the distributed groups of neurons must engage in strong and rapid reentrant interactions."[10] We do not have an answer to this question of how we get from neuronal events to the feeling of what happens, but we will suggest that humans may have developed behavioral strategies to turn the mind back upon the brain in order to be able to live with the complexity of the brain and its attendant threat of fragmentation. Behavior that induces the kinds of neural activation described by Edelman and Tononi may be a mechanism for or manner of constructing a quality of consciousness. The complexity of human experience, as mediated through the brain, must have called for evolutionary strategies for its management.

We have referenced the neuroscientific "hard problem" of explaining the subjective experience of unitary consciousness. The field of religious studies contains a similarly fundamental problem, that of defining what religion is in a manner that accounts for all types of religious expression. Attempts to define religion have broken down because they have tended to focus on one or another element or function of some religions, and have failed to include the varieties of religious experience.[11] In consonance with the etymological meaning of the word "religion" (commonly agreed as derived from *ligare*, to bind, or *ligamentum*, a tie, with the prefix *re-* indicating an intentional

strengthening or renewing of bindings), and rooted in neuroscientific and natural philosophical perspectives, we suggest that religion is in fact a universal human adaptation for the behavioral maintenance of bindings, from the neuronal level, through the levels of subjectively experienced self and world, to the social and ecological, and all the way to the level of transcendence. We propose that religious and spiritual practices are culturally specific forms of a universal type of behavioral strategy for managing the complexity of brain and human subjective experience.

In other words, we are developing a natural theory of religion, with reference to classical and unsolved problems in the fields of both neuroscience and religious studies. We further propose that religious and spiritual practices are not merely vestigial cultural organs, as suggested by early anthropologists Edward Burnett Tylor and James G. Frazer and by contemporary champions of progress such as David Lewis-Williams, who suggests that we are yet traveling out of the caves of the Upper Paleolithic into the realms of reason.[12] We propose that contemporary humans can and should reclaim spiritual practice as an evolutionary adaptation integral to human living. This is what we are naming the *new archaic*, a reclamation of spiritual practice as a universal and culturally old form of biopsychosocially adaptive behavior; and in this new context of meaning, it appears as a performative neurotechnology for bending the mind back upon the brain to orchestrate an especially adaptive subjective "here I am." Further, such spiritual practice intentionally places the subjective self in a context much larger than that of self-concern in everyday life: an individually and collectively adaptive balance to the demands made by our complex human existence, and an assurance of belonging in spite of sometimes dangerous social conflict.

The Brain and Behavioral Binding

In order to make the case for performance becoming person, we need to examine briefly the mechanisms by which behavior can become brain. The human brain, we now know, is composed of multiple networks, connecting but not perfectly synchronous, leading to discontinuity of experience and the anxiety of uncertainty that characterizes the human condition, as we unconsciously fill in the gaps of what we do not know, find that we do not know

our own selves, and experience that we are seen in ways we cannot see. There are four general features of the brain conducive to our line of reasoning that spiritual practice may be a mechanism for integrating neural activities into a unified subjective sense of self in relation to the world: the brain's complexity; its plasticity; the mechanism of mutual adaptation between the brain and the body's systems, commonly described in neuroscience as "bottom-up" and "top-down"; and the brain's essentially social nature. In relation to these four features of the brain, we suggest that integration or "binding" occurs at multiple levels and may be initiated at the level of behavior as well as at that of neurons.

We have all become so accustomed to media images of the two-lobed, crinkly organ that sits on a stem, with some kind of bumps on the bottom, that the real complexity of the human brain is lost to the popular imagination. The ubiquitous diagrams with brightly colored arrows pointing to various functional spots upon its surface or deep in its center sometimes reduce even serious scholarship to addressing brain function in simplified or simplistic fashion (for example, in relation to the supposed "God spot" in the brain).

The true complexity of the brain is difficult to imagine. Consider for a moment that the brain is composed of about one hundred billion neurons, of about 150 different types, with specialized shapes and locations, and that this number is what remains after two major developmental neural prunings that together reduce the number of living neurons by some 50 to 70 percent. Consider that each neuron is a self-organized structure with very specific functions, including decision-making functions (to fire or not to fire), and that neurons communicate across space and are not physically connected, except by the sending and receiving of chemical messages across the synaptic gap. Consider that there are about one hundred trillion synapses, or spaces wherein the communication of individual neurons occurs, and that at those synaptic spaces are teams of glial cells, astrocytes, and oligodendrites that facilitate the health and function of each neuron by digesting neurotoxins, transporting nutrition, assisting in chemical transport and re-uptake, and providing conduction material in the form of myelin sheaths. There are more than sixty identified kinds of neurotransmitters and neuromodulators, with some of the more familiar ones, such as dopamine and serotonin, having different functions at different sites. Consider, too, that the brain organizes

information within and across large functional systems, including the sensory system, motor system, limbic system, and association and executive systems of the neocortex, each of them comprising specialized gathering, organizing, and communicating power.

Likewise, sensory systems break information into minute details, reconstructing it as the subjective percept of sound, sight, taste, or touch. The visual system, for example, can discriminate between six million hues of color, and is composed of retinal rods and cones, each of which receives and sends information about a specific feature, such as motion or a particular color wavelength. This information is then transported by multiple parallel routes to the hippocampus (lateral geniculate nucleus) and then to the primary visual area (Brodmann area 17) in the occipital region. From there, the percept information is routed to about thirty higher-order visual processing centers, all so that the individual can have a picture of the world that is before his eyes.

Yet another significant arrangement of this same dense and compact brain is the bihemispheric organization that permits us to have, in essence, two independent brains in one cranium. Left and right are connected by the corpus callosum, itself made of about three hundred million neural axons to facilitate communication between the two hemispheres. Suffice it to say that the human brain is the most complex system known intimately to humans, with so much yet unknown about it. It seems to us not a far leap to conjecture that we humans might have developed behavioral systems as particular mechanisms for orchestrating our own biological and subjectively experienced complexity.

Not only does the generally complex arrangement of brains hold true for everyone, but each person's brain is uniquely complex as genetic programs, individual interests and abilities, and life experience form its neuroarchitecture. This circular process, the creation of unique neural pathways as individual architecture that resides within the phenotypic organization of the human brain, is called in the language of neuroscience the brain's experience-dependent plasticity. Neuroscientists have established that the brain is not fixed or "hard-wired," but plastic and formed by experience (the process we know as learning) as dendrites continuously connect and disconnect. The individual has autobiographical memory, recorded and revised in the left hippocampus, and procedural memory (by virtue of which one

can ride a bicycle after twenty years of not doing so), residing in the neurally dense cerebellum, as well as more complex forms of association memories whose mechanisms are not yet known. Most forms of memory can be modified with new experience, giving us a vast store of information and range of choices for response to new situations.

Contrary to popular and recent scientific belief, the brain is able to develop new neurons through mitosis. Though this is relatively rare as a neural process, new neurons may be generated in the hippocampus, a paleocortical center involved in new learning, throughout the life span.[13] Illustrative for our purposes, behavioral events can influence this process. Recent findings indicate, for example, that older mice who engage in physical exercise have greater capacity to generate new neurons in the hippocampus.[14] It is much more common, however, for individual experience-based neuroarchitecture to be developed through synaptic plasticity (the ability of individual neurons to use up to ten thousand dendritic connections to reach one another). The mechanisms of synaptic transmission function to prune and to grow new connective branches, and to become more or less efficacious by modifying the chemical messages between neurons.

To illustrate this experience-dependent plasticity of the brain, let us consider the case of an older infant who is attracted to music. She may receive information about rhythm and pitch in her auditory center, yet may be unaware of her particular attraction to it as she moves her little legs toward a piano or source of recorded sound. This interest in which her body participates, her awareness of tone and of tonal differences in sound, and the proprioceptive sense of body movement to accompany the rate of the changing tones, or rhythm, becomes a part not only of her musical knowledge but also of her implicit embodied sense of self, developed in her right frontal cortex during her infancy.[15] As she grows and forms an abstract understanding that she is a musically gifted person, this will become part of her autobiographical self, created and revised in the left hippocampus and likely routed to the right frontal cortex to be integrated into the implicit, or unconscious, sense of self.[16] Finally, these two processes of information ("bottom-up," or body to brain, and "top-down," or brain to body) form her subjective sense of self and of the world in intricate and ongoing ways. She is moved by the music she

makes and she experiences herself as the music — or at least as being "about" the music, and the music is, in a very literal way, making her.

We see in this example the circular relationship between the child's natural interest in music, her engagement in activities related to music, and the way in which these activities create patterns of neural connection in her brain structure: the auditory center, the "language" center of the right hemisphere with its specialization in the prosody of speech, and related motor areas, in addition to those higher-order association areas with which she learns to read, write, perform, and "think" music. In adulthood, the planum temporale region of her left hemisphere will be larger than the same region in a non-musician.[17] In fact, if she grows up to be a concert pianist, the neural map in her somatosensory cortex will contain a greater than normal representation of each finger of each hand as a consequence of her repeated use of and attention to her individual fingers. The activities of her fingers will have created the capacities of her brain, just as surely as the capacities of her brain enable her to engage musical activities.

Another common experience of the "bottom-up" and "top-down" exchange is the use of a soothing image to calm uncomfortable physiological arousal (and there is both a medical literature and an industry to support the use of imagery as intentional manipulation of body-brain interaction).[18] Likewise, individuals practice self-modulation of body and brain by engaging in activities that stimulate the chemical release of pleasant sensations: tasty meals, delightful sexual encounters, favorite hobbies, walks in nature, and, we posit, spiritual practice or ritual.

One further example illustrating the mutually modifying interaction of body and brain, relevant to our purpose, is the placebo effect. Until recently, this term was used derisively to indicate that some effect was "all in the head" of the person having the experience. When the light of research was turned upon it, however, the placebo effect began to be described as a powerful natural mechanism that might be intentionally manipulated for human well-being.[19]

The fourth feature of the brain that supports our thesis is the fact that the human brain is essentially social, which is evident in a number of its specific features: the human sense of hearing is specifically tuned to the range of

sounds that are made by human voices; the visual sense has specific mechanisms for face recognition; and humans are born with an "instinct" for learning language, as evidenced by the natural capacity to acquire grammar. Steven Mithen suggests that humans also have universal capacities for understanding and learning music, and Michael Gazzaniga hypothesizes the same for social mores.[20] Humans, of course, like many other mammals, have mirror neurons in motor and limbic areas—in the former to facilitate the learning of motor skills, and in the latter to engender the sense of empathy. It is broadly accepted that, for humans, what is biologically adaptive is not only that which gives individual survival and reproductive advantage, but also that which facilitates cooperative social living. Although there is ongoing debate about which evolved first to facilitate the arrival of the others, highly complex social life, language for communication and generation of information, and technological capacity are the hallmarks of human specialization.[21] John Cacioppo, Penny Visser, and Cynthia Pickett describe the complexity of human social life thus: "In short, humans have evolved a brain and biology whose functions include formation and maintenance of social recognition, attachments, alliances, and collectives; and development of communication, deception, and reasoning about the mental states of others."[22] The essentially social life and intelligence of humans imply a requirement for strategies that are adaptive at the level of relationship and context.

In summary, these general features of the human brain (its complexity, plasticity, mutually modifying relationship with the body, and essentially social nature) point to the complexity of human life well beyond the level that is biologically necessary for mammals in general, and beyond that of nonhuman primates and other social species. Each individual human brain shares a common phenotypic structure and organization, yet is modified by culture, allowing the collective mind of the past to interact with the individual mind of the present. This encultured brain is further differentiated within the universal species phenotype and cultural context by its own unique experience of the world, and by its capacity to modify what is "out there" on the basis of how it is experienced "in here." Taken together, these facts about the brain, and the life whose subjective experience it creates, describe the mechanisms by which practice can become person and also form a case for the adaptive

advantage of managing subjective complexity by way of behavioral intervention.

Disintegrations

The complexity of human lives and human brains is necessarily related to a tendency toward varieties of disintegration at multiple levels. While this is especially true at the level of complex emotions (jealousy, love, and pride, for example; in contrast to basic or primal emotions essential for survival, such as fear and rage) and the social context out of which they arise, it has also become a model for understanding human disease conditions.[23] The biopsychosocial continuum is now seen as a continuous communications system whose dysregulation causes disease. James Parker, Michael Bagby, and Graeme Taylor note a "growing realization in medicine and psychiatry that most illnesses and diseases are the result of dysregulations within the vast network of communicating systems that comprise the human organism."[24]

At the level of neural disintegration, the clinical case records are replete with the strange, fascinating, and tragic ways in which the cohesion that most of us take for granted may come apart. In the extreme, injuries to the frontal cortices—like those experienced by Phineas Gage, a classic subject of neuroscience literature—or diseases like Alzheimer's may cause a loss of the subjective experience of self. Injuries to the hippocampus can prohibit new learning, leaving older memories intact. People with serious neck injuries may lose the sense of their body's complete information and become emotionally dulled as a consequence. It is tragically common that an individual's endogenous reward system is hijacked by a foreign substance, such as cocaine or alcohol, and his capacity for moral behavior lost as part of an addiction process.[25] All these instances, and many more, are recorded in the annals of neuroscience. Add to these rather unusual cases an extreme that we all experience: we live our lives in awareness of an ultimate disintegration, that of the subjective self of consciousness from the embodied self who lives. We humans, with all of our emotional elaboration and sensitivity, live in explicit awareness of death.

Most disintegration in the biopsychosocial life of humans is more subtle

and mundane, however, than that described in the literature of clinical neu-rology. Discussing normal emotion-regulated life, Joseph LeDoux notes that lack of awareness of emotional states is the norm, something that most people tend to reject, disliking the notion that we typically do not control our own feelings and that the body creates them: "Absence of awareness is the rule of mental life, rather than the exception, throughout the animal kingdom. . . . Emotional responses are, for the most part, generated unconsciously. Freud was right on the mark when he described consciousness as the tip of the men-tal iceberg."[26] The field of psychotherapy is given to conscious integration or reintegration of aspects of the self, or of the self in the social context. Psy-chological disintegration or disharmony is also neurally modulated, as is all human experience. Mood disorders are instances of affect dysregulation, in most instances acquired developmentally and treated therapeutically as neu-rological dysregulation at the biological level and as lack of self-awareness at the level of subjective experience (we often experience a discrepancy be-tween a person's autobiographical self and our experience of that person in social contexts: for example, when a person says he is not afraid, yet appears hyper-attentive to any sign of threat or danger). The treatment of choice is to bring the developmental disintegrations into conscious awareness by creat-ing neural connections between the right frontal and limbic centers and the narrative regions of the brain through the cognitive process of talking about it in psychotherapy.[27]

Another area of disintegration is that which occurs socially. All the emo-tionally motivated problems of social life, from violent crime to petty bick-ering, may also be interpreted in terms of lack of integration in the subjec-tive social experience of people. A certain degree of social disharmony may best be accounted for as competition for resources, but much else is a con-sequence of the underlying biology of attachments and social alliances with their attendant complex emotions, rather than being directly physiologically motivated. The "theory of mind" that is the hallmark of human social cog-nition, by which we guess what someone else is thinking and feeling inside of themselves, is necessary and fallible, and some people are more successful than others in this crucial social cognition; consider the arguments that result from incorrectly reading the mind of the other![28]

A further area of disintegration that must necessarily be added today to

the list of neural, psychological, and social dysregulations is that of ecological disintegration: the separation of humans from nature that at least Western humans typically experience as part of their subjective media-driven and technologically shaped lives. The consequence of this disintegration is the cognitive substrate of ecological destabilization that threatens the human species in a new and unprecedented way.

We return, then, to our hypothesis that religious and spiritual practices are adaptive behavioral systems for managing the complexity of the brain and the subjective experience of self embedded within complex relationships. This neuroscientific approach to religious behavior, we note, does not reduce religion to something other than what it understands itself to be— namely, a system for maintaining the bonds of relationship as necessary to life itself, fulfilling the ethical behavioral requirements of human lives, and adding meaning to biological necessity, all within the context of the greater whole. The regulatory or integrating aspect of spiritual practice is especially important in consequence of our complex emotional nature and social life, which exists at the cost of sometimes maladaptive behavior and emotional pain, including awareness of our own impending death.

The Shaman's Dance and the High Mass

We have repeatedly referred to religious and spiritual practice as being adaptive. Roy Rappaport describes adaptation as the mechanism whereby "living systems of all sorts—organisms, populations, societies, possibly ecosystems or even the biosphere as a whole—maintain themselves in the face of perturbations continuously threatening them with death, disruption, or extinction."[29] It is in this sense that we suggest that religious and spiritual practice is adaptive for humans. And here we must pause to consider what it is that constitutes such practice. Although religion is notoriously difficult to define, it is characterized by practice that may broadly be called ritual, and also by ideas or beliefs. While recognizing that it is difficult to imagine a religion without verbal transmission of ideas, it is our contention that performative practice is the essence of the adaptive mechanism of religion. We have stated that spiritual practice is complex and multimodal, involving intentional stimulation of multiple sensory and motor systems, the limbic system, and higher-order

thought processes. And we have suggested that the intentional performance of these complex acts for the purpose of binding does in fact create binding.

While admitting to the challenges of defining ritual, Catherine Bell suggests the following considerations:

> First, ritualization involves the differentiation and privileging of particular activities. Theoretically, these activities may differentiate themselves by a number of features; in practice, some general tendencies are obvious. For example, these activities may use a delineated and structured space to which access is restricted; a special periodicity for the occurrence and internal orchestration of the activities; restricted codes of communication to heighten the formality of movement and speech; distinct and specialized personnel; objects, texts, and dress designated for use in these activities alone; verbal and gestural communications that evoke or purport to be the way things have always been done; preparations that involve particular mental or physical states; and the involvement of a particular constituency not necessarily assembled for any other activities.[30]

In this list, we would emphasize the multisensory and performance dimensions of ritual practice: things that engage the auditory and olfactory senses, music and bells and incense, and movement involving the body, from postures to processions to prostrations. Even those practices aimed at stilling the senses and the mind, as in most forms of Eastern meditation, are introduced by way of ritual and with the aid of ritual objects, such as the bowing of the body or burning of incense, and with the use of specific postural supports and body coverings.

Given the plasticity of the brain, the mutually modifying relationship of body and brain, and the social nature of human cognition, it seems obvious that the repetition of such practices would create neural architecture for the experience of cognition of a mantic type, in which the individual learns to navigate the relational map of subjective reality and to be oriented to his place within that relational map. In the case of spiritual practice, this knowing is greater even than the individual's mantic knowledge of belonging to her own group and kin; it is essentially an encounter with what is greater than self and even tribe or nation. This binding encounter is likely to be of

high valence for limbic structures and for emotional integration and motiva-
tion. LeDoux, commenting again on the normal use of behavioral strategies
for emotional self-regulation but in terms relevant to ritual, says that "exter-
nal events are simply arranged so that the stimuli that automatically trigger
emotions will be present. . . . [C]onnections from the emotional systems to
the cognitive systems are stronger than connections from the cognitive to
the emotional systems. Finally, once emotions occur they become powerful
motivators of future behaviors."[31]

Certainly there are variations in the behaviors practiced and in the expla-
nations provided for them, and we do not pretend to be able to evaluate all
instances of religious practice in terms of how they fulfill their adaptive his-
tory or promise. But our contention is that varieties of religious practice are
expressions of a universal adaptive strategy. Spiritual practice that engages
this mantic kind of knowing, we suggest, represents an ancient cultural map
for the creation of a neural map by which we locate ourselves as humans in the
world, finding our place in the greater whole.

Neurologist, neuroscientist, and artist Audrius Plioplys speaks to connec-
tions between spiritual practice and neuronal complexity in his image *Theo-
logical Thoughts* (figure 6.3), of which he says: "The neuronal arborizations re-
veal underlying artistic processes, artistic memories, and creative thoughts.
From neuronal complexity thoughts emerge, words emerge, and theology
emerges."[32] With this in mind, let us move to consideration of spiritual prac-
tice as neurointegration. When we consider the elements of religious rit-
ual—from the sensory spare forms, such as a Quaker prayer meeting or a Zen
meditation session, to very culturally elaborate forms, such as a high mass or
a tantric Buddhist celebration—we see that the event is neurologically multi-
modal and most often communal, or at least oriented towards a community.
A lone meditator, for instance, has learned meditation from people who rep-
resent a lineage, and he meditates not only for himself but for the well-being
of the whole. For millions, such practice comes in the shape of practicing yoga
or meditation, in saying prayers at regular intervals, or in attending mass; for
others, it might be speaking in tongues, engaging in ritual purification, say-
ing the rosary, inducing shamanic trance, or interpreting visions induced by
fasting. In each of these ways, virtually the whole neural capacity of a human
being in a waking state is directed by the practice: the sensory systems are

FIGURE 6.3. *Theological Thoughts.* © Audrius V. Plioplys. Used by kind permission of the artist.

engaged, the motor system is engaged, the limbic system is engaged, and the association and executive areas are engaged, all in a manner ritualized to create mantic knowledge.

The cloaked woman of the labyrinth image, with which we began, is removed from her ordinary life by the putting on of her mantle; she does not

merely think or talk about things spiritual, but symbolically alters her very self, walking the inbound spiral with inward gaze. She may already have fasted and prepared herself by disengaging from everyday life. And then she walks within an inherited imaginal structure that is related to her community of practitioners and her natural environment: she not only integrates all of her sensory modalities, but integrates them with her ancestral lineage by way of the archetypal image of the labyrinth. This practice, one among many of its kind, serves to bring the practitioner's consciousness out of the ordinary and into a specific form of altered state — one within which humans are oriented to their place in the whole.[33]

The shaman participates in a similar knowing in his dance, a behavioral technology for the alteration of consciousness that has attracted the attention of neuroscientists, who have confirmed that in the dance his entire brain is engaged.[34] Understood from this perspective, the shaman's ritual is not mere entertainment, but rather a multiple set of symbols in which he involves all his senses, using visual images, incense and rhythm, music and movement. He too has put on a symbolic costume or painted his body so as to alter it to express another way of being a human. And when he raises his feet in imitation of the movement of the crane, he stretches forward his neck and flaps his great wings in a movement that is not practical for a human. Why does he do this? It is to bring his own consciousness and that of his community, by vicarious participation, into a new relation, in this case with particular emphasis on relation to the spirits of nature specific to his location.[35] When the shaman visits the spirit world on behalf of his community, he is the community, he is the world, and he is himself. In his evocative work hypothesizing the evolution of music as a precedent of language, Steven Mithen describes the ways in which music, rhythm, and dance were likely used in a similar manner by Neanderthals as mechanisms of communication and something we might call "community building."[36] These actions cannot be reduced, by way of explanation, to expressions of primal fear, nor to a desire to control the uncontrollable; rather, they are multisensory and multimodal feats used intentionally to remove the shaman from ordinary waking consciousness and to take him elsewhere, to a place that is consistently described as not less but *more* real than everyday life.

In order to illustrate the particular quality of mantic knowing that we hy-

LEVEL	APPROXIMATE NUMBER OF YEARS SINCE PERIOD OF ORIGIN	APPROXIMATE MEDIAN DIAMETER SIZE (IN METERS)
Cell	3×10^9	10^{-6}
Organ	$5 \times 10^{8}+?$	10^{-3}
Organism	5×10^8	10^{-2}
Group	5×10^8 ?	10^{-1}
Organization	1.1×10^4	10^2
Society	7×10^3	10^6
Supranational System	4.5×10^3	5×10^6

FIGURE 6.4. Holon. © James Grier Miller, *Living Systems* (McGraw-Hill, 1978). Reproduced with permission of the McGraw-Hill Companies.

pothesize to be the goal of religious practice, we draw upon the holarchical principle from systems theory.[37] This principle is based upon the idea that everything that exists is a part of both more complex and less complex organizations. Human bodies, for example, are parts of ecosystems and social systems that organize and orchestrate them, and these same bodies serve as organizers for the cells and organs that in turn comprise them. It is through the brain that we subjectively experience these nested holarchies—the brain that gives us the means to experience, know, and navigate them (and, over millennia, to mark paths of spiritual pilgrimage with archetypal rock cairns strikingly similar to the images of nested holarchies that are used to illustrate

FIGURE 6.5. Rocks on the isle of Iona. Photo by Anne C. Benvenuti.

a systems view of reality; see figure 6.4). In this schema, religious knowing allows us the subjective experience of ourselves within that of which we are a part, comparable perhaps to how it might feel to be a cell waking up to its place within the body and intuitively knowing itself within the greater whole. It is commonplace to understand that we can dissect that which lies

"below" us on a systems scale, to see how it is constructed and to explain its workings; but we must orient ourselves differently to that which is "above" us on that scale, and we are able to do so because as humans we have within us the capacity for multiple modes of cognition and even consciousness. Religious practice, as we have suggested, is a kind of biological technology for neural integration of our situatedness in greater wholes, in contrast to the workings of ordinary consciousness, which we generally use to manipulate the world to our purposes. This orientation towards cohesion or integration is a necessary balance to our tendencies toward disintegration.

We should note at this point, by way of disclaimer, that neuroscientists cannot prove (nor should they seek to prove) that religious experience can be reduced to a series of neurochemical events in the brain, nor that such neurochemical events point to the existence of "God" or the gods.[38] It is, of course, a fundamental misunderstanding of epistemological issues to think that science can prove the existence of a divine being, or the lack thereof. Scientific methodology is necessarily reductionist, and it can tell us about parts and their relations. It is the grasping of the whole that religious knowing permits, but only as an intersubjective event and not by objective or measurable means. What neuroscientists can do is describe the objective correlates of subjective religious experience, and we may extrapolate interpretations from these correlates. Of course, as Eugene d'Aquili and Andrew Newberg rightly note, all experience is equal in this regard, which is to say that the experience of eating apple pie has neural correlates in the same manner as does religious experience.[39] The neural participation neither reduces, expands, nor explains the pleasure of eating, but simply happens along with it. With an understanding of the neural correlates of religious experience, however, we believe it is possible to construct an epistemological model, using a neurophenomenological approach that sheds light on the functions, both positive and negative, that religion may play in human life.

The Neuroscience of Spiritual and Religious Practices

There exist already significant findings in neuroscientific research to support the notion that religious practice creates and maintains integration within the brain, correlating to the described experience and intention of religious

practitioners. Further, neuroscientific findings support the notion that the cognitive and behavioral dimensions of the lives of religious practitioners are changed by such practice in ways that correlate to the subjective experience of its being more "real" and meaningful than ordinary consciousness and its concerns.

In particular, neuroscientists (and those who seek to interpret their findings) have paid significant attention to correlates of religious or spiritual activities. Anne Runehov, in her analysis of Michael Persinger's research on the right temporal lobe, concludes that Persinger's demonstration of the greater than normal activation of the right hemisphere in states of religious experience, and of the neural activity necessary to the coordinated interaction of right and left hemispheres which occurs immediately after initial right-hemispheric activation, is tantamount to *activation of virtually the entire brain*.[40] This coordinated effort of the brain is an example of the kind of integration of brain circuitry that we propose religious practice accomplishes.

Eugene d'Aquili and Andrew Newberg offer a universal and neural description of religious practice, based upon observable neural correlates and the ways in which such practice creates a mystical state of mind.[41] Their model posits two categories of ritual practice, fast (as, for example, in Sufi dervish dancing) and slow (as in meditation), each of which creates a condition of "overdrive," an overdrive of quiescence in the practice of slow ritual and of arousal in the practice of fast ritual. D'Aquili and Newberg propose that when the state of overdrive is reached, it in turn activates the complementary state, so that the end result is the simultaneous activation of two complementary and non-ordinary states of consciousness. This experience is later interpreted by verbal means, creating a further integration of these states with ordinary cognitive processes, and it is filtered through individual and cultural lenses to create the myriad forms of religious expression that we encounter.

Significantly, these intentionally induced states of mind and their cultural-religious interpretations also lead to alterations of behavior. James Austin, in his study of Buddhist monks, found that enhanced activity in regions of the brain associated with equanimity creates a long-lasting effect expressed later in persistent positive changes in attitude and behavior.[42] Commenting on these findings, noted scholar of religion John Hick says that the experience

of enlightenment "changes the way that subjects think about themselves and about the rest of the world, and it transforms their behavior."[43] This indicates that sequential levels of integration, from integration within the brain to social integration of behavior, occur as a result of religious practice.

D'Aquili and Newberg also emphasize the role of "deafferentation," or the neural inhibition of information that allows the brain to experience itself as mind, independent of sensory input.[44] When certain association areas of the brain, normally assigned to create a sense of subjective location in time and space, are deafferentated (as may occur during practice of meditation), the mind experiences itself as infinite and as a unitive part of a greater whole. This is the experience of the cave as described by Barbara Stafford in her Templeton Lectures: the cave as the locus of that inner sky which becomes accessible under conditions of sensory deprivation.[45] In the cave it is clear that nothing is clearly defined, and that the deafferentated mind, given this physical context, might experience itself as pure mind, or as one with all being.

The work of d'Aquili and Newberg further suggests that meditative individual devotion and group ritual practices have two important common neural components: the emotional discharges that are subjectively described as experiences of awe, peace, tranquility, and ecstasy, and varying degrees of unitary experience. "The result is a decreased sense or awareness of the boundaries between the subject and other individuals. This breakdown of boundaries allows for a heightened sense of community among individuals."[46]

In independent studies of two different forms of Buddhist meditation practice, Richard Davidson and James Austin (to whose study we have already made reference) each found evidence of non-normal activation of the left prefrontal cortex which corresponds with subjective reports of happiness, and with more positive interpretations in general.[47] Perhaps we should consider these positive states of mind that have been intentionally induced by way of ancient technologies of spirit to create lasting change in the brains of those who engage them. In a discussion of spirituality, suffering, and the self, James Giordano and Nikola Boris Kohls speak of a similar effect with regard to the experience of pain: "Pain can be both an intrinsic part of the person, and a way of being in the world—it becomes part of the self, may define the self, and can become something greater than the self."[48] Might joy, with a corresponding experience of "ego reduction" or perceived greater unity of

the self with the rest of reality, have similar effects of deep and long-lasting change? The research of Davidson and Austin seems to indicate that such is the case: that fundamental positive emotional states can be cultivated by way of spiritual practice.

We might add that these varying degrees of unitary experience are likely to contain subjectively experienced differences of content, correlating objectively to differences of integration in neural circuitry, so that a whole series of nested integrations may be created and maintained by way of the variety of religious practice. Thus, in d'Aquili and Newberg's words, religious experience "facilitate[s] both a reorganization of the personality structure and a realignment of the individual toward the cosmos."[49] In this context we would allow for multiple layers of potential integration within a series of nested holarchies: the internal integration of aspects of the self, such as conscious and unconscious content of mind; the integration of social groups by way of both neural entrainment via music and movement and cognitive commitment via creeds and prayers; and the integration of self and/or social group into the local ecosystem or the planet as a whole.

Also strongly supporting our hypothesis regarding non-ordinary neural integration at multiple levels is the research of Mario Beauregard and Denyse O'Leary on the neural correlates of mystical experience in a group of Carmelite nuns.[50] Beauregard and O'Leary developed a research strategy of using memory recall of past mystical experiences to measure the neural correlates of such experiences in the laboratory. They wanted to determine whether the vaunted "God spot" in the brain existed, and specifically whether that spot was located in the temporal lobes, as had been repeatedly suggested. But instead of any such spot, they found a complex and non-ordinary activation of no fewer than seventeen distinct brain areas, in both hemispheres and at all levels. They concluded: "RSMEs [religious, spiritual, and mystical experiences] are complex and multidimensional and mediated by a number of brain regions normally implicated in perception, cognition, emotion, body representation, and self-consciousness."[51] Their list of brain areas activated by the RSME state includes numerous distinct regions of the brain, regions that under "normal conditions" are associated with the activities of everyday life. It is likely then that these regions are integrated with each other differently in mystical states of mind.

Discussion of Research and Questions

These results suggest further questions to be asked about the relationship between religious practice and the mystical mind. Does ordinary religious practice create and strengthen the circuitry that is necessary for profound mystical or spiritual experience? If so, is the circuitry to be valued for the spiritual state it potentiates (traditional spiritual direction in most religions would respond in the negative to this idea), or does it have other effects at less intense levels of activation? We posit that religious practice makes possible the subjective experience of mystical and spiritual states, and that these states may be advanced levels of recognizing or intuiting the integrations or unifications that have been occurring through such practice as the practitioner develops and grows. In other words, we expect that in most people, religious experience is at least partly a consequence of having practiced and learned *skills of internal behavior*, and that it is the gradually altered self rather than the ecstatic non-ordinary experience that is the highly valued outcome of these skills.

It is our expectation that cumulative neuroscience research will show that ordinary religious practice brings about integrated neurocircuitry that is distinct from "ordinary consciousness" but may be continuous with it, and that such practices may also create neural networks for extraordinary religious experience. We expect that most religious consciousness will be not so non-ordinary as to be unspeakable after the manner of states of shamanic trance, samadhi, epileptic seizures, or hallucinogenic experiences. Rather, it is likely that a parallel interpretive neural structure is developed along with skill in reaching it and using it. Interpretation of events from within the context of the "big picture" rather than from the point of view of ordinary consciousness (based on the emotional valence of objects in the world for "me and my purposes") is likely to flow from and feed back into such a religious neural architecture.

We expect that the key component at the heart of the neurological correlates of religious experience will be varieties of integration: the integration of neurons and neural circuits in states not facilitated by ordinary waking consciousness, and, on the side of subjective experience, the integration that practitioners experience in cognitive and behavioral ways by feeling better,

by creating a sense of possibility, or by supporting behavior more in keeping with their self-expectations or desires.

Objectively, then, religious practice (ritual and also practices involving mental concentration and ethical practices) may be demonstrated to create neural circuitry that integrates the brain in ways distinct from ordinary waking consciousness, correlatively creating in the mind the subjective experience of meaning: literally giving coordinates for the mapping of reality within the self and the placement of the self within a greater reality. This coordination to our place within larger systems is the objective biological requirement for maintenance of balance in the ecosystem that is our human niche. Because we can override the natural balances of life forms in ecosystems by way of technology and culture, however, we are able to bring ourselves, and other species and systems, to ultimate disintegration in a way that no other species can. The subjective experience of this objective reality includes, therefore, the religious and ethical imperative to behave in caring ways and to limit the satisfaction of desire by practices of self-discipline so that we might survive, transcend ourselves, and perhaps even transform the nature of consciousness itself.

We should note that there remains neuroscientific work to be done in investigating and providing clearer definitions of ordinary waking consciousness, in mapping altered states of consciousness, and in offering information about the interaction between these different states. There remains work also for ethicists, for whom the suggested connection between archaic integrative practices and ethical human behavior offers a rich field of investigation, and for philosophers, who might take findings from neuroscience in regard to the ritual and praxis of religion and use them to further develop comprehensive models of intersubjectivity.

We should also note, of course, that there are other kinds of ritual performance that are not always easily distinguished from those we call religious and spiritual practices. Among these are the arts (and, some might add, baseball!), with their expression via image and other sensory mechanisms, and their capacity to evoke strong emotional experiences and motivational states. The distinction may be that in spiritual practice, those present are participatory in a different manner. At the ballet performance or the ballgame, members of the audience watch "out" from within the self. In spiritual practice,

the self enters into the encounter repeatedly with his whole being, forming his very self upon the ritual in which he participates. Nonetheless, while this distinction is important, we do not want to reduce the similarities between spiritual practice and performative art because we expect that in the end they operate on persons by way of similar mechanisms, especially with reference to neuroarchitecture and cognition.

Another arena that has profound resonance with our description of religious and spiritual practices and their effects is that of medicine, or the healing arts, and especially psychiatry and psychology. Joseph LeDoux, speaking of that largely unconscious emotional brain to which we referred earlier, says: "Mental health is maintained by emotional hygiene, and mental problems, to a large extent, reflect a breakdown of emotional order. Emotions can have both useful and pathological consequences."[52] To the extent that spiritual practices may be able to create and maintain "emotional hygiene," the world of religion may have something to share with mental health practitioners.[53] Conversely, of course, to the extent that religious practice may create emotional dysregulation, mental health practitioners may have something to share with the world of religion. Not surprisingly, the general move towards more complex models for understanding and treating human affliction has resulted in the active incorporation of spiritual practices, particularly mindfulness meditation, into the treatment of mental and physical illness.[54] Lawrence LeShan notes the tensions that come with the tradition of psychotherapy having descended from parents from two different paradigms: a medical paradigm in search of cure, and a spiritual paradigm in search of healthy self-realization.[55] The medical literature on palliative care makes the distinction between cure and care, or cure and healing, in recognition of the fact that much of the suffering of human life is "incurable" and requires a different approach than that typical of medical methods.[56]

The religious perspective is about healing, as it may have been for those early ancestors surrounded by their cave paintings.[57] This is evidenced by the fact that most rituals and spiritual practices invoke the brokenness of incompleteness or the anxiety of normal human life as a typical "second act" after naming the ritual or gathering, and before offering the reconciliation, treatment, or transformation. Within this broad scope of healing that is a

large part of religion's domain, medicine and psychotherapy are specialized and secularized, and yet they share both mission and techniques for healing. Anthony Clare, speaking of the goals and methods of psychiatry in an evidence-driven model, concludes that "psychiatry, of all the branches in medicine, is concerned with the most intricate and challenging questions concerning human life, namely the relationships between brain and mind, between genes and environment, between the individual and the group, between family and society, between the transcendent and the mundane."[58]

Implications for Other Fields of Study

We have offered elements of a natural theory of religion in which praxis is primary—for its capacity to create the neuroarchitecture, subjective experience of mantic knowledge, and orientation of the brain, self, and community of practice—to a sense of being embedded within and responsible to a network of relationships. We hypothesize that religious knowing has religious practice at its core, that religious knowing is beyond words because words are essentially a reduction of reality, and that religious knowing has as its goal the situating of humans within the greater whole of reality. We are speaking both of a way of knowing and of a body of knowledge, but suggesting that the way of knowing is definitive: it nourishes and vitalizes the knower, situating her within the nest of holarchies within which she exists and upon which she depends.

The neuroscientist, by locating and describing the neural mechanisms, can describe religious knowledge in ways that simultaneously demonstrate its value and point to the wholeness in which it exists. The ground is thus prepared for a new theology held accountable to compatibility (or at least respectful conversation) with scientific knowledge, a theology that may embrace the non-rational, nonverbal, and nonlinear without condoning, much less practicing or requiring, irrationality; and a theology that is grounded in the body instead of in opposition to it. Dogma and faith both fade in the context of practice, the religious experience—the inner workings of which can now be measured in and described as the workings of the neural processes of the brain. For the field of theology, this predicates practice and mantic

knowing as primary, and hermeneutic knowing, or interpretation, as second-ary, thus representing a major shift of emphasis from the theologies of the modern era.

For the field of religious studies, we are suggesting a new approach to the thorny question of religious epistemology. The fact remains that, two cen-turies of modern and postmodern scholarly exploration notwithstanding, no definitive understanding exists in relation to what religion is and what it does. In contrast to scientific knowing, religious knowing appears to be with-out grounding in material reality and to lack method for demonstrating its own validity, even for those who embrace its basic worldview. Consequently, any religious knowledge claim is seemingly as good or bad as any other; and religious knowledge appears entirely subject to vagaries of individual prefer-ence or cultural predisposition (though it should be noted that religion has an historically ancient and cross-culturally shared validation for spiritual ex-perience, especially claims to revelation, in the form of behavioral outcomes including the capacity for compassion). Neuroscience stands to make the contribution of describing not only the neurological correlates of religious experience, but also the influence of such practice on brains over time. This objective foundational knowledge may be a major building block towards a new religious epistemology constructed in more complex style, and center-ing the performative and artistic rather than relegating them to the periph-ery. This is perhaps similar to the way in which the world of medicine, espe-cially by way of neuroscience, has already moved (back) in the direction of acknowledging the spiritual dimension of healing, particularly in relation to the subjective experience of pain and the ultimate certainty of death for ev-ery patient. Such an articulated and validated form of religious epistemology suggests a foundation for understanding and evaluating religious knowing. This foundation would then provide a context in which scholars of religion can conduct the kinds of intergroup reliability analysis of religious knowing that has been suggested as a strong model for its social validation.[59]

Not surprisingly, the recognition of the significance of neuroscientific findings for religious studies, in terms of the relation of the subjective experi-ence and objective world in the context of an intersubjective paradigm, holds implications for other fields of study as well. In the health sciences, this model would point to designating forms of practice targeted to the specific needs of

individuals in a kind of clinical model of spirituality. The patient with a strong sense of self but a culturally mandated disconnection from bodily experience, for example, would be helped to find practices that awaken the body, creating an integration of the narrative self and the embodied self. In the social sciences, it would point to the encouragement of practices that bring about integration between self and community. In the biological sciences, the ritualized integration of human communities with the natural world—the arena of our most intractable and threatening problems—might be emphasized.

We are suggesting, then, that religious knowing is in its essence experiential, wholistic, and integrative, and that neuroscience can demonstrate this in accordance with scientific norms. This opens the way for the growth of a new archaic, the embrace of what is human beyond words: the knowing embodied in the shaman's dance, in contemporary sacramental and ritual practice, and in the adornment of old monuments with new garments—a practice that is literally carried out all over the world in a spirit of reverence, as in the new dressing of the ancient statue of the Hindu god Vishnu (figure 6.6).

What we call the new archaic is the postmodern search of inherited religious traditions for medicine to treat the ailments resulting from human alienation from ourselves, each other, and the natural world that is so easily a consequence of our complex and discontinuous consciousness. We suspect that traditions of spiritual practice do potentially contain several of the medicines we seek, in addition to inert and toxic components. One of the intellectual tasks of our century may well be the new gleaning of what is valuable in these archaic modalities of practice, including contemporary reinventions. And a first step in this task will be to understand more fully the ways in which spiritual practice serves to integrate and regulate human beings, from the level of neural networks to the level of ecosystems.

We propose that the integrations created through embodied religious practice are knowledge states necessary to the integration of a self that is otherwise experienced as fragmentary and unrelated, to the social cohesion that is a hallmark of human ways of living, and to human and environmental integration. And we suggest that neuroscientific demonstration has the potential both to ground religious knowing in observable, material, and shared reality, and to provide a theoretical model that transcends particular practices or religious traditions. Spiritual knowledge may distinctively serve along with

FIGURE 6.6. Refurbishing the old. Photo by Anne C. Benvenuti.

science to articulate the nature of reality, but from a viewpoint within the context of the whole, rather than from the perspective of the relationship of the parts. It is this larger context that science, religion, and all human endeavor serve; and in the process we find our own well-being. At least, such is the perspective of religious knowing.

Notes

1. Barbara Maria Stafford, "Crystal and Smoke: Putting Image Back in Mind," *2008 USC Templeton Lectures*, http://www.usc.edu/schools/college/templetonlectures/.

2. Steven Mithen, *The Singing Neanderthals: The Origins of Music, Language, Mind, and Body* (Cambridge, MA: Harvard University Press, 2006), 217–20; Ralph S. Solecki, Rose L. Solecki and Anagnostis P. Agelarakis, *The Proto-Neolithic Cemetery in Shanidar Cave* (College Station: Texas A&M University Press, 2004); David Lewis-Williams, *The Mind in the Cave: Consciousness and the Origins of Art* (London: Thames & Hudson, 2002), 138–79.

3. J. David Lewis-Williams and Thomas A. Dowson, "Signs of All Times: Entoptic Phenomena in Upper Paleolithic Art," *Current Anthropology* 29 (1988): 205–41. See also Williams's earlier study, *Believing and Seeing: Symbolic Meanings in Southern San Rock Paintings* (Studies in Anthropology) (New York: Academic Press, 1981).

4. David Whitley, *Cave Paintings and the Human Spirit: The Origin of Creativity and Belief* (Amherst, NY: Prometheus Books, 2009).

5. Mark Johnson, *The Meaning of the Body: Aesthetics of Human Understanding* (Chicago: University of Chicago Press, 2007), 34.

6. Ibid.

7. Cf. Stephen E. Nadeau, Tanya S. Ferguson, Edward Valenstein, Charles J. Vierck, Jeffrey C. Petruska, Wolfgang J. Streit, and Louis A. Ritz, *Medical Neuroscience* (Philadelphia: Saunders, 2004); and Jackson Beatty, *The Human Brain: Essentials of Behavioral Neuroscience* (Thousand Oaks, CA: Sage Publications, 2001).

8. Antonio Damasio, *The Feeling of What Happens: Body, Emotion, and the Making of Consciousness* (London: Heinemann, 1999).

9. Gerald M. Edelman and Giulio Tononi, *A Universe of Consciousness: How Matter Becomes Imagination* (New York: Basic Books, 2000), 62.

10. Ibid.

11. Cf. Daniel Pals, *Eight Theories of Religion* (Oxford: Oxford University Press, 2006).

12. Edward Burnett Tylor, *Primitive Culture* (first published 1871); James G. Frazer, *The Golden Bough: A Study of Magic and Religion* (first published 1890); David Lewis-Williams, op. cit., 287–91.

13. Hongjun Song, Gerd Kempermann, Linda Overstreet Wadiche, Chunmei Zhao, Alejandro F. Schinder, and Josef Bischofberger, "New Neurons in the Adult Mammalian Brain: Synaptogenesis and Functional Integration," *The Journal of Neuroscience* 25(45) (2005): 10366–68.

14. Chih-Wei Wu, Ya-Ting Chang, Lung Yu, Hsiun-ing Chen, Chauying J. Jen, Shih-Ying Wu, Chen-Peng Lo, and Yu-Min Ku, "Exercise Enhances the Proliferation of Neural Stem Cells and Neurite Growth and Survival of Neuronal Progenitor Cells in Dentate Gyrus of Middle-Aged Mice," *Journal of Applied Physiology* 105 (2008): 1585–94.

15. Allan N. Schore, *Affect Dysregulation and Disorders of the Self* (New York: W.W. Norton, 2003), 239–43.

16. Ibid., 187–201.

17. Mithen, op. cit., 34.

18. See, for example, Jeanne Achterberg, *Imagery in Healing: Shamanism and Modern Medicine* (Boston, MA: Shambhala Publications, 1985); and Belleruth Naparstek, *Invisible Heroes: Survivors of Trauma and How They Heal* (New York: Bantam Dell, 2004).

19. Cf. Herbert Benson, "Harnessing the Power of the Placebo Effect and Renaming It 'Remembered Wellness,'" *Annual Review of Medicine* 47 (1996): 193–99; and Herbert Benson with Marg Stark, *Timeless Healing: The Power and Biology of Belief* (New York: Simon and Schuster, 1997).

20. Mithen, op. cit.; Michael Gazzaniga, *The Ethical Brain* (New York: Dana Press, 2005).

21. Steven Pinker, *How the Mind Works* (New York: W.W. Norton, 2005); Mithen, op. cit.

22. John T. Cacioppo, Penny S. Visser, and Cynthia L. Pickett, eds., *Social Neuroscience: People Thinking about Thinking People* (Cambridge, MA: MIT Press, 2006), xii.

23. Cf. Joseph LeDoux, *The Emotional Brain: The Mysterious Underpinnings of Emotional Life* (New York: Simon and Schuster, 1996).

24. James Parker, Michael Bagby, and Graeme Taylor, "Future Directions," in Graeme J. Taylor, R. Michael Bagby, James D. A. Parker, and James Grotstein, eds., *Disorders of Affect Regulation: Alexithymia in Medical and Psychiatric Illness* (Cambridge: Cambridge University Press, 1997), 270.

25. Gazzaniga, op. cit.

26. LeDoux, op. cit., 17.

27. Cf. Schore, *Affect Dysregulation*, op. cit.

28. Cf. Rebecca Saxe, "Four Brain Regions for One Theory of Mind?" in Cacioppo et al., op. cit., 83–101.

29. Roy A. Rappaport, *Ritual and Religion in the Making of Humanity* (Cambridge: Cambridge University Press, 1999), 6.

30. Catherine Bell, *Ritual Theory, Ritual Practice* (Oxford: Oxford University Press, 1992), 204–5.

31. LeDoux, op. cit., 19.

32. Audrius V. Plioplys, e-mail to Elizabeth Davenport (2008), including this brief explanation of the process of creating this image: "Over 100 years ago, Santiago Ramón y Cajal, a Spanish neuroanatomist, published landmark studies about the neuronal fine structure of the human cerebral cortex. Cajal's drawings were subtracted from the background color, revealing deeper layers of underlying art works, photographs, thoughts and memories. The underlying images are all previous photographic pieces that I have shown in exhibits across the United States and internationally."

33. Cf. Michael Winkelman, *Shamanism: The Neural Ecology of Consciousness and Healing* (Westport, CT: Bergin & Garvey, 2000).

34. Anne Runehov, *Sacred or Neural? The Potential of Neuroscience to Explain Religious Experience* (Gottingen: Vandenhoeck and Ruprecht, 2007), 92.

35. For a discussion of the mechanisms of image and mind, see Barbara Maria Stafford, *Echo Objects: The Cognitive Work of Images* (Chicago: University of Chicago Press, 2007), 111–12.

36. Mithen, op. cit., 205–18.

37. Cf. James Grier Miller, *Living Systems* (New York: McGraw-Hill, 1978).

38. Mario Beauregard and Denyse O'Leary, *The Spiritual Brain: A Neuroscientist's Case for the Existence of the Soul* (New York: Harper Collins, 2007), 289.

39. As referenced in Runehov, op cit., 169.

40. Runehov, op. cit., 92.

41. D'Aquili and Newberg, op. cit., 95ff.

42. James Austin, *Zen and the Brain* (Cambridge, MA: MIT Press, 1998), 641–44.

43. John Hick, *The New Frontier of Religion and Science: Religious Experience, Neuroscience, and the Transcendent* (New York: Palgrave Macmillan, 2006), 44.

44. D'Aquili and Newberg, op. cit., 109ff.

45. Stafford, Templeton Lectures.

46. D'Aquili and Newberg, op. cit., 13.

47. Richard Davidson, "Wellbeing and Affective Style: Neural Substrates and Biobehavioral Correlates," in *Philosophical Transactions of the Royal Society* 359 (2004): 1395–1411; Austin, op. cit.

48. James Giordano and Nikola Boris Kohls, "Spirituality, Suffering, and the Self," *Mind and Matter* 6, no.2 (2008): 179–91, 181.

49. D'Aquili and Newberg, op. cit., 149.

50. Beauregard and O'Leary, op. cit.

51. Ibid., 272.

52. LeDoux, op. cit., 20.

53. Cf. Austin, op. cit.

54. See, for example, Marsha Linehan, *Cognitive-Behavioral Treatment of Borderline Personality Disorder* (New York: Guilford Press, 1993); and Jon Kabat-Zinn, *Coming to Our Senses: Healing Ourselves and the World through Mindfulness* (New York: Hyperion, 2005).

55. Lawrence LeShan, *Beyond Technique: Psychotherapy for the 21st Century* (Northvale, NJ: Jason Aronson, 1996).

56. Cf. Giordano and Kohls, op. cit.

57. Cf. Lewis-Williams, *Mind in the Cave.*

58. Anthony Clare, foreword to *Evidence in Mental Health Care*, ed. Stefan Priebe and Mike Slade (Hove, UK: Brunner-Routledge, 2002).

59. Cf. Nancey Murphy, "What Has Theology to Learn from Scientific Methodology?" in Murray Rae, Hilary Regan, and John Stenhouse, eds., *Science and Theology: Questions at the Interface* (Edinburgh: T & T Clark, 1994, 101–26).

Lifting the Foot

THE NEURAL UNDERPINNINGS OF THE
"PATHOLOGICAL" RESPONSE TO MUSIC

David Michael Bashwiner

> It is not because it is dance music that it lifts the foot;
> rather it is because it lifts the foot that it is dance music.
> —EDUARD HANSLICK, *On the Musically Beautiful* (1854)

Listeners have attested for ages that music elicits a "physical" response of sorts, whether it be called emotion, pleasure, or the compulsion to dance. Aestheticians, however, have just as consistently failed to explain this response. This chapter uses the mid-nineteenth century as a launching ground for considering how the neuroaesthetic approach offers a unique and crucial perspective on this difficult issue. Two composers are contrasted, Johann Strauss, Sr., and Johann Nepomuk Hummel, both of whom wrote waltzes, but only one of whose waltzes drove listeners to "bewildering heights of frenzy."[1] Seeking to understand this difference, we will turn to the most influential musical aesthetician of the day, Eduard Hanslick, whom we will find unable to account for it. For Hanslick, the emotional response was simply "pathological" and therefore completely irrelevant to aesthetics—a perspective that persists to this day in the writings of philosophers Peter Kivy and Nick Zangwill.[2] However, a contemporary of Hanslick's, Hermann von Helmholtz—Germany's preeminent physician and the writer of a highly influential treatise on the physiology of hearing and its relevance to musical aesthetics—provides a means of at least beginning to sort out the physiological puzzle of how music and the emotions interface. Given the profound advances made in both musical and affective neuroscience since the mid-nineteenth century, today's musical aesthetics seems to be more than primed for its long-awaited Kuhnian revolution. The remainder of this chapter sketches out a hypothesis for how the "pathological" and "aesthetical" components of the musical response (Hanslick's terms) interact at the neural level. My ultimate argument is that,

whatever our sensibilities—Victorian or otherwise—to understand the one, we must understand the other as well.

A Scandalous Debut: The Throne of Waltz King in Dispute

It is the fifteenth of October, 1844, at Dommayer's Garden Restaurant in the posh Hietzing district of Vienna. An advertisement for the evening's event reads, "Invitation to a Soirée Dansante . . . even in unfavourable weather . . . Johann Strauss (son) will have the honour to conduct his own orchestra. . . . First appearance. . . ."[3]

This is no ordinary evening, however, for "a gigantic scandal hover[s] in the air."[4] In the front row stands an opposition party, consisting largely of confidants of the elder Johann Strauss, who accuse the son of attempting to swindle the public through unjust appropriation of his father's famous name. Indignantly retorting are the boy's supporters, who "[know] how the elder Strauss treat[s] his family" and lament that "now the boy [has] to fiddle for the money that his father's mistress waste[s]."[5]

The story is sad but true. Strauss Senior, the most respected bandleader in Europe and the idol of the ruling as well as the musical elite, has been less than a model family man. He has abandoned his wife and five children in order to take up with another woman and raise five more, the eldest of whom he has had the audacity also to name Johann. And although he earns exorbitant sums with his music, he and his new wife spend them profligately, so that Anna, the abandoned wife, has been forced to think creatively.

Johann Senior had always forbidden his children to learn the violin, and under no circumstances were they to perform professionally, heaven forbid take up the baton. But in her desperation, Anna, the deserted wife, has allowed her sons to secretly study violin and composition, and is now urging the eldest, Johann Junior, to assemble an orchestra and begin challenging his father for the throne of Waltz King.

Shouts rise from both corners of the room as the novice conductor enters the stage. Anna sits quietly and nervously in back. She listens as insults are slung back and forth. But in the end, all arguments are futile. "The wisest gossipers," writes Strauss biographer Heinrich Jacob, "said that the only thing that mattered was whether young Strauss had talent or not."[6] It would all

depend, in other words, upon whether young Strauss could make his audience *dance*.

Compulsion and Choice: The Waltz and the Minuet

There is a distinction to be made between music that affords dancing and music that compels it. The music of Strauss—the elder, at least—compelled it. Wagner, in his autobiography, wrote that Strauss's audiences would become "frantic with delight": "At the beginning of a new waltz this demon of the Viennese musical spirit shook like a Pythian priestess on the tripod, and veritable groans of ecstasy . . . raised their worship for the magic violinist to almost bewildering heights of frenzy."[7]

Such accolades were never used to describe the music of say, Hummel. Pupil of Mozart, confidant of Beethoven, and among the most respected pianists and composers of his age, Johann Nepomuk Hummel was commissioned by Dr. Sigmund Wolffsohn in 1808 to write a set of waltzes to celebrate the opening of what would be the largest and most expensive dancehall in Europe—able to accommodate six thousand dancers—the Apollo Palace. Hummel, however, "was no dance composer," says Jacob, and even had he wanted to, he could not have fulfilled Wolffsohn's real purpose. "It is hardly possible to dance to his waltzes . . . They sound like a minuet."[8]

FIGURE 7.1. Johann Nepomuk Hummel, waltz.

FIGURE 7.2. *Minuet at a Formal Ball.* Engraving from Pierre Rameau, *Le maître a danser,* 1725.

. .

On paper the waltz and the minuet look similar. Each is in 3/4 time (having three beats per measure), their phrases are of the same length, and their tempi, though a bit faster and more variable in the case of the waltz, are nevertheless roughly equivalent.[9] But on the dance floor the two could not be more different. The minuet is danced by one couple at a time while the rest of the company watches. The dancers, after bowing to the king or whomever is pre-

FIGURE 7.3. Andreas Geiger, *Der große Galopp von Joh. Strauß*, 1839. Colored etching, 26.3 × 29.7 cm.

siding over the evening's festivities, begin by positioning themselves on opposite ends of the dance floor and approach one another only gradually. The first time they pass at the center of the floor, they make no contact; on successive passes they exchange a single hand and circle about one another; on the final pass, the "climax," they exchange both hands and make several turns.[10]

Such restraint is in the most marked contrast with the hedonism that characterized the waltz, as described, for instance, by the late eighteenth-century travel writer Ernst Moritz Arndt:

The male dancers grasped the long dresses of their partners so that they would not drag and be trodden upon, and lifted them high, holding them in this cloak which brought both bodies under one cover, as closely as possible against each other, and in this way the whirling continued in the most indecent positions; the supporting hand lay firmly on the breasts, at each

movement making little lustful pressures; the girls went wild and looked as if they would drop. When waltzing on the darker side of the room there were bolder embraces and kisses. The custom of the country; it is not as bad as it looks, they exclaim: but now I understand very well why here and there in parts of Swabia and Switzerland the waltz has been prohibited.[11]

Similar at the level of the musical text, the waltz and the minuet are at opposite ends of the spectrum in terms of the dances that accompany them. What accounts for this difference?

Music's Effect at First Blush: The Association of Ideas Theory

Certainly the difference could be attributed simply to custom. This would be the social constructivist position, which would rely upon an "association of ideas" theory of mechanism. Peter Kivy offers the following definition:

[The association of ideas theory] arises from the trivial and true observation that we tend, other things being equal, to think of B after perceiving or experiencing or thinking of A, if, in the past, we perceived or experienced A and B together; or tend to feel a certain way, all things being equal, when we perceive or experience or think of A, if we felt that way in the past when we perceived or experienced A.[12]

According to such a theory, the environment—both social and physical—in which a dance is practiced is taken to be the ultimate cause of the music-mediated effect, whether that effect be one of frenzy or composure. The male dancer's grasping of his partner's long dress, in other words, his bringing of their bodies "as closely as possible against each other," the whirling, the placement of the supporting hand, and the darkness of certain parts of the room—any or all of this, according to the theory, will become associated in the minds of the dancers and their onlookers with the types of music heard in such contexts. Similar music will then, in the future, as a result of such associations, wield the power to call up these memories and, by chain of reaction, elicit the same or related effects.

By such means some sense can be made of the waltz's capacity to elicit frenzy and the minuet's tendency to promote composure. The minuet was, after all, an aristocratic dance, whereas the waltz had been appropriated from the peasantry.[13] But note that no solution is offered as to why Hummel's waltzes had the effect of minuets. The cultural accoutrements of a Hummel waltz would in theory all have been in place: the hall built, the chandeliers lit, the dancers in place and ready to waltz—and yet, if we are to grant Jacob's criticism, the music did not make them especially want to do so; it did not *compel* them to twirl. It merely made twirling possible.

This was the effect that Johann Junior's supporters worried his music would have. They expected him to be a competent bandleader, violinist, and composer. But could he put on the type of concert that would not only afford dancing, but compel it? The hall, the crowd, and the expectations were all in place for Johann Junior's music to have a sensational effect. But whether it would do so would depend upon something not as straightforward as genres or even particular pieces played. There would be something ineffable, something at the level of the piece's *effect itself* that would determine whether Johann Junior would emerge that evening as a valid contender to his father's throne.

It is this effect that we wish to understand. The musical text itself does not appear sufficient to explain it, nor are customs, associations, or expectations. The difference between good music and great music—or, more accurately, between the experience of a particular piece as good and the experience of it as great—lies neither in the work itself nor in the mind, it would appear, but rather somewhere in between.[14]

Lifting the Foot: The Pathological Response to Music

Danceability is a criterion mysteriously absent from musical treatises. A rare exception is a short passage from Eduard Hanslick's *On the Musically Beautiful* (first edition 1854), which, consistent with the anti-associationist perspective taken here, holds that "it is not because it is dance music that it lifts the foot; rather it is because it lifts the foot that it is dance music." The immediate context is as follows:

It is not to be denied that dance music brings about a twitching of the
body, especially in the feet, of young people whose natural disposition
is not entirely inhibited by the constraints of civilization. It would be
pedantic to deny the physiological effect of marches and dance music
and to seek to reduce it merely to the psychological association of ideas.
What is psychological about it, namely, awakened memories and the
well-known pleasure of dancing, is not lacking in explanation, but the
explanation is not at all adequate. It is not because it is dance music that it
lifts the foot; rather it is because it lifts the foot that it is dance music.[15]

This passage finds Hanslick conceding that music is capable of inducing a
physiological response, one that cannot simply be attributed to condition-
ing or association.

Within Hanslick's larger argument, however, this passage is merely a con-
cession, the ultimate aim being to establish *not* that music has direct physi-
ological effects, but that, *despite* the fact that it does, they are of little import.
"The fact that this art is intimately related to our feelings," he writes, "in no
way supports the view that the aesthetical significance of music resides in this
relationship."[16] In fact, for Hanslick, feeling, or what he calls the "pathologi-
cal response" to music, is directly opposed to what he calls the "aesthetical
response," which he defines as "pure contemplation."[17] The former consists
of a mere "stimulation of the nerves,"[18] while the latter is "the only artistic,
true form" of hearing.[19]

Hanslick does not deny that music induces nervous stimulation of the
pathological sort—such as the "lifting of the foot" by dance music, the "great
rapture" evoked by "a simple horn call or a yodeller in the mountains,"[20] or
the pleasure aroused by the "unintelligible wailing" of the South Sea Islander
as he "bangs rhythmically with bits of metal and wooden staves."[21] But the
response being pathological, the stimulus, by definition, "just is not *music.*"[22]
"Music begins," he asserts, "where [these] isolated effects leave off."[23]

In more recent years, philosopher Peter Kivy has also argued that music
that arouses genuine physical effects is "not music": "Music is an object for
the mind, at no matter what level it is appreciated. When it ceases to be that,
as when soft, soothing sounds calm a babe in arms, it ceases to be music."[24]

In doing so, both he and Hanslick make it possible to deduce logically that music and feeling relate to one another only incidentally, thus creating for themselves (though in different ways) purely "aesthetical" philosophical systems—systems free of the unwieldiness of music's "pathological" aspect.

This Sphinx Will Never Throw Herself Off Her Rock

But upon what grounds does an aesthetic system such as Hanslick's declare physiological responses to be off limits? One motivation, certainly, was Kantian: Hanslick sought to secure for music its rightful place among the arts, which had been denied in Kant's third *Critique*, the philosopher debating only whether music was, on one alternative, a "beautiful interplay of emotions" or, on the other, far worse, alternative, a "beautiful interplay of *pleasurable* emotions."[25] Hanslick's declaration that "the content of music is tonally moving forms" was no doubt a corrective to the Kantian claim that, being limited to sensation, music lacked content, and thus was "the least among the fine arts."[26]

There may have been an additional guiding factor, however—a practical one. Had Hanslick even wanted to reconcile the aesthetical and pathological responses to music, the means of doing so might not have been available to him. The pathological response to music is, after all, almost by definition a *physiological* response; and science in the mid-nineteenth century appeared unready to permit a physiological approach to aesthetics. This is in fact the conclusion at which Hanslick arrived—but only after a thorough investigation into the topic.

Hanslick recognized that it was somewhat irresponsible to simply state categorically that feelings are incidental to aesthetic concerns: "In practical musical life, the positive manifestations of feeling retain too conspicuous and important a role for them to be set aside on account of mere subordination."[27] He thus devoted an entire chapter to analyzing the relationship between music's pathological aspect—that is, feeling—and its aesthetical aspect—the contemplation of tonally moving forms. "The musician can attain no scientific certainty with regard to [the emotional response to music]," he reasoned, "unless he makes himself acquainted with the results of contempo-

rary physiological research on the connection of music with the feelings."[28] Thus Hanslick surveyed the writings of a number of contemporary physiologists—Whytt, Goldberger, Carus, Lotze—on such topics as the connection of the auditory nerve to the other nerves, the electrical induction of illness, the purported origin of the auditory nerve in the cerebellum, and the possibility of comprehending the relationship between the "transition of the nerves from one kind of excitation to another" and the "powerful aesthetical feelings which follow the change of tones."[29]

But following this responsibly thorough investigation, Hanslick concluded skeptically that the gap between the crudeness of science and the sophistication of musical contemplation was too large to bridge. Musical perception was poorly understood:

> What physiology does not tell us . . . is the particular way in which particular musical factors, such as chords, rhythms, and instruments, act on different nerves.[30]

Nor was there any sort of general understanding of the physiology of emotion:

> Of course the basis of every feeling aroused by music must lie first of all in a particular manner of affecting the nerves by an auditory impression. But how an excitation of the auditory nerve, which we cannot even trace to its origins, is perceived as a particular sense quality; how the bodily impression becomes a mental state; finally, how sensation becomes feeling: All that lies on the other side of the mysterious divide which no investigator has crossed.[31]

And thus, because it did not appear that physiological science would ever be able to match humanistic aesthetics in sophistication, Hanslick ultimately determined that the pursuit was doomed:

> There are paraphrases a thousandfold of this one ancient riddle: How the body is connected to the soul. This sphinx will never throw herself off her rock.[32]

Helmholtz's Physiological Aesthetics
and the Importance of Sensation

At the same time that Hanslick was concluding skeptically that the purity of aesthetical contemplation and the inscrutability of the pathological response to music could never be reconciled, a treatise promising to do precisely that was published by Germany's preeminent physiologist, Hermann L. F. Helmholtz. This treatise, called *On the Sensations of Tone as a Physiological Basis for the Theory of Music*,[33] differed considerably from Hanslick's in approach, but its ultimate aim—to revolutionize musical aesthetics—was similar.

In his introduction, Helmholtz remarked that the study of music had been traditionally divided into two "practically distinct" fields, physics and psychology, the former giving rise to the study of acoustics, the latter to aesthetics. Each had "made unmistakable advances" in its own area, but the lack of dialogue between the two had been problematic, and any apparent connection had been "wholly external, and may be regarded rather as an expression given to the feeling that such a connection must exist, than as its actual formulation."[34]

The "essential facts" of acoustics "have been known from the earliest times," he wrote. Pythagoras (sixth century BCE) is credited with the discovery that the consonances—octave, fifth, fourth, and so on—result from simple mathematical proportions. Two strings of equal weight and tension, for instance, will sound at the unison when of the same length, at the octave when one is half the length of the other, at the fifth when one is two-thirds the length of the other, at the fourth when one is three-quarters the length of the other, and so on. The same is true of weights, as Pythagoras is fabled to have discovered on a visit to a smithy: hammers weighing the same amount, irrespective of the force with which they are struck, will sound at the unison; hammers in the weight ratio of 2:1 will sound an octave, in the ratio of 3:2 will sound a fifth, in the ratio of 4:3 will sound a fourth, and so on. String lengths (or hammer weights) related to one another only by complex or irrational proportion will, in contrast, sound dissonant.

This discovery of Pythagoras's had given rise in ancient times to the understanding that the psychoacoustic properties of consonance and dissonance

have bases in physical reality, the implication being, however bafflingly, that proportion is an audible—one could even say *felt*—property of sound. And although it had long been known, until Helmholtz's day this strange fact remained unexplained: "Musicians, as well as philosophers and physicists, have generally contented themselves with saying in effect that human minds were in some unknown manner so constituted as to discover the numerical relations of musical vibrations, and to have a peculiar pleasure in contemplating simple ratios which are readily comprehensible."[35] Such content attribution of "peculiar pleasures" to "unknown manners" of mental constitution Helmholtz found unsatisfactory. An understanding of only the physics of consonance and dissonance was an insufficient basis upon which to ground a musical aesthetics.

Nor was psychology on its own sufficient. Hanslick is cited approvingly for having "triumphantly attacked the false standpoint of exaggerated sentimentality" in aesthetic treatises of his day. "But all such investigations," Helmholtz writes, "however fertile they may have been, cannot have been otherwise than imperfect and uncertain, so long as they were without their proper origin and foundation, that is, so long as there was no scientific foundation for their elementary rules relating to the construction of scales, chords, keys and modes."[36] Just as physics alone cannot account for the "pleasure in contemplating simple ratios," psychology unchecked can amount to no more than "unfettered artistic inventions."[37]

Though both broadly interested in the subject of musical aesthetics, Hanslick and Helmholtz clearly approached their subject in very different ways. That difference is exemplified in their treatment of the concept of *sensation*. "Sensation," as Hanslick defines the term, "is the perception of a specific sense quality: this particular tone, that particular colour." This term he distinguishes from two others central to his aesthetics: *feeling*, which "is becoming aware of our mental state with regard to its furtherance or inhibition, thus of well-being or distress," and *beauty*, which is equated with "aesthetical pleasure," and which is thus the result of the "pure contemplation" of tones.[38] Feeling, as we know, corresponds to the pathological aspect of musical listening, while beauty arises in response to its aesthetical aspect. Sensation, a third component, is essential to both, functioning as the mediating step between the object perceived and the response to that object. Simple mechani-

cal mediator that it is, however, sensation itself is of no interest to Hanslick, and is considered to be of no relevance whatsoever to his aesthetics of music. "It takes no skill to stimulate sensation," Hanslick writes. "A single tone, a single colour can do it."[39] It is beauty Hanslick is after, not feeling, and not sensation: like feeling, sensation is only tangentially related to the aesthetical aspect of music. Sensation is a necessary but insubstantial step in the perceptual process.

In Helmholtz's view, in contrast, sensation is by all means substantial. In this way music somewhat differs from the other arts. In the plastic arts, the dramatic arts, and poetry, *representations* are said to be the artistic materials, with sensations functioning only as intermediaries to those representations. Painting is a mixed case, Helmholtz notes, color being equally important in both its sensational and its representational component. But in music, there are no representations at all: "The sensations of tone are the material of the art."[40] Sensation, for Helmholtz, is thus more fundamental to music than it is to the other arts.

For Helmholtz, then, the means whereby the "artistic inventions" of aestheticians were to be "fettered" was precisely through an understanding of sensation. And such understanding could be arrived at only through physiological investigation—acoustics and aesthetics on their own being insufficient. Only by understanding human physiology, in other words, could it be understood why the physical sounds emitted from proportionately sized and weighted objects sound aesthetically consonant in relation to one another. And only upon such physiological foundations, finally, can the aesthetician discern intelligently which aspects of the "scales, chords, keys and modes" employed by any given culture or composer have been chosen freely, and which instead betray external influence. To this last point, we shall give somewhat more extended consideration.

Consonance, Dissonance, and the Basilar Membrane

For someone for whom music was only a secondary or tertiary field (and who was the foremost researcher in numerous other fields, including optics and acoustics), Helmholtz conducted an impressively thorough survey of the world's musical systems. He concluded from this survey that musical systems

differ significantly across cultures. It thus followed "that the system of Scales, Modes, and Harmonic Tissues [of Western music] does not rest solely upon inalterable natural laws, but is also, at least partly, the result of esthetical principles, which have already changed, and will still further change, with the progressive development of humanity."[41] But, though not totally predetermined, the musical systems found throughout the world are necessarily constructed in *some* sort of correspondence with "the laws of the natural function of our ear," laws that are "the building stones with which the edifice of our musical system has been erected." To understand "the construction of the edifice itself," it is necessary to "accurately understand . . . the nature of these materials," and thereby—and only thereby—the laws from which they arise.[42] Physical and physiological laws themselves are not aesthetic principles, nor are aesthetic principles laws. But to distinguish choice from law— edifice from material—requires that the nature of that material, and the laws that restrict its construction, be understood.

One notable law, perhaps the most fundamental, from which have been derived the "edifices" of the scales, modes, and harmonies used throughout the world, is the law of consonance and dissonance. This law, Helmholtz demonstrates, arises—as do the practices that derive from it—from the physiological structure of the ear. Consonance and dissonance are *not* objective qualities in nature, but rather are artifacts of the process of sensation. They emerge only subjectively, as by-products of the particular way in which vibratory patterns reaching the eardrum are translated into neural signals by the inner ear—more specifically, by an organ inside the cochlea of the ear called the basilar membrane.

Before discussing either tone quality or consonance, therefore, let us first consider simply how a single resonant sound gets translated into a series of nerve impulses by the physiological mechanism of the ear. When a string is struck or bowed, air particles surrounding it are thrown into motion, and by a series of chains of collisions, air particles at the ear of a nearby observer will also be set into motion. Vibration within the observer's external ear canal then causes sympathetic vibration in the *tympanum* or eardrum, which in turn communicates these vibrations, via the three tiny bones of the inner ear to which the drumhead is attached (the hammer, anvil, and stirrup), to a long, fluid-filled, snail-shaped chamber called the cochlea. Within the

cochlea resides a similarly long, thin, trapezoidal strip of tissue called the basilar membrane, along which are found thousands of tiny hair cells, each of which vibrates at a certain "best frequency" and attaches to one or more nerve fibers which make their way (via a series of way stations) to the brain. The hair cells at the wider end of the basilar membrane resonate with higher frequencies, and those at the smaller end (toward the center of the cochlea's spiral) resonate with lower frequencies. Thus the basilar membrane is said to be "tonotopically" arranged: frequency space maps directly onto the membrane's length dimension.

When a single *simple tone* is sounded (a tone with only a single frequency and no upper partial tones), the hairs of only a single portion of the basilar membrane will resonate in sympathy with it. The movement of those hairs, in turn, will elicit action potentials in the cells of the auditory nerve to which they are attached, and signals will be sent (through the way-station relays) toward the brain.

When *two* simple tones are sounded, one of two things can happen. If the distance between the tones is large enough in frequency space (corresponding roughly to a minor third at the center of the range of hearing, an interval called a "critical band"), the membrane's response to either tone will not interfere with its response to the other, and the individual sounds will be processed in simple additive fashion—that is, as if each were the only sound being perceived. If, however, the sounds are close together in frequency space, then the processing of the one will interfere with that of the other.[43] Physiologically speaking, this interference will be manifested in the nerves themselves, and not earlier;[44] the effect will be one of "intermittent excitement of certain auditory nerve fibres," an excitement which probably "deadens [the nerve's] excitability, and consequently renders it less sensitive to fresh irritants."[45] Psychologically speaking, the effect will be experienced either as *beating* (if the tones are nearly identical in pitch), or as *dissonance* (if they are more distant in pitch, though no larger than a critical band), with maximal dissonance resulting at the distance of about a semitone. In describing the effect of the dissonance created by two simple tones, Helmholtz writes: "The mass of tone becomes confused, which I principally refer to the psychological impressions. We actually hear a series of pulses of tone, and are able to recognise it as such, although no longer capable of following each singly or sepa-

rating one from the other. But besides this psychological consideration, the sensible impression is also unpleasant. Such rapidly beating tones are jarring and rough. The distinctive property of jarring, is the intermittent character of the sound."[46]

Simple tones (i.e., those described above) are rare. They emerge only occasionally from such instruments as flutes and certain organ pipes. More usually, tones produced by musical instruments (including the voice) are *complex*, meaning that they consist not only of a single fundamental frequency, but of several *upper partial tones* as well. The upper partial tones derive from the frequency of the fundamental tone by simple multiplication, so that a string, say, resonating at x Hz (x vibrations per second) will also produce vibrations at $2x$ Hz (though at only half the intensity), $3x$ Hz (at a third of the intensity), $4x$ Hz (at a fourth of the intensity), and so on. Different musical instruments create and foster upper partial resonances in different ways, a fact that corresponds directly to the subjective experience of the *timbre* or *tone quality* of an instrument: "Compound tones with many high upper partials are cutting, jarring, or braying . . . On the other hand simple tones, or compound tones which have only a few of the lower upper partials, lying at wide intervals apart, must produce perfectly continuous sensations in the ear, and make a soft and gentle impression, without much energy, even when they are in reality relatively strong."[47]

Why this is so is explicable, once again, only through a thorough understanding of the physiology of the inner ear; that understanding will, however, lead in turn to an account of why some tones more distant than a minor third are perceived as dissonant—which they certainly are, if the "edifice" of the Western tonal system is to be admitted as evidence.

When a complex tone reaches the ear, it maintains its complexity until it reaches the basilar membrane, at which point it is resolved into its component frequencies.[48] A *single* complex tone thereby elicits not just one but a number of vibrations along the basilar membrane. The lower partials of any complex tone are distant in frequency space: the interval between the first two is an octave, between the second two a fifth, between the next two a fourth, between the next two a major third, and so on, continuing to diminish in size.[49] As the series of partial tones progresses, therefore, the distance between tones diminishes, so that intervals smaller than a minor third begin

to be found starting with the seventh partial. In musical tones of more "sooth-
ing" timbres (e.g., a plucked double bass, or the sung vowel "oh"), only the
lower partials are loud enough to be audible. But in harsher timbres (e.g., a
muted trumpet, or the sung vowel "ee"), the higher partials are loud enough
to be audible, and—as a result of the processing interference caused at the
level of the basilar membrane—they clash with one another.

Thus partial tones *within a single complex tone* can create sensory disso-
nance. This is the explanation for the tone qualities or timbres associated
with individual instruments and with ways of producing tone generally. It is
furthermore the case that upper partial tones *between* complex tones can clash
with one another as well. And this explains—finally returning to our Pythag-
orean dilemma—why complex tones whose fundamental frequencies are re-
lated by simple proportion sound consonant with one another, while those
whose fundamental frequencies are related by complex or irrational propor-
tion—even those whose fundamentals are not within a minor third of one an-
other—sound dissonant.[50] The long-awaited answer to this perennial ques-
tion is thus to be found in the basilar membrane. It could not be answered by
"physics" and "psychology" alone—it demanded Helmholtz's "physiological"
approach. Today we would call that approach "neuroaesthetic."[51]

Lifting the Foot: A Neuroaesthetic Approach

Having established the foundations of what a neuroaesthetic approach is and
what it can do, let us return to our original concern regarding music's capac-
ity to "lift the foot." Recognizing *that* music could do this, Hanslick, we are
reminded, determined that he would never be able to understand *how* it did
so. And as a result, he deemed the aesthetical and pathological responses to
music irreconcilable: "Those theorists who erect the principle of the beauti-
ful in music upon the effects of feeling are lost, scientifically speaking. This
is because they can know nothing about the nature of the relation between
sensation and feeling[;] therefore, at best, they can only indulge in guess-
work and fantasy. No artistic or scientific definition of music will ever be able
to amount to anything if it is based upon feeling."[52] Rather than "indulge in
guesswork and fantasy," then, Hanslick sought to rid aesthetic discourse of
its "basis in feeling."

Twenty-first-century physiology is in a profoundly different state, however, and therefore so are twenty-first-century aestheticians. At the time that Hanslick's and Helmholtz's treatises were first written, the destination of the auditory nerve after it left the ear was unknown (it was believed that it ended in the cerebellum). It was not until the mid-1870s that David Ferrier, using the technique of electrical stimulation of the brain (ESB), first proposed that the temporal lobes might serve the function of audition, and the validity of this claim was highly contested through the end of the century. Only in the first decades of the twentieth century, with the development of new staining techniques (developed by Sigmund Freud, among others), did it become possible to trace the exact pathway followed by the auditory nerve—through the cochlear nucleus, the superior olivary complex, the lateral lemniscus, the inferior colliculus, and the medial geniculate nucleus of the thalamus—to its first cortical destination in the temporal lobes of the cerebral cortex.[53] And only relatively recently has it been determined that, once information arrives at the primary auditory cortex, it is obligatorily projected first to secondary auditory association areas within the temporal lobe (in the superior temporal gyrus and superior temporal sulcus), and then, in turn (though less obligatorily), to heteromodal areas (in the prefrontal, posterior parietal, and lateral temporal cortices), paralimbic areas (including the orbitofrontal cortex, insula, temporal poles, and parahippocampal gyrus) and finally limbic areas (including the amygdala, hippocampus, and hypothalamus).[54] This organization is schematically presented in figure 7.4.

We might ask, however, where feeling enters the equation. The lower left-hand portion of figure 7.4 is marked "sensation," the upper left-hand portion "perception," the entirety of the upper portion "cognition," and the lower right-hand portion "action."[55] What is feeling, from a neurological perspective, and where might it enter the information-flow pathway? Figure 7.5 suggests a neurological foundation for the pathological aspect of the musical experience and its relationship to music cognition. The most basic pathological response to sound is known as the startle response, which, as shown, requires a minimum of processing resources: information reaching the cochlear nucleus passes immediately to the nucleus of the lateral lemniscus (skipping the superior olive) and then passes laterally to the reticular formation (a region responsible for wakefulness and arousal), from which signals are sent directly

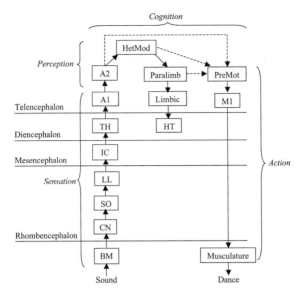

FIGURE 7.4. The sound processing pathway. Based largely on Wallin, *Biomusicology* (1991), and Mesulam, "From Sensation to Cognition" (1998). BM = basilar membrane; CN = cochlear nucleus; SO = superior olive; LL = lateral lemniscus; IC = inferior colliculus; TH = thalamus; A1 = primary auditory cortex; A2 = secondary auditory association areas; HetMod = heteromodal association areas; Paralimb = paralimbic areas; Limbic = limbic regions; HT = hypothalamus; PreMot = secondary motor association areas; M1 = primary motor areas.

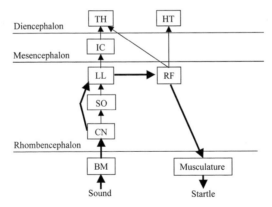

FIGURE 7.5. The startle response. Based on Eaton, *Neural Mechanisms* (1984), and Juslin and Västfjäll, "Emotional Responses to Music" (2008). RF = reticular formation. For remaining abbreviations, see figure 7.4.

to the musculature.[56] The reticular formation also triggers regions above it, such as the thalamus and hypothalamus, as well as the other members of the complex known as the ascending reticular activation system (ARAS). Activation in these areas affects the flow of acetylcholine, dopamine, serotonin, and norepinephrine throughout the brain, and these neurotransmitters in turn profoundly affect cognitive functioning. Acetylcholine, for instance, increases the receptivity of cortical neurons to sensory stimulation; dopamine enhances curiosity and interest and facilitates working memory; serotonin promotes well-being and sociality; and norepinephrine promotes attention by enhancing signal-to-noise ratios and facilitating the storage and retrieval of emotionally relevant memories.[57] Thus, while figure 7.4 presents a mostly "vertical" view of how sensation turns into cognition, figure 7.5 reveals that "horizontal" connections—from strictly information-processing areas to more neuromodulatory areas—begin to take place even at very low levels, before stimulation arrives at the cortex. Joseph LeDoux calls such horizontal routes "low roads" (he speaks specifically of the thalamo-amygdala route), in contrast to the more involved—and thus slower—cortical "high road." Information, he explains, can reach the amygdala either by way of direct input from the thalamus (not shown in figures 7.4 or 7.5), or indirectly through the cortex, the first route being faster, the latter more nuanced. "The Beatles and Rolling Stones," he writes, ". . . will sound the same to the amygdala by way of the thalamic projections but quite different by way of the cortical projections."[58]

Figure 7.6 represents the "high road" in somewhat more detail. But note the extent to which what might be called "pure (cortical) contemplation" is interpenetrated by the effects of processing in the more "pathological" ("low-road") subcortical areas. As Mesulam explains, activations in the reticular activating and limbic systems significantly affect functioning throughout the cortex. The amygdala, for instance, "is reciprocally interconnected with unimodal sensory association cortices in the superior and inferior temporal gyri . . . Through these connections, the amygdala can selectively modulate sensory responses in a manner that reflects their intrinsic or acquired emotional relevance."[59] The amygdala also has a role in attention, "selectively enhanc[ing] the processing resources allocated to ambient events with high emotional and hedonic valence."[60] And acetylcholine released from the nu-

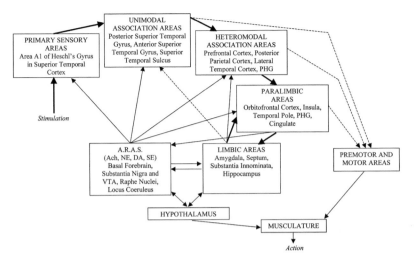

FIGURE 7.6. Interpenetration of affective-motivational and sensory-perceptual systems. The sensation-into-action pathway is in black; the neuromodulatory pathways are in gray. Based largely on Mesulam, "From Sensation to Cognition" (1998). A1 = primary auditory cortex; PHG = parahippocampal gyrus; A.R.A.S. = ascending reticular activating system. Ach = acetylcholine; NE = norepinephrine; DA = dopamine; SE = serotonin; VTA = ventral tegmental area.

cleus basalis elicits its effects by causing "a prolonged reduction of potassium conductance so as to make cortical neurons more receptive to sensory stimulation."[61] Thus a constant interpenetration of cognition into feeling, and feeling into cognition, typifies experience. The aesthetical aspect of the response to music, we are to conclude, is inseparable from the pathological aspect: contemplation is never pure.

Musical Meaning and Musical Emotion

If the claim that the aesthetical and pathological modes of listening are separable were confined to a single nineteenth-century treatise, or even to an earlier time period, arguing against it as methodically as I have done here would be pedantic. On the contrary, however, the notion of separability is embodied in the very language used to describe music to this day, and thus is symptomatic of a rather serious and systemic problem confronting the discipline of musicology as a whole. As analysts and philosophers have lamented of late, the language of music theory is technical, while the experience of music tends to be

emotive and dramatic.[62] Attempts to bridge that gap—to make technical description more dramatic,[63] and emotive description more objective[64]—have proven to be no more than superficial fixes.

The seriousness of the problem can be clarified via a linguistic parallel. The technical language of music theory is comparable to the apparatus used in linguistics to analyze syntax and grammar. In language, however, a separate field of *semantics* exists, whereas in music no such parallel field exists. Recent analysts and philosophers have sought to derive a framework in which "absolute music" (music without words) can be somehow "meaningful" despite its independence from external reference—that is, despite its apparent lack of a semantic dimension.

Music is not as obviously *semantically* meaningful as language is, but it arguably does communicate or induce a sense of significance or meaning in a listener.[65] Its capacity to do this, I would argue, is dependent upon its capacity to modulate the arousal, attentional, and emotional state of the listener as she attends either to the music or to something else (an accompanying drama, the dance steps she is executing, the partner into whose eyes she is gazing). If music's capacity to be meaningful and contribute to meaning is dependent upon its capacity to affect the emotional, arousal, and attentional state of the listener—and not by anything more concrete than that—then, at least given the framework laid out above, a search for musical "meaning" ought properly to at least take into consideration how music interacts with the body's neuro-affective apparatus. A neuroaesthetics just might prove to be the missing link between the inscrutability of feeling and the determinate coldness of theoretical categorization.

Conclusion: Sparks and Electric Shocks

The day after young Strauss's debut performance, reviewer Liepold Wiest described the outcome in the *Wanderer*: "He is met by a tempest, but Strauss Junior seems to stand firmly on his feet . . . Now he swings his bow, now he starts to play; one, two, three strokes and electric shocks run through our bodies; and now the man facing us sprays sparks as from a galvanic battery."[66] The effect Wiest describes is one that we have all felt. We have all been "elec-

trified" by musical performances, we have all felt at one time or another physically compelled to dance, we have all been moved to tears by a fortuitously encountered adagio.[67] Music has the capacity to do these very strange things to us in ways that have always been mysterious—and will likely continue to be so.

In order to capture this inexplicable sensation in words, Wiest could not use reason; he was forced to rely upon metaphor. Metaphors are *important*, and they function in a necessary way: to explain the as yet unexplained. They give rise to literature and poetry. To invoke Jung's "Psychology and Literature,"[68] they allow the creator to think in symbols without having to decode those symbols. To invoke Barbara Stafford's *Echo Objects: The Cognitive Work of Images*, metaphors sanction an intuitive, "mantic" form of consciousness which denotative, "hermeneutic" rigor tends to inhibit.[69] Metaphor is a legitimate mode of thought.

The physical nature of music's effect—its "pathological aspect"—has been eternally inexplicable. Writers have consistently sought to explain it using the methods available to them. Until recently, these have been limited to what Helmholtz called the physical and the psychological. No doubt productive within their circumscribed realms, these methods have nevertheless left many of the "big" questions about the musical experience unanswered, such as: Why does some music seem merely good, and other music great? Why do some pieces merely afford dancing, while others compel it? How can the same piece be heard sometimes with indifference and at other times with rapture? Why is the response to music so different from the response to nonmusical and speech sounds? How is it that music has such powerful effects in dramatic situations even when perceived only subliminally? Does music have meaning, and if so, what is its relationship to linguistic meaning? And finally, the perennial Pythagorean question: Why are tones in simple proportion perceived not just as related, but as *pleasantly* related?

Traditional methods have by all means provided partial answers to these questions. Associations no doubt account for *some* of the feelings we experience in response to familiar music. And the science of resonance offers hints as to why some sounds might be preferred over others. But without an understanding of the physiological apparatus across which the physical and psy-

chological realms interface, answers provided by investigations into either of these realms, singly or in combination, cannot be expected to give rise to much more than metaphors—in Hanslick's words, "guesswork and fantasy"; in Helmholtz's, "unfettered artistic invention."[70]

It is only since the mid- to late nineteenth century that a physiological aesthetics has even been conceivable; and it is only with the neuroscientific developments of the past two decades that it has become practicable. But practicable it now is. Musical aesthetics is poised for its Kuhnian revolution. As we once shed our Victorian moral frigidity, so too may we someday see the aesthetical beauty in even the most pathological of musical pleasures.

Notes

1. Richard Wagner, *Mein Leben* (New York: Dodd, Mead and Company, 1911), 77.

2. Peter Kivy, *Sound Sentiment: An Essay on the Musical Emotions, Including the Complete Text of The Corded Shell* (Philadelphia: Temple University Press, 1989); Peter Kivy, *Music Alone: Philosophical Reflections on the Purely Musical Experience* (Ithaca, NY: Cornell University Press, 1990); Nick Zangwill, "Against Emotion: Hanslick was Right about Music," *British Society of Aesthetics* 44, no. 1 (2004): 29–43; Nick Zangwill, "Music, Metaphor, and Emotion," *Journal of Aesthetics and Art Criticism* 65, no. 4 (2007): 391–400.

3. Heinrich Eduard Jacob, *Johann Strauss: A Century of Light Music* (London: Hutchinson and Co., 1940), 120.

4. Ibid.

5. Ibid., 121.

6. Ibid.

7. *Mein Leben*, 77.

8. Jacob, *Johann Strauss*, 44.

9. For a more thorough comparison, see Wye Jamison Allanbrook, *Rhythmic Gesture in Mozart: Le Nozze di Figaro and Don Giovanni* (Chicago: University of Chicago Press, 1983), 33–36, 39, and 59–60. The picture is complicated by the fact that the social role played by the minuet changed over the course of the eighteenth century, and as a result its tempo slowed considerably. But since the Hummel waltz, composed mostly of quarter notes, resembles the old "quick minuet," rather than the newer, more rhythmically intricate one, the comparison is justified.

10. Meredith Ellis Little, "Minuet," *The New Grove Dictionary of Music and Musicians* (London: Macmillan Publishers, 2001), 16: 741.

11. Andrew Lamb, "Waltz," *The New Grove Dictionary of Music and Musicians* (London: Macmillan Publishers, 2001), 27: 73.

12. *Sound Sentiment*, 29.

13. Jacob, *Johann Strauss*, 11–22.

14. A similar point is made in Leonard B. Meyer, *Emotion and Meaning in Music* (Chicago: University of Chicago Press, 1956), 13.

15. Eduard Hanslick, *On the Musically Beautiful*, translated by Geoffrey Payzant (Indianapolis: Hackett Publishing, 1986), 54. The translation is of the eighth edition of the treatise, published in 1891.

16. Ibid., 3.

17. Ibid., 57.

18. Ibid., 51.

19. Ibid., 63.

20. Ibid., 66.

21. Ibid., 69–70.

22. Ibid., 70.

23. Ibid., 52.

24. *Sound Sentiment*, 216. See also *Music Alone*, 41.

25. *Kritik der Urteilskraft*, part 1, book 2, section 51. In *Music and Aesthetics in the Eighteenth and Early-Nineteenth Centuries*, ed. Peter le Huray and James Day, abridged edition (Cambridge: Cambridge University Press, 1988), 161.

26. Ibid., 162 (part 1, book 2, section 53).

27. Hanslick, *On the Musically Beautiful*, 45.

28. Ibid., 53–54.

29. Ibid., 52–55.

30. Ibid., 54.

31. Ibid., 55–56.

32. Ibid., 56. In some accounts of the tale, when Oedipus answers the Sphinx's riddle correctly with the word "man," she throws herself off the rock upon which she is perched.

33. First edition published 1863. Translated by Alexander J. Ellis from the fourth (and last) German edition of 1877 (New York: Dover Publications), 1885. Translation reprinted 1954.

34. Ibid., 1.

35. Helmholtz, *On the Sensations of Tone*, 2.

36. Ibid., 2.

37. Ibid.

38. Hanslick, *On the Musically Beautiful*, 3–4.

39. Helmholtz, *On the Sensations of Tone*, 4.

40. Ibid., 3.

41. Ibid., 235. Emphasis removed.

42. Ibid., 365–66.

43. Ibid., 160.

44. Ibid., 166.

45. Ibid., 169.

46. Ibid., 168.

47. Ibid., 178–79.

48. Ibid., 229.

49. Note that musical interval space (octaves, fifths, etc.) is logarithmic in relation to frequency space. Thus, while frequencies of partial tones will appear to proceed by equal degrees (e.g., 100 Hz, 200 Hz, 300 Hz, 400 Hz, etc.), in musical interval space they correspond to intervals which are not equal but which diminish in size (octave, fifth, fourth, etc.).

50. The upper partials of two complex tones in the ratio of, say, 3:2 (a perfect fifth), will begin to clash prominently only at the level of the lower tone's eighth partial and the higher tone's fifth partial—which will be a semitone's distance apart (16:15). Two tones in the ratio of 45:32, on the other hand (a ratio known as the *diabolus in musica* in the Middle Ages) will see a semitonal clash as early as the lower tone's third partial and the higher tone's second partial. The processing of two tones in the ratio 45:32 will thus be consonant—i.e., they will elicit no sensory roughness—*only* in the rare case in which the tones are both simple, with no upper partials.

51. Helmholtz's theory is largely accepted to this day (e.g., R. Plomp and W. J. M. Levelt, "Tonal Consonance and Critical Bandwidth," *Journal of the Acoustical Society of America* 38 [1965]: 548–60). One problem with the theory, however, as demonstrated by A. J. M. Houtsma and J. L. Goldstein ("The Central Origin of the Pitch of Complex Tones: Evidence from Musical Interval Recognition," *Journal of the Acoustical Society of America* 51 [1972] 520–29), is that dissonance and beating can be perceived between tones that are presented *dichotically*, i.e., one to each ear. This suggests that the mechanism may not be located in (or limited to) the cochlea, and may instead (or additionally) have a brainstem locale. Gavin M. Bidelman and Ananthanarayan Krishnan locate this mechanism in the inferior colliculus ("Neural Correlates of Consonance, Dissonance, and the Hierarchy of Musical Pitch in the Human Brainstem," *The Journal of Neuroscience* 29, no. 42 [2009]: 13165–71), a hypothesis supported by the anatomical and functional analysis of the same region in cats (Günter Ehret and Michael M. Merzenich, "Complex Sound Analysis [Frequency Resolution, Filtering and Spectral Integration] by Single Units of the Inferior Colliculus of the Cat," *Brain Research Reviews* 13 [1988]: 139–63).

52. Hanslick, *On the Musically Beautiful*, 56.

53. Stanley Finger, *Origins of Neuroscience: A History of Exploration into Brain Function* (New York: Oxford University Press, 1994), 123–26. See also Nils L. Wallin, *Biomusicology: Neurophysiological, Neuropsychological, and Evolutionary Perspectives on the Origins and Purposes of Music* (Stuyvesant, NY: Pendragon Press, 1991); Gerald Langner and Mi-

chael Ochse, "The Neural Basis of Pitch and Harmony in the Auditory System," *Musicae Scientiae* (Special Issue 2005/2006).

54. M.-Marsel Mesulam, "From Sensation to Cognition," *Brain* 121 (1998): 1015–17. Mesulam's presentation is by no means either music-specific or audition-specific. For a persuasive model of how the temporal and frontal lobes of the brain process the vocal sounds involved in speech, see Gregory Hickok and David Poeppel, "The Cortical Organization of Speech Processing," *Nature Reviews Neuroscience* 8 (2007): 393–402. For a music-specific model, see Stefan Koelsch and Walter A. Siebel, "Towards a Neural Basis of Music Perception," *Trends in Cognitive Sciences* 9, no. 12 (2005): 578–84.

55. Mesulam's larger argument is that complex brains differ from simple brains precisely as a function of their having more intermediate steps between sensation and action. In the frog brain, for instance, the sensory faculties connect directly to the motor apparatus; in the human brain, a flowering of intermediary steps intervenes. These intermediary steps Mesulam terms "cognition," a term which refers to "the diverse manifestations of memory, emotion, attention, language, thought and consciousness" (1015). Percept formation ("perception") appears to be defined as the enhancement of sensation through association, and if I read him correctly it is thus also included under the rubric of "cognition."

56. Robert C. Eaton, *Neural Mechanisms of Startle Behavior* (New York: Plenum Press, 1984). See also Patrik N. Juslin and Daniel Västfjäll, "Emotional Responses to Music: The Need to Consider Underlying Mechanisms," *Behavioral and Brain Sciences* 31 (2008): 564.

57. Ibid., 1036–37. See also Jaak Panksepp, *Affective Neuroscience: The Foundations of Human and Animal Emotions* (Oxford: Oxford University Press), 1998.

58. Joseph LeDoux, *The Emotional Brain: The Mysterious Underpinnings of Emotional Life* (New York: Simon and Schuster, 1996), 162. A number of studies have implicated the amygdala (and other subcortical structures) in the emotional response to music: see Natalie Gosselin, Isabelle Peretz, Marion Noulhiane, Dominique Hasboun, Christine Beckett, Michel Baulac, and Séverine Samson, "Impaired Recognition of Scary Music Following Unilateral Temporal Lobe Excision," *Brain* 128 (2005): 628–40; Natalie Gosselin, Séverine Samson, Ralph Adolphs, Marion Noulhaine, Mathieu Roy, Dominique Hasboun, Michel Baulac, and Isabelle Peretz, "Emotional Responses to Unpleasant Music Correlates with Damage to the Parahippocampal Cortex," *Brain* 129 (2006): 2585–92; Anne J. Blood, Robert J. Zatorre, Patrick Bermudez and Alan C. Evans, "Emotional Responses to Pleasant and Unpleasant Music Correlate with Activity in Paralimbic Brain Regions," *Nature Neuroscience* 2, no. 4 (1999): 382–87; Anne J. Blood and Robert J. Zatorre, "Intensely Pleasurable Responses to Music Correlate with Activity in Brain Regions Implicated in Reward and Emotion," *Proceedings of the National Academy of Sciences* 98, no. 20 (2001): 11818–23; V. Menon and D. J. Levitin, "The Rewards of Music Listening: Response and Physiological Connectivity of the

Mesolimbic System," *NeuroImage* 28, no. 1 (2005): 175–84; Steven Brown, Michael J. Martinez and Lawrence M. Parsons, "Passive Music Listening Spontaneously Engages Limbic and Paralimbic Systems," *Neuroreport* 15, no. 13 (2004): 2033–37; and Stefan Koelsch, Thomas Fritz, D. Yves v. Cramon, Karsten Müller, and Angela D. Friederici, "Investigating Emotion With Music: An fMRI Study," *Human Brain Mapping* 27 (2006): 239–50.

59. Mesulam, "From Sensation to Cognition," 1035.

60. Ibid.

61. Ibid., 1036.

62. See, for instance, Stephen Davies, *Musical Meaning and Expression* (Ithaca, NY: Cornell University Press, 1994); Kofi V. Agawu, *Playing with Signs: A Semiotic Interpretation of Classic Music* (Princeton, NJ: Princeton University Press, 1991); and Robert S. Hatten, *Musical Meaning in Beethoven: Markedness, Correlation, and Interpretation* (Bloomington: Indiana University Press, 1994).

63. Fred Everett Maus, "Music as Drama," *Music Theory Spectrum* 10 (1988): 56–73.

64. Kivy, *Sound Sentiment*.

65. Meyer, *Emotion and Meaning in Music*.

66. Jacob, *Johann Strauss*, 123.

67. I invoke here one of Oliver Sacks's personal anecdotes in the wonderful book *Musicophilia: Tales of Music and the Brain* (New York: Alfred A. Knopf, 2008). For discussions of music's use in everyday life, the pioneering work is Tia DeNora's *Music in Everyday Life* (Cambridge: Cambridge University Press, 2000). An updated review of this literature with special attention given to emotion can be found in John Sloboda's "Music in Everyday Life: The Role of the Emotions" in the *Handbook of Music and Emotion: Theory, Research, Applications*, ed. Patrik N. Juslin and John A. Sloboda (Oxford: Oxford University Press, 2010), 493–514.

68. "Psychology and Literature," in *Modern Man in Search of a Soul*, trans. William Stanley Dell (New York: Harcourt Trade, 1966), 152–72.

69. Barbara Maria Stafford, *Echo Objects: The Cognitive Work of Images* (Chicago: University of Chicago Press, 2007), 3.

70. *On the Musically Beautiful*, 56; *On the Sensations of Tone*, 2.

EIGHT Alvar Aalto's Astonishing
Rationalism

. **Sarah Williams Goldhagen**

Most people take the mandate that architects should design rationally as a
given, in their reasonable assumption that a well-designed building will pro-
tect them from a rainy day. It is true that the architect's design must stand up,
stay strong, let in light, and keep out rain. It is also true that the principles of
gravity are constant, and that substantive revolutions in engineering knowl-
edge and building materials are few.

Despite these invariables or infrequently varied factors, the history of
architecture shows that the look of buildings and the arrangement of their
spaces differ greatly over time and, in any given slice of time, in space. The
rich polyphony that is the built environment can be and has been explained
by material variations in geography, climate, and materials; by cultural and
social differences among and within cultures in living habits, norms, beliefs,
and tastes; and by the rich, continuous, and refractive interplay between
these phenomena.

Another factor, less frequently discussed but central to the design of
buildings, lies—along with the practice of architecture itself—at midpoint
between humanities and sciences. That is the question of rationalism: if a
building must be designed rationally, then what, beyond the mandate to
protect humans from the elements, is rational? How might rationalism—a
philosophical notion that historically has been grounded in scientific knowl-
edge—inform the art of architectural design?

These questions can be discerned in the cacophony of contemporary archi-
tectural practice, particularly among practitioners in the medical and mental
health industries who advocate designing health care facilities with reference
to the results of scientific studies on the effects of light, air, noise, and other
conditions on patient outcomes—a field now called evidence-based design.
But at few moments in architectural history were such questions more domi-

nant than in the early twentieth century with the birth of the new architectural movement, or rather the panoply of loosely affiliated movements, now often collected under the single eponym "modernism." The rallying cry of modernists was that new architectural design should emerge out of a "rational" deployment of materials, a "rational" development and expression of the building's structure, and a "rational" assessment of the needs of the client and of the larger society.

Modernism offers itself up as an arena that can be understood properly only by breaking through disciplinary boundaries, and by looking to multiple forms of historical and philosophical investigation, the history of science and psychology, and modern and contemporary theories of mind. Within modernism, the work of the Finnish architect Alvar Aalto (1898–1976) especially illustrates the necessity of a broad-based, interdisciplinary approach. Such an approach answers essential questions about Aalto's work; it also illuminates dark rooms in the understanding of modernism, and indeed in the understanding of architecture itself.

Aalto is often treated in the story of modern architecture as the most important and greatest early modernist who doesn't fit. The mainstream, nearly filmic narrative typically begins with the work of the American architect Frank Lloyd Wright and then, in a series of cuts, shifts to continental Europe, with the Swiss-Frenchman Le Corbusier, the Dutchman J. J. P. Oud, and the Germans Ludwig Mies van der Rohe and Walter Gropius in leading roles. Only later, separately, comes the short on Aalto. The story of this Finnish outlier, lauded throughout his career and to this day by an underpopulated if devoted coterie of admirers, continues to be treated as a puzzling, if important, outtake not often shown in the crowded theater of modernism.

Aalto embraced many of modernism's first principles. He, along with his better-known colleagues, insisted that the social, political, economic, and technological changes of the late nineteenth and early twentieth centuries demanded a new architecture. He also insisted that this new architecture had to approach design by privileging rationalism over precedent and tradition. For Aalto, as for his colleagues, rationalism mandated the use of new materials (steel, reinforced concrete) and new products (large plate glass windows, elevators) to create airy, open spaces with an unprecedented flow inside, and from outside to in. Early modernism in architecture frequently developed

hand-in-hand with modernist art, and so it was in Aalto's case; his appreciation of the everyday and incidental and his penchant for organic curves flourished along with his friendships with leading artists—Hans Arp, Lázló Moholy-Nagy, and Alexander Calder. Aalto also shared with many of his colleagues the conviction that good design should no longer serve only the elite classes and the institutions of power: architecture should be for everyone, and it could be an instrument helping to advance social justice.

Although Aalto embraced most of modern architecture's canonical principles, he also deliberately and insistently contravened many precepts by which modernism typically was and is conceived and practiced. If modernism was concerned with standardization, Aalto rebuked Gropius, Le Corbusier, and others for an approach to standardization that, he maintained, bulldozed through and leveled human particularity. He instead advocated and practiced what he called the "flexible standardization" of a building's parts but never of the architectural whole, which he insisted should be planned and constructed with attention to the needs of individual users and the building site's topography, climate, and constructed traditions. The Taylorist and Ford-fueled craze in Europe (and especially Germany) in the 1920s for the materials and methods of mass production, best encapsulated by Le Corbusier's apothegm that the modern house was "a machine for living in," inspired Aalto to develop his own mass-produced line of furniture—but in wood!—and to flagrantly, almost defiantly, celebrate the idiosyncrasies of handicraft in high-profile projects, including in the widely published Villa Mairea in Noormarku. Mies, Gropius, Le Corbusier, and others insisted upon a design method that bore at least the pretense of structural expression; Aalto refused to bend over backwards to integrate structure with form, and often developed hybrid structural solutions—load-bearing masonry here, steel beams or poured concrete there—which he masked as he deemed aesthetically necessary.[1] If modernism suffered the anxiety of influence, especially from tradition, Aalto drew liberally and openly from precedents high and low, contemporary and historic: Le Corbusier's Villa Savoye, Italian Renaissance palazzi, Finnish country churches, Karelian courtyard farmhouses, ancient Greek amphitheaters. If modernism whispered or shouted transparency, Aalto's buildings revel in their four minutes and thirty-three seconds of opacity. If modernism aspired to the universalism of an "international style,"

FIGURE 8.1. Alvar Aalto, Paimio Sanitorium. Paimio, Finland.

Aalto practiced and preached particularism. If modernism mandated functionalism as the "rational" approach to planning the distribution of spaces, Aalto deployed his designs through complex schemas driven by figuration and metaphor.[2]

How to understand modernism with Aalto's work in its pantheon? Answering this question requires challenging architectural history's somewhat self-reflexive narrative on the nature and development of modernism, examining Aalto's work and ideas in several overlapping contexts: early twentieth-century scientific research in human psychology; philosophical phenomenology; twenty-first-century research in cognitive neuroscience, neuropsychology, and linguistics on the nature of human cognition; and various architectural and philosophical concepts of rationalism and their role in the construction of modernist praxis.

For Aalto, the term "rationalism" was practically coterminous with the word "humanism." This may make for a somewhat counterintuitive notion of rationalism, but Aalto's notion of rationalism, once unpacked, better describes what we now understand to be the cognitive realities of human experience than did the multiple rationalisms advanced by his better-known

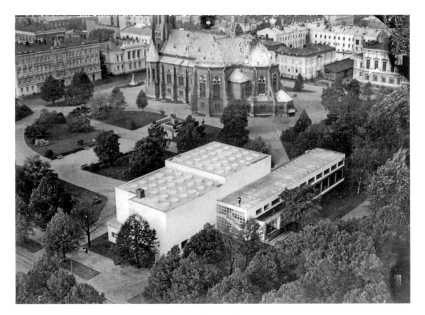

FIGURE 8.2. Alvar Aalto, Viipuri Library, completed 1935.

architectural contemporaries. Aalto's conflation of rationalism with human-ism makes sense only when each term is reflected through the prism of phe-nomenology, which has taken various forms, from early twentieth-century experimental psychology and mid-twentieth-century phenomenological philosophy to contemporary cognitive linguistics and neuroscience. Aalto developed his singular and lasting approach to modernism, which he con-ceptualized through the early-twentieth-century lenses of phenomenology and experimental psychology, partly by imbuing, partly by intuiting a model of human cognition and reason grounded in what contemporary research in cognitive neuroscience has revealed about the workings of the human mind.[3]

Constructing the appropriate cognitive and historical frame for Aalto's work opens the way to revisiting two of his greatest early buildings, the Sana-torium in Paimio (1929–32) and the Municipal Library in Viipuri (1927–35; the city of Viipuri, now in Russia, has been renamed Vyborg; figures 8.1 and 8.2). Aalto repeatedly claimed that these buildings were foundational to his later work and central to his philosophy of architecture; they are also the

works that first captured the attention of the international architectural community and secured Aalto's place in the discourse of modernism.

When the Paimio Sanitorium and Viipuri Library are properly understood, Aalto's extravasation from the central discourse of modernism disappears. Not only that, but a more theoretically adequate and historically accurate conception of modernism itself emerges. Aalto's oft-repeated insistence on these buildings' importance — and on their *rationalism*—was based on his belief that these projects articulated a new, more promising strain of modernism that was anchored in a scientifically grounded understanding of cognition, and was therefore better suited to the human and necessarily embodied experience of the built world.

Triangulated Rationalism and the Challenge of Embodiment

Throughout his career, Aalto broadcast and rebroadcast his commitments to modernism and rationalism. He contended that modernists (by which he largely meant his colleagues in the Congrès Internationaux d'Architects Modernes, or CIAM) had "no reason" to dispense with the pursuit of rationalism, which itself was not wrong. But he gently suggested that the way in which his colleagues conceptualized reason and rationalism was shallow, even wrong-headed. Rationalism, he maintained, "has not gone deep enough."[4] By equating rationalism with the rationalization of the building process, or with structural or mathematical logic, his celebrated colleagues were propagating an aesthetic that violated basic human needs. In a barely veiled reference to Le Corbusier, who had declared that his model dwellings for the Weissenhofsiedlung were "as efficient as a railway car," Aalto wrote, "By the word 'economical' I do not mean the economy that prevailed in the early days in the railway cars of the Pullman Company."[5] Pullman cars were "said to be practical and economical, but the wise traveler was quick to point out that their practicality and economy provided significant advantages only to the Pullman company, not to the passengers." Similarly, his colleagues' attempts to "rationalize" lighting (surely Aalto was referring to the lighting designs emerging from the Bauhaus workshops under the tutelage of Marcel Breuer and Gropius) had "introduced little else but blindingly white porce-

lain spheres or opal cubes"—again reaping profits for the manufacturer, but visiting upon the consumer little more than headaches and hotspots.[6]

Modernist architects needed to expand their understanding of rationalism, to analyze "more of the qualities" intrinsic to the architecture they designed. Comparing the array of human needs that architecture accommodates to hues on a color spectrum, Aalto contended that designers must consider not only architecture's "visible" colors—program, economy, technology, hygiene, site—but also its invisible "ultraviolet band." There the "purely human questions" lurk. Buildings should serve everyday human needs. Architectural environments must at once accommodate users and slow them down, forcing them to appreciate "the value of the fleeting moment."[7] Sometimes, Aalto acknowledged, architectural methods need "resemble scientific ones": an analytical, rational approach to the multiplicity of human needs, and a "process of research, such as science employs, can be adopted also in architecture." Nevertheless, "always there will be more of instinct and art" in this process. Intuition, he asserted elsewhere, "can be astonishingly rational."[8]

Whatever Aalto meant by rationalism, his use of the term certainly differed from its common usage among his colleagues. To elucidate these worlds of difference we need to examine the term *rationalism* not only in modern architecture but also in modern philosophy, because it is on philosophical notions of rationalism that the early modernist approach to rationalism largely rests.

In discussions of modern architecture, *rationalism* elicits a fairly standard set of meanings in terms of both design method and formal aesthetic.[9] Twentieth-century rationalism, developed between the two world wars, was the intertwined theoretical legacy of two nineteenth-century traditions: the structural rationalism of Eugène-Emmanuel Viollet-le-Duc and Auguste Choisy and the typological functionalism of Jean-Nicholas Durand.[10] Aalto's colleagues conjoined structural rationalism and typological functionalism into a set of guiding principles for design—although, in practice, these were applied in such sundry combinations that rationalism became nearly topological, a single lump of theoretical clay ever transforming into a multiplicity of forms. Mies became the supposedly unschooled successor to nineteenth-century structural rationalism while rejecting typological functionalism as unsuited to the psychic and locational needs of ever-transitory

modern man.[11] Le Corbusier and Gropius insisted upon pressing new technologies into what they claimed were architecture's logical structural, functional, and aesthetic ends; a frequent adjunct to this techno-rationalism mandated that architectural design should be developed according to the dictates of the anticipated construction process, preferably mass production. Formally, these technologically-oriented strains of rationalism, most famously represented in Mies's Barcelona Pavilion (1929), Le Corbusier's Villa Savoye (1929), and Gropius' Bauhaus at Dessau (1926), drew from the grid and Euclidean geometry. Combined, these formal tropes became the symbolic language of rationalist design.

For some of the techno-rationalists' contemporaries, such as Hugo Häring and Hans Scharoun, rationalism in design did not begin from a building's formal disposition but from the architect's handling of human social functions. Often called organic functionalists, these architects owed to Durand their insistence that a building's shape and plan suit its projected use, yet they rejected Durand's typological approach as being so saturated in historical precedent that it prohibited individuated solutions to architectural design. A new architecture needed to serve *modern* life. For the organic functionalists, a building's design must emerge first from the specifics of program and site.

Most architects and critics of the 1920s and 1930s considered these two theoretical strains of modernist practice, techno-rationalism and organic functionalism, to be diametrically opposed.[12] And this was not without reason. Techno-rationalists began from the object, organic functionalists from its users. Techno-rationalists employed (or purported to employ) mathematically-based formal systems of geometry or physics; organic functionalists shunned such abstractions (even as they occasionally used them) in favor of the contingencies of site and patterns of human social interaction. Techno-rationalism revered systematic, parsed-out logic; organic functionalism, pragmatic analysis of the empirical world. Techno-rationalism, straight lines; organic functionalism, curves.

Early modernist theory's binary opposition of these approaches indicates the loose affiliation of each with an epistemological tradition that itself has been historically opposed to the other: the intellectualism of Descartes on the one hand, and the empiricism of Burke and Locke on the other.[13] The philosophical debate on rationalism versus empiricism is long-standing, and

it need not be examined in depth here. Suffice it to say that the debate re-volves around the extent to which people gain knowledge by way of infor-mation acquired through the senses. Descartes' "I think, therefore I am" fa-mously epitomizes the intellectualist position: The mind at all times knows its own ideas, thought is wholly conscious, the structure of the mind is di-rectly accessible to itself, and certain forms of knowledge are constructed without input from sensory experience.[14] The empiricist tradition rests on most of these same premises, but differs in its contention that *only* from data acquired through sensory experience can human knowledge emerge.

In early twentieth-century architectural discourse, the parallels between these two dominant strains of modernism and their philosophical ana-logues—intellectualism and techno-rationalism on the one hand, empiri-cism and organic functionalism on the other—are not exact. Still, they are suggestive. The techno-rationalists propounded formal, rule-bound, abstract systems of logic and analysis that bore the stamp of Cartesian intellectualism. The organic functionalists asserted that design should begin with the archi-tect's study of the empirical world, with *data* gathered from the projected users' sensory experiences, patterns of social interaction, and experience of the site.

Not surprisingly, the tendency of early modernist architects and critics to oppose techno-rationalism to organic functionalism blinded them to the effective continuities between the two traditions, as is true in the case of their philosophical second cousins.[15] Both techno-rationalism and organic functionalism operate from the premise that the mind can know or excavate its own ideas, that human thought is largely conscious, and that the mind's structure is accessible to itself. Both employ a logic-driven approach based in science, differing only on *what kind* of data is offered up to human cognition. Both insist that architecture reflect and serve the conditions of modern life. Both hold that the makers and users of buildings are thinking subjects ca-pable of cognitions dispassionately constructed from rational analysis, and that this thinking subject is categorically distinct from the object-world of other people and of buildings, cities, and nature.

Techno-rationalists and organic functionalists both disliked Dada and sur-realism, artistic movements that celebrated personal self-expression and the irrational. Surrealism, led by one of Aalto's closest friends, Hans Arp, along

276 || CHAPTER EIGHT

with others such as Kurt Schwitters, André Breton, and Max Ernst, established rapid-fire currency among avant-garde intellectuals in the same years that techno-rationalism and organic functionalism earned widespread recognition. Dada and surrealist artists and their occasional architect friends—Berthold Lubetkin, Friedrich Kiesler, Paul Nelson, and (sometimes) Le Corbusier—assembled a self-consciously impudent, here-and-there aesthetic that they believed expressed and even provoked primal human drives. Analysis, logic, and empirical data were shunned. Surrealism celebrated the poetic, the associative, and the uncanny.

Surrealism was the stepchild of Freud's id, the shadowy unconscious force that the Viennese psychoanalyst contended is twinned to and navigated by the necessary strictures of the prudential ego. Like his philosophical confederates, Freud presumed the existence of a split between the thinking subject and the object world, with the id militiating against grounded interpretations of empirically verifiable realities. Reason's "other," the id, is the ghost ever threatening the smooth operation of the human machine, perverting one's cognitions of and interactions with the object world. The cognitive style of the id is everything that its putative opposites are not: organic, primal, ecstatic, symbolic.

Throughout the twentieth century, this three-point philosophical model of human cognition—intellection, empiricism, and irrationalism—governed much humanistic thought, art and architecture included. Popularly taken as commonsensical, it is a triangle of unstable dimensions, ever more tottering, but yet to collapse. At its foundation is the assumption that cognition and reason are the collaborative products of successively executed faculties. This model of cognition has been characterized by George Lakoff, a cognitive linguist, and Mark Johnson, a philosopher, as "the Society of Mind."[16] In it, input is processed from the bottom up. Intellection and empiricism both posit that the human senses receive bits of information and then hand them up to perception, the brain's preliminary synthetic faculty. Perception registers the information and then transmits it to its "higher" (and more sophisticated) processor, imagination, at which point the mind forms a preliminary interpretation of the data received. Imagination, however, is inevitably colored by feeling—undisciplined, irrational, and out of control; an unruly child or a threateningly emotive woman. In cognitive

pursuit of "true" understanding, the brain's higher-level function, reason, remains dissatisfied with interpretations that rely solely on the putatively lower-level processes of sensation, perception, imagination, and feeling. Searching for a more solid foundation on which to rest its conclusions, the brain hands its preliminary interpretation up to its preexisting data bank of received wisdom: memory. Yet memory, too, distorts. So this already highly processed cognition is once more handed upward, this time to the mind's most sophisticated arbiter, reason. Reason differs in kind from the mind's lower-caste members: it is unflinchingly guided by discipline, logic, and analysis. Bound by rules and clear-sighted, reason plays the man of cool systematization.

A stunning amount of research and scholarship in the last two decades, including by Lakoff and Johnson, in overlapping but professionally distinct disciplines such as language acquisition, cognitive and historical linguistics, gesture analyses, cognitive neuroscience and neuropsychology, falsifies the triangulated model of human reason and unreason and the Society of Mind paradigm of cognition on which it rests. Facilitated in part by recent technological developments such as computerized data analysis, positron emission tomography scans, and functional magnetic resonance imaging, this research, which draws from several long-standing intellectual traditions, determines that the machinations of the human mind do not concord with any part of the "common sense" three-point model of cognition: neither Cartesian intellectualism, nor empiricism, nor the Freudian notion of the irrational. Cartesian intellectualism does not exist. The presumption it shares with empiricism, that a divide separates the thinking subject from her perceived world, is misconceived. Consequently, accepted notions of the irrational as the "other" of rationalism need also to be toppled.

A twenty-first-century view of human cognition, one that leaves the Society of Mind behind, is earning ever wider acceptance in the sciences and social sciences. It holds that human cognition is approximately 90 percent *unconscious*, and demonstrates that human cognition—and, therefore, human reason and knowledge—is intricately structured in determinative patterns by the reality of a person's bodily inhabitation of the world.[17] Contra the Society of Mind, cognition is not the progressive analytic synthesis of information received from the external world via the senses. Everyday and "higher"

cognitions emerge unconsciously and intersensorily; they are imaginative and they are emotion-driven. How I interpret what I see is intermeshed with what I have seen and what I anticipate seeing; with what I hear, have heard, and anticipate hearing; and with what I touch, have touched, and anticipate touching.[18]

A simple, powerful falsifier of the triangulated model of human cognition lies in the global, cross-cultural universality of body-based metaphors that are used to describe everyday human sensory experience in space and time.[19] In every known language, spoken and nonspoken, humans employ and, as far as scholars know, have always employed the same or an extremely similar set of metaphors to characterize emotional and intellectual states and to describe how they attain knowledge about the world. The coupling of human affection with physical warmth is an example.[20] This so-called primary metaphor is probably forged during infancy in what linguists and neurologists call a cross-domain association: newborns conflate the psychological experience of affection with the physical warmth they experience in the close embrace of their caretaker's body. "Affection equals warmth" becomes "neurally instantiated" in the brain as a cognitive schema. From then on, "we are not free to think just anything."[21]

Some cognitive linguists and neuropsychologists point out that infants in all cultures begin to employ primary metaphors in the same developmental sequence, which strongly suggests their neurological basis. A host of other such metaphors reveal additional cognitive schemas, all hung upon the scaffolding of human embodiment. An expression commonly used to describe a volatile emotional state—"unstable"—equates a disequilibriated feeling state with a disequilibriated physical one. "I feel at home there" conflates the emotion of feeling secure with the physical experience of inhabiting a spatial container—in this instance, a familiar building. Such cognitive schemas belong to a vast and fluid body of primary metaphors, common in aggregate to every culture, that frame cognitive states around the blunt fact of human embodiment. Users and listeners comprehend these primary metaphors, despite their sometimes patent illogic, precisely because the cognitions they describe are born of our irreducible physiological constitution as human beings.

The cognitive framing of emotional states often refers to bodily movement through space and time. In day-to-day physio-perceptual experience,

moments abound in which people routinely orient themselves emotionally with respect to other people, other objects, and other containers. Cognitive orientation schemas are instantiated in such primary metaphors as "change is motion," which are exemplified in familiar phrases such as describing one's progress on a project with "I'm getting there"—a change in an emotional or intellectual state is metaphorically equated to a change in physical location and with forward, and sometimes upward, movement. Acquiring knowledge is moving from the unseeing state of darkness into vision and light: "I'm beginning to see the light." In this instance, too, the brain's neurological architecture likely underlies the consistency and universality of these metaphors: neuroscientists now propose a neurally instantiated interconnectedness of proprioceptive sensory perception, conceptual inference, and motor control.[22]

The diachronic and synchronic persistence of primary metaphors confirms that our minds develop in total integration with our bodily experience. An embodied theory of the mind does not belie that human consciousness is profoundly inflected by political, economic, scientific, social, and cultural phenomena, nor does it deny the wide variability across cultures and over time in how people interpret the primary metaphors and cognitive schemas they employ. Yet the facts on the ground remain. The space of the world is not, and could never be, exterior to the space of the bodily self. No throne elevates reason above sensory experience, as the Society of Mind model of cognition suggests. As a thinking subject the bodily self is, as Maurice Merleau-Ponty wrote, "the zero degree of spatiality." The simple antonymic relationship of "here"—within or of our body—to "there"—outside it—says so.[23] Rationality is "imbued with a sensibility, and vice versa."[24] Reason is unconscious and intuitive; it is simultaneously "rational" and "irrational," analytical and poetic, systematic and associative, logical and metaphoric.[25]

Embodied Rationalism and Experimental Psychology

Among nineteenth- and twentieth-century intellectuals who considered the nature of human rationality, only phenomenologically-oriented experimental psychologists, phenomenological philosophers, and those in related fields questioned the substantive premises of the three-point model of human cog-

nition. Aalto's early intellectual biography and projects strongly suggests that he should be counted among this group, and the insights of Aalto and these other thinkers in some cases foreshadow contemporary findings on the embodied mind—or, conversely, recent research attests to the correctness of phenomenology's fundamental principles. From his student days, Aalto knew the basic precepts if not the specifics of proto-phenomenological experimental psychology. Certainly, by the late 1920s he was extremely familiar with its central ideas.[26]

Founded in the mid-nineteenth century and centered in Germany, scientific or experimental psychology encompassed adjacent and related fields such as phonetics, linguistics, aesthetics, philosophy, and the study of culture.[27] The physicist Gustav Fechner (1801–1887) first advanced some of its principles in his *Elements of Psychophysics* in 1860; his best-known pupil, Wilhelm Wundt (1832–1920), developed his mentor's ideas into a scholarly agenda to scientifically investigate a vast constellation of human cognitive processes.[28] Founding a laboratory of experimental psychology at the University of Leipzig in 1874, Wundt's wide-ranging research included systematic controlled experiments on human reaction times in muscular sensations and reflexes, on the experience of binocular vision, and on the visual perception of color. Through such experiments, Wundt established many of contemporary experimental psychology's paradigmatic precepts: that human perception is an act of creative synthesis, that emotion is a determining factor in any and all mental processes, and that no split divides human consciousness (the subject) from the physical world (the object). By the 1880s, Wundt was devoting much of his work to exploring the philosophical and cultural implications of his scientific findings, founding the journal *Philosophical Studies* in 1881 and writing what would eventually become a ten-volume study, *Cultural Psychology* (1900–1920).

From the University of Leipzig, where Wundt presided over the laboratory of experimental psychology and taught for more than forty-five years, he legitimized the discipline, shaped its research agendas, and disseminated its findings. He was enormously popular among students—enrollment in his lecture classes sometimes exceeded six hundred—and in his lifetime he granted more doctorates in psychology than any other scientist in Germany.

He hired like-minded and widely influential scholars, including the art historian August Schmarsow (1853–1936), who was chair of the Department of Art History from 1893 to 1919. By 1914, Wundt's laboratory of experimental psychology had become the leading center and model for psychological research in the world, and it was replicated all over Europe as well as in the United States, India, and Japan.

Wundt's colleague Schmarsow pursued a new way to interpret artistic intention and experience by calling for what he, referring to Kant, specifically described as a phenomenologically-based approach.[29] Criticizing Alois Riegl's *Spätrömische Kunstindustrie* as too narrowly focused on optical experience to the exclusion of the other senses, Schmarsow contended that if experimental psychology took a too strictly scientific approach to the study of aesthetics, it would get on "the wrong track" because it unrealistically abstracted human consciousness "from all the contingencies of the earthly scene."[30]

Cognition, Schmarsow contended, encompassed "the whole physis of the perceiver," including an awareness of that "physis," or body. Any notion of reason must encompass the imagination and the "play of associative factors."[31] Foreshadowing the phenomenology of Merleau-Ponty, Schmarsow posited the human body as degree zero in the human perception of space and time, writing that our cognitive understanding of verticality drew from our phenomenological experience of standing, of measure from "the reach of our arms" and a person's projected or actual position in and movement through space.

By 1900, experimental psychology had developed two equally wide estuaries: one more philosophical, represented in the work of Wundt and Schmarsow, and one more scientifically oriented, propounded most prominently by Theodor Lipps (1851–1914), whose Psychological Institute in Munich was founded in 1894 and quickly became the main institutional competitor to Wundt's laboratory in Leipzig. Lipps, a theoretical psychologist who is best known among art historians as the founder of empathy theory, advocated a more scientific approach to the study of cognition, rejecting what he held was the Leipzig School's emphasis on subjectivism. Advocating a strictly scientific approach, Lipps disseminated his research on human physiological response to sensory stimuli in numerous books on the human perception of time,

music, space, and visuality. Like Wundt, he also wrote on aesthetics, and he founded the well-known *Beiträge zur Aesthetik*, which he edited for many years.

Although Schmarsow pointedly criticized Lipps' approach as being overly driven by scientific method and pursuits, the Munich and Leipzig schools of experimental psychology both insisted upon the centrality of human embodiment to an understanding of cognition and reason. Thus, by the early twentieth century, a number of prominent psychologists and aestheticians held that human cognition and reason are fundamentally embodied, fundamentally intersensory, and fundamentally creative; that emotion, memory, and imagination are integral to human reason; and that the commonly accepted gulf dividing subject from object does not exist. These early experimental psychologists had not identified the more or less stable set of cognitive schemas, basic-level categories, and primary metaphors that underlie the operations of human cognition and reason. Still, this German scholarship in psychology, philosophy, and aesthetics established a body of knowledge and intellectual positions that today's research, with its more refined research tools and methods, confirms in its essence but vastly elaborates upon in its details.

How might this knowledge of experimental psychology, or of phenomenology, or of cognitive neuroscience and linguistics, change or develop our understanding of modernism, Aalto's place within modernism, and cognition in general? If we reexamine Aalto's work and intellectual development in light of this intellectual background, many of his design practices and theoretical statements that appear to violate the basic premises of canonical modernism can be recast as a transparent project to articulate a modern architecture that takes advantage of the opportunities modernity presents, ameliorates the psychic casualties it leaves in its wake, and springs from the essentially embodied nature of cognition. Aalto drew on primary metaphors and cognitive schemas even in his earliest published writings on architecture, often conceptualizing them with the somewhat blunt instruments he had at hand: the scientific language of experimental psychology.

Aalto Embodied

From 1900 to 1921—the years of Aalto's childhood, basic education at the *lyceum* in Jyväskylä, and architectural training in Helsinki—European intel-

lectuals in the sciences, arts, philosophy, and culture were schooled in the basic insights and findings of proto-phenomenological experimental psychology. Although the field was centered in Germany, interest in its findings extended into Germanophile countries, including Finland.[32] By 1902, Uppsala University in Sweden had established a major psychology laboratory, and by 1917, when Aalto was nineteen years old, a member of the Department of Pedagogy at the University of Jyväskylä was advocating the founding of a laboratory of experimental psychology.[33]

Aalto read German fluently and closely followed intellectual currents in Europe. During his basic training in Jyväskylä, he learned of empathy theory and, more broadly, the basic precepts of experimental psychology.[34] As a young man and throughout his career, he sketched mainly in perspective, an embodied (if still artificially constructed) point of view, and he never drew in axonometric—the disembodied language of mathematically abstracted spatial depiction.[35] His writings are saturated with the precepts of embodied rationalism: at the age of twenty-six he wrote that the beauty of a hilltop town in Tuscany (which he saw on his honeymoon in 1924) shone forth especially "when seen from the level of the human eye, that is, from the ground level," because only from this perspective was "a vision the senses receive whole and undisrupted, adapted to human size and limitations."[36]

Proposing a sauna for a hilltop ridge in Jyväskylä to serve as a national monument to Finnish culture, Aalto described his "Roman bath—a Finnish sauna" as a building "caress[ing] the senses" to spark deep memories and profound emotions. Swimming in the language of the sensorium, he describes his imagined sauna's smells, textures, and sights: the aroma of burning spruce and juniper twigs, the warmth of "a stove with a crackling fire of choice logs," the soft, warm light emitting from a colored lamp, the textures of "changing rooms covered with beautiful Nordic woven fabrics."[37] Such early writings and projects intimate the young Finnish architect's grasp of philosophical and psychological concepts that today's scholarship lays bare: the intersensory and often unconscious nature of cognition, and reason's deep enmeshment with emotion, memory, and bodily experience.

When earning his architectural degree at the Polytechnic Institute in Helsinki in the years 1916 to 1921, Aalto became close to several of his professors, including Selim Lindqvist, who paid far closer attention to architectural and

intellectual trends in Europe than to the National Romantic movement that predominated in Finland at the time, and who was especially interested in the *Jugendstil* movement that had been so deeply influenced by the ideas of Lipps.[38] When Aalto moved in 1927 to Turku, he had chosen a coastal city where intellectual, economic, and social exchange with Stockholm and the rest of Europe dominated local culture. After 1928 he became still more deeply involved in European architectural discourse and was further exposed to proto-phenomenological experimental psychology during trips to Germany, when he became familiar with the work of early modernist artists at the Bauhaus, including Oskar Schlemmer, Paul Klee, and, most importantly, Moholy-Nagy, who became his lifelong friend.[39] Klee and Moholy-Nagy's interest in experimental psychology is well documented; the latter explicitly used the discipline's contemporary jargon, describing his artistic project as the "psycho-biological" experience of man, by which he meant the sentient person's intersubjective relationship with space, time, and light.[40]

From the mid-1920s onward, Aalto felt his way toward a formal idiom equal to and shaped by his understanding of the embodied nature of human cognition. Repeatedly his writings invoke the language of experimental psychology: he argued that "the rationalist working method" must encompass "psychological requirements" such as neurophysiology and the "general physiological properties" of human beings.[41] "My aim," he wrote, "was to show that real rationalism means dealing with *all* [my italics] questions related to the object . . . [the architect must] take a rational attitude also to demands that are often dismissed as vague issues of individual taste, but are shown by more detailed analysis to be derived partly from neurophysiology, and partly from psychology." Once architects adopt such an approach, he continued, explicitly connecting his sort of rationalism with the humanism he often discussed, "we will have extended the rationalist working method enough to make it easier to prevent inhuman results."[42] Rationalism "should be extended to the psychological domain," he insisted. "Only one book has not yet been published anywhere in the world, *The Physiological Home*."[43]

Throughout his career, Aalto repeatedly invoked the word "human," asserting that architecture should "serve human life," or that it must "humanize" an overwrought world. These vague, repeated, sometimes repetitious incantations to humanism—the word appears no less than thirty-two

times in a single article — can be and at times have been misleading. They allude not, as some writers have assumed or concluded, to a kinder, gentler modernism, nor to the European classical tradition, nor do they herald the regionalist-inspired, woody familiarity of the later British New Empiricism or the American Bay Region Styles. By "humanism" Aalto meant to exhort modernists to create a rationalist architecture of the *human being*: a physiological, perceiving, thinking creature whose experiences and cognitions are by their very nature phenomenological.

Astonishing Rationalism

During his first teaching stint at MIT, in 1940, Aalto published in the school's journal *Technology Review* an article describing for his American audience his two most celebrated Finnish buildings, the sanatorium in Paimio and the town library in Viipuri. Years after their completion, Aalto presents these early projects as central to his intellectual and architectural vision. He explains that in designing them, he rejected extraphenomenological compositional systems such as the grid, then so popular among techno-rationalists. Such undifferentiated, mathematically regularized notions of space were and are wholly antithetical to the premises of "The Humanizing of Architecture," which is the article's title. Buildings, Aalto explained, must be designed around the rhythms and patterns of daily life, their spaces emanating from the body, degree zero of human cognitive experience. In describing the sanatorium and library, Aalto reveals how he shaped them, from conception to built form, around the human mind's fundamentally intersensory, fundamentally metaphoric apprehension of the world. The principles that underlay these projects' designs, Aalto hoped, might inspire his students and colleagues to redirect modernism, which he portrays as a right-thinking movement gone astray.[44]

Discussing the Paimio sanatorium, Aalto explains that the design emerged only after he conducted "experiments" examining his projected users' daily rituals and routines and their psychological reactions to room forms, shades and degrees of colors, and types and intensities of light. Echoing experimental psychology's research experiments conducted at the universities in Leipzig and Munich, he recounts analyzing the impact on patients of variations in temperature, types or degrees of ventilation, and levels of noise. From

the "results" of these "experiments," he concluded that the sanatorium's de-
sign needed to address an intertwined array of physiognomic, phenomeno-
logical, and cognitive phenomena particular to its afflicted users' needs. The
organizing spatial principle for patients' rooms needed to differ from that
of ordinary rooms. In a perhaps direct, perhaps unconscious, and perhaps
completely unrelated allusion to one of Schmarsow's best-known premises—
that spatial experience depends on a vertically-aligned, ambulatory, embod-
ied subject—Aalto wrote that although most interior architectural spaces
accommodate an ambulatory person whose body is oriented along a verti-
cal axis, Paimio's patients would be lying down. Hence a sanatorium's spatial
organization needed to dissimilate the ordinary room in that it should be
designed not around a vertical axis in motion but around a stationary, low-
slung, horizontal one.[45]

One consequence, he continued, would be that ceilings, which archi-
tects typically over- (or, more accurately, under-) look, took on an unusually
prominent role in the design. Aalto thought through how his infirm users
would respond, visually and perceptually, to different ceiling colors and il-
lumination schemes. He oriented their bedrooms south-southeast, which, he
explained, offered the most variable natural light and allowed resting invalids
to bask in the morning's softer rays while shading their eyes from the glare of
the afternoon sun. He painted some walls to reflect light, others to absorb
it, depending upon how much sun each would receive in different seasons
and at different times of day. In the interest of visual variety, he exaggerated
tonal variation in the ceilings and used a dark-hued, highly saturated (and
therefore perceptually variable) bluish-green (figure 8.3). No overhead fix-
tures cast light into these resting patient's eyes: Aalto's scheme for artificial
lighting, combined with the room's dark tonal values, would greatly reduce
eye-stressing glare.

Aalto recounts the multitude of ways in which his analysis of his prospec-
tive users' auditory, sensorimotor, tactile, proprioceptive and psychologi-
cal experiences guided the design of the patient's rooms. Quiet reigned. He
placed access panels to plumbing fixtures in the hallways outside the bed-
rooms so that pipes could be serviced without disturbing a patient's rest.
He packed one wall in each room with sound-absorbing materials. Most
famously, he specially designed "noiseless sinks," reconfiguring the conven-

FIGURE 8.3. Paimio Sanitorium, patients' room with variations in painted ceiling.

FIGURE 8.4. Paimio Sanitorium, "noiseless" sink design. From pamphlet c. 1929.

tional sink basin to reduce the auditory disruption of tap water splashing at acute angles onto an impermeable porcelain surface (figure 8.4).

Attention to ambulatory spatial experience, and particularly to its potential to elicit metaphorical associations, also shaped the Paimio design. Entrants exit their automobiles at the turnabout and first come upon a low, somewhat dark space where they are diagonally deflected toward a large, light-flooded staircase backed wall to wall, floor to ceiling, by a multistory window. Aalto exaggerated this carefully constructed darkness-into-light spatial sequence, painting the staircase floors a highly saturated bright yellow (figure 8.5). Although the staircase's banister is metal—a signifier for modernity, efficiency, and hygiene—its handrail is wood, which he preferred because it is so much warmer to the touch. In a gentlemanly but devastating critique of Breuer's famous and endlessly reproduced chair designs, written

FIGURE 8.5. Paimio Sanitorium, staircase to patients' rooms.

FIGURE 8.6. Marcel Breuer, chair.

at about this time, Aalto counseled his colleagues that any object that comes "into close touch with the skin must not be made of a material that is an effective heat [and cold] conductor" (figures 8.6 and 8.7).[46]

A patient's experience of entering the world of the sanatorium metaphorically reenacts the experience of redemptive healing: one leaves the automobile, icon of modernity, and processes from darkness toward the sun, looking out onto the vast lucid stillness of wooded nature. The floor plans of the patients' bedrooms were also designed to reinforce the invalid's associations of warmth, brightness, and tranquility, with rooms arranged so that the patient can move easily from bed to wall-length desk (figure 8.8). Once seated, the patient looks out picture windows into the surrounding forest, an omnipresent reminder of her needed escape from the stresses and pollutants of urban life. In between the double-glazed windows Aalto threaded

FIGURE 8.7. Alvar Aalto, Paimio chair.

a heating element, warming the glass, a material highly sensitive to variations in temperature. Ensconced at her desk, the patient could read, write, or just look, resting her feet on the curving footrest protruding from that typically-recessed moment in a room where floor meets wall.

Aalto contended that the design principles he established in the Paimio project offered modernists a "deeper" rationalism, configured neither around abstract, mathematically bound systems (as did the techno-rationalists, with their grids and Euclidean geometries), nor around an analysis of a specific individual's or family's needs and the contours of that building's site (as might the organic functionalists, with their idiosyncratic curves), nor around the protean id seething beneath the socially adept ego (as might a

Venetian blinds
Fresh-air intake
Load-bearing structure

Bed
Bedside table
Soft surface to wall
Hard surface to wall

Lavatory basin

Load-bearing structure
Sanitary block

Ceiling painted dark

Bright, reflecting zone of ceiling
Light fitting
Radiant ceiling heating panel

FIGURE 8.8. Alvar Aalto, floor plan of patients' room at Paimio Sanatorium.

surrealist-inspired architecture). The rationalism of the sanatorium at Paimio accommodates the full experiential range of embodied cognitions, the true common property of human life.

Aalto's design of the sanatorium complex—its relationship to its site, the patients' rooms, the built-in and freestanding furniture, the heating and plumbing systems, the materials, the colors—all took form from his imagined projection of an embodied user hearing, seeing, and prospecting; touching windows, doors, handrails and sink handles; resting, walking, or being wheeled on a stretcher; consciously or unconsciously remembering past visual, tactile, and auditory cognitions. Aalto's explicitly detailed imaginings of

how his sanatorium patient would experience the building, physiologically and perceptually, demonstrates his deep assimilation of the principles of German experimental psychology, and his intuitive — "astonishingly rational" — sense that the available models of rationalism in architecture made no sense. The sanatorium interweaves the cognitive experience of the human sensorium with mnemonic associations, cognitive schemes, and primary metaphors to create a lived experience of peaceful comfort and psychic calm.

In his library for the town of Viipuri, Finland (now Vyborg, Russia), Aalto was charged with designing "the soul of the town's cultural life," a public library that sits perpendicular to a major nineteenth-century church, its main facade articulating one edge of a formal park and its rear façade looking out onto a forest.[47] The design process for the Viipuri Library was protracted over seven years. During this time the project's style evolved from a lightly ornamented neoclassicism to the purist geometry of the final, executed scheme: two rectangular prisms joined on one long side, with the smaller slid off the larger's line of symmetry. A foyer near the corner of the smaller, single-story block contained a dog-leg staircase backed floor-to-ceiling with plate glass.

Aalto's idiom did change from the first to the final schemes of the library, undoubtedly because he came under the influence of his German colleagues after a trip to a CIAM conference there in 1929. But in "The Humanizing of Architecture," Aalto insisted that throughout the long design process the library's central concept held. "When I designed the city library at Viipuri," he wrote, "I pursued the solution with the help of primitive sketches from some kind of fantastic mountain landscapes with cliffs lit up by suns in different positions" (figure 8.9). Aalto never really explained the meaning of this im-

FIGURE 8.9. Alvar Aalto, initial concept sketch of Viipuri Library.

age, which he implied had come upon him spontaneously. But from this vision, he "gradually arrived at the [architectural] concept for the library building."[48] The compositional transformation of the library project's idiom, he insisted, owed much to the particularities of its resiting to face both a formal park on one side and an informal woodland on the other.[49] The configuration of this final site inspired him, he wrote, to seek a less symmetrical, less historicizing composition, but changed nothing of the building's initial spatial concept: a fantastic mountain landscape with cliffs, lit up by suns in different positions.[50]

Taking Aalto at his word, delving not into the project's stylistic transformations but instead into the meaning of those initial "primitive" sketches, clarifies his guiding concept for the building and its continuity throughout its conception and execution. His sketchy imaginings elicit a raft of primary metaphors that steer the central compositional features of the library design. To adduce only examples discussed in the section on embodied rationalism above, using the idea of ascending a fantastic mountainscape for a library, "the soul of the town's cultural life," alludes to metaphors such as "knowledge is light," "the acquisition of knowledge is ascent up a path toward a given destination," and "thinking is seeing." Climbing a mountain, surveying and contemplating the views as light and shadows change with the day's passing, anticipating the monumental isolation and psychic clarity of the summit: these metaphors constitute the Viipuri library's central organizational tropes.

Giving architectural form to this vision of ascent inspired Aalto to employ a sectional approach. For the primary spatial sequence he exaggerated the user's procession from the distracting cacophony and visual "bombardment" of everyday life to an internalized, silent world. From one secondary entrance, closest to the street, the user enters a periodical reading room located below the main reading room, filled with rows of shoulder-height reading stands (figure 8.10). The room metaphorically evokes the transitory hustle and bustle of modern life: one imagines a user taking a quick detour inside on his way to work to scan the day's headlines, and then running back out without even so much as sitting down.

By contrast, from the main entrance foyer a user traverses an unwindowed path, then turns onto the cross-axis to ascend a dog-leg staircase that increases in width and illumination until entering at the upper level of a large,

FIGURE 8.10. Viipuri Library, periodical reading room.

double-height, single-span, multistory room that falls away from its apex at the access desk, like a cliff from a mountain summit (figures 8.11 and 8.12). A reading room, Aalto wrote, needs "a conserving and externally closed character." No views open up to the distractions of the world. As in Paimio, Aalto packed these brick walls with sound-absorbing materials, but here he also made them look "exceptionally strong." An otherworldly realm of silence, the reading room's visual, auditory, tactile, and spatial features focus the user on the central purpose of her destination. Here, as Aalto put it, is where books and people meet.[51] Vertically, bookshelves line the room; horizontally, large communal reading tables offer surfaces on which to lay out one's work. Another part of the room is filled with rows of individual carrels, each furnished with a bentwood storage unit to facilitate the reader's use of space without inhibiting her views of the roomscape, of other cliffs, and of other people.

In designing the reading room, Aalto wrote, he was principally concerned with the interrelationship of the reader, the book, and light. He determined that physiologically a reader needs even, indirect light for two reasons: so that distracting shadows will not fall upon her open book, and so that bright light will not reflect from the white page back into her eyes. His architectural

FIGURE 8.11. Viipuri Library, sequence to reading room.

FIGURE 8.12. Viipuri Library, reading room.

solution lay in the library's fifty-seven conical concrete skylights, each nearly four feet wide and six feet deep. The shape of the cones was determined by the angle the summer sun reaches at its highest possible point at that latitude on earth. Each skylight also contains retractable spotlights, which can be switched on and off to compensate for glare or shadows as the sun moves across the sky. This system, Aalto explained, made it possible in the Viipuri reading room, as at the top of a mountain, for light to come "from millions of directions" (figures 8.13 and 8.14).[52]

These skylights fulfill the physiologically and phenomenologically determined program Aalto set for himself in the library project: reader, book, light. Together with the room's horizontally and vertically expansive multileveled form, they also comprise the room's central compositional trope: a fantastic mountain landscape lit by many suns. Replete with accommodations to the bodily basis of human cognitive experience, the reading room also relies on universal cognitive schemas and primary metaphors. To reach it, the user must literally and figuratively ascend in order to attain a goal. The reading room is shaped around the user's bodily aspect when engaged in different pursuits: a researcher standing and moving about (see bottom of figure 8.13), a reader quietly sitting in imaginative thought.

Aalto's kit-of-parts organization for the library plan explicitly differentiated programmatically, architecturally, and experientially between what he called the "social" block and the block in which the reading room is housed. In choosing such an organization, Aalto draws upon the cognitive schema "Emotional states are physical containers" (as the primary metaphor "I feel at home there" serves to describe the sense of emotional well-being). The larger block, designed around the reader, silent and opaque to the external world, mainly contains the multilevel reading room. The smaller, narrower single-story "social" block houses offices, the periodical and children's reading rooms, and the famously wavy-ceilinged auditorium. The design of the reading room is centered on silent, private experience; the social block nurtures connections among people, and between people and the natural world.

The principal entrance to the social block, adjacent to the woodland park, begins in a foyer bathed in the filtered light of layered transparency, a space of transition from nature and urbanity to the sheltered world of social interchange and private scholarly pursuit. Aalto, symbolically emphasizing the

FIGURE 8.13. Alvar Aalto, sketch showing reader reading under artificial light, Viipuri Library.

. .

liminality of the foyer, trained vines to grow inside the floor-to-ceiling windows. He continued this theme of filtered layers of transparency between the space of the world and the communal spaces of the social block by containing the social activities within while offering his user the chance to imaginatively project her escape to a quieter world. Such a compositional strategy is especially evident in Aalto's design of the auditorium, where he reinforces the user's peripheral awareness of the woodland park by butting the wavy-shaped ceiling against the room's rectangular plate-glass windows. The windows look out into the forest canopy, as uneven and fluid as the ceiling inside. Aalto echoes this intermeshing of his projected user's fluid and multidirectional experience of the space of the world and her axial and directional

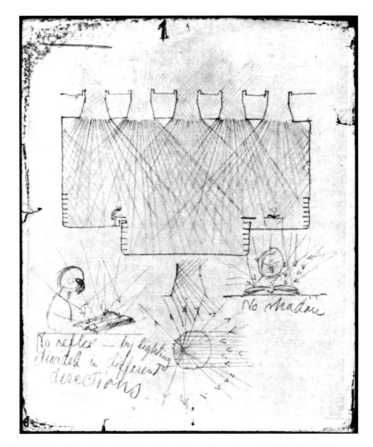

FIGURE 8.14. Alvar Aalto, sketch showing reader reading under natural light, Viipuri Library.

experience of the space of the library in the corridor walls that lead to the auditorium: at one moment, an apparently load-bearing wall breaks into a trunklike pair of columns; at another, these walls break into curves that arc this way, then that, gently shepherding comers inside.

Aalto explained how he had decided upon the undulating, wood-slat-covered ceiling of the long, narrow auditorium by considering the acoustical experience of both listeners and lecturers (figures 8.15 and 8.16). Although he spoke of the social block as the "block for the ear," his theoretical declarations and compositional gestures indicate that he referred to the ear not just in its biological sense: "I conceive acoustic questions mainly as physiological and psychological questions," he wrote. "Purely mechanical solutions are not

FIGURE 8.15. Viipuri Library, auditorium.

justifiable." He wanted to design a lecture hall without a lecture, imagining a room filled with participants engaged in a common discussion, sound waves traveling forward and backward. Revealing his socially democratic ideals, Aalto wrote that even in the design of a lecture hall, "general discussions should be just as important as individual performances."[53]

As in the Viipuri reading room, Aalto's physiognomically-derived solution becomes the compositional datum for the auditorium space, which formally instantiates the back-and-forth movement of conversation that it technically facilitates. (At the same time, it breaks up the linearity of what perhaps would otherwise be an excessively long and narrow room.) Finally, the dropped ceiling, which hides both the room's mechanical equipment and its structural armature, brings the room's vertical scale more into line with that of the human body.

Throughout the building, architectural details offer rich and highly variable tactile, visual, auditory, and experiential moments. Moving through the spaces of the library offers multiple opportunities for heightened sensory awareness: stucco walls, rubber flooring, plate glass, steel, and a wide variety

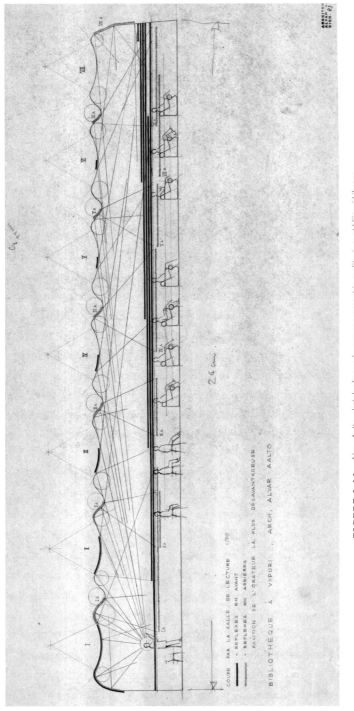

COUPE PAR LA SALLE DE LECTURE 1/50
* REFLEXES EN AVANT
* REFLEXES EN ARRIÈRES
POSITION DE L'ORATEUR LA PLUS DÉSAVANTAGEUSE

BIBLIOTHÈQUE À VIIPURI , ARCH. ALVAR AALTO

FIGURE 8.16. Alvar Aalto, sketch of sound wave movement in auditorium at Viipuri Library.

of woods—sycamore, oak, birch, red beech, and teak—each material placed according to its color, grain, tactile qualities and the level of wear Aalto anticipated it would receive.[54] The midsections of many interior columns are wrapped with rattan sheathing, offering extra stimulus and proprioceptive markers to passing hands. Woven wastebaskets are furnished with a rectangular shelf placed above their circular apertures, offering the user a surface so that she might shuffle through collected papers, separating wanted from unwanted. Here, as in the Paimio sanatorium, Aalto detailed and furnished the building by thinking through the users' often overlooked, sometimes invisible everyday needs.

Aalto's use of organic curves, careful attention to natural light, metaphoric references to the forms of nature (and in other instances also to local vernacular traditions), and frequent use of wood are often gathered into the rubric of his putative regionalism. Very often, his work exhibits an extraordinary sensitivity to the inflections, nuances, and character of a particular site or locale. Yet Aalto's regionalism, if we must employ that term, constituted part of his larger agenda, which was to create an architecture of embodied rationalism. The Paimio Sanitorium and Viipuri Library established the framework from which he drew in his designs for many subsequent works. These buildings are "regionalist" because the sensitivity to site, season, place, and memory inevitably figures into a phenomenologically-grounded modernism. After all, a perceiving, thinking subject is always situated in and bound to a place and a time.

In the Paimio Sanitorium and the Viipuri Library, Aalto offers two models of what he called for in "The Humanizing of Architecture": the "enlargement of rational method to encompass related fields." His enlarged rationalism is based on the phenomenological principles of embodied cognition: to paraphrase his own words, his rationalism would "prevent inhuman" (and therefore instead effectuate "humanist") results. Aalto's embodied rationalism, developed early in his career, continued to guide his approach to design for the rest of his life, and enabled him to create a number of iconic projects, many of which justly hold their place as some of the twentieth century's greatest buildings. Such projects include the Town Hall and Library at Säynätsalo, the Cultural Center in Wolfsburg, the MIT dormitories in Cambridge, and the House of Culture and National Pensions Buildings in Helsinki. In these and

other projects, Aalto developed a quiet, nuanced, phenomenologically dense architecture that remains unparalleled in the history of modernism.

Enlarging Rationalism

That the art of architecture would be impossible without the science of building is well known. With structural engineering buildings stand up; with mechanical engineering they are made habitable. Scientific research into existing materials and the creation of new materials centrally constitute the structural and tactile properties of the built world. New developments in technology and manufacturing systems provide the matter for evolutions, and lay the foundations for revolutions in architectural form.

Unlike many of the arts, then, architecture is inherently and inescapably embedded in the world of science. Yet, as our consideration of Aalto suggests, a more fundamental if less concrete way in which scientific thought shapes the conceptualization, practice, use, and interpretation of architecture has been too often ignored: the scientific research into the configuration and dynamics of human cognition. Aalto developed a philosophy and manner of design that were fundamentally shaped by notions about the nature of human perception and cognition—notions based on research generated by the scientific psychologists of his time. Using contemporary research methods as his model, Aalto also, although hardly systematically, conducted his own scientific investigations in the hopes of rationally determining the embodied effects of different architectural gestures and decisions. In this manner he developed his singular and lasting species of modernism.

What is indisputable about Aalto, and so deeply and manifestly embedded in his practice and product, is also true about other architects, historically and today. Aalto's modernist contemporaries were also beholden to a theory of mind: they were collectively in thrall to the dominant, triangulated model of rationalism that is now almost thoroughly discredited. It is, in fact, all but unimaginable that architects could design any building without—whether more or less self-consciously—bringing one or another theory of mind to bear on their work. Today we can find rafts of architects who are—more or less self-consciously—exploring the legacy of Aalto's embodied rationalism, drawing as he did—more or less self-consciously—on

contemporary research in cognitive neuroscience and neuropsychology on the nature of consciousness and perception. Examples run the gamut from high-profile designers such as the Pritzker Prize–winning Peter Zumthor to the less-celebrated architects of the contemporary spaces where the mental and emotional well-being of users is thought to be at a premium: hospitals, residential treatment centers for the mentally ill, and long-term residential facilities for the elderly.

Science must be integrated into our understanding of architecture and design in the various stages of the construction of the built environment, and for the various actors moving on the stage of the built world. Science and humanism interact to affect the architect's thinking, and to affect her design of a building. They interact to affect the building's effects upon the people inhabiting, moving through, and moving past it. They interact to affect our interpretations—artistic, humanistic, and scientific—of each stage of this process. They interact to affect how we, as pedagogues, teach architects their craft and teach the interpreters of architecture theirs. And each stage of these dynamics affects each of the others, actually and potentially, prospectively and recursively.

It is incumbent upon everyone involved in this web of practices—designers, clients, users, interpreters, and teachers—to become and make others more conscious of the many ways in which science and humanism merge in the built environment and in its effects on us all. More specifically, it is incumbent upon us all to develop and disseminate the best scientific notions about the embodied nature of human cognition and experience, so that our built world—our *world*—will be as human, as humane as it can possibly be.

Notes

1. Edward Ford, *The Details of Modern Architecture, Volume 2:1928–1988* (Cambridge, MA: MIT Press, 1996), 121–22.

2. Richard Weston, "Between Nature and Culture: Reflections on the Villa Mairea," in Winfried Nerdinger, ed., *Alvar Aalto: Toward a Human Modernism* (New York: Prestel, 1999), 61–76.

3. In the architectural history and theory of twentieth-century modernism, phenomenology is very often—one might even say almost always—associated with the mystical, antimodern phenomenology of Martin Heidegger. Because of this close

association with Heideggerian philosophy—with all its mystical, antimodern, and even quasi-fascistic implications—phenomenology has, in the discourse of the history and theory of modernism in architecture, either provoked outright hostility or simply been ignored by the two other dominant strains in the field: Marxist and post-Marxist studies influenced by the Frankfurt School, and psychoanalytically oriented studies influenced by Sigmund Freud and his followers. On the differences between Heideggerian phenomenology and the sort of phenomenology discussed here, most famously propounded by Maurice Merleau-Ponty, see Dermont Moran, *Introduction to Phenomenology*, (London: Routledge, 2000), 412, and passim.

4. Aalto, "The Humanizing of Architecture," *Technology Review* (1940), 15.

5. Aalto, "The Housing Problem" (1930) in Göran Schildt, *Alvar Aalto in His Own Words* (Helsinki: Otava Publishing, 1997), 80. The subsequent quotation by Aalto is from the same essay.

6. Aalto, "Rationalism and Man" (1935), in Schildt, idem., 91. The subsequent two quotations by Aalto are from the same essay.

7. Aalto, "The Stockholm Exhibition" (1930), in Schildt, idem., 76.

8. First two quotations are from Aalto, "Rationalism and Man," in Schildt, idem., 91; the quotation on intuition is Aalto to Göran Schildt, in Schildt, *Interviews with Alvar Aalto* (1972).

9. For discussions of rationalism in modern architecture, see Adrian Forty, *Words and Buildings: A Vocabulary of Modern Architecture* (New York: Thames & Hudson, 2000), 174–95, 276–91; Vittorio Lampugnani, *Encyclopedia of 20th-Century Architecture* (New York: Abrams, 1986), 275–78; Antoine Picon, introduction to Jean-Nicholas-Louis Durand, *Précis of the Lectures on Architecture* (Santa Monica: Getty Publications, 2000), 1–68.

10. Reyner Banham, *Theory and Design in the First Machine Age* (New York: Praeger, 1960), 9–34; Kenneth Frampton, *Modern Architecture: A Critical History*, third ed. (New York: Thames & Hudson, 1992), 12–19 and passim.; Robin Middleton and David Watkin, *Neoclassical and Nineteenth-Century Architecture* (New York: Rizzoli, 1987), passim.

11. See Vittorio Magnago Lampugnani, "Berlin Modernism and the Architecture of the Metropolis," 35–65; and Detlef Mertins, "Architectures of Becoming: Mies van der Rohe and the Avant Garde," 106–33; in *Mies in America*, ed. Terence Riley and Barry Bergdoll (New York: Museum of Modern Art, 2001).

12. For selected examples of this diametric opposition of techno-rationalism and organic functionalism, widely ranging in time, see Adolf Behne, *The Modern Functional Building* (1926; Santa Monica: Getty Publications, 1996); Sigfried Giedion, *Space, Time, and Architecture: The Growth of a New Tradition* (Cambridge, MA: Harvard University Press, 1941); Peter Blundell-Jones, *Hugo Häring: The Organic versus the Geometric* (Stuttgart: Axel Menges, 1999); Colin St. John Wilson, *The Other Tradition of Modern Architecture: The Uncompleted Project* (London: Academy Editions, 1995). Such oppositions

do not begin to capture the actual complexity of modernism in architecture; see Sarah Williams Goldhagen, "Something to Talk About: Modernism, Discourse, Style," *Journal of the Society of Architectural Historians* 64 (Summer 2006): 144–67.

13. Peter Markie, "Rationalism vs. Empiricism," *Stanford Encyclopedia of Philosophy*, http://plato.stanford.edu/entries/rationalism-empiricism.

14. George Lakoff and Mark Johnson, *Philosophy in the Flesh: The Embodied Mind and its Challenge to Western Thought* (New York: Basic Books, 1999), 391 ff.

15. Markie, idem., 4–5.

16. Lakoff and Johnson, *In the Flesh*, idem., 410–14.

17. Francisco Varela, Evan T. Thompson, and Eleanor Rosch, *The Embodied Mind: Cognitive Science and the Human Experience* (Cambridge, MA: MIT Press, 1991); many of the essays in José Luis Bermúdez, Anthony Marcel, and Naomi Eilan, *The Body and the Self* (Cambridge, MA: MIT Press, 1995); Anthony Dimasio, *Descartes' Error: Emotion, Reason, and the Human Brain* (New York: Avon Books, 1994); Anthony Dimasio, *The Feeling of What Happens: Body and Emotion in the Making of Consciousness* (New York: Harvest Books, 2000); George Lakoff and Mark Johnson, *Metaphors We Live By* (Chicago: University of Chicago Press, 1980) and *In the Flesh* (idem.); Mark L. Johnson, "Embodied Reason," in *Perspectives on Embodiment: The Intersections of Nature and Culture*, ed. Gail Weiss & Honi Fern Haber (New York: Routledge, 1999), 81–102; Steven Pinker, *The Language Instinct: How the Mind Creates Language* (New York: Williams Morrow, 1994).

18. Antonio Damasio, *Descartes' Error: Emotion, Reason, and the Human Brain* (New York: Picador, 1995); Antonio Damasio, *The Feeling of What Happens: Body and Emotion in the Making of Consciousness* (New York: Harvest, 2000).

19. Andrew N. Meltzoff and M. Keith Moore, "Infants' Understanding of People and Things: From Body Imitation to Folk Psychology," in *The Body and the Self*, 43–69.

20. Shaun Gallagher, "Body Schema and Intentionality," in *The Body and the Self*, 225–44; Maurice Merleau-Ponty, *The Phenomenology of Perception* (London: Routeledge, 1962), 118–19; Merleau-Ponty, "The Eye and the Mind," *The Primacy of Perception* (Evanston, IL: Northwestern University Press, 1964), 159–92; on Merleau-Ponty, see also Moran, *Introduction to Phenomenology*, idem., 391–434; Hubert L. Dreyfus, "Merleau-Ponty and Recent Cognitive Science," 129–50, and Richard Shusterman, "The Silent, Limping Body of Philosophy," 151–80, in *The Cambridge Companion to Merleau-Ponty*, Taylor Carman and Mark B. N. Hansen, eds. (New York: Cambridge University Press, 2005).

21. Lakoff and Johnson, *In the Flesh*, idem., 5. The discussion of primary metaphors and cognitive schemas in the subsequent two paragraphs is based on Lakoff and Johnson, 30–38 and 45–94.

22. Lakoff and Johnson, idem., 22–24.

23. Merleau-Ponty writes in *Phenomenology*, 100: "The word 'here' applied to my body does not refer to a determinate position in relation to other positions or to external co-ordinates, but the laying down of first co-ordinates."

24. Moran on Merleau-Ponty, idem., 423; see also Antonio Damasio, *Descartes' Error: Emotion, Reason, and the Human Brain* (New yYrk: Avon Books, 1995).

25. Mark Johnson, "Embodied Reason," in *Perspectives on Embodiment*, idem., passim, and Lakoff and Johnson, *In the Flesh*, idem., 122–37.

26. Eeva-Liisa Pelkonen first brought to light Aalto's exposure to empathy theory and scientific psychology in her *Alvar Aalto: Architecture, Modernity, Geopolitics* (New Haven: Yale University Press, 2009), although she takes her analysis of Aalto's work and his ideas in a very different direction than I do here.

27. Duane P. Schultz and Sydney Ellen Schultz, *A History of Modern Psychology*, 8th ed. (Belmont, CA: Wadsworth Publishers, 2004); Harry Francis Mallgrave and Eleftherios Ikonomou, introduction to *Empathy, Form, and Space: Problems in German Aesthetics 1873–1893* (Santa Monica, CA: Getty Publications, 1994), 1–85.

28. Wilhelm Wundt, *Principles of Physiological Psychology*, 1874; see also the section on Wundt in Schultze and Schultze, idem., 87–100, and R. I. Watson, Sr., *The Great Psychologists*, 4th edition (New York: J. B. Lippincott, 1978), chapter 12.

29. On Schmarsow, see Mallgrave and Ikonomou, idem., 60–66.

30. See Schmarsow, "The Essence of Architectural Creation" (1893), in Mallgrave and Ikonomou, *Empathy*, idem., 281–97 ("earthly scene" phrase appears on page 291); see also Michael Podro, *The Critical Historians of Art* (New Haven: Yale University Press, 1982), 143–49; Mitchell W. Schwarzer, "The Emergence of Architectural Space: August Schmarsow's Theory of *Raumgestaltung*," *Assemblage* 15 (August 1991), 48–61.

31. Schmarsow, "Essence," in *Empathy*, idem., 283.

32. Ritva Wäre, "National Romanticism in Finnish Architecture," www.broehan-museum.de.

33. Jyväskylä Department of Psychology website, http://www.jyu.fi/indexeng. Experimental psychology within the academy only became institutionalized as a separate discipline in the 1940s; Schultze and Schultze, *History*, idem., 100. For background information, see also Mark Jarzombek, *The Psychologizing of Modernity: Art/Architecture/History* (New York: Cambridge University Press, 2000).

34. Pelkonen, *Alvar Aalto*, idem.

35. Göran Schildt in Schildt, ed., *In His Own Words*, idem., 35.

36. Aalto, "The Hilltop Town," in Schildt, ed., idem., 49.

37. Aalto, "Temple Baths on Jyväskylä Ridge," in Schildt, ed., *In His Own Words*, idem., 18–19.

38. Schildt, "Alvar Aalto," *Grove Dictionary of Art Online* (New York: Grove, 1999).

39. Paul Klee's interest in phenomenology is discussed in Victoria Salley, "The

Master Years," in *Paul Klee: Selected by Genius, 1917–1933*, Roland Doschka, ed. (New York: Prestel, 2001), 12–14; Schildt discusses Aalto's friendship with Moholy-Nagy in *Alvar Aalto: The Decisive Years* (New York: Rizzoli, 1986), 70–78.

40. See, for example, Lásló Moholy-Nagy, *Vom Material zu Architektur* (Munich: Lagen, 1929).

41. Aalto, "Rationalism and Man," in Schildt, *In His Own Words*, idem., 92.

42. Ibid.

43. Aalto, "The Housing Problem," in Schildt, ed., *In His Own Words*, idem., 83.

44. Aalto, "The Humanizing of Architecture," idem., 14–15.

45. Schmarsow, "The Essence of Architectural Creation," in Mallgrave and Ikonomou, *Empath*, 289n35; also, in the same volume, Mallgrave and Ikonomou, introduction, 15.

46. Aalto, "Rationalism and Man," in Schildt, ed., *In His Own Words*, idem., 90.

47. Aalto, "Municipal Library in Viipuri: Description of the Building's Construction," *Municipal Library, Viipuri* (Jyväskylä: Alvar Aalto Museum, 1997), unpaginated. On the design process of the library, see also Spens' *Vipurii Library*, idem.

48. Aalto, quoted in Spens, idem., 36.

49. Aalto, "Municipal Library in Viipuri: Description of the Building's Construction," *Municipal Library, Viipuri* (Jyväskylä: Alvar Aalto Museum, 1997), unpaginated. On the design process of the library, see also Spens, *Vipurii Library*, idem.

50. Aalto, "Municipal Library," idem.

51. Ibid.

52. Aalto, "The Humanizing of Architecture," *Technology Review*, 36.

53. Aalto, "Municipal Library," idem.

54. Ibid.

NINE **Semantic Reciprocity**

. TOWARD A NEUROSCIENCE

OF CULTURAL CHANGE

. **Nicholas Tresilian**

This chapter looks at the two great periods of creative change in Western visual art, the Renaissance and the modern period, each of which correlates motivationally with a distinct phase in the evolution of the human ecology: the proto-industrial and the industrial respectively. These correlations raise two specific groups of questions for neuroscience. The proto-industrial phase raises questions about the reciprocal nature of our cognitive sensitivities to broad evolutionary change, given that the Renaissance constituted a shift from *closed* to *open* evolution while the correlative cultural change was from open to closed images. The industrial period raises questions about the nature of cognitive capacity, given that the "shrinking signal" of modernist visual art, far from being exceptional and against the cultural stream as was first thought, now stands revealed as one strand among very many shrinking signals marking the ubiquitous reductionism of the industrial age: in information-theoretic terms, apparent evidence of a culture or population experiencing semantic overload. A certain amount of art-historical brushwood first must be cleared away in order to reveal this picture: the Renaissance, with its cultural bias towards closed images, was largely successful in destroying the credibility of open images as an alternative basis for art—a bias arguably now working against the reemergence of open images in the installation and contextual art of recent decades. In order to present neuroscience with the story of Western art as it really happened, rather than as the West chose later to remember it, we must first of all reinstate the open ritualistic image as a valid alternative to the closed aesthetic image. In addition we will need to think the unthinkable by way of proposing a generalized mathematical description for the *attracting images* that are the common element in the art of every age.

Mirror, Mirror on the Wall

The essential connections between neuroscience and the single work of art, in this author's belief, have already been made in the pioneering work of Barbara Maria Stafford. Her recent publication *Echo Objects*[1] and her subsequent Templeton Lectures[2] have treated at length the mutual interpenetration of the individual mind and the single art object, in the process combining an art historian's sensitivity to the object with a neuroscientist's curiosity about human cognition. Just as important, this work has greatly widened the range of "objects" that can be considered relevant to the discussion of art, while locating mirroring at the center of the process of creating and responding to visual images. When visitors to an art gallery, like bees cruising an herbaceous border in search of pollen and honey, roam the picture rows in search of the subjective "hit" of aesthetic pleasure, Stafford has in effect been there ahead of them, providing the most authoritative description yet of what may be said to be happening cognitively in the act of aesthetic contemplation.

The Hall of Mirrors

There is another way of roaming the walls of any great art gallery offering a representative survey of Western art history since medieval times—at least where the works of art are displayed in chronological sequence and not in some curatorial rearrangement. That is to pay heed to the changing look of visual art across the ages, much as when a succession of still images on separate cards is "flickered" between finger and thumb to produce an animation of a walking man or a jumping horse—in this case, flickering the existing art-historical record to produce an animation of a distinctive strand of Western culture changing across time. But here we have a problem. The story of art,[3] as presented in our great art galleries and museums, has been edited to align it with the long-standing Western bias in favor of closed images: mainly easel paintings and free-standing sculptures. In line with this belief the sacred sites of the ancient world have been stripped of their painted and carved images, which are brought back into the Western museums and art galleries for exhibition profoundly out of context as examples

of primitive art: "noisy," childlike evidence of the nursery slopes of an art history exclusively dedicated to mankind's conquest of complex aesthetic space—a conquest first achieved in the "noiseless" imagery of classical art, and replicated two thousand years later in Western Renaissance painting and sculpture.

What would we actually find if we could rewind the videotape of the last several thousand years of art history; remove the barbed wire and tarmac encampments of the international heritage industry from around the ancient sacred sites; take away the signage, the public lavatories, and the visitors' shops; undo modern attempts at conservation; restore the walls, retile the roofs, reinstall the vandalized paintings and sculptures; repopulate the halls and courtyards with princes, priests and the common people; relight the smoking censers, guttering candles, and sacrificial fires; and reinstate the ancient liturgies? It surely would be nothing resembling a modern art gallery or museum—at least insofar as a gallery is a site specialized for the individual contemplation of closed aesthetic images, impermeable to external events. The sacred sites of old—the found environments of hunter-gatherer cave art and the constructed environments of agrarian temple art—were multidisciplinary interactive art environments, employed as channels for the production of collective rites of passage, and as such systemically open and permeable to external events. Their rich content of carved and painted art objects, representing divinities and positioned most often in interrelated series, were in place to participate as actors in rituals that took the form of events-in-time rather than objects-in-space, extended in the inexhaustibly novel space-time of human behavior.

The later Western preoccupation with the aesthetics of the art object has been allowed to bias the presentation of art history to the virtual exclusion of art's alternative, ritualistic origins. Yet the provision of symbolic content within sites intended for the performance of ritual was clearly the main occupation of visual artists throughout most of the history of art itself: thirty thousand years of hunter-gatherer ritualistic art at caves, sacred groves, mountaintops and other found environments, succeeded by a further ten thousand years of agrarian ritualistic art in ever more complex constructed environments: temples, henges, mastabas, tomb complexes, stone rows, ba-

silicas, sacred cities, mosques—not to mention the cathedrals, abbeys, and churches of the Christian religion, many of which are still in use today.

Holding the Mirror Up to Nature

If the Western-centric bias towards the object-in-space and against the event-in-time is one factor that undermines a more objective view of art history, another is the prevailing Western bias towards communication as a distribution of information from a sender to a receiver, to the exclusion of *attraction* as an alternative form of communication. Yet semantic attraction is fundamental to art in all its forms.

In this sense a great work of Renaissance art is like a two-way mirror. It *reflects back* to the eye a quantitative image, an imitation of some external signified (real or imaginary): a portrait of an important personage; a reclining nude; a landscape, an historical or mythological event; a rural or domestic scene; a still life of flowers, fishes, or slabs of beef. At the same time it also lets the eye *pass through* to relationships that are entirely qualitative, extended exclusively in the categories of space: hue, texture, tonality, outline and volume, relationships that have no intrinsic representational value at all, but in which, as scholars, critics, and art lovers broadly agree, the ultimate aesthetic value resides. Both these views afforded by the work of art, its *outscape* and *inscape*[4] respectively, are equally present to the attentive eye. But they deliver quite different kinds of meaning. The imitative outscape delivers a signal composed entirely of quantitative information. As such, it functions as a vector, obedient to the Aristotelian principle of contradictions which states that no entity can both have and not have the same property: black cannot simultaneously be white, death cannot be life, x cannot at the same time be not-x, and in engineering terms signal cannot simultaneously be noise. But if we now turn to the aesthetic inscape, to which the rational outscape effectively acts as a portal, we encounter a different set of values altogether. The inscape is all about qualitative relationships: it has to do with the simultaneity rather than the separation of opposites; it speaks in syncretisms, light/dark, near/far, great/small, active/passive, warm/cold; it is about bringing these simultaneities into equilibrium within the confines of the image, so that every x balances out with its correlative not-x, every dark is simultaneous with

light, everything near in three-dimensional perspective is simultaneous with far, and the work of art is thus cognitively "self-sufficient," containing all its meaning within its own boundaries.

So in Giorgione's *The Tempest*, in the Venice Accademia, the fractured light of an approaching thunderstorm suddenly brings human figures, the landscape, the far-off townscape, and the overarching menace of the sky into a single emotional unity. In the late self-portraits of Rembrandt, the grizzled head and battered features simultaneously emerge out of shadow and fall back into it as the forces of life contend with the gravitational inevitability of old age. The muted but crystalline light of a Vermeer interior simultaneously reveals and conceals the relationships of the individuals portrayed. And on an altogether more cosmological scale, Michelangelo's *Creation* in the Sistine Chapel opens up the tangled wood of the medieval scholiasts to the brilliant sunlight of Renaissance humanism while simultaneously embodying the values of both epochs. In all these instances the juxtaposition and equilibrium of opposing states of mind are driven by the juxtaposition and equilibrium of opposing plastic values.

Classical works of art may thus be described as possessing the property of "dual semantic organization": they are at once vectors distributing meaning and attractors binding meaning. The distributed meaning is the rational description of the replicated external other. The bound meaning, implicated in the physical object itself, is essentially *relational*: that is to say, it involves the observer in an act of bonding, an identification of self with the object observed, and a willing suspension of separate identity to achieve the necessary transfer of meaning between the work of art and the attentive eye.[5] In this sense a work of art is latently both "smooth" and "sticky": a platform for two orthogonally intersecting genres of meaning in the same semantic space.[6] Furthermore, only the rational quotient of the meaning of the work of art can, strictly speaking, be replicated. The relational quotient, namely the meaning embedded in the attractor, being integral with the materials of the work itself, constitutes a semantic singularity, and as such is nonreplicable.[7] The tourists who queue to flash their cameras at the triple panes of bulletproof glass protecting Leonardo's *Mona Lisa* may be prevented by the multiple reflections from ever seeing the work clearly, but they have been *in the presence of the unique object*, and their experience of the iconic work is to that extent authenticated.

The Stellar Cloud of Attractors

If works of art can function semantically as attractors, then surely art has little or nothing to do with the cultural isolation of the legendary ivory tower. On the contrary, art images must be seen as constituting just one small, albeit privileged, constellation amidst the vast stellar cloud of semantic attractors that animate contemporary culture. Advertisements, brands, and commercial products are attractors. Stars, celebrities, gurus, and popular leaders are attractors. Gigs, grand prix, grand slams, cup finals, and corridas are attractors. Fads, fashions, and lifestyles are attractors, as also on a notionally higher level of commitment are political ideologies and religious faiths. Clubs, corporate cultures, gangs, and families are attractors. Lovers, siblings, parents, friends, personal possessions, and superstitions are attractors. In effect, attractors are the "dark matter" of contemporary communication, still largely invisible to rational science, but massive in the cultural account.

That said, the great majority of semantic attractors in contemporary culture are directly subordinated to some overriding vector of rational interest—rates of exchange, ratings, revenues, market share, profitability, votes cast, and opinions sounded—or in the form of our personal dreams they are simply subject to affordability. It is in this respect that the attractors of visual art, and works of art generally, earn their often tendentious privileges. In art, normatively at least, relational meaning takes precedence over the rational: "fine" artists are in the business of producing *unsubordinated* attractors. In this way art fulfils its role as a pathfinding system for relational meaning in the world within which it is produced, and thereby functions as a source of wider creative influence for related visual media.

This does not change the fact that Western concepts of communication are strongly biased against the idea of semantic attraction per se. Despite Marshall McLuhan's postulate of the elision of medium and message in the mass media,[8] and despite the structuralists' insistence on the syncretism of the signifier and the signified,[9] the way to full scientific recognition of the semantic attractor is still blocked by the rationalist's bible on semantic issues: Claude Shannon and Warren Weaver's *Mathematical Theory of Communication*.[10]

The Thermodynamics of Communication

Claude Shannon's great aperçu in the *Theory* was that communication could be equated probabilistically with thermodynamic process: information, as a statistical measure, correlates mathematically with the entropy function. Entropy is a negative value measuring the loss of thermal efficiency from a heat engine due to turbulence within hot gas when it is performing work. The equation of information with "negative entropy" inspired Shannon to recognize equivalent inefficiencies in human communication, in the form of noise—a source of semantic turbulence reducing the information in the transmitted signal. Communication engineers seek to maximize signal and minimize noise. Shannon showed that if the input information H could be matched very precisely to the channel capacity c, such that $H = C$, then with correct coding the noise in the output could be reduced to a trivial quantity ε^{11} and a noiseless transmission of information could be achieved.

The Prigogine Attractor

Though Shannon's mathematical theory itself makes no reference to the semantics of attraction, if we accept Shannon's equation of communication with thermodynamic process, then in another part of the thermodynamic woods there exists an equation by Ilya Prigogine[12] which does indeed provide a generalized mathematical representation of an attractor. Consider any system with both closed and open characteristics (any living system would be a suitable example). The system can thus be characterized by a pair of entropy flows, $d_i S$ and $d_e S$, representing its *internal* and *external* processes respectively. Under the second principle of thermodynamics (the entropy of a closed system cannot decrease), any flow of the $d_i S$ must be positive. The flow of the $d_e S$, on the other hand, can be negative, representing the importation of more ordered materials into the system from the surrounding environment (e.g., information into the mind, food into the stomach). Where the internal and external entropy flows are equal and opposite and therefore the total entropy of the system dS sums to zero,

$$d_i S + d_e S \rightarrow dS \rightarrow 0$$

If the d_iS and d_eS can sum to zero in this way, then according to Prigogine the system will spontaneously return to equilibrium "for small fluctuations in its environment." In other words, the equilibrium state for the system *is itself the attractor*. Here in information-theoretic terms we have the familiar characteristics of the semantic attractor referred to above: the simultaneity of opposites, their juxtaposition within a single system, the association of equilibrium with spontaneity, and the homeostatic conservation or binding of systemic structure. The ubiquity of semantic attractors raises the question of whether the present experimental techniques of neuroscience, based as they often are on the presentation of simple flash cards, yet match up to the inherent complexity and ambiguity of the cultural messages which form the everyday basis of human communication.

A Thought Experiment in an Artist's Studio

As for the question of the relative validity of closed versus open attractors, consider the following thought experiment. In an artist's studio, compare the different ways in which the eye perceives the artist's life model when (a) the human body is at rest (e.g., the nude reclines) and (b) the human body is in motion (e.g., the nude descends a staircase).

- The nude reclining is an object-in-space, extended in the idiom of color, tonality, texture, outline, and volume.
- The nude descending the staircase is an event-in-time, extended in the idiom of frequency, amplitude, momentum, orientation, and velocity.

FIGURE 9.1. Left: nude reclining. Right: nude descending. Video captures © Artstation 1990.

Furthermore, there is a fundamental systemic difference between the two manifestations of the nude.

- The nude as object, isolated by the immobility of the pose, is systemically closed to events external to itself.
- The nude as event, in motion and on an advance to contact, is systemically open to events external to itself.

As a result, the distinguishing signal of each nude is a noise source for perception of the other.

- An event is a source of noise in our intuition of the object (when the model breaks the pose, the nude as object is immediately "misted" with visual uncertainty and the artist must stop work).
- Immobility is a source of noise in our intuition of the event (when the model stops moving, the nude as event is misted in uncertainty and the advance to contact is broken off).

Here, then, is one way of saying that ours is a species with one pair of eyes but two equally valid but mutually complementary ways of experiencing the world visually: as an object-in-space and as an event-in-time respectively. (Were human perception not polarized in this way, it would arguably be impossible ever to cross a busy road safely.) For the same reason, we also have two equally valid but mutually complementary opposite ways of producing the images of visual art: as attracting objects and as attracting events, each with their own distinctive "relations of production." Since attractors bind their own meaning, it is appropriate to distinguish between time-binding and space-binding art (see table 9.1).

TABLE 9.1

	Time-binding art	Space-binding art
	Open attractors	Closed attractors
	Rites of passage	Easel-paintings, plinth-sculptures
	"Environmental" in scale	Compact in scale
	Multidisciplinary	Single-disciplinary
	Macrocosmic in perspective	Microcosmic in perspective
	Permeable to external events	Impermeable to external events
	Temporally complex	Spatially complex
	Inclusive of space	Exclusive of time
	Interactive	Contemplative
	Eye-inside-looking-out	Eye-outside-looking-in
	Shared experience	Individual experience
	Ritualistic value	Aesthetic value

The event-in-time and the object-in-space are in this sense the "wave" and the "particle" of human communications, complementary conjugates such that the more we have of the one, the less we can possess of the other. Therefore, the ascendancy of the one genre of communications always undermines the validity of the other. Thus, during the five-hundred-year hegemony of the closed, spatial attractor in Western art, the alternative semantic potentials of the open, temporal attractor steadily lost their cultural appeal, progressively weakening the claims of the Christian religion, which, ever since bifurcating during the Renaissance into Reformation versus Counter-Reformation versions, has been in more or less continuous crisis. (It is to be noted, however, that the hegemony of space was exclusively a feature of Western elite culture. Popular culture remained firmly rooted in an earlier time-binding cultural tradition of ritualistic attractors—an orientation that still persists strongly in today's industrialized mass media).

Towards a New "Story of Art": The Renaissance

We can now begin to reconstruct the history of Western art on the basis of there being two equally valid but opposite "ways of seeing,"[13] and therefore also two "equal and opposite" ways of producing the attracting images of visual art. One thousand years ago Western art, far from being in a primitive state as our museums are mostly arranged to suggest, represented the fully ripened development of a tradition of agrarian temple art whose earliest origins are to be found in Asia Minor some ten thousand years ago. Its churches and cathedrals were massively constructed, environmentally scaled channels for the production of communal ritual in the form of the liturgy of the Christian religion, its key festivals locked into the seasonal cycle of the agrarian year. Visual art, in the form of painting, sculpture, and the emergent discipline of stained glass, made its contribution to the multidisciplinary continuum of music, movement, speech, and structured space-time through which the liturgy was enacted. The liturgy itself was "chunked" into formal modules of prayer, confession, intercession, celebration, readings, and communion, to be combined in appropriately ordered strings to provide rites of passage for the crucial points of transition in collective and individual life: the outbreak of war, the coming of spring, deaths and entrances, and so on.

The solidity and capital-intensive nature of the religious buildings in use one thousand years ago spoke of a world of settled ecological relationships based on the agrarian principle of "many tools for one use," which had long since given civilized settlement its defining sinews: agronomy, husbandry, construction, irrigation, transportation, the large-scale working of wood and stone, ceramics, weaving, metalworking . . . and later, numeration and writing. Whatever period of ecological improvisation and experiment had first brought agrarianism into being in the course of the great global warming at the end of the last ice age, and whatever competitive advantage it conferred on its early adopters, the innovative momentum had dissipated millennia before. This left agrarianism a globalized ecology in closed, iterative evolution, constrained to slow, self-similar growth by an "economics of scarcity" based on the deferral of risk through systems of reciprocal exchange and mutual obligation,[14] not dissimilar in structure and purpose to modern derivatives.

In the course of the Middle Ages, however, Western European civilization became the platform for a dizzying cross-weave of cultural changes, as the Western ecology migrated from closed/iterative to open/innovative evolution while art migrated in the opposite direction, from the open to the closed attractor. The Gothic arch and perspective geometry were the two principal agents of change for visual art, supplying the push and the pull respectively. The Gothic arch leveraged the semantic deconstruction of the old time-binding ritualistic environments by progressively penetrating, complicating, and attenuating their fabric, thereby multiplying the number of internal boundaries and closed niches. The architectural trend toward micro-enclosure in turn nudged church art towards the closed, space-binding attractor. (Milan Cathedral offers an example of the niche-enclosing tendency carried to the ultimate extreme.) The rediscovery of classical art simultaneously tilted the balance of artistic production strongly toward illusionistic space. Here the particular Western contribution was to systematize perspective geometry, so that the vanishing point fixed the illusion and at the same time provided a fulcrum around which the image could be brought into equilibrium, thereby promoting aesthetic self-sufficiency. Creative deconstruction and reconstruction thus went hand in hand in the evolution of the new space-binding art of the Renaissance: bringing with it the "rebirth"

of classical culture in the West some thousand years after the collapse of the original Western Roman Empire.

Far from emerging in a state of isolation, the new space-binding visual art was in its turn part of an exploding supernova of object-based "fine arts" appearing at the end of the medieval period, as the ritualistic event gave way to the aesthetic object in literature, drama, music, dance, and opera—books, poems, plays, ballets, operas, symphonies all being systemically "closed" in the sense that their aesthetic value was vested in a fixed and unique text, score, or notation essentially impermeable to time.

The proliferation of closed relational images in the fine arts was paralleled in the same period by a second supernova of mutually discrete *rational* disciplines as the "dark wood" of medieval scholasticism with its rambling syncretism of religion, mythology, astrology, divination, alchemy, necromancy ,and plain superstition deconstructed also, to reveal newly emergent forms of philosophy, law, mathematics, and science. These, too, took their lead from a rediscovered classical culture and were also produced in the form of closed, non-time-dependent cognitive images: equations, formulas, laws, principles, and "universals," all seeking to represent a non-time-dependent "truth."

This *swarming of the disciplines*, relational and rational together, with their synchronous transfer of attention from the open to the closed image and from temporal to spatial complexity, is the most remarkable phenomenon of the Western Renaissance. The obvious question it raises is lent added force by the "exploding supernova" aspect of Renaissance culture: Why did so many strongly motivated individuals in mutually discrete and largely autonomous disciplines march in apparent lockstep from the world as event to the world as object? What was the communal causation for the collective cultural action? The question becomes still curiouser, as Alice might say, when we recognize that in the same period the human ecology was migrating *in the opposite direction*, from closed to open evolution.

The Paradox of the Proto-Industrial

Some one thousand years ago the agrarian world from which the Renaissance presently unfolded was itself characterized by a closed/iterative ecology rich in self-similarity and the internal connectivity that flows from a culture of

open images. Yet throughout the Middle Ages the Western ecology was migrating systemically in the opposite direction to the Renaissance itself, towards a proto-industrial ecology in open/innovative growth.

The proto-industrial was the West's "hidden" revolution, twice screened from modern eyes. First it was screened because it was not in a full sense a "revolution," being essentially reversible: the proto-industrial retained the "many-hand-tools-for-one-use" ecology of the agrarians, speeding it up to deliver greater productivity by ganging tools together in machines and by coupling its machines to naturally available sources of energy within the biosphere, all while retaining manual forms of control. (Classical civilization, which was proto-industrial in all but name, achieved a similar ecological mobilization, which reverted back to a pond-like agrarianism after the collapse of the Western Roman Empire.) Second, it was screened by the much greater scale of the industrial revolution proper, which replaced the naturally available but unreliable energy sources for its machines by more reliable and controllable high-energy prime movers in the form of man-made engines: first the steam engine, and later the internal combustion engine, electric motor, gas turbine, and nuclear reactor. Industrialization, with its new techniques of mechanized mass production, rapidly overturned the refined materialism that lay at the heart of the proto-industrial mode of production (epitomized in the infinitely subtle surfaces of the closed Renaissance art image), and in the process set in train the work of decoupling the human hand from the human ecology, which the recent development of automation has since then massively accelerated.

The historian Fernand Braudel[15] was the great chronicler of the proto-industrial world and the poet of its refined materialism. Our concern with the proto-industrial here is only insofar as it provided the platform for the Western migration from closed to open evolution by the development of a new and highly competitive ecology of machines: a direction that would be continued in ever-accelerated form in the industrial age. Proof of the competitive superiority of the proto-industrial over the agrarian form of ecology was well established by the annus mirabilis of 1492, when the last Moorish dynasty was thrown out of Spain and the conquest of the Americas was set in train by Christopher Columbus. Thereafter the West converted its ecological superiority over the world's great agrarian civilizations into a license to expropriate

their economic and demographic resources, and on this basis it developed its own highly competitive and risk-positive "economics of plenty," animated by the permanent expectation of unlimited economic resources—the expectation which still drives capitalism today (though in the light of growing global shortages it is perhaps no longer so plausible).

Of Figures and Grounds

In the course of the Middle Ages, then, the proto-industrial West went from closed to open evolution while the culture of the Western elites went in the opposite direction, from the open to the closed image—in the process migrating visual art from a ritualistic to an aesthetic orientation. Yet for all that ideology and ecology seemed each to be going against the grain of the other, the two developments were mutually self-reinforcing. The cultural migration from the open to the closed image gave a new priority to the rational disciplines—particularly science, which in turn contributed materially to the ecological migration from closed to open evolution. In short, we are looking at a process of *mutual coevolution*, which suggests that we should be looking for our source of causation *within the process itself* rather than from somewhere beyond it. In addition, given that cultural change occurred across relational and rational disciplines simultaneously, we must be looking for a source of causation with a certain intrinsic universality.

The underlying causation for this pattern of reciprocal coevolutionary change must therefore be found in some basic cognitive mechanism, common to creative individuals across the disciplines and with the characteristic of mutual reciprocity already built in. In this sense the phenomenon of cultural reciprocity seems to point us directly to an already well-known feature of human perception: the mutual opposition of "figure" and "ground," whereby our visual system simplifies any visual scene into a figure which is perceptually dominant and a ground which contains everything else and is perceptually recessive: an economical distribution of attention in full accordance with the principle of least action (in the unthinkable alternative the ground would be dominant and the figure recessive). The opposition has mainly been studied by perceptual psychologists in terms of figure/ground ambiguities: notably the "Rubin vase," in which two juxtaposed profiled faces

Figure vs Ground

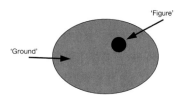

FIGURE 9.2. Figure versus ground.

. .

in black simultaneously outline a vase in white between them. Figure/ground equivocation also generated the characteristic counterillusionistic space of much op and kinetic art. But semantic reciprocity in the form in which we find it in art history has more to do with the normative status of the opposition than with its marginal effects.

The perceptual dominance of the figure vis-à-vis the recessive characteristics of the ground gives rise to the impression that perceptual selection is driven by the choice of figure, which in turn determines what is perceived as ground. The way images swarm synchronously across the disciplines in response to the changing dynamics of ecological evolution suggests, on the other hand, that where cultural evolution is concerned, variations in the perceived evolutionary ground determine reciprocal variations in the produced cultural figure—whence the open image prevails under conditions of closed evolution, the closed image under open evolution, each figure an emergent property of its complementary evolutionary ground. In cognitive terms, it seems, the human mind is *individually* sensitive to the dynamics of evolutionary context, giving rise by aggregation to *collective* reciprocal behavior. (Indeed, sensitivity to evolutionary context seems confirmed by the division of sensibility between elite and popular culture that arose out of the division of labor in the machine age: the closed, competitive culture of the ruling elites reflecting a perceived opening of evolutionary boundaries; the open, convivial culture of the working class reflecting a state of enclosure within the poverty and hard labor of the factory system.)

On this basis there is no need to postulate a "collective consciousness," let alone a "zeitgeist," to account for collective cultural change. The motivational

drivers for collective cultural change are already present in the individual brain, in the form of cognitive sensitivities to broad evolutionary context: sensitivities giving rise to cognitive responses which periodically both refresh and refocus individual creativity, and which at the same time complement rather than interfere in the localized mirroring activities we find expressed on the individual image. But if human cognition is context-sensitive in its attention to the changing ecological boundaries of human life, at how many other levels of social, cultural, and economic openness or closure does the context-sensitive mind also influence cultural output? The whole question of the relationship of context to content in human cognition seems potentially to lie open to neuroscience on this basis—at the same time opening yet another window upon the relationship between waking consciousness itself and "the secret hegemony of the unconscious mind."[16]

The Mirror Fragmented

The modern age was the second epoch of cultural deconstruction to shape and be shaped by the West's continued evolutionary progression towards open evolution. But whereas the evolutionary progression itself was intelligible enough—a process of ever-accelerating ecological development converting ever more economic resources to human use by the use of ever more powerful high-energy machines—the corresponding cultural changes were a source of considerable confusion—nowhere more so than in the "modernization" of visual art.

If further corroboration were needed of the linkage between change in art and change in the human ecology, it is surely to be seen in the progressive collapse of the noiseless Renaissance image from the mid-nineteenth century onwards, as the industrial revolution with its ever-accelerating dynamic began decisively to overwrite the proto-industrial world which had provided the Renaissance with its motivation. The notorious failure of the "noiseless" image to support aesthetic spontaneity in mid-nineteenth-century academic art prompted younger generations of artists to explore the alternative aesthetic potentials of the noisy image. But the noisy image in visual art proved to be a slippery slope. The "low-noise" paintings and sculptures

of the realists, impressionists and symbolists of the later nineteenth century were followed by the "intermediate noisiness" of the early-twentieth-century fauves, expressionists, and cubists, which in turn prompted the "high-noise" images of the abstract expressionists, suprematists, vorticists, futurists, constructivists, and Dadaists—the pioneers of nonfigural art. The academic indignation that had greeted the first low-noise images was nothing to the mass outrage caused by the chaotically simplified imagery of early non-figural art, which was widely deemed to have abolished aesthetic value altogether. A worldwide backlash against modernist art followed in the interwar years: a "return to the figure" enforced by political violence in the totalitarian states, and in the liberal economies somewhat improbably led by the former arch-modernist himself, Pablo Picasso. Only after World War II was the drive towards the aesthetics of chaos resumed—albeit with a certain sense of déjà vu—led at at first by the New York School, later expanded into the international lingua franca of minimalism. Minimalism in its turn would pave the way to the evanescent images of concept art, indeterminate between object and event, marking a new and potentially more disturbing creative threshold: the point of entry to a new phase of time-binding art.

Modernism in visual art effectively shattered the mirror of space-binding representation into myriad smaller pieces, but each of these pieces continued in its own way to reflect an aspect of an external world, albeit a world seen "in close-up," on an altogether larger scale of cultural magnification than before. In this sense nonfigural art continued to produce images with the characteristic two-way mirror-function of traditional fine art, with a rational outscape acting as portal to a relational inscape, but now on the basis of greatly reduced amounts of visual information—modernism's ever-shrinking signal. Although the portal to the modernist image was characteristically austere, consisting in some apparently random assemblage of points, lines, and planes, the vitality of the attractor still depended on the painter's or sculptor's ability to bring these elements into an active equilibrium, either in two or three dimensions of space. From this point of view it could be said that modernist art plumbed the fractal of the visible world at ever more elemental levels, and that at every level it has continued to reveal new aesthetic potentials to the attentive eye.

The Age of Reductionism

When modernism made its first entry into Western art, it had been as a thief in the night, stealing away piece by piece from from art itself everything that had seemed to make it accessible: fine finish, sensuous complexity, narrative content, figural representation, and most of all the art lover's cherished "hit" of aesthetic pleasure. By the second half of the twentieth century, however, the eyes of fresh generations of art critics, dealers, public patrons, and private collectors had recalibrated to the "shrinking signal" of minimalist art, while the pop art of the same period had defused the old "figural versus abstract" conflict by transferring figural imagery directly into nonfigural aesthetic space. In addition, in both pop art and minimalism, artists were freely taking imagery from the commercial worlds of the mass media and industrial design—an exchange taking place in both directions, as commercial media reciprocally took imagery from contemporary art. By then the thief in the night had finally come in from the cold, and from the 1970s onwards nonfigural art marched confidently into the world's great public art galleries and museums as an authentic representation of the space-binding tradition of visual art in its latest and most elegantly parsimonious form.

By now, too, modernist art with its shrinking signal could itself be seen as representative of an altogether wider movement in twentieth-century culture: the deconstructed idiom of *reductionism*—arguably the defining idiom of the industrial age. Had reductionism an ideology, a conscious system of belief, it would have been the one ideology held in common by left and right alike during its long heyday. But reductionism, like semantic reciprocity in the form in which we found it above, seems fundamentally reflexive—a subliminal bias which has driven a second cultural "swarming" in the form of a worldwide shrinkage of the semantic signal across all disciplines. Ludwig Mies van der Rohe's often-quoted dictum "less is more" was coined to rationalize reductionism. It also cleverly masked reductionism's abrupt inversion of classical values: where the complexity of Renaissance art had been central to its aesthetic value, modernist artists came to regard aesthetic complexity as so much noise, and to pursue an ever more simplified signal—and in this they both set and followed the pattern of thought that characterized the

industrial age. The reductionist pursuit of ultimate simplicities in every domain of human activity has entailed a systematic assault on known complexity in all its forms. It has most famously "split" the atom, reducing the complexity of the physical world to "elementary particles." In the same spirit it has also digitized money and meaning, atomized culture, McDonaldized the consumer society, and "monadised" the individual consumer; it has nucleated the old extended family and "dumbed down" education and mass entertainment; it has brought us human rights, global brands, and the urbanized indifference of "cool"; and above all it has produced a form of civilization uniquely adapted to continuous evolutionary development, a construction site for a new globalized ecology, simultaneously shantytown and casino city, shimmering in its own bright lights, economically dissipative and therefore perhaps ultimately transient.

The Issue of Cognitive Capacity

The flight from Renaissance aesthetic complexity in the modern age and the subsequent deconstruction of the work of art to the transient ambiguities of the artist's "mark," the "elementary particle" of aesthetic intuition explored in concept art, introduces a different set of issues for neuroscience: *namely cognitive capacity and the cultural effects of informational overload*. In this context it is appropriate to begin with the classical statement on the matter. The eleventh or "capacity" theorem of Claude Shannon's *Mathematical Theory of Communication*[17] deals with the performance of communication channels of finite carrying capacity, and with how they behave, depending on the amount of information transmitted through them. It states that for a channel of finite information capacity c receiving an informational input of amount H, if the input H is less than or equal to the capacity C ($H \leq C$ below), the informational content will be transmitted as an intact "signal," excepting only the trivial residual amount of entropy, "noise," or uncertainty ε already mentioned, which can be disregarded for all practical purposes.

But then the eleventh theorem goes on to deal with cases in which the information content of the input signal h *exceeds* the channel capacity C ($H > C$ below). The theorem states that in these cases, the surplus of H over C—the

Shannon's 11th Theorem

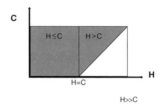

FIGURE 9.3. Shannon's eleventh theorem.

information overload $(H - C)$—will give rise to a proportional amount of "noise" in the channel output, thus reducing the informational value of the "signal" by the corresponding arithmetical amount.

In figure 9.3, the grey region corresponds to transmitted signal and the white region represents the progressive increase of noise in the transmitted output as the information overload $H - C$ increases towards $H = 2C$ and the signal "shrinks" accordingly towards zero.

Taking both parts of the narrative together, left-hand side first and then right-hand-side, Shannon's fundamental theorem for a discrete channel with noise seems accurately to represent the general evolution of cultural "signal" through the whole of the Western period of open/innovative ecological evolution: the left-hand side of figure 9.3 accounting for the "clean feed" of cultural complexity in the proto-industrial period $(H \leq C)$ and the right-hand-side for the shrinking aesthetic signal during the modern age—both migrations seen in the context of the steadily rising tide of cultural information resulting from the continuous expansion of the West's all-conquering machine ecology through its proto-industrial and industrial phases.

The evidence of Western art suggests that it was in the second half of the nineteenth century that the flow of information produced by continuing evolutionary growth began to exceed the capacity of human cognition or human culture (or perhaps both) to process it in its entirety—a subliminal threshold first marked in visual art by the spectacular mid-century collapse of the "fine finish" academic model of attractor already noted, with its bifurcation into the rationalized (and more accessible) forms of decorative and narrative art respectively. The corresponding suffusion of aesthetic imagery with

noise in realist, impressionist and symbolist painting and sculpture from the mid-century onwards, and with it Western artists' deeply controversial engagement with the shrinking cultural signal of the modern age was, from this point of view, a necessary *sauve-qui-peut* for aesthetic spontaneity itself.

If so, as well as questions for neuroscience about macroscopic *sensitivities* in human cognition, we now also have questions about macroscopic *constraints* on human cognition, arguably themselves arising from cultural overproduction. Can the mind be treated scientifically as a channel of limited capacity in the sense of Shannon? If so, is it able to "channel-switch" in order to produce different cultural outputs in different informational environments? Issues of cognitive "editing," cognitive self-management—and, for that matter, cognitive management of the individual by third parties controlling an information flow—are also raised here. In this respect an information-theoretic view of cognitive capacities seems to open the window directly onto issues of freedom and control in contemporary culture.

Reflecting Forward

Meanwhile the argument for semantic asymmetry has taken an unexpected new turn at the end of the modern age. Recent decades have seen the emergence of *postreductionist* cultural forms, apparently seeking a new engagement between culture and its evolutionary context. Here concept art—reductionism's last word on the visual arts—with its images, as already noted, *indeterminate between object and event*, far from representing the "death of art" which many opponents of modernism and some Dadaists had forecast, has turned out to mark the point of transition from the old space-binding painting and sculpture to the new installation and contextual art of the later twentieth and early twenty-first century. For all its unexpected emergence from a "quantum foam" of fugitive imagery, for all its *à tâtons* mode of progress, the new postreductionism brings artists to the foot of a potentially immense new creative learning curve, associated with the rediscovery and representation of their world in terms of *temporal* (as opposed to spatial) complexity. If in this respect the new time-binding art is delivering *speculative value* rather than any kind of cultural consensus, it is at the same time close in its questioning spirit to the ethos of Professor Stafford's *Echo Objects*, which has inspired

this present chapter. *Echo Objects*, in its turn, in its cross-disciplinary merging of art history with neuroscience, shares a spirit of cultural convergence with the postreductionist sciences of chaos and complexity, themselves actively addressing nature and culture as interrelating hierarchies of temporal systems,[18] and in the process redressing the former cultural imbalance towards elementary simplicities.

In short, the cultural figure seems now to be migrating strongly towards systemically *open* cognitive images again, and it is doing so apparently across both relational and rational disciplines. Might these changes in cultural production in their turn be giving us advance warning of a reciprocal change in the human ecology in the opposite direction, towards *closed* evolution? Notwithstanding the continuing capitalist commitment to the economics of super-plenty in the industrial age, might the "early adopters" in art and science already be picking up a different set of subliminal signals from the world around them: signals from a global ecology increasingly constrained in real terms by the economics of superscarcity—scarcity at a higher ecological level, the consequence of globalization itself bringing the whole of the human species into the same competition for industrial resources? There are certainly enough indicators of a coming superscarcity—in water, energy, agricultural land, clean air, and communications bandwidth—to justify active speculation about a return to closed, iterative evolution after the recent centuries of open, innovative ecological transformation. After all, thirty thousand years of hunter-gatherer cave art followed by ten thousand years of agrarian temple art sends us a strong message from the past that closed iterative evolution resulting in self-similar growth has been the default position for human evolution across many millennia at a time. On the same basis it could be argued that scarcity appears to be the default position for the human economy. In these circumstances it is no longer altogether unreasonable to postulate a possible scarcity-constrained future world in which ritual once again assumes the central role it used to play in human cultures, principally as a mediator of change. One of the abiding quests of the reductionist age has been for a grand unifying theory, or GUT, in physics, bringing gravitation, electromagnetism, and the strong and weak forces into a single theoretic framework. On the same basis one might think of a postreductionist age culturally dominated by GURs or grand unifying rituals. Little would be gained

by trying to second-guess the unguessable GURs of some post-industrial world of the future, needing to balance out the imponderables of supply and demand in a globalized and automated machine ecology. But a pointer to those GURs of the future might be found in certain GURs with origins far in the past. For instance, the formation flying of murmurations of starlings over their roosting grounds creates a rite of passage in which vast numbers of birds participate simultaneously, appearing to mediate the transition from competitive feeding to cooperative roosting at the end of the day, and clearly functioning as an attractor.

As dusk falls, thousands of birds have already formed into a billowing balloon which swells and rolls around in the air over the chosen wood, like a playful cumulonimbus cloud suddenly drawn close to the ground. Smaller flocks of birds returning from further fields continue to fly fast into the murmuration and are instantly absorbed into the great game. The game pits birds in compact formations, flying rapidly outwards to escape through the outer skin of the balloon, against the entire formation of birds forming the balloon itself, which is just as rapidly bulging its outer skin to outfly and contain the escapers. Occasionally groups of escapers fly fast enough to burst the skin, and the balloon billows out to reabsorb them. Other groups, playing their own game or simply outpaced, spin simultaneously in the air as they approach the freedom of the boundary skin, instantly merging back into the mass. Finally, in the last of the dusk and as though some desired point of mutual equilibrium between competition and cooperation has now been attained, the entire vast formation suddenly collapses into a thick black column of birds funnelling down through a single narrow aperture in the air, to spread out in their thousands across the tops of the trees and sink into the branches. Starlings are notoriously talkative creatures, but the formation flying has been carried out in total silence, barring the rapt whirring of thousands of pairs of wings. Now, as the birds touch down in the trees, suddenly the entire flock bursts out chattering.

Notes

1. Stafford, B. 2007. *Echo Objects: The Cognitive Work of Images* Chicago: University of Chicago Press.

2. Stafford, B. 2008. Lecture series as Templeton Fellow, "Crystal and Smoke: Facets of Cognitive Aesthetics," University of Southern California. Cf .the extended discussion of the cognitive implications of the patterned surface of a paved road in lecture 2: "Cold Intimacy/Hot Entanglement: Meaning in Combinations."

3. The definitive Western-centric account is to be found in Gombrich, E. H. 1950. *The Story of Art*. London: Phaidon Press.

4. The term "inscape" was coined by the Victorian poet Gerard Manley Hopkins in reference to the unique patterning of individual identity in things and people. An updated version of the same idea is to be found in David Bohm's concept of *implicate order* in Bohm, D. 1980. *Wholeness and the Implicate Order*. London: Routledge & Kegan Paul.

5. The art lover earnestly bonding with the aesthetic attractor was the subject of much ribaldry over the years in the leading British humor magazine *Punch*.

6. In a longer discussion, the "orthogonal" relationship of relational and rational meaning suggested here might cautiously be bracketed with the concept of "bisociation," as in Koestler, A. 1967. *The Act of Creation*. New York: Dell.

7. The element of relational nonreplicability in works of art would seem to disqualify them as "memes" in the sense of Richard Dawkins in Dawkins, R. 1976. *The Selfish Gene*. Oxford: Oxford University Press. An alternative argument might be that meme theory has not yet come to terms with the real complexity of culture, and if it is ever going to do so it will surely need to prioritize the brain as producer of cognitive images over the brain as receiver.

8. McLuhan, M., and Fiore, Q., 1967. *The Medium is the Massage*. New York: Bantam Books/Random House.

9. Levi-Strauss, C. 1963. *Structural Anthropology*. New York: Basic Books.

10. Shannon, C. E., and Weaver, W. 1949/69. *The Mathematical Theory of Communication*. Chicago and London: University of Illinois Press.

11. Shannon's ε may arguably be seen as the communications equivalent of Planck's constant h—the acknowledgement of an irreducible least amount of semantic uncertainty in every act of communication.

12. Prigogine, I. 1955/67. *Introduction to the Thermodynamics of Irreversible Process*. New York: Interscience.

13. The critic John Berger came close to recognizing the complementary relationship of space-binding and time-binding images, but was arguably prevented by his political commitment to an ideology of painterly realism. Berger, J. 1972. *Ways of Seeing*. London: British Broadcasting Corporation and Penguin Books.

14. A statement of some of the fundamental issues of the economics of scarcity is to be found in: Sahlins, M. 1972/2004. *Stone Age Economics*. London: Routledge.

15. Braudel, F. 1981. *The Structures of Everyday Life*, vols I–III. London: Collins. New York: Harper & Row.

SEMANTIC RECIPCROCITY || 333

16. I owe this phrase to David Eagleman, from his lecture *The Brain and the Law*, at The Royal Society of Arts, London, April 21, 2009. (Available from the sound archive at www.thersa.com)

17. Ibid. p.71.

18. A groundbreaking "hierarchical theory of time" is to be found in Fraser. J. T., 1987. *Time the Familiar Stranger*, Amherst: University of Massachusetts Press, USA.

Contributors

David Michael Bashwiner is assistant professor of music theory at the University of New Mexico. In 2010 he graduated with a PhD in the history and theory of music from the University of Chicago, having authored a dissertation entitled "Musical Emotion: Towards a Biologically Grounded Theory." In addition to his theoretical work, he also composes both popular songs and film scores, including the soundtrack to the feature film *Crime Fiction* (2007).

Anne C. Benvenuti is professor of philosophy and psychology at Cerro Coso College, California, visiting scholar at the University of Chicago Divinity School, and visiting scholar at Georgetown University Medical School, engaged in interdisciplinary research in theology, philosophy, psychology, and neuroscience. She is a member of the Chicago Group on Science and Religion. She holds a BA in theology from the University of San Francisco and MA and PhD degrees in psychology from the University of California, Los Angeles, and is a licensed clinical psychologist.

Elizabeth J. L. Davenport is dean of Rockefeller Chapel and director of spiritual life at the University of Chicago, and senior lecturer at the University of Chicago Divinity School. She holds BA and MA degrees in theology from Oxford University and a PhD in religion and social ethics from the University of Southern California, where she was on the faculty at the Keck School of Medicine while also serving as senior associate dean of religious life.

Frank Echenhofer has been a professor of clinical psychology at the California Institute of Integral Studies in San Francisco since 1999. He teaches experiential and transpersonal psychotherapy, lifespan developmental psychology, and the cognitive and affective foundations of behavior, among other courses. He was the principal investigator examining the EEG correlates of Tibetan Buddhist meditators in the Dalai Lama's monastery in India in 1991. Since 2000 he has conducted EEG research in shamanic journey practices in the Brazilian and Peruvian Amazon. His current primary area of basic research is the comparative and multidisciplinary study of visionary and kinesthetic process experiences in different spiritual traditions and the related iconography, symbolism, and sacred arts indicative

of these experiences. His current applied area of research is in exploring ways to facilitate visionary and kinesthetic process experiences for healing purposes in psychotherapy and the healing arts.

Philip J. Ethington is professor of history and political science at the University of Southern California, North American editor and multimedia editor of the journal *Urban History* (Cambridge University Press and Cambridge Journals Online), and codirector (with Tara McPherson) of the USC Center for Transformative Scholarship. An interdisciplinary historian of cities, Ethington explores the past as a cartography of time. Mobilizing the tools of social sciences, humanities, and graphic arts, he also experiments with new media to expand the range of analysis and publication to study and represent the vastly complex global metropolis. His recent published work includes writings on a spatiovisual theory of historical epistemology ("Placing the Past"); sociological studies of residential segregation; global narratives of Los Angeles; large-format "chronocartography"; digital archive and online access collaborations (*HyperCities*); the life and work of photographer Julius Shulman (writer, *Visual Acoustics*, premiered June 2008); a geographic model of American political development (with David Levitus); studies in urban residential stability and change (with urban economist Chris Redfearn); and multimedia collaborations with the artists Robbert Flick and Tomo Isoyama. Ethington was a founding member and longtime leader of the LA as Subject Archives Forum, a consortium of more than two hundred archives in the Los Angeles region. He is a co-recipient of the MacArthur/HASTAC Digital Media and Learning competition for *HyperCities* (with Todd Presner, et al.). As director of digital archive integration (1997–2003) and associate dean of libraries (2003–7), Ethington played a key role in the creation of USC's digital archives. He also serves as the chair of the Academic Advisory Board to the Los Angeles City Human Relations Commission. Ethington's photography and cartography has been published and exhibited internationally; he is currently completing a large-format graphic book, interactive online publication, and public art exhibit entitled *Ghost Metropolis: Los Angeles Since 13,000 BP*.

Sarah Williams Goldhagen, the *New Republic*'s architecture critic, is a historian, critic, and theorist of modern and contemporary architecture. Before deciding to devote herself full-time to writing, she taught for ten years at the Harvard Design School; she has also taught and lectured at numerous other colleges and universities. Goldhagen is the author of *Louis Kahn's Situated Modernism* (Yale University Press, 2001) and editor, with Réjean Legault, of *Anxious Modernisms: Experi-*

mentation in Postwar Architectural Culture (MIT Press, 2001). Her writings have appeared in numerous scholarly and general interest publications. She is currently writing a book on the experience of the built environment.

Thomas Habinek is professor and chair of classics at the University of Southern California. His previous work has focused on the pragmatics of cultural production, especially in classical Rome. His books include *The Politics of Latin Literature* (Princeton 1998), *Ancient Rhetoric and Oratory* (Blackwell 2005), and *The World of Roman Song: From Ritualized Speech to Social Order* (Johns Hopkins 2005), winner of an Outstanding Achievement Award from the Association of American Publishers. His essay in this volume is part of a new set of projects considering the aesthetic and ethical implications of models of mind, past, and present.

Naoum P. Issa received his doctoral degrees in medicine and neuroscience from the University of Texas–Southwestern Medical Center, where he studied hair cells of the vestibular system. He then studied cortical processing of visual stimuli as a postdoctoral fellow at the University of California, San Francisco. In 2001 he joined the faculty of the University of Chicago, where his lab studied the neural processing of sensory stimuli in both cortical and subcortical structures.

Susanne Küchler is professor of anthropology at University College, specializing in material culture studies. She has undertaken anthropological research in Papua New Guinea and in Polynesia and has published widely on image, memory and exchange, as well as on innovation, materiality, and material translation. Her most recent work is concerned with new materials and questions of the mind.

Ari Rosenberg received his BA in liberal arts and sciences with a concentration in cognitive science from the Wilkes Honors College of Florida Atlantic University, where he studied the dimensionality of sociopolitical attitudes. He then received his PhD in computational neuroscience from the University of Chicago, where he studied nonlinear processing in the early visual system. He is currently a postdoctoral scholar at the Washington University School of Medicine in St. Louis. His contribution to this work was supported by National Institutes of Health grant EY13360.

Nicholas Tresilian is an art historian, broadcaster, and former founding director of media PLCs in the UK and Europe, including Classic FM, for which he also broadcast for ten years. Author of the Private Landscapes series of films for BBC Two, he lectured on twentieth-century art, media, and science at the Central

School in London, at Maidstone and Cardiff Colleges of Art, and at the Architectural Association. He was for many years a director of the Artist Placement Group and its successor Organisation and Imagination Ltd., pioneers in the placement of artists within government organizations. He was recently vice president of the US–based International Society for the Study of Time, of which he remains a member. He lectures and writes on the relationship between art history and cultural evolution. He lives in Bath in the United Kingdom and near Cordoba in Spain.

Index

Aalto, Alvar, x, 3, 268; and experimental psychology, 271, 280, 282–86, 293; figuration and metaphor, 270; flexible standardization, 269; humanism of, 270–71, 284–85, 293–94, 302–3; influences, 269; Paimio Sanatorium, 271, 272, 285–93, 295, 302; particularism, 270; and phenomenology, 271; rationalism of, 270–71, 272, 284, 285–304, 294, 302, 303–4; Viipuri Library, 271, 272, 285, 293–302
abstract expressionism, 130–31, 325
abstraction, 55–56
action, perception and, 76
addiction: and moral behavior, 215; treatment, 179–80; and video games, 50
adoration, 53, 55
Adorno, Theodor, 133
aesthetics: art as aesthetic entertainment with leisure value, 5–6; and physiological reactions, ix; physiological response to, 246–51, 252–59; science of sensuous knowing, 1; of surrender, 19
affective power, 11, 47; of the sonic and the gestural, x
AI, 91–92
Alberti, Leon Battista, 129, 130
alchemy, 163
Alpers, Svetlana, 131
Althusser, L., 73
altruistic behavior, 31
Alzheimer's disease, 215
Amazonian brew of ayahuasca. See ayahuasca
Amiet, Cuno, 48–49
amygdala, x, 256, 258
anthropology, ix, 2–3, 32, 149; Cook Island quilts, 97–102; experiential transformational change processes, 158; and neuroscience, 85, 95–96, 102, 104; relativism in, 128; and smart materials, 94, 96–97
Anzieu, Didier, 85–86, 88–89

architecture, ix, 3, 5; acoustics, 299–300, 301 fig. 8.16; connection of design to phenomenology of body-based metaphors, x; epistemological tradition in, 274–75; functionalism, 269, 270; materiality of exteriorized interiority, 87–88; modernism, 268–72, organic functionalism, 274, 275, 276, 291; particularism, 270; photographs of vertical architecture-scapes, 15; rationalism in, 267–69, 270–71, 272–79, 284, 285–304, 294; Romanesque capitals, 27; spatial experience, 286, 288, 290, 292–93; standardization in, 269; structural rationalism, 273–74; techno-rationalism, 273–74, 275, 276, 291; transdisciplinary multimedia museums, 6; universal style, 269–70. See also names of architects
Aristotle, 6, 67
Arkana, Elizabeth, 98
Arndt, Ernst Moritz, 243–44
Arnheim, Rudolf, 130–31, 188
Arp, Hans, 269, 275–76
art: as adaptive social practice, 10; as aesthetic entertainment with leisure value, 5–6; as biological, 17; correlating with brain sciences, viii; defined by Rilke, 23; as magical thinking, 17; and mirror-neuron theory, 11–12; precortical principles of perception manifested in, 3; as romance, 17; skeletal formats underlying complex artistic productions, 14–15; sociable art, 6; as social, 17; as synthetic, 17; theory of, 11; and the truths of science, 1. See also art history; visual art
art history, ix, x, 3–4, 123, 310–12
artificial intelligence, 91
artificial life, biological approaches to, 91–92
artistic formats, 19

artistic mimesis, 23
Ashby, Jonathan, 93–94
as-if body states, 30
Asplund, Eric Gunnar, 293
assent, impulse and, 76
association of ideas theory, 244–45
attentional system, 50, 52, 53, 55, 147, 258–59
attractors, 314, 328; closed vs. open, 316–18, 319, 320, 322; semantic attractors, 314, 315–16, 318; visual art as, 313, 314, 315–16
attunement, 174, 176–77, 184, 188, 191, 192
Auden, W. H., 53
auditory illusions, 110–13
Austen, Jane, 30
Austin, James, 225, 226–27
Australopithecus, 36
automaticity, 47, 51, 52
autonomous systems, creation of, ix
ayahuasca, 41, 153; and brain function, 158; and creative processes, 159–60; EEG studies, 180–84, 193–94; and healing processes, 159–60, 176; imagery during use, 177; models of dreaming or waking spontaneous experience, 165–72; neuroscience correlates of, 178–84, 193–96; and spiritual development, 159–60; as state of consciousness, 158; visionary themes during use, ix, 3, 154–57, 170–72

Bagby, Michael, 215
Ball, Phillip, 92
Bartels, Andreas, 138
Barthes, Roland, 133, 136
Bashwiner, David Michael, x, 3, 24, 239–62
Bauhaus workshops, 272–73, 274
Baxandall, Michael, 74
Beauregard, Mario, 227
Beckett, Samuel, 47
behavioral binding, 218–19; and the brain, 209–15
being, integral sense of, 206–7
Bell, C., 73
Benjamin, Walter, 133
Benvenuti, Anne C., ix–x, 3, 15, 41
Bergson, Henri, 24
Berkeley, George, 48
biology: cells as hardware, 21; coevolv-

ing with culture, 2; and sociology, ix; synthetic biology, 21; transdisciplinary multimedia museums, 6
biomimesis, 92
Birmingham School of cultural Marxism, 126
Blake, William, 14–15
blogging, 49
body-based metaphors, 3; connection of building design to, x
Book of Hours, The (Rilke), 23
Bourdieu, Pierre, 73, 128
brain function: and ayahuasca use, 158; and behavior, 209–15; experience-dependent plasticity, 211–13; injuries, 215; neurons, 210–12, 214; and spiritual practices, 225–28
brain mapping, 125, 143; and subjective experiences, 207–9
brain-mind continuum, 125
brain sciences, 45, 125; basal ganglia function, 47; correlating with arts, humanities, and social sciences, viii; dance activating subcortical basal ganglia, 24; drive and seeking system distinguished, 50; engram-like memory pockets, x; inner synchronization, 26; language and localized cortical structures, 24; micro-structure of brain states and worldly macro-trends, 3–4; mirror neurons (*see* mirror neurons); neural Darwinism (*see* neural Darwinism); neurogenesis or neuroplasticity, 8, 10; in piecing formats, 47–48; primate studies, 13–14; and reading, 33; right-hemisphere functions, 37, 50; self-organizing and highly structured brain activity, 19; spontaneous generation of hybrid images during psychedelic healing, ix; subcortical activity, 51–52; subcortical structure and prelinguistic past, 24–25; and the truths of art, 1, 33; voluntary movements, 8
Braudel, Fernand, 321–22
Breton, André, 276
Breuer, Marcel, 272–73, 288, 290
Brewster, David, 135, 141–42
Brodmann, Korbinian, 143
Brooks, Rodney, 77

Brunelleschi, Filippo, 129
Buci-Glucksmann, Christine, 131
Buddhist meditation practice, 225–27
Burghers of Calais (Rodin), 52
burial rites and sites, 40–41
Burke, Edmund, 274–75
Byatt, A. S., 35
Byrne, Richard, 31

Cacioppo, John, 214
Cage, John, 28
Cagnacci, Guido, 52
Calder, Alexander, 269
Camera Lucida (Barthes), 133
camera obscura, use of, 131
Campbell, Alfred W., 143
Campbell, Joseph, 165
capitalist consumer culture, 133, 141, 330
Carmelite nuns, mystical experience of, 227
Carr, Nicholas, 51
Cartesian dualism, 206
Cartesian intellectualism, 276–77
Casey, Edward, 127
causation, chain of, 75
cave art, 38–39, 204, 206, 230, 330
caves: adaptive demands on viewer, 41; as
 synonymous with mind, 36–37, 41–42
Cayley, John, 25
cell phones, face-to-face interactions and, 49
cells as hardware, 21
central nervous system, evolution of, 14
cerebral cartography. *See* brain mapping
cerebral cortex: chronoarchitecture of, 138;
 and perception, 119–20; in vision, 114–15
Changeux, Jean-Pierre, ix, 7–8, 10, 11
Chaves, Milciades, 154
Chavin religious practices, 186–87, 191
chemical theory of vision, 7–8
chemistry, smart materials and, 95
chimpanzees, mimicry of, 30
Choisy, Auguste, 273
Chomsky, Noam, 24, 126
Cicero, 74
Clare, Anthony, 231
Clark, Andy, 5, 84
classics, ix, 123
cognition, 30, 37, 277–78; as both external

and internal, 65–78; constraints on,
329; in constructive re-imaging or re-
imagining, 11; decentralized mode of,
89–90; as disconnected control, 72; em-
bedded in motor skills, 29; as inhabited
interaction, 72; nonconscious mecha-
nisms integrated with, 15; philosophical
model of, 276, 278, 279–80; scientific ap-
proach to, 281–82; Stoic view of, 65–78;
subjectivism, 281
cognitive capacity, 327–29
cognitively sticky inter-artifactual relations,
94
cognitive philosophy, 126
cognitive psychology, ix, 3; enaction in, 5
cognitive sciences, 4; innovations coming
 from, vii
cognitive work, 186
collective visual cultural action, x, 323–24
Collins, Billy, 17
commingling of discrete entities, 66
communication of data, 6–7
complexity, 327–28; science of, 21
complexity theory, 168
compositional entanglement, 21–22
computer sciences: smart materials (*see*
 smart materials); transdisciplinary mul-
 timedia museums, 6
concept construction, role of images in, 5
concrete, 94; and smart materials, 96–102
conflagration doctrine, 71
Congrès Internationaux d'Architects Mod-
 ernes, 272, 293
connectivity, 85, 95; abstract modeling of,
 90–91; Goethe's concept of, 84; immate-
 rial modality of, 90; and smart materials,
 95–96
consciousness, 50, 95, 193, 208; autonoetic
 consciousness, 39; and ayahuasca use,
 158; decentralized self-organizing, ix; as
 first-person and third-person phenom-
 enon, 23–24; meditative self-awareness
 integrated with planetary consciousness,
 x; memory as, 35; performative theory of,
 8–9; and place, 35–36, 280; religious rituals
 and initiatory ordeals, 37–38; and spiritual
 practices, 225–28; as a stream, 46